Yesterday's Silver

for Today's Table

A Silver Collector's Guide to Elegant Dining

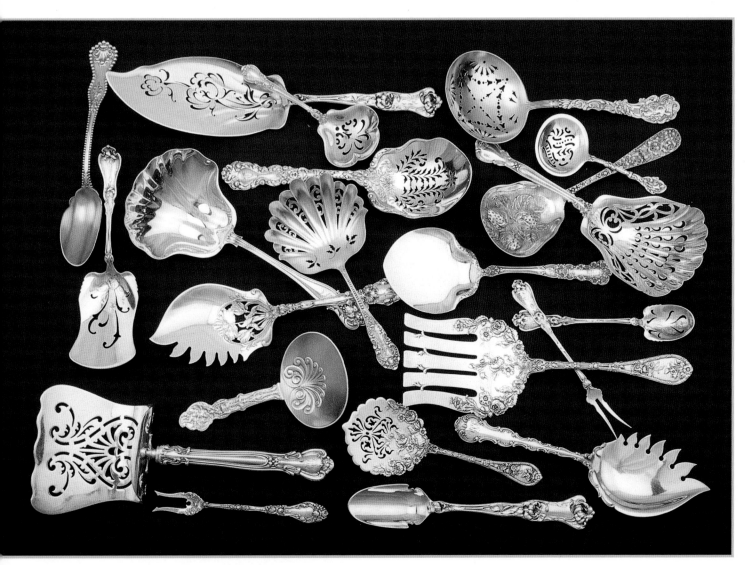

Richard Osterberg

4880 Lower Valley Road, Atglen, PA 19310 USA

Dedication

This book is dedicated to all those people who through the years shared their love and lore of silver with me. Thanks to each and every one of you and especially to Jane Dickinson, a long time friend and a true silver aficionado.

Library of Congress Cataloging-in-Publication Data

Osterberg, Richard F., 1938-
 Yesterday's silver for today's table: a silver collector's guide to elegant dining/Richard Osterberg.
 p. cm.
 ISBN 0-7643-1420-3
 1. Silver flatware--Collectors and collecting--United States--Catalogs. 2. Silver flatware--United States--History--19th century--Catalogs, 3. Silver flatware--Patterns. I. Title.
 NK7234 .O886 2001
 739.2'3773'075--dc21
 2001003207

Designed by "Sue"
Type set in Nuptial BT/Korinna BT

ISBN: 0-7643-1420-3
Printed in China
1 2 3 4

Published by Schiffer Publishing Ltd.
4880 Lower Valley Road
Atglen, PA 19310
Phone: (610) 593-1777; Fax: (610) 593-2002
E-mail: Schifferbk@aol.com
Please visit our web site catalog at **www.schifferbooks.com**
We are always looking for people to write books on new and related subjects. If you have an idea for a book please contact us at the above address.

This book may be purchased from the publisher.
Include $3.95 for shipping.
Please try your bookstore first.
You may write for a free catalog.

In Europe, Schiffer books are distributed by
Bushwood Books
6 Marksbury Ave.
Kew Gardens
Surrey TW9 4JF England
Phone: 44 (0) 20 8392-8585; Fax: 44 (0) 20 8392-9876
E-mail: Bushwd@aol.com
Free postage in the U.K., Europe; air mail at cost.

Contents

Acknowledgments

This section of any book begins with the author listing people directly involved with the final product. This book is no different. It never would have been possible without the aid and assistance of the photographer Richard Shaw who took all of the photographs that began this process and of Schiffer Publishing's Douglas Congdon-Martin who completed the photographic process in a matter of days and was also the editor. In addition two friends, Michael Lord and Edward Pia, helped me set up place settings and the individual silver pieces for the photographs. Marie Whiteside, a long time friend, helped by providing the dining room that marks the final pictures in this book. My grateful thanks to each of you. You made this book a reality.

In addition to the list above, the following individuals allowed me to borrow, from their own collections or inventory, many of the wonderful items found in this book: To the following list of contributors I send my thanks; this project would never have been possible without your specific help and assistance.

Alysia Janine
Fred Bologna
Peter M. Braswell
Patrick M. Curry, Curry and I, 17000 Highway 12,
 Boyes Hot Springs, CA 95416
Phil, Angela and Pam Dries, Antique Cupboard,
 1936 MacArthur Road, Waukesha, WI, 53188
Richard Hester
Mack Kelly, North Cliff Trading Co., P.O. Box 8449,
 Langley Park, MD 200707
Maxine Klaput, Maxine Klaput Antiques, Court of the
 Fountains, P.O. Box 5628, Carmel, CA 93921
Paul Koch
Gregory Lancaster
John D. L. Marquardt
Anthony J. Marzullo
Michael S. McHale, McHale's, PMB 441, 2510 G Las
 Posas Rd, Camarillo, CA 93010
Mary E. Moore, Silver Lane Antiques, P. O. Box 322,
 San Leandro, CA 94577

Todd and Christine Osterberg
Robert L. Owen
Edward F. Pia
Sandy Plumb, Sandy's Sterling Shop, 40 Main Street,
 N. Adams, MA 01247
Benjamin Randolph, The Eden Sterling Co., 7672
 Montgomery Road #244, Cincinnati, OH 45236
Steve Reeves
Priscilla Robertson
Wendell and Jane Schollander
Gail E. Tompkins
Carissa D. Vanitzian
Mrs. Roy Van Sicklin
Marie Whiteside
Carol Williams

If I have left off any name or names, please forgive me; it was only accidental. Thanks again to each of you.

Richard Osterberg
P.O. Box 14755
Pinedale, CA 93650
Phone: 559-431-1925 or FAX 559-431-1994
email: richardo@csufresno.edu

Part 1

Silver: From c. 1850 — c. 1875/85

Victorian silver from the time period c. 1850 –1875/80 is marked with the American silversmith's exuberance, bringing silver to a high point of popularity. During this time, silver ranged from very expensive to a point where silver was almost on a cost par with silverplate. The western expansion and the discovery of silver in Nevada (Comstock Lode) and Idaho did much to force the price of silver down, thus increasing the number of people who could afford sterling. The price of silver, which had hovered around $1.035 per ounce, suddenly dipped to $.61 per troy ounce because of the sheer volume of silver entering the market. At the same time, developments in industry and transportation did much to aid the silver industry. Manufacturers produced ever-pleasing designs and patterns thus insuring that more of their products would be sold. With the drop in the price of silver, bringing prices down a larger market was created for silver goods. The designs of the time reflected current interests in art and history, and design became more important as graduates from design schools began their contributions to the silver industry.

At the same time, manufacturers were increasingly aware of silver experts in the European market and several important designers were enticed to come to the United States. Gorham brought William C. Codman, who became one of Gorham's most important designers. Reed and Barton had Ernest Meyer, who developed *Francis I*, their company's most popular pattern. Antoine Heller was a contributor to Gorham and also to Tiffany.

The opening of Japan in 1854 by Commodore Perry brought the mystery of the Asia closer to the American public. As the American public's interest in things of the Orient grew, so too did the ability of the American Silver industry in their attempt to bring designs reflecting this interest. As a result, Tiffany introduced their pattern called "Japanese" in 1871, which later became "Audubon," based entirely on Japanese birds and flora. Other manufacturers took the gauntlet and the Oriental phase was quickly ushered into existence. Whiting marketed a design very similar to Tiffany's and a lawsuit quickly ensued, over the Whiting product.

Studying the design and the application of design on these sterling items shows the creative genius of the silversmith coupled with the growth of the silver industry in the United States. This was toward the end of the Victorian era, and while many of the sterling patterns were very busy and highly decorated, other examples show the remnants of excellent basic design found on handmade silver with simpler designs.

The pieces found in this section were collected over a number of years. To have so many examples from this time period is remarkable owing to the large amount of silver that was melted during the high price of silver in the 1980s. A value has not been placed on these items as so few turn up at shows or on ebay. Many of these examples are ensconced in museums and private collections, thus adding to their rarity. To have the opportunity to photograph and handle such an array of magnificent silver was fantastic.

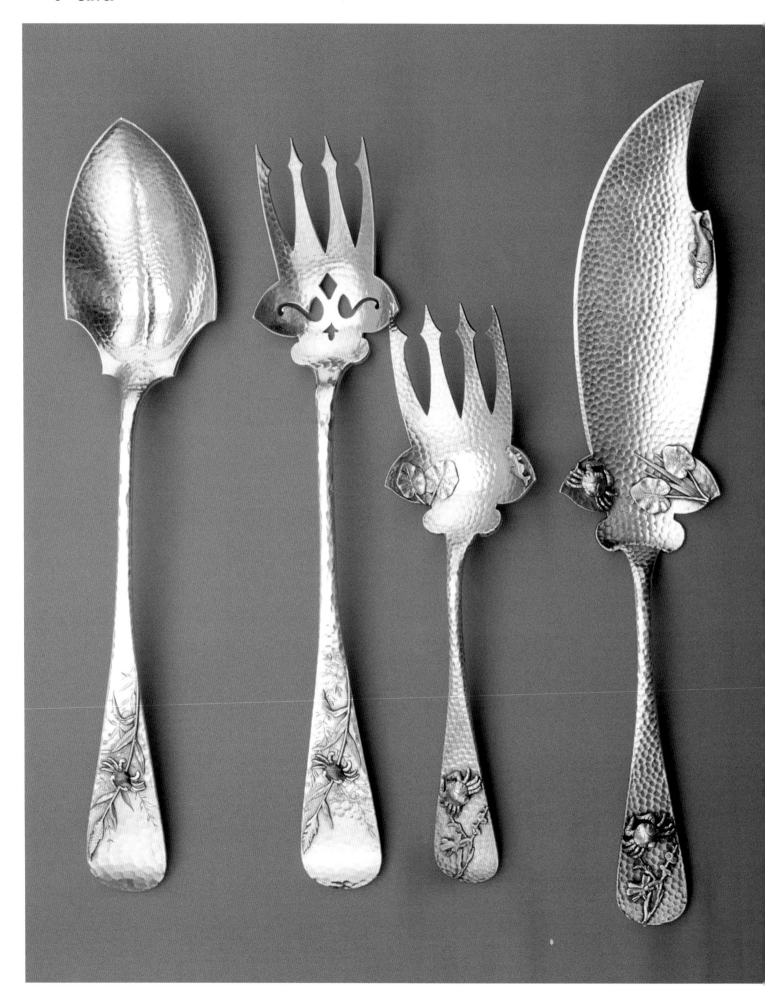

Opposite page:
Figure 1.001. Two examples of applied and mixed metals with sterling. The long-handled salad set by Whiting (fork, 11-3/4", and the spoon, 12-3/8") show the ability of the American silversmith to create unusual new forms in response to demand. The two-piece fish set by Duhme (fork 11-3/4", and the blade, 12-3/8"), shows a water lily and crab on the blade.

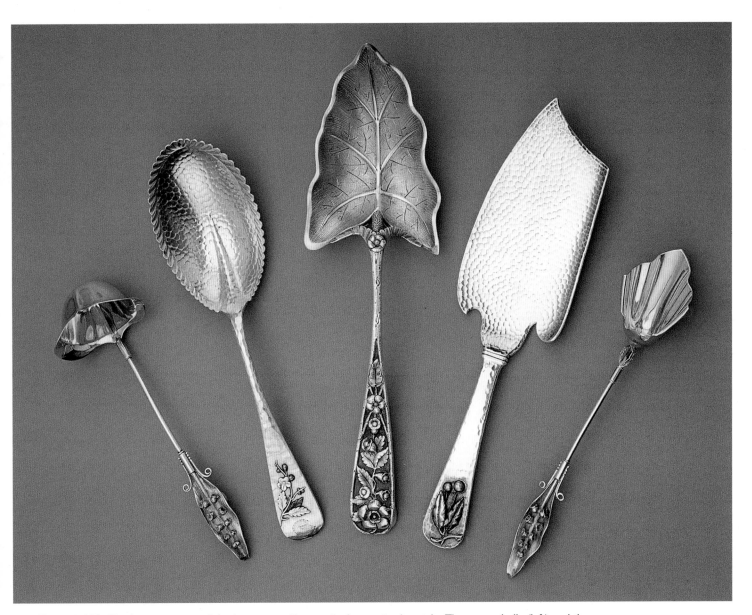

Figure 1.002. The berry spoon and the ice cream slice, again, have mixed metals. The cream ladle (left) and the cheese scoop (right), both by Wood and Hughes, show the silversmith's attempt to use silver to add a dimensional form to the silver. The cream ladle is 7-1/4" and the cheese scoop is 7-1/2". The berry spoon by Whiting, next to the cream ladle, has applied plum blossoms along its 9-1/2" length. The central item, a Duhme and Company 10-5/8" Calla Leaf berry spoon is truly magnificent and an excellent example for this category. The last piece, an ice cream slice by Gorham, with a 10" gold-washed blade, has cherries in another metal, most likely copper.

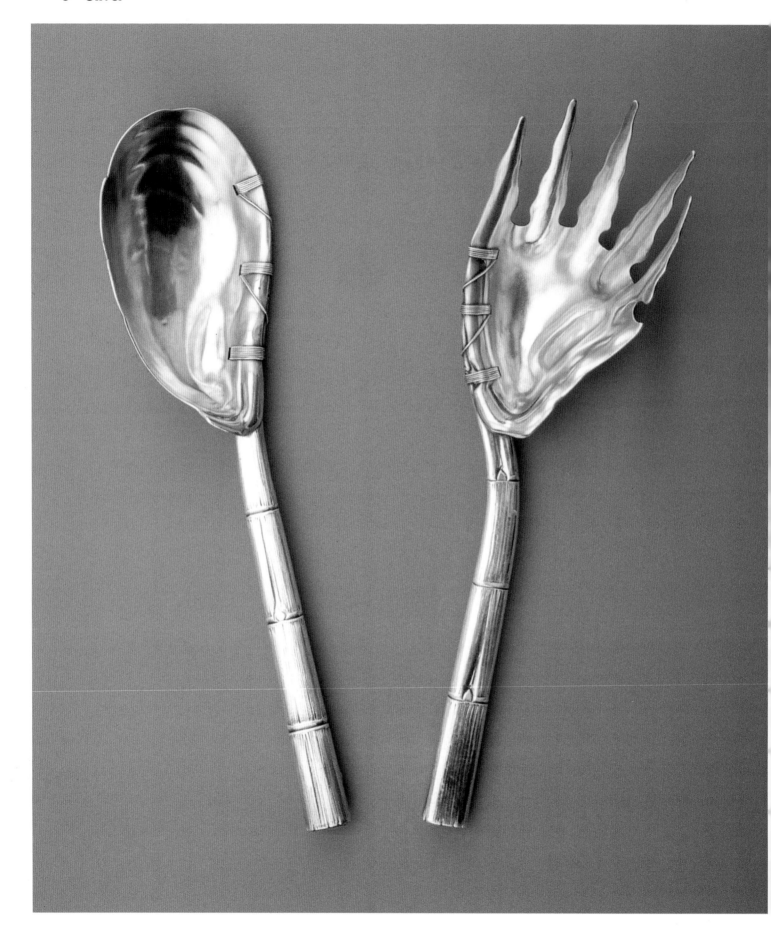

Opposite page:
Figure 1.003. A salad serving set by Gorham. Lettuce salad was, by this time, becoming a status symbol and a necessary part of the American diet. The development of the refrigerated railroad car also contributed heavily to the changing American diet.

The fork in this picture is 10" and the spoon is 9-5/8". The silver salad set gives the appearance of having been made from items found along the seashore—shells and bamboo sticks, pulled together by thin strands of what may be seaweed. This set is sometimes found with gold-washed bowls and tines. The bottom of the silver piece resembles a bamboo stick, with a number of lines, the xylem, found when a piece of bamboo is cut. It would appear that the designer was very familiar with bamboo since the resemblance is so lifelike. These two items are another example of the Japanese influence at its best.

Below:
Figure 1.004. These figural items give but a hint of what the silversmith was able to do to reduce nature to a silver form. The gold-washed and heavily pierced nut scoop (left) by Sharp, 10-1/4" is representative of forms in this category. The all-silver pie server by Gorham, 10-5/8", appears to have a birdlike nest at the end, but not be an example of that particular pattern produced by Gorham. The berry spoon at the right (9-1/4"), an example in coin silver, is by McCarty.

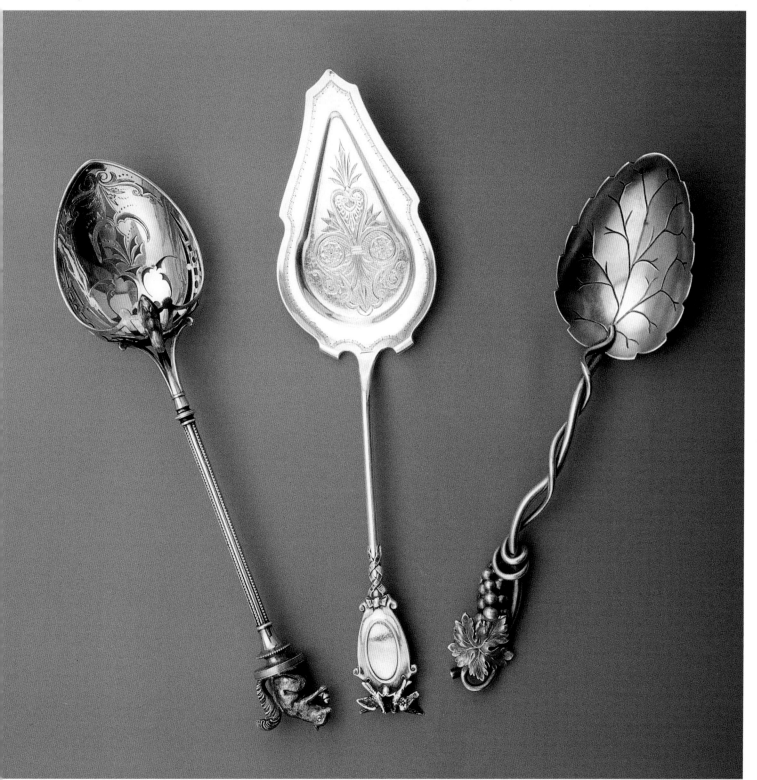

Figure 1.005. The image features a variety of the forms found during this time period. Moving from left to right, we start with the pastry server, in unmarked coin, in the Prince Albert pattern, 10". The second item, a 9-1/4" vegetable fork, is by Hotschiss and Schroeder. The third piece, a stunning ten-tine fish fork, 10-1/8", is by George Sharp. The fourth item, an early example of a macaroni server, is 11-1/8" long. This piece bears the San Francisco maker's name, Vanderslice, the word "coin," and a mark for Nevada. The pointed pancake server, 8-3/4", was made by Osgood, in Lewiston, Pennsylvania. The last item, a buckwheat server (8-1/8"), only bears the mark "Coin."

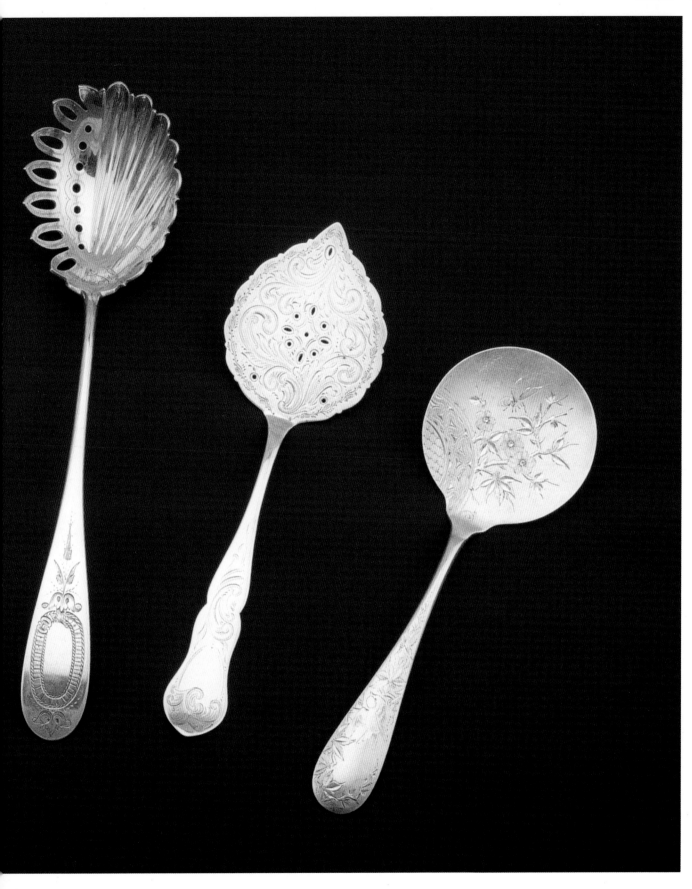

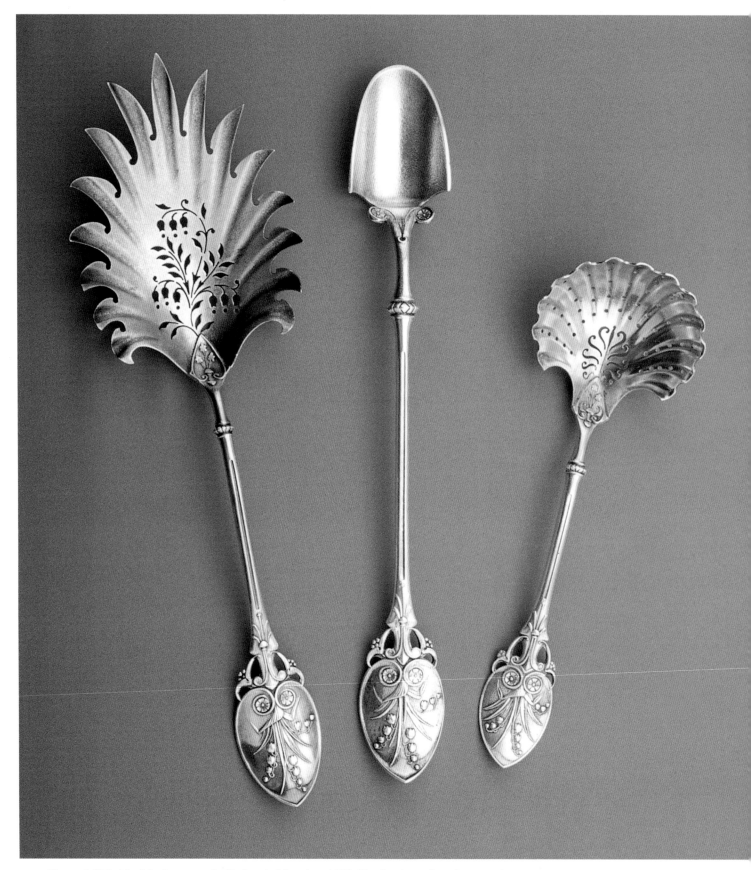

Figure 1.006. All of the items are in Gorham's *Lily*, circa 1870. The first item, heavily pierced, appears to be a macaroni server and is 9-5/8". The next item in the pattern is a long-handled cheese scoop at 9-1/8". The last example is a heavily pierced sugar sifter and is 6-3/4" long.

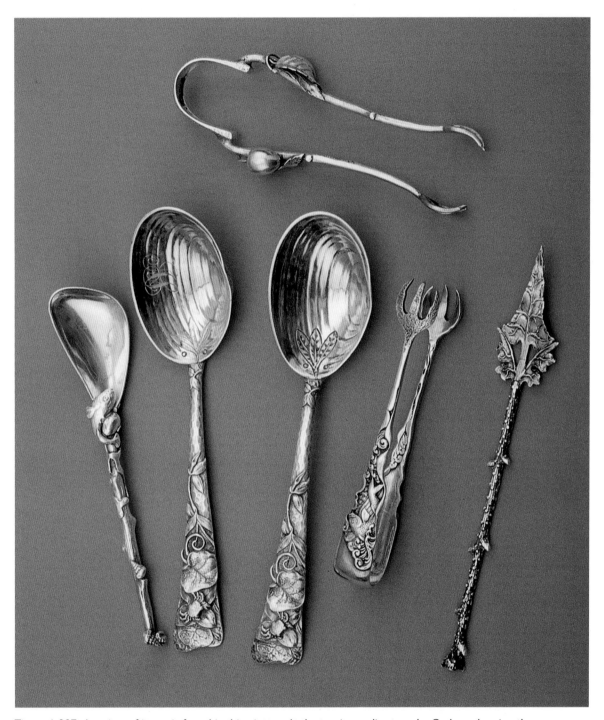

Figure 1.007. A variety of items is found in this picture. At the top is an olive tong by Gorham, bearing the number 515; it is 5-7/8" long. At the left is a smallish spoon, which may be a sugar spoon, also by Gorham; it is 5-1/2". The next two spoons, also by Gorham, are 6-5/8" long. The shell bowl and the elaborate handle set these apart. Note the unusual placement of a monogram on the left side of the bowl of one of the spoons. Next are Gorham sugar tongs at 4-1/2". The last item is a stylized butter pick at 6-1/8".

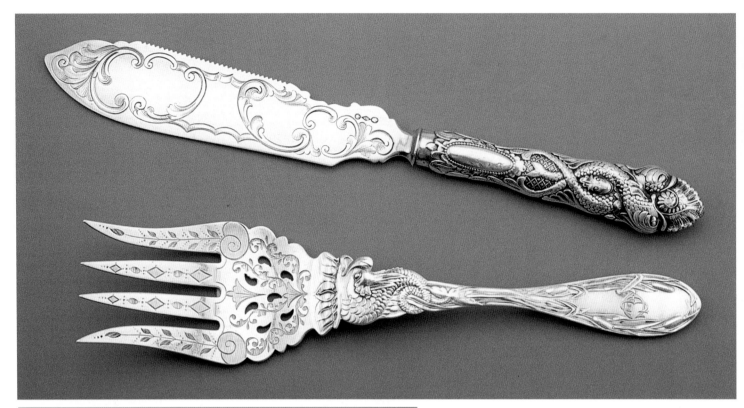

Figure 1.008. These two pieces, a fish fork and a fish knife, are both by Albert Cole. They are not from the same set, yet are examples of this silversmith's carefully crafted work. The knife is 11-3/8" long and the fork is 10-1/4".

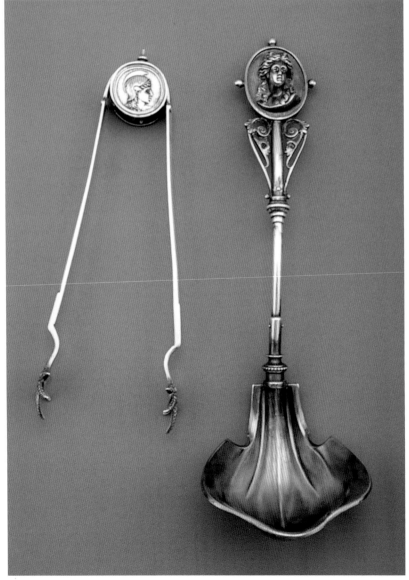

Left:
Figure 1.009. On the left are ice tongs, which bear the marks, "Frederick," "Coin," and "Carson City," and are 7" in length. The very unusual manner in which the silversmith has crafted the tongs is very interesting. Note how the head is applied to the central area of this piece. The other item, a magnificent gravy ladle with the three-dimensional applied head in a medallion pattern, is outstanding. The ladle is 9-1/8", gold-washed and was made by Wood and Hughes.

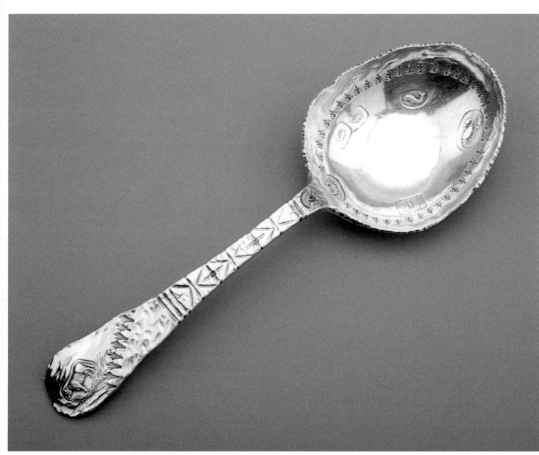

Figure 1.010. A large, 9-1/8" long, spoon featuring a cow. There are no marks, yet the spoon bears a resemblance to early Shiebler work.

Below:
Figure 1.011. These large tongs by Gorham, heavily pierced, appear to be for serving asparagus. Note the very fine work in the piercing. The piece is 11-1/2" long.

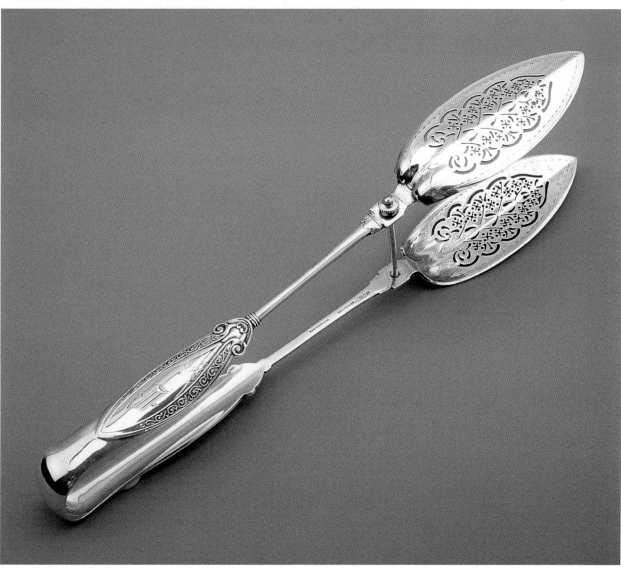

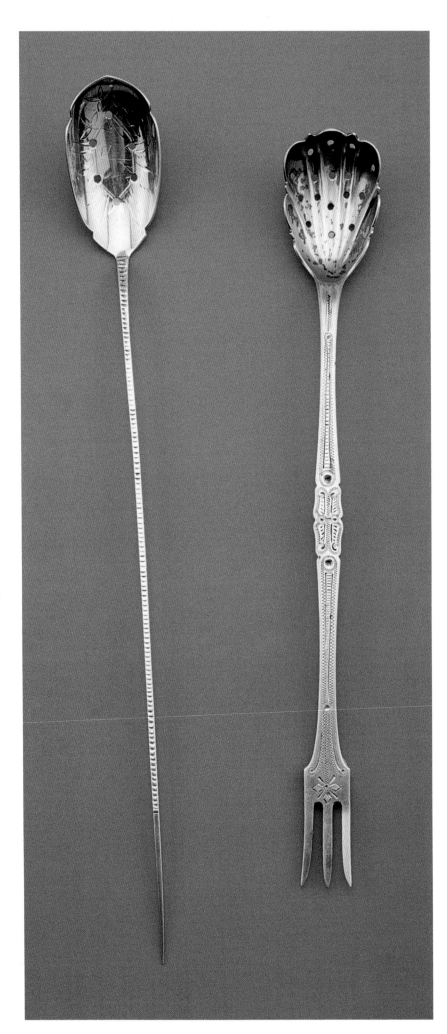

Figure 1.012. Left: The moat spoon, marked "sterling," is most unusual in American silver. This was developed to remove tea leaves caught in the spouts of teapots. When the teapot spout became clogged, one inserted the thin part of the spoon into the spout to alleviate the clogging. The moat spoon is 11-15/16". Right: a spork (combination of a fork and a spoon) is 10" long.

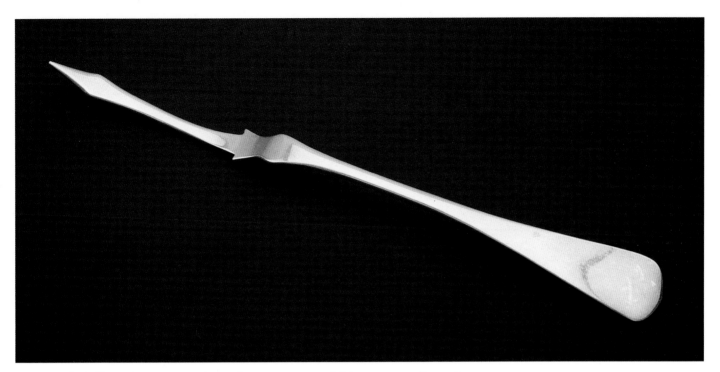

Figure 1.013. This early piece, in a shape of a spear is unusual. It bears no specific mark.

Figure 1.014. A collection of eighteen different pie or pickle forks in a wide
variety of early patterns. The forks also display a number of tine designs.

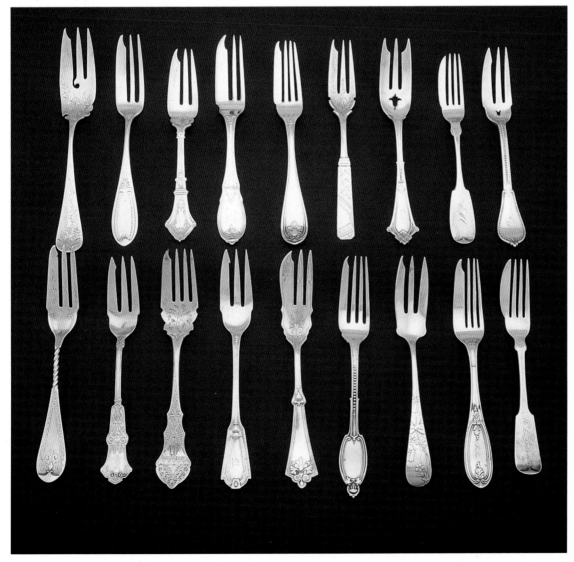

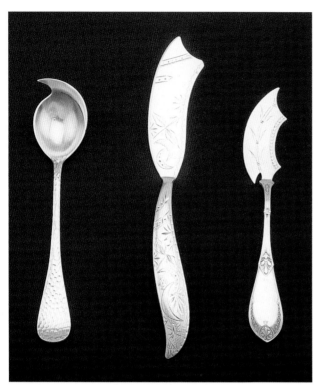

Figure 1.015. Three examples of how different silversmiths could manufacture an item to serve a particular food for their customers. The first item (left), with the sharp, pointed tine, may have been an early example of a "peach pitter," used to rid a piece of fruit of its hard pit. In the center, this butter server is an example of good design and workmanship. The last item, again designed for a particular purpose which has been lost in time, could have been for butter, cheese, or whatever the designer/manufacturer had in mind.

Below:
Figure 1.016. Six items in Whiting's *Ivy*, a non line pattern (n.l.p.) that was introduced about 1870. From the left the items include two ladles, a newer gold-washed gravy variety, 7-1/4", and an older ladle, 7-3/4". Note the differences in the bowl shapes. The shape of the older ladle can be found in Whiting ladles of many larger sizes—oyster, soup and punch. The preserve spoon (center) is also gold-washed and is 9-15/16" long. Next comes a sugar shell, 6-13/16" long. A gold washed mustard ladle, 5-1/4", is next, followed by a master salt at 3-13/16".

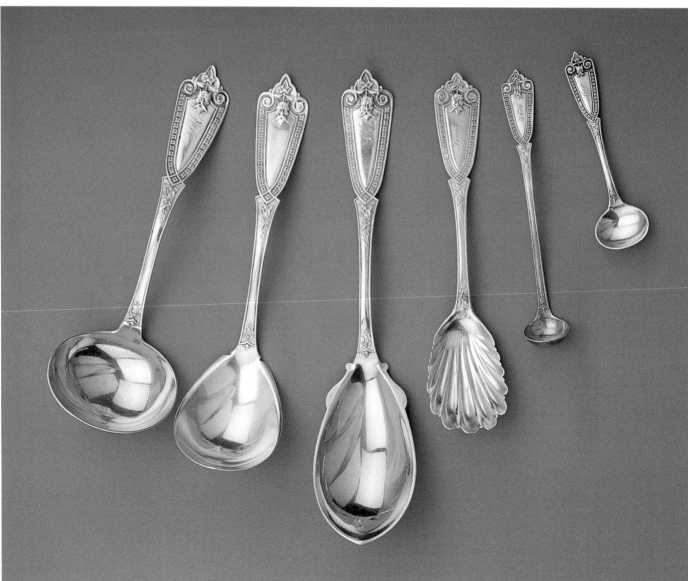

Serving Pieces

Introduction

The items in this section represent a number of examples of the silversmith's art produced, from the close of the Civil War, approximately, to the present day. Serving pieces were not made in the quantity of place pieces and are not as easily found. The cost of serving pieces is dictated by rarity, pattern desirability, and usefulness. To the collector, only the first two items matter, and possession is more important. The situation is made more confusing by the fact that some patterns are more popular in different parts of the country, thus adding a range of pricing.

Rarity can be a multisided situation. The cause for rarity may be that not many items were manufactured or that the items were a specialty, available for only a very short time. One silver company once advertised that they had new sterling items every few weeks, and to watch for the newest items they had available. Some of the rarity can be traced to the tremendous meltdown in the 1980s, which caused the loss of many fantastic silver pieces that can never be duplicated again. Whatever the reason, serving pieces hold a mystique for the collector, be it because of pattern or form. Cheese scoops, sardine forks, claret spoons have a number of collectors hunting for examples in these specific pieces. There is a collector for every item produced.

Whether the serving piece matches the flatware design or is coordinated with the china and crystal, depends on the choice of the collector. Some customers over the years have been interested in collecting examples of all types and manufacturers of serving pieces, while others only want to have matching accessories to their pattern. Personally, this collector chooses to go both ways. By collecting patterns as well as types/styles/items the table can be set creatively in countless different ways.

Forks

Asparagus Forks

Figure 2.001. Here are examples representing all three of the types of serving items made for asparagus throughout the years. All the styles are in the *Versailles* pattern manufactured by Gorham. The fork is 9"; the hooded server is 9" and the tong is 8-1/2". Finding all three examples is difficult. Again, prices for all of these implements would be high, and any price from $1250 up would be in line for most of these items.

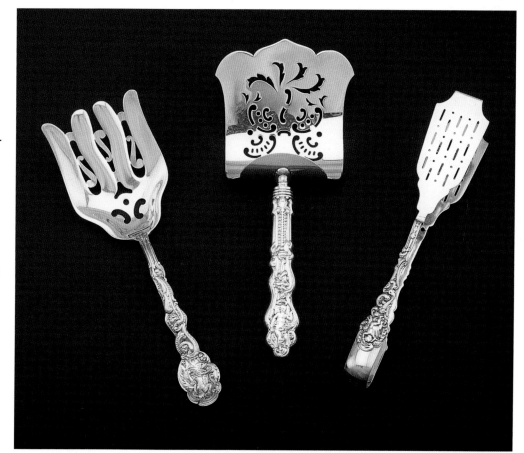

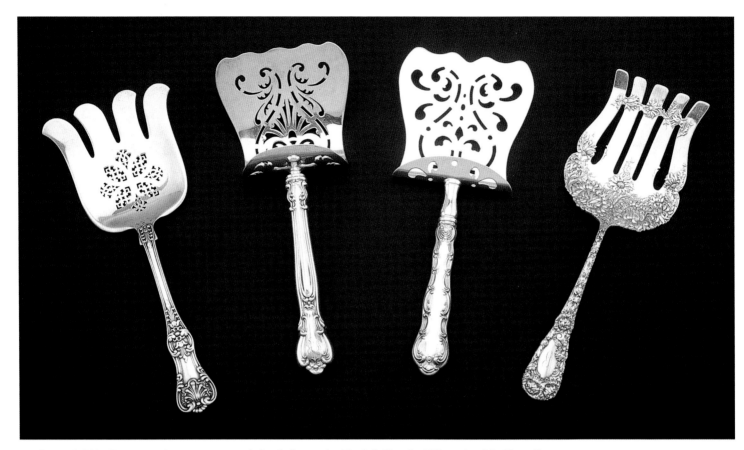

Figure 2.002. Four magnificent asparagus forks. Left to right: *English King* by Tiffany, 9-1/2"; *Chantilly* (hooded) by Gorham, 9-3/8"; a new *Strasbourg* item (hooded) with a silverplated pierced finding placed into a sterling handle, 9-7/8"; and *Chrysanthemum* by Durgin, 9-3/4". The servers have a wide range of prices. The new hooded asparagus server in *Strasbourg* can range from $70 to over $85. The other items command much larger prices—from a minimum of $1250 and up.

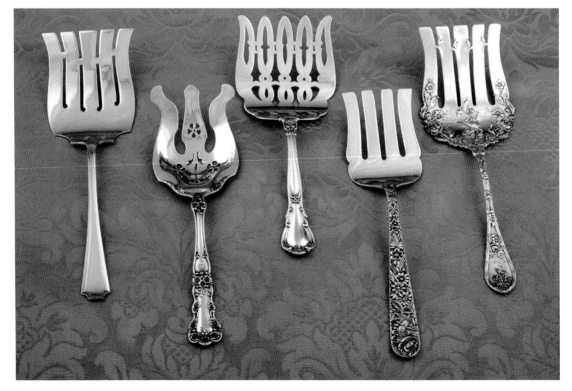

Figure 2.003. Five asparagus forks. Left to right: *Fairfax* by Durgin, 9-11/16"; *Buttercup* by Gorham, 9-1/8"; *Chantilly* by Gorham, 8-1/2"; *Repoussé by* Kirk, 9-3/8"; and *Dauphin* by Durgin, 9-11/16". Prices for these items range from $295 to $1295.

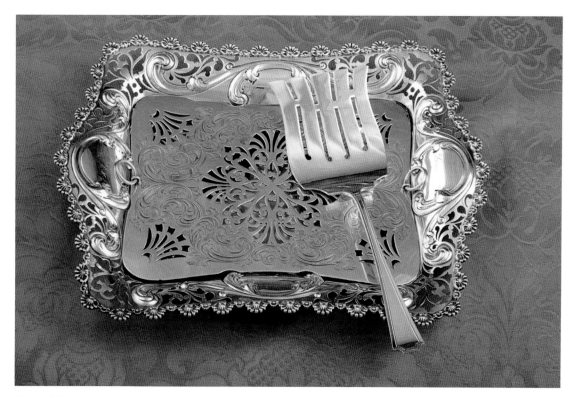

Figure 2.004. A Dominic and Haff two-part asparagus dish, accompanied by the *Fairfax* (Durgin) 9-11/16" asparagus fork. This particular dish has the date mark of 1899, and the inscription shows that it was a Christmas gift in 1902. The asparagus dish is difficult to locate and would command a price around $4500. The asparagus fork could range from $295 to $550.

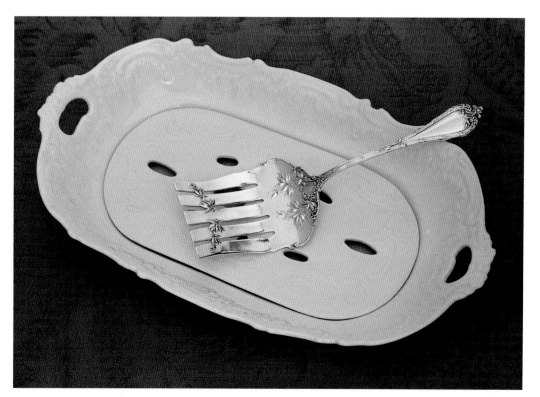

Figure 2.005. A Haviland two-part asparagus dish, dish and liner, featuring a large asparagus fork in Durgin's *Madam Royale*. The fork is again 9-11/16", which appears to be a standard size for Durgin asparagus forks. The fork in this figure would range from $295 to $650.

Bacon Fork

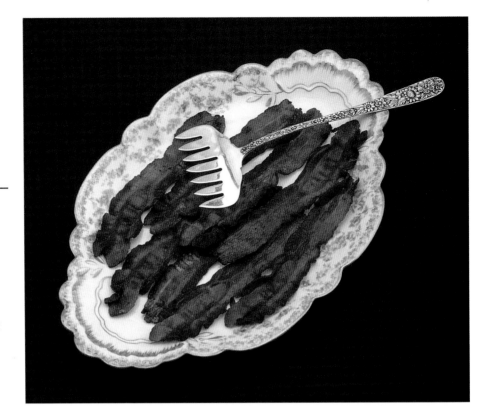

Figure 2.006. A *Repoussé* Bacon Fork, 7-1/16" in length, is displayed on a Haviland bacon platter in pattern #271C by H and Co. The value of the Bacon serving fork would range from $95 to approximately $150.

Baked Potato/Sandwich Forks

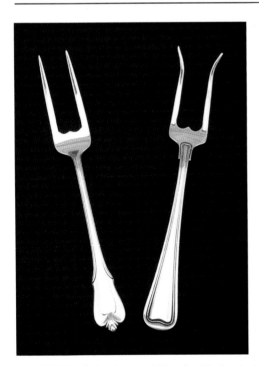

Figure 2.007. Two forks that could be classified as baked potato forks. Both of these forks do not appear to be original; in fact, so many have been made-up from luncheon, place, and dinner forks in recent years that now it is almost impossible to find an original factory representative in this category. Made-up examples would range in value from $59 to approximately $95, depending on the fork being used. Original items, if they can be proven to be so, would cost around $195. Both of these forks are 7-1/8" long. *Grand Colonial* by Wallace is on the left and *Old French* by Gorham is on the right.

Figure 2.008. *Francis I.* This is a made up item, and the price should range in the $59 to 95 range. None of the Reed and Barton brochures show any baked potato forks. The size of this fork is, again, 7-1/8".

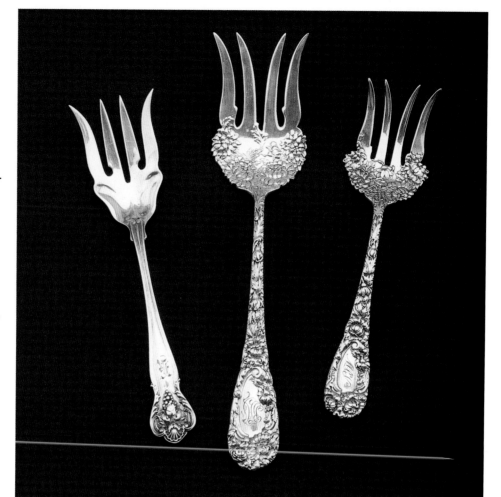

Beef Forks

Figure 2.009. Beef forks by Durgin. These forks were made in small and large sizes, and turn up with regularity on the market. The *New Vintage* fork (left) is 6" in length. The center fork is *Chrysanthemum,* 7-7/16" in length. The smaller *Chrysanthemum* fork on the right is 5-3/4" in length. Beef forks range in price from $75 to upwards of $475 for very good patterns.

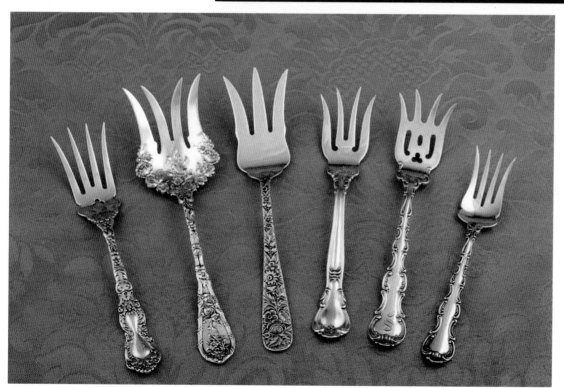

Figure 2.010. A raft of beef forks. From left to right are: *Imperial Chrysanthemum* by Gorham, 613/16"; *Dauphin* by Durgin, 7-1/2"; *Repoussé* by Kirk, 8-5/8"; *Chantilly* by Gorham, 6-3/4"; and both sizes represented in *Strasbourg* by Gorham, large, 6-13/16", and small, 5-3/4". Values of these forks would range from $95 to $475 for the *Dauphin* example.

Butter Forks/Picks

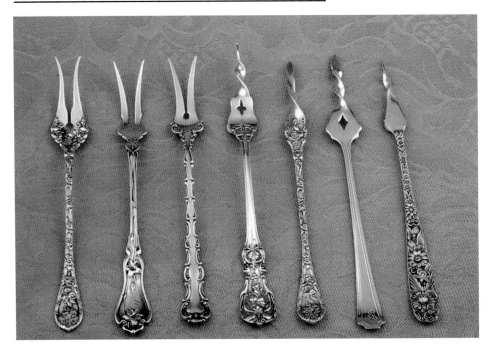

Figure 2.011. A variety of typical butter forks or picks. From the left: Durgin's *Dauphin*, 6-1/16"; Whiting's *Violet*, 6"; Gorham's *Strasbourg*, 5-15/16". Butter picks include (beginning in the center): Reed and Barton's *Francis I*, 6-3/8"; Durgin's *Dauphin*, 5-13/16"; *Fairfax*, 6-3/8"; and Kirk's *Repoussé*, 6-1/16". Butter forks would sell from $75 to about $195, while the butter picks are somewhat more collectable and would range from $75 to $225. While not illustrated, a butter pick-knife, being more rare, would go from $95 in nondescript patterns to over $300 in highly desirable patterns.

Figure 2.012. A butter basket in a Haviland pattern in the Osier blank, with a butter pick in Lunt's *Chippendale*. The pick is used to pick up the butter slices and place them onto individual butter pats, as seen in the figure. The individual butter pat is in Haviland's pattern #52, with an individual butter knife in Whiting's *Violet*.

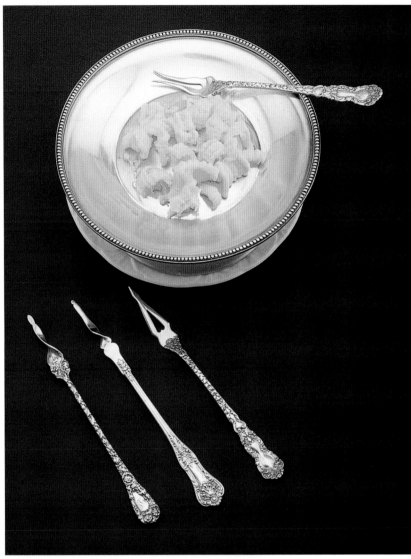

Figure 2.013. A selection of different butter picks, paired with a piece of French silverplate which creates butter curls. At the bottom of the picture, from left to right are: Durgin's *Chrysanthemum*, 5-7/8"; Tiffany's *English King*, 6"; and Gorham's *Imperial Chrysanthemum*, 5-3/4". At the top is another *Imperial Chrysanthemum* butter fork.

Carving Implements

Below:
Figure 2.014. A variety of carving implements. On the left is a large roast set by Kirk in *Repoussé*. The fork is 11-3/4" and the knife is 15" long. Next is a very useful roast holder; also in *Repoussé*, it is 9-3/8" long. Next are two carving sets in Gorham's *Versailles*. The larger set, a bird set, has a knife, 12" long, and a fork, 10-5/8" long. The smaller is a steak set with the knife, 10" long and the fork, 9". Carving sets could range in prices from $175 to well over $900, depending on the number of items in the set and the desirability of the pattern.

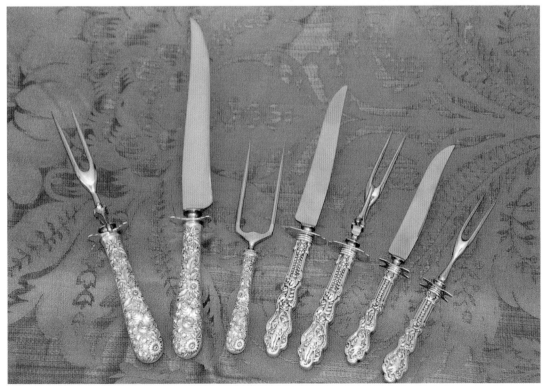

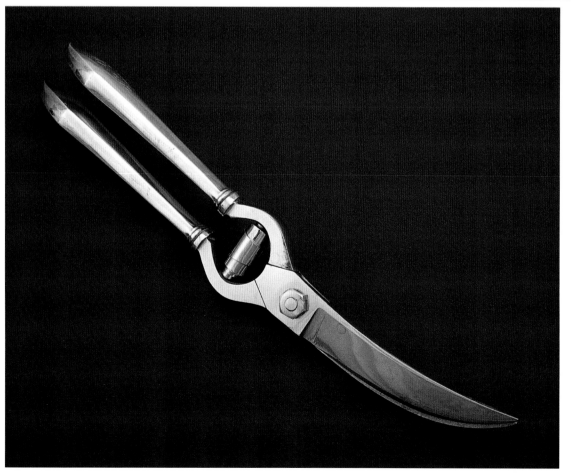

Figure 2.015. A Haviland game set. The individual game plates each have a different bird placed in the center of the plate. The small game set in Gorham's *Versailles*, described previously, is shown in this picture.

Below:
Figure 2.016. Durgin poultry shears. The pattern is called *Chatham*, and was introduced to the public in 1915. The example is 10-5/8" long. The value of this pattern would be approximately $145.

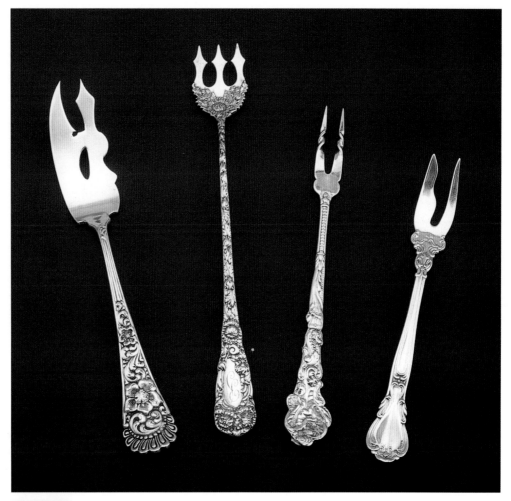

Cheese Forks/Servers

Figure 2.017. Four examples showing the wide variety of shapes in this category. From left to right: an early example in an unknown pattern and marked H & D, is 6-7/16"; Durgin's *Chrysanthemum*, 7-5/16" (note this fork is the long-handled version, and Durgin did make a shorter fork); Gorham's *Versailles* at 6-5/8" (note the unusual twisted tines); and *Chantilly* at 5-1/2". Cheese forks are rather rare and simple ones would demand a minimum of $195; those in highly desirable patterns could range well into $400 or more.

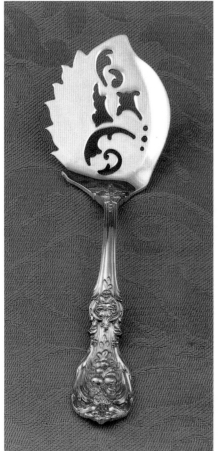

Figure 2.018. An example of a cheese server in *Francis I*, at 5-3/4". The delicate piercing adds to the beauty of the piece. This piece is a restrike and relatively new; the price should be under $100.

Cold Meat Forks

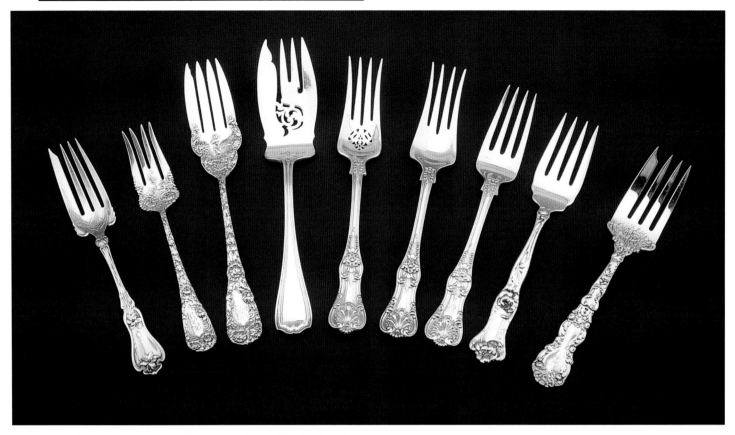

Figure 2.019. A wide variety of cold meat forks. The first four, from left to right, are: Whiting's *Violet*, 7-5/8"; Durgin's *Chrysanthemum* (small and large) at 7-3/8" and 9-1/4" (the smaller fork is also listed as a fish/salad fork large); Reed and Barton's *Hepplewhite*, 9-1/4". The next three examples, all in Tiffany's *English King*, are all variations that can be found in the pattern. The sizes range from 8-1/2" to 8-3/4". The final two are Wallace's *Peony* at 8-1/4", followed by Gorham's *Imperial Chrysanthemum* at 8-1/16". Cold meat forks can be found prices from below $75 to well over $450, depending on the rarity of the pattern and its desirability.

Below:
Figure 2.020. Cold meat forks showing the variety found within a manufacturer's offerings and also within patterns. The first four examples, all by Durgin, can be classified as cold meat forks, but at the same time they can be referenced as fish or salad forks large in their respective patterns. The size of the regular cold meat forks in the Durgin patterns almost makes it a necessity to have the smaller fork for smaller cuts of meat. The first two forks are *New Vintage* at 7-3/8" and, the larger one, 9-3/16". The *Dauphin* examples are slightly larger, at 7-11/32" and 9-5/16".

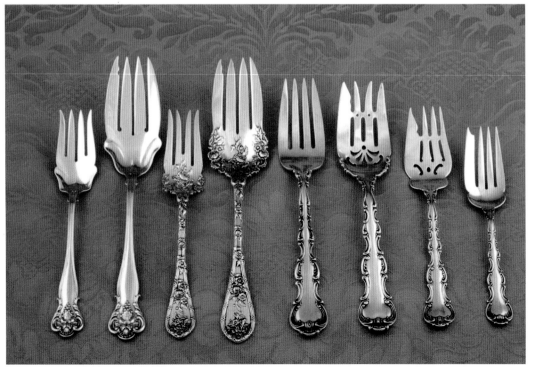

The four examples in Gorham's *Strasbourg* show the pattern through the years. The first fork in the series is the currently produced cold meat fork, and is 8-1/2" in length. The next three forks all have the original patent mark, meaning they were produced during the first 16 years of the pattern's production. The largest fork is 8-3/16", the next is 7-1/4", and the last is 6-15/16". One additional note to the reader, the *Dauphin* shown here is the old version and not the currently available fork in the Masterpiece collection. To see the current fork, please turn to page 31, where the current fork is paired with an original fish blade to make a two-piece fish set.

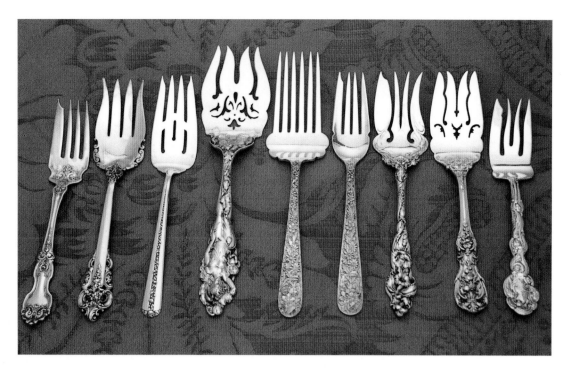

Figure 2.021.1. A wide variety of forks made over a long number of years by several manufacturers. Measurements are not available for many of these forks. From left to right: Wallace's *La Reine;* Wallace's *Grand Baroque;* Towle's *Rambler Rose;* Reed and Barton's *Love Disarmed,* 10-1/2"; two examples of Kirk's *Repoussé, one* with six tines, 9-7/8" long, and one 7-1/2" long; *Les Six Fleurs; Francis I; and* Gorham's *Versailles* pattern, 8" long.

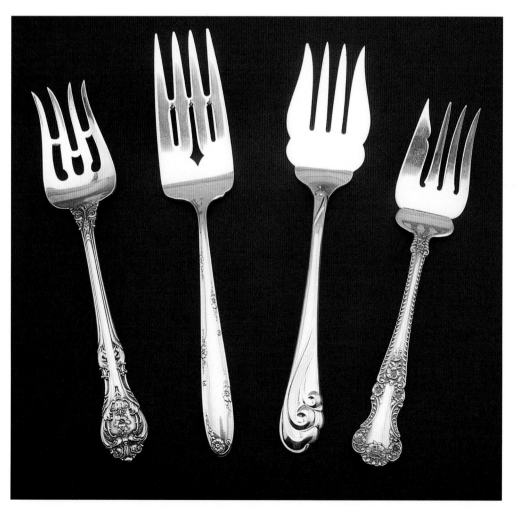

Figure 2.021.2. Four examples of cold meat forks. The first, Gorham's *King Edward* is 7-1/2" long. This fork and many of the serving pieces in the pattern are very similar to Gorham's *Tuilleries.* It would appear that manufacturers can use the handle from one pattern and vary the bowl or tines to create another item. This would be very cost effective as new dies would not have to be made for some time, allowing the silver company to reuse older patterns. Next is Towle's *Madeira,* at 9-5/16"; Kirk's *Surf,* at 8-1/8" followed by Gorham's *Cambridge,* at 6-11/32". Values of these forks would run between $85 and $195 for the *King Edward* fork.

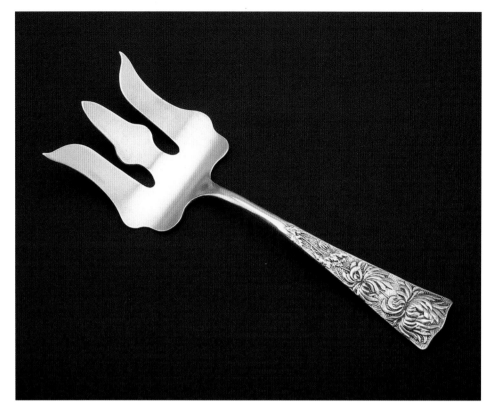

Right:
Figure 2.022. This fork may be a cucumber server or a petit four fork in Shiebler's *Chrysanthemum*. Measurements are not available, but the item should be valued at approximately $175 and up.

Figure 2.023. Two examples of small fish sets from Gorham on either side of an individual fish serving fork from Durgin, centered in the picture. On the left is Gorham's *Imperial Chrysanthemum* with the fork at 7-5/8" and the knife at 10-3/16". The Durgin fork is 8" and the pattern is also *Chrysanthemum*. The pair at the right, in Gorham's *Chantilly* has 7-1/2" fork and a 10-5/8" knife. The values of the sets would be approximately $595 and up, while the large fork would be worth approximately $395. Pairs, that is knife and fork, usually command a higher price, especially in desirable patterns.

Fish Sets _____

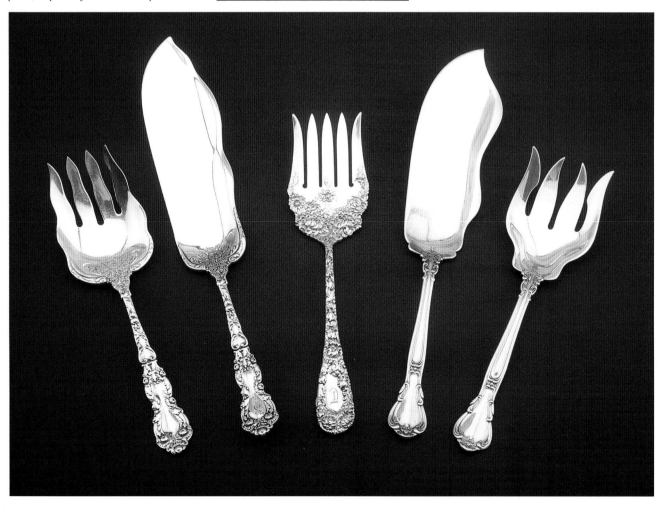

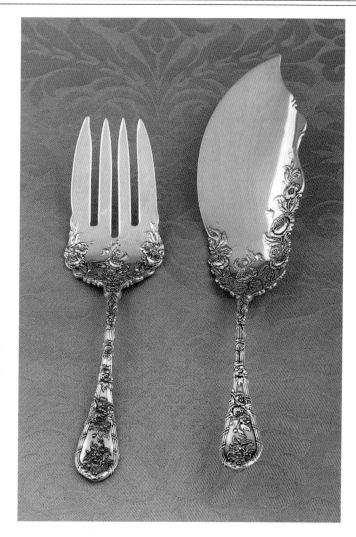

Figure 2.024. While the fish blade is original, the fork is the currently made fork being sold as a cold meat fork in the Masterpiece collection. It would appear that the dies for the fork were too worn, so Gorham took the fish fork, reduced the tines by one, and made this fork. Together they make an excellent pair. Even though both items are not old, this set would command a price in the vicinity of $695 and up.

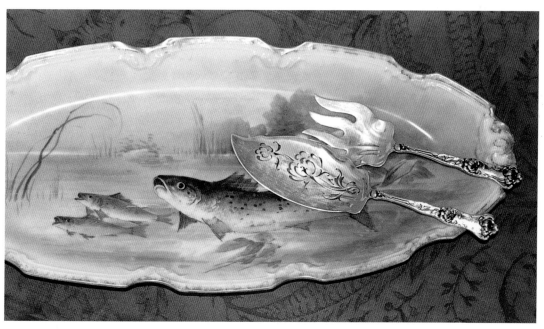

Figure 2.025. A beautiful Haviland fish platter is teamed with a pair of fish servers in Wallace's *Peony*. These two items were not found at the same time, as evidenced by the lack of gold wash on the fish fork, and also the lack of piercing on the fork. The original price list from Wallace shows that the items could be purchased pierced or not, and gold-washed or not, depending on the whim of the buyer. This highly desirable art nouveau pattern would be worth $700 or more.

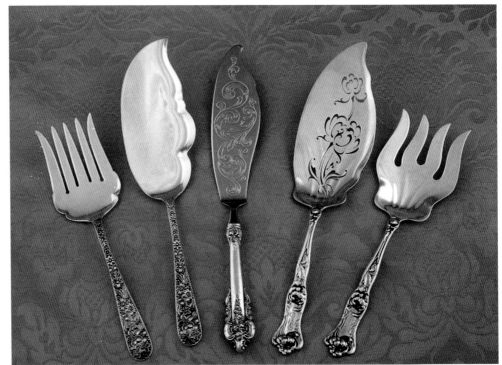

Figure 2.026. Two fish sets on either side of a fish server with a stainless blade. The first set (left) in *Repoussé* by Kirk is worth approximately $550. The fork is 9-1/16" and the knife is 11 7 /16" long. The central item, in Wallace's *Grand Baroque,* has a sterling handle and a stainless blade that is incised with a design. It is worth approximately $79. The last set is the Wallace *Peony.* The knife is 11-3/8" and the fork is 9-3/16".

Lemon Forks

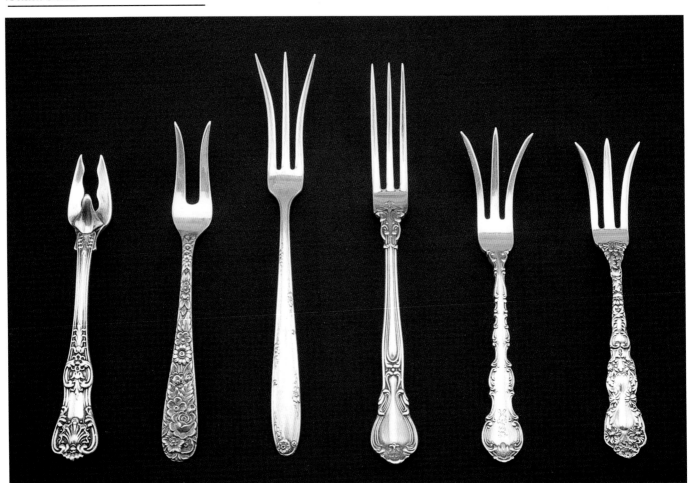

Figure 2.027. The majority of the shapes commonly associated with lemons. The first example (left), in Tiffany's *English King*, is 4" in length. Note the very unusual "hook" on the base of the tines. This is followed (left to right) by: Kirk's *Repoussé*, 4-1/2"; Towle's *Madeira*, 5-7/16"; and Gorham's *Chantilly*, 5-3/8". This is an early example in *Chantilly*, and is sometimes found with splayed tines. Finally, the last two examples, also from Gorham, are in *Strasbourg*, 4-3/8", and *Imperial Chrysanthemum*, 4-1/4". The value of these forks would be $75 and under, except for the Tiffany piece.

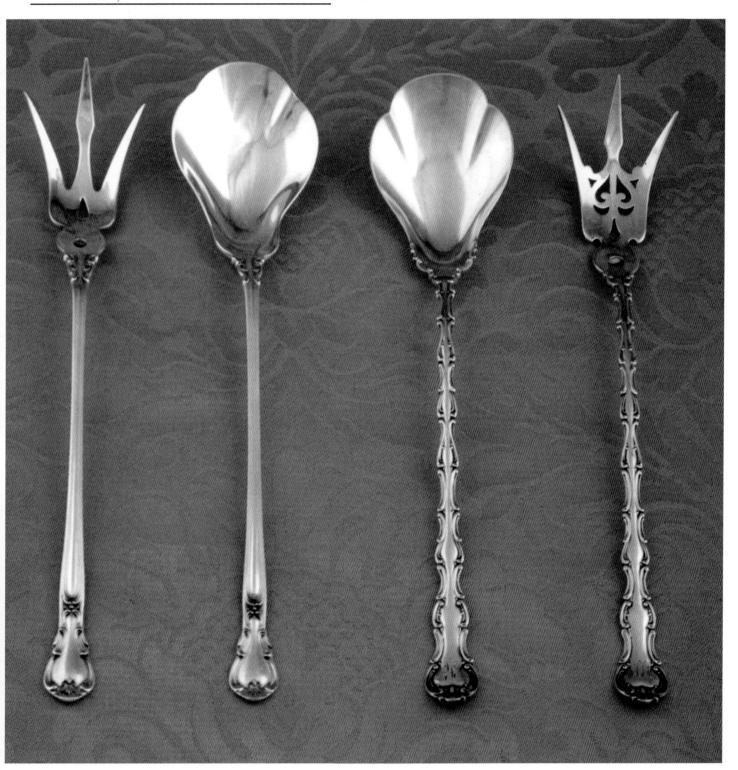

Figure 2.028. Two pairs of lettuce forks and spoons. Both of the sets are products of Gorham. The first, on the left, is in newly produced *Chantilly*. The fork is 9-1/4" and the spoon is 10-3/8". The second set in *Strasbourg* is original and has a gold washed spoon. Both of these are 9-1/4" in length. The value of these sets would be approximately $275 depending upon age—more for original items, somewhat less for new versions.

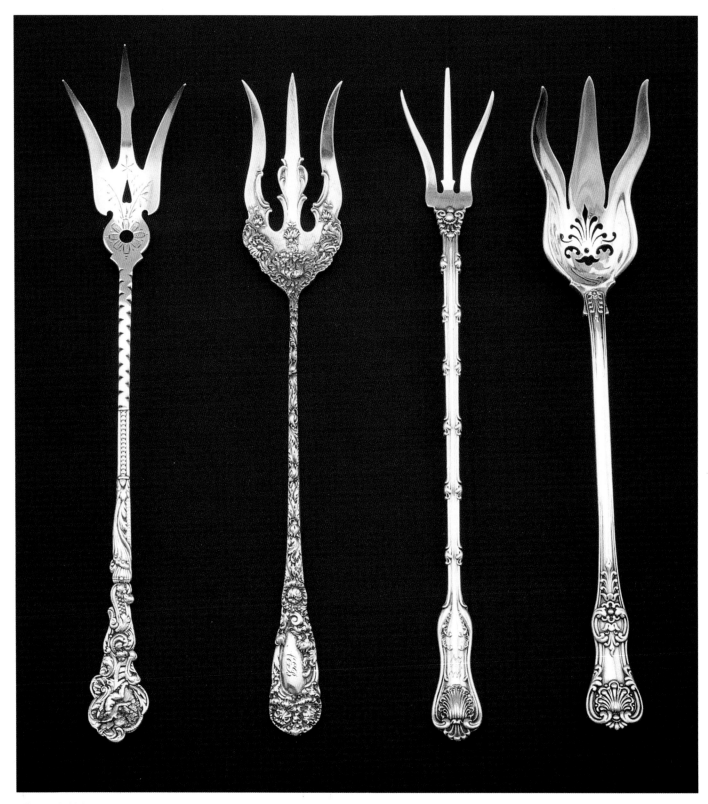

Figure 2.029. Lettuce Forks are sometimes part of a lettuce set, consisting of a fork and a spoon. Lettuce was expensive and as such serving it to guests was a sure indicator of the host/hostess's financial status. The figure shows four lettuce forks. The first one (left) is in Gorham's *Versailles*, and it is 9-1/8"; the second is Durgin's *Chrysanthemum* at 8-7/8"; the next is Whiting's *Imperial Queen*, at 9-1/8"; followed by Tiffany's *English King* at 8-1/2". The value of each of these forks would be $195 to $295, as each of these are premium patterns.

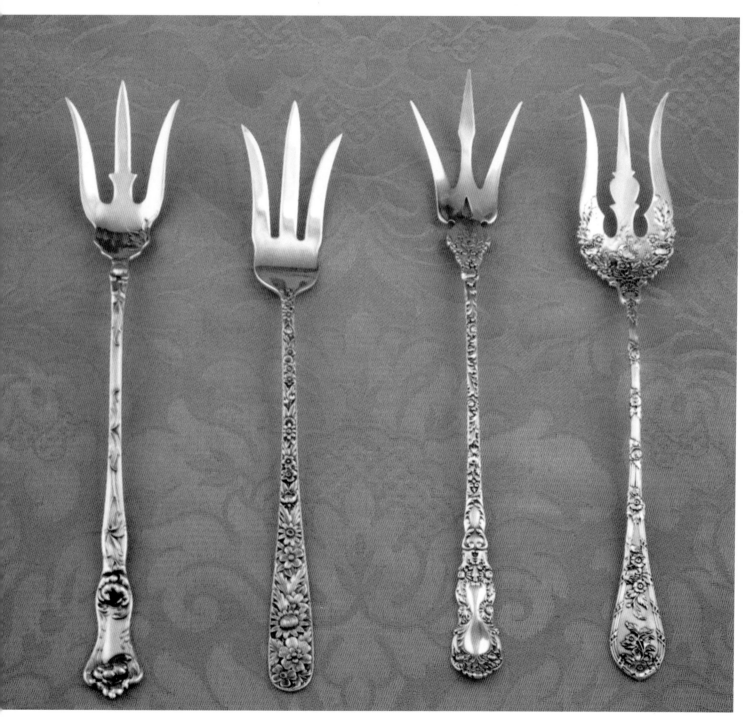

Figure 2.030. Four lettuce forks. Left to right: Wallace's *Peony*, 9-3/16"; Kirk's *Repoussé*. 8-3/4"; Gorham's *Imperial Chrysanthemum* at 9-1/8"; and Durgin's *Dauphin* at 8-3/4". These forks would be worth approximately $125 each, with the exception of the *Dauphin* fork which would run $295 and up.

Pickle-Olive Forks/Spoons/Sets

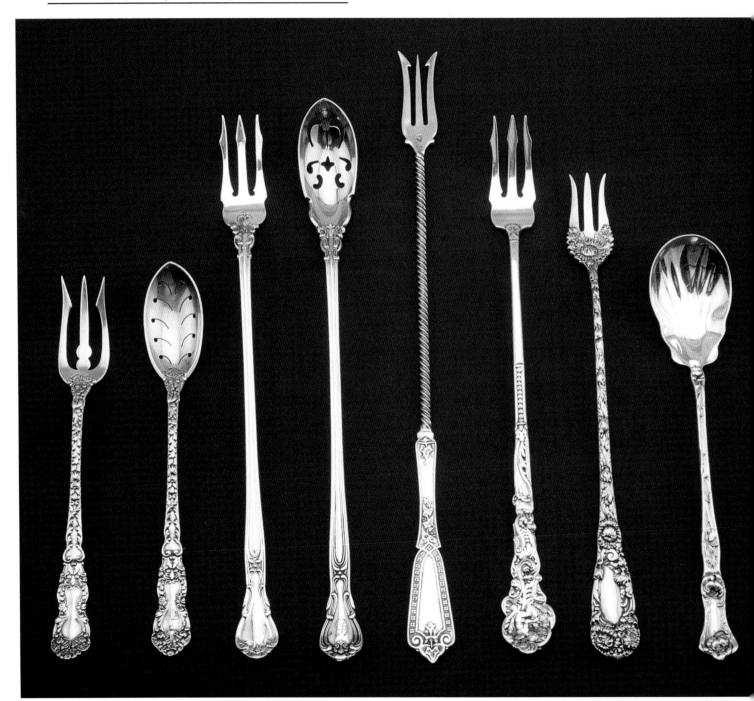

Figure 2.031. A very wide variety of implements in the pickle/olive category. On the left is a set by Gorham in *Imperial Chrysanthemum*. The fork is 5-5/16" and the Spoon is 5-3/4". Next is a long-handled set, also by Gorham, in their *Chantilly* pattern. The fork is 8-1/4" and the Spoon is 8-3/8" in length. The next three forks are: Whiting's *Ivy*, 9-9/16"; Gorham's *Versailles*, 8-1/16", and Durgin's *Chrysanthemum*, 7-3/8". The last item in this figure is a Wallace *Peony* olive spoon, that is not pierced. Prices for these items would vary considerably. Whole sets, that is both fork and spoon, would command a premium price, while single items would be much less. Sets would range in price from $235 and up, while single items would be in the range beginning with $135 and up, depending upon pattern desirability.

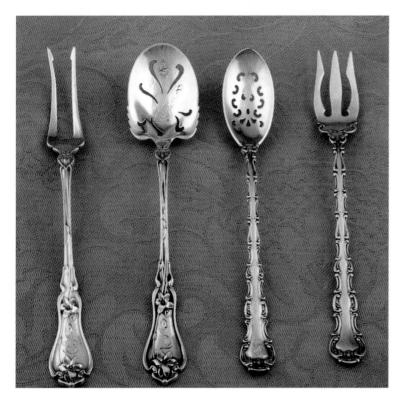

Figure 2.032. Two sets by different manufacturers. The tines on the forks are very different, as is the size and shape of the bowl of the spoons. The first, on the left, is Whiting's *Violet* with a 6-1/4" fork and a 6" spoon. The second set is in Gorham's *Strasbourg;* the spoon is 5-13/16", while the fork is 5-3/4". The value of each set would be $175 to $200.

Figure 2.033. This collection of pickle/olive forks represents four manufacturers and covers almost a hundred years of manufacturing. The first three forks (left to right) are: Wallace's *Grand Colonial,* 5-9/16"; Durgin's *Marechal Niel,* 5-9/16"; and Gorham's *King Edward,* 5-3/4". The next two forks are in Durgin's *Dauphin* pattern. The first is most likely a pickle fork, and is 7-5/16". The second is 8-3/4" long and was most likely for olives. The next fork, in Kirk's *Repoussé,* is 6". The last two forks are by Gorham. The first is in the pattern *Décor,* 6-3/4", and the last is *Chantilly,* 5-13/16". The *Chantilly* fork at one time was labeled by Gorham as the butter fork pick, but in recent years this has become the pickle fork. The currently produced forks would be valued at $45-65, and the Dauphin forks would each be worth about $250 and up.

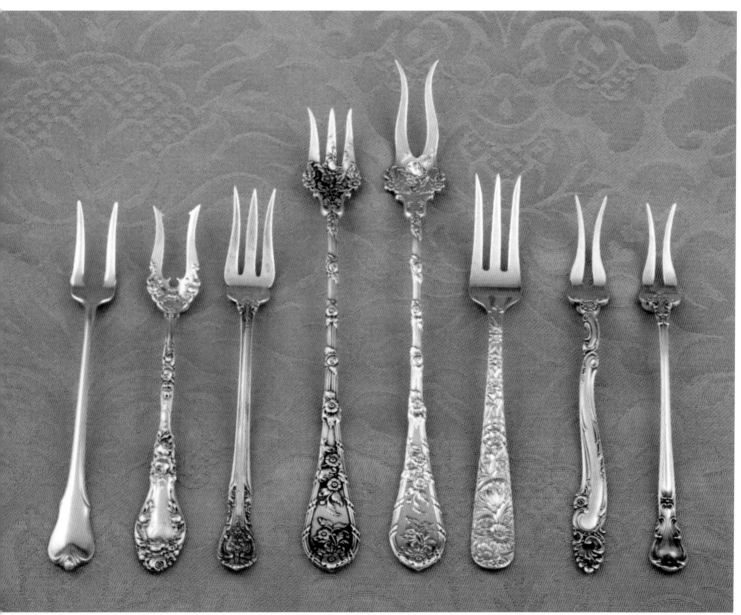

Figure 2.034. A Haviland nappy is used to serve gerkins with a Wallace *Violet* pickle fork.

Piccalilli and Chow Chow Forks/Spoons/Sets

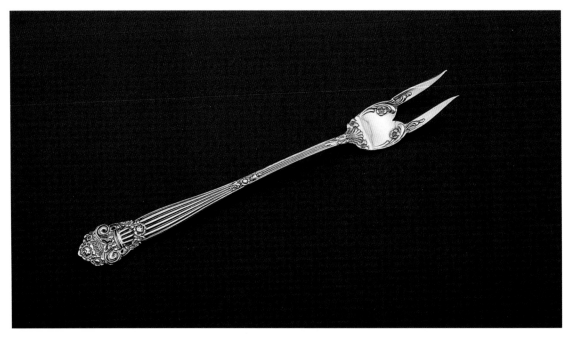

Figure 2.035. Piccalilli sets were not made by many manufacturers, but Towle did make a set. This fork is representative of Towle's work. The pattern is *Georgian* and the fork is 5-7/8", valued at $95.

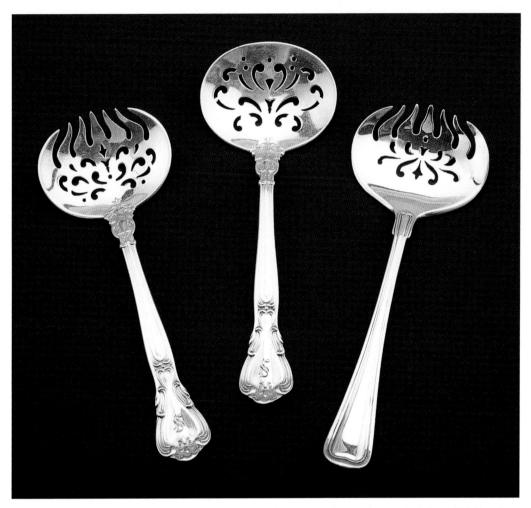

Figure 2.036. This figure contains a set in Gorham's *Chantilly* (right), and a single fork in *Old French* (left). All of the pieces are 5-3/8" in size. The set is valued at $325 and up, while the single fork would bring approximately $165.

Figure 2.037. A Haviland Jelly or Nappy in pattern 266 on Blank 9 with a relish spoon by Reed and Barton in the *Francis I* pattern; it is 6-3/8" long.

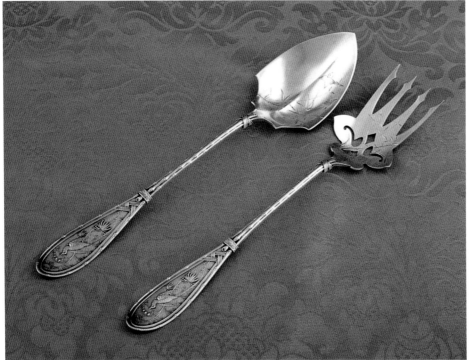

Figure 2.038. Whiting's *Japanese* is represented by a beautiful pair of long-handled salad servers—fork and spoon. The fork is 12-1/4" long and the spoon is 12-1/2" long. The pair would be valued at approximately $1295.

Below:
Figure 2.039. These salad servers, in Gorham's *Imperial Chrysanthemum,* show the difference between long- and regular-handled salad sets. In the long-handled set, the fork is 10" and the spoon is 10-3/16". Notice how the tines of the fork and the bowl of the spoon match the size of those in the other set. The salad set, regular size, has an 8-11/16" spoon and a fork that is 8-5/8". The value of the long-handled set would be approximately $595, while the regular set would be about $450.

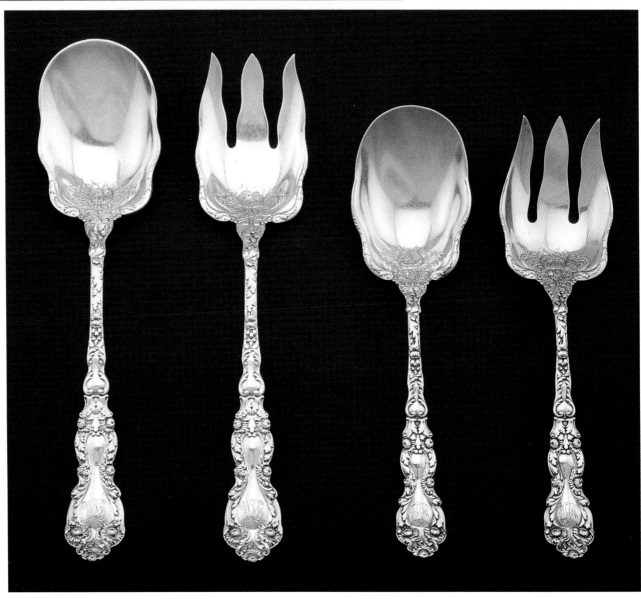

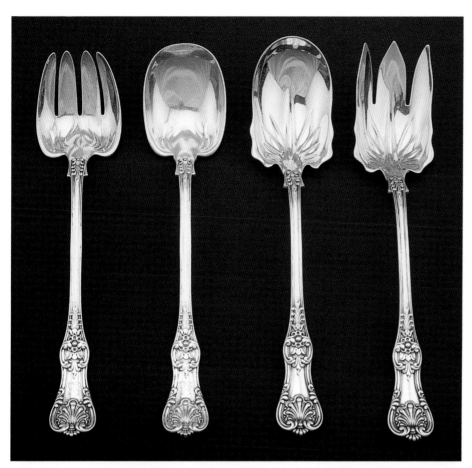

Figure 2.040. A salad set and a seafood set in Tiffany's *English King.* In the salad set (right) both pieces are 10" in length, while in the seafood set (left), both pieces are 9-5/8". Prices for a two-piece salad set would be about $895 and up, with the seafood set commanding a higher price.

Below:
Figure 2.041. Three different sets. On the left is a long-handled set in Gorham's *Poppy.* Both pieces are 10-5/8" in length. The middle set, in Durgin's *Chrysanthemum,* has a 9" spoon and an 8-11/16" fork. The last set, another original long-handled salad set in Gorham's *Chantilly,* has a fork that is 10-1/4" and a spoon that is 10-3/8". The values for these sets would be upward from $595 per pair.

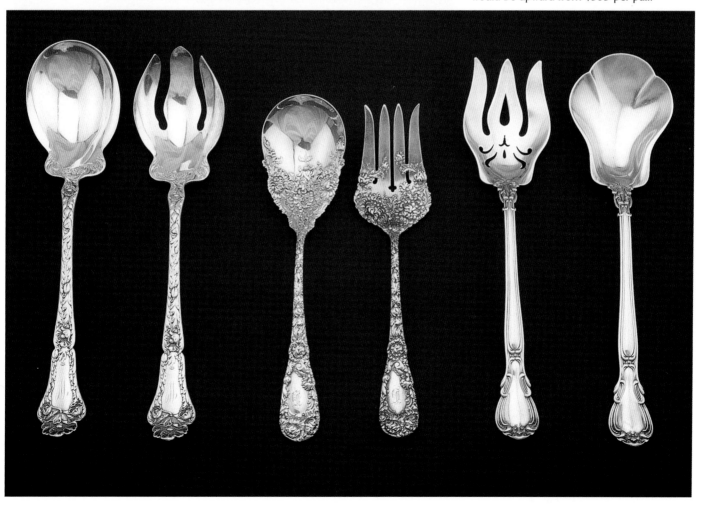

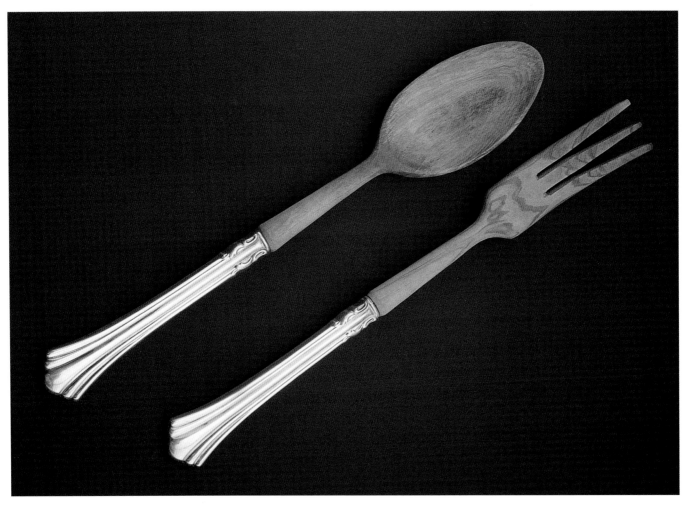

Figure 2.042. A salad set by Reed and Baron made by using sterling handles with wooden inserts. In this case the pattern is *18ᵗʰ Century* and the value of such a set would be approximately $125. The value of this type of set is that, when it is paired with a silver bowl to serve salad, the implements will not scratch the bowl's interior surface.

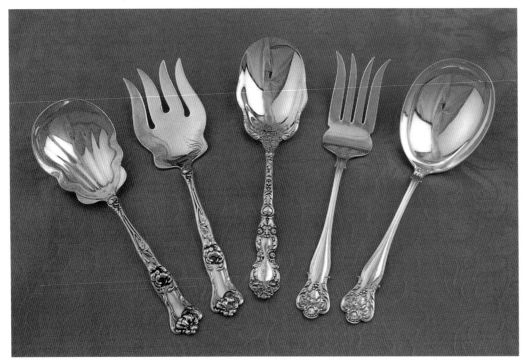

Figure 2.043. Two pairs of matched servers with an additional salad serving spoon in the center. On the left is Wallace's *Peony* with an 8-11/16" fork and a 9" spoon. In the center is Gorham's *Imperial Chrysanthemum* at 8-11/16". Having an extra salad serving spoon is useful for the buffet table and helps serve slightly larger portions. The pair at the right is in Durgin's *New Vintage*. Here the fork and spoon are both 8-15/16". The spoon makes a very useful server for berries, etc. The value of the sets would be about $450 and up. The spoon by itself would be approximately $200 and up.

Figure 2.044. A long-handled salad set in Gorham's *Cluny* is shown with a Libby signed bowl, blue cut to clear. The salad set has a fork that is 10-1/2" and a spoon that is 10-3/4". The beauty of this pattern is in its weight and the wonderful engraving on the tines and bowls of these two pieces. A set like this should be worth in the area of $795 and up.

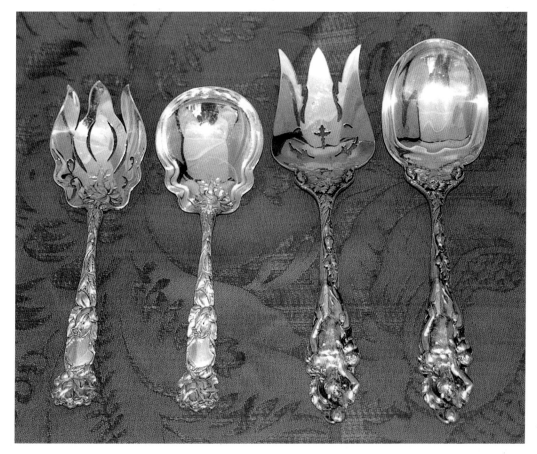

Figure 2.045. Alvin's *Bridal Rose (left)* and Reed and Barton's *Love Disarmed* (right) salad sets. The value of the pieces is from $595 and up. In *Bridal Rose* the fork and spoon are both 9" in length. The huge *Love Disarmed* set has a 10-3/8" fork and a 10-5/8" spoon.

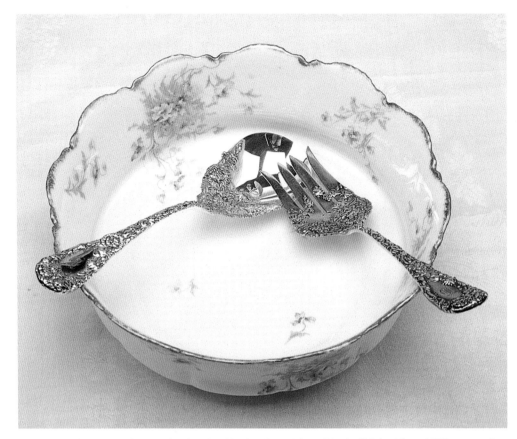

Figure 2.046. A magnificent salad bowl in Haviland's 147A on Blank 133 (gold) c. 1895 is paired with the salad set by Durgin in *Chrysanthemum*. The fork is 8-7/8" and the spoon is 9".

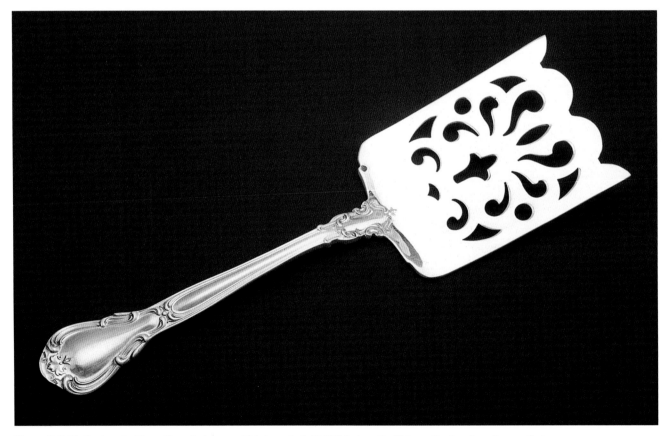

Figure 2.047. Gorham's *Chantilly* salad server. This item is 8-15/16" in length. This particular piece is one that Gorham made in 1995 and marked as part of the 100th anniversary of the pattern. It should sell from $275 and up.

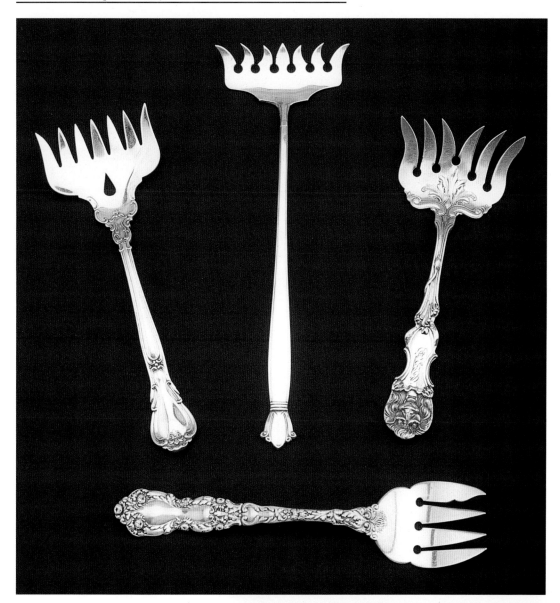

Figure 2.048. A variety of sardine/anchovy forks. At the top left, the *Chantillly* sardine fork by Gorham is 5-7/16" and has the old mark. The middle fork, most likely for anchovies, was manufactured by the Weidlich Sterling Company in their pattern, *Jenny Lind*. It is 6-5/8". The fork on the right is by Frank Smith in the *Lion* pattern and is 5-1/4". The sardine fork on the bottom is Gorham's *Imperial Chrysanthemum* and is 5-7/16". The values for these forks would be approximately $95 for the *Jenny Lind* pattern and $145 and up for the other items.

Figure 2.049. A sardine fork in *Love Disarmed* by Reed and Barton is paired with a Meissen sardine box . The value of the silver would be approximately $135 and up.

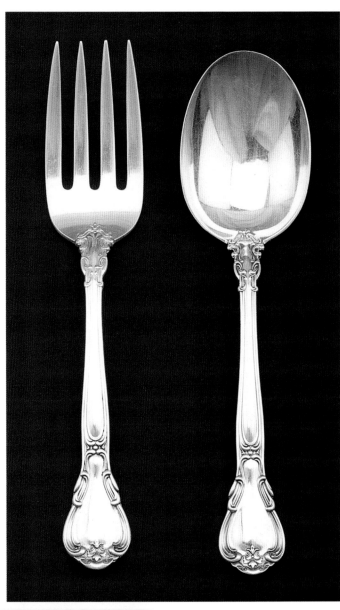

Serving Forks/Spoons

Figure 2.050. This set, or pair, of servers is in Gorham's *Chantilly*. The fork is 8-5/8" and the spoon is 8-7/16". The *Chantilly* set featured in the Place Setting Section, which displaying an original set of *Chantilly* in the original box, had a pair of the spoons, but no forks. For an illustration of this, please see Figures 4.012 and 4.013. The value of the set would be $450 and up.

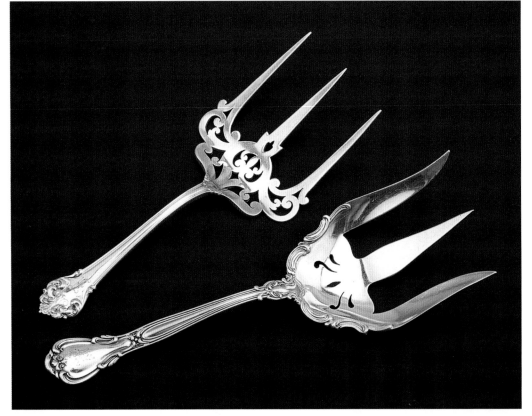

Toast/Bread Forks

Figure 2.051. Two examples of toast/bread forks. At one time it was considered impolite to touch food while being served, and thus the necessity for the toast fork. The Gorham *Chantilly* fork is 7-3/4" and had three tines. The second example, in Reed and Barton's *Elegant*, is 7" in length. Note the very delicate piercing on both of these examples. The value of these would be $495 and up.

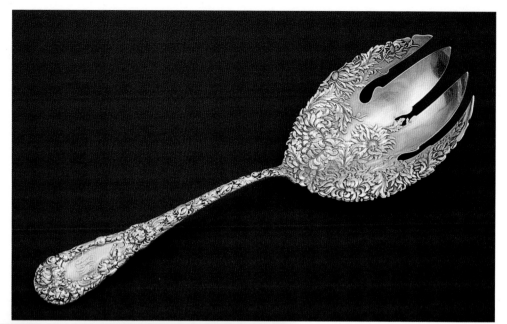

Vegetable Forks, Spoons, and Sets

Figure 2.052. Here is a lone example in Durgin's *Chrysanthemum*. Pairing this fork with the large berry spoon makes a fantastic salad serving set. The fork is 9-3/8" in length. The value for this rare piece is $795 and up.

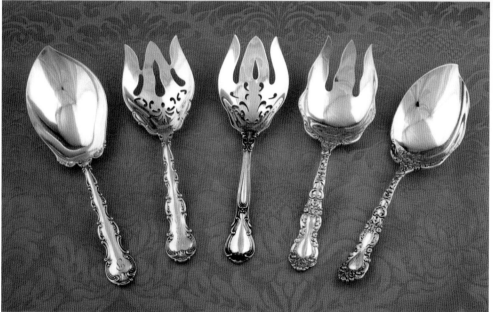

Figure 2.053. In this example, two sets and a single fork are shown. They were are all manufactured by Gorham. On the left is a *Strasbourg* set; the fork is 8-3/4" and the spoon is 9-5/8". The *Chantilly* fork in the middle is 8-3/4", and the *Imperial Chrysanthemum* set on the right has a 9" spoon and an 8-7/8" fork. The sets are worth from $895 up and the single fork is $450. These items are extremely useful on the buffet table.

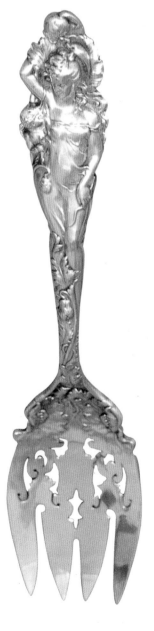

Figure 2.054. Another example in *Love Disarmed* by Reed and Barton. This serving fork is 10-1/4" long. The value of this would be $250 and up. This pattern at this time is currently available.

Knives

Butter Knives

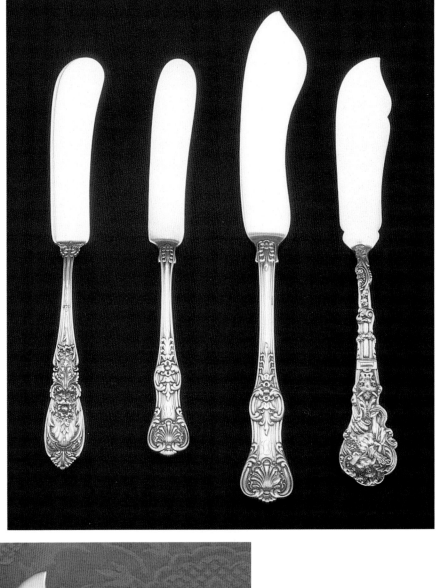

Figure 2.055. Four all-silver butter knives. On the left is International's *Richleau*, 7-1/4" long. Notice the differently shaped blade. Next are two examples in Tiffany's *English King*. The first is 7" and is most likely a pickle knife or small butter knife, and the second is a master butter knife at 8-3/4". Last is Gorham's *Versailles* at 7-1/4". The value of these knives would be from approximately $85 to over $145 in the highly desirable patterns.

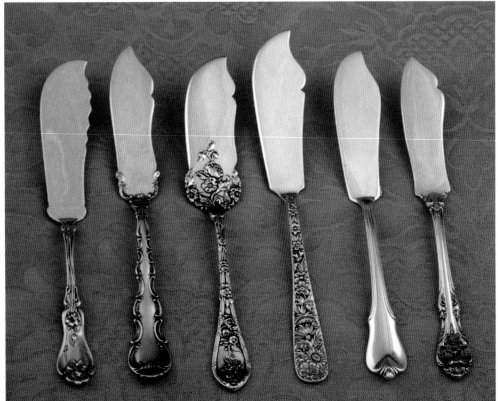

Figure 2.056. The reader can compare a number of manufacturers' butter knives. From left to right: Whiting's *Violet* at 6-3/4"; Gorham's *Strasbourg* at 6-13/16"; Durgin's *Dauphin* at 6-7/8"; Kirk's *Repoussé* at 7-1/8"; Wallace's *Grand Colonial* at 6-15/16"; and Gorham's *King Edward* at 6-13/16". The value of these knives would range again from $65 to over $125 in the more highly collectable patterns.

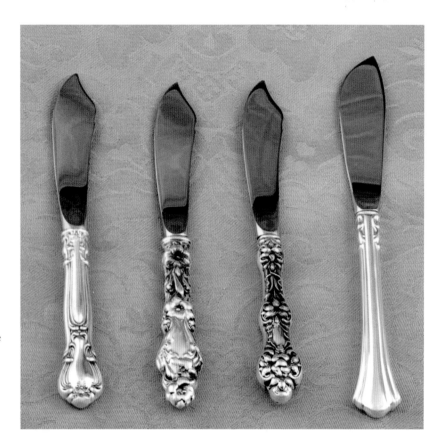

Figure 2.057. Hollow-handled butter serving knives. Frequently the size of the handle is the same as an individual butter server or, as in the cases of *Lily* and *Old Orange Blossom*, the same length as the tea knife. In the figure, from left to right: Gorham's *Chantilly*, 6-5/8"; Whiting's *Lily*, at 6-5/8"; Alvin's *Old Orange Blossom*; at 6-5/8"; and Reed and Barton's *Eighteenth Century*, at 7-1/2". $49 to $79.

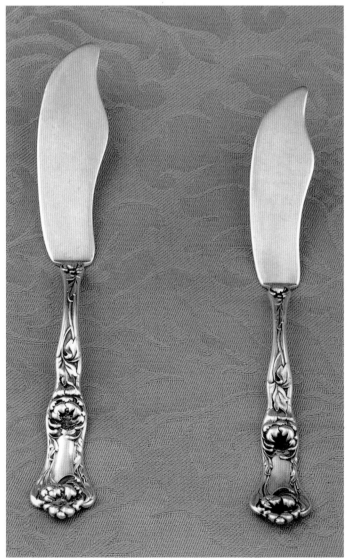

Figure 2.058. A comparison between the master butter knife and the pickle knife/small butter server in Wallace's *Peony*. The large knife is 6-7/8" and the master butter knife is 7-5/8". Value for these knives would be approximately $79 for the smaller knife and $145 for the larger knife.

Cake/Pie/Pastry All–Silver Knives

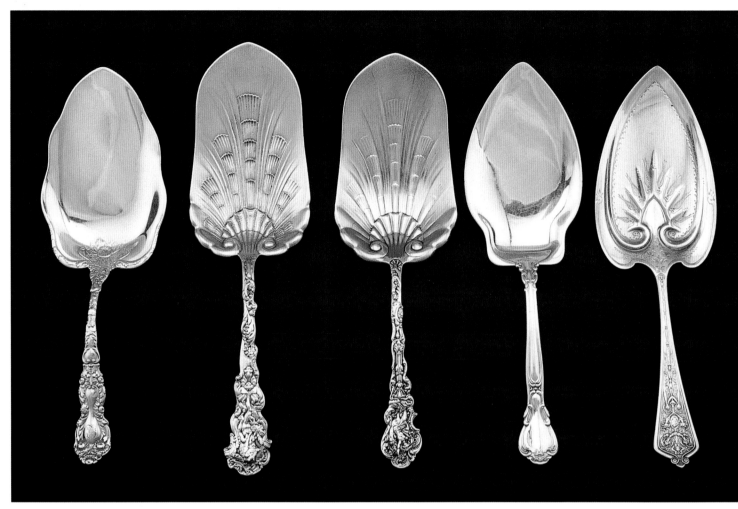

Figure 2.059. All-silver pie or cake servers manufactured by Gorham. On the left is *Imperial Chrysanthemum* at 8-13/16". Next are two versions in *Versailles*. The difference between the two pieces is in the handle length and width. The larger piece is 9-11/16" and the smaller item is 9-3/8". *Chantilly* is the next server and it is 9" in length. Last is an old pattern, *Lady Washington*, and it is 9-1/8". The value of these items would range from $195 to well over $450.

Figure 2.061. In this figure a jelly cake knife and an individual salad fork in Reed and Barton's *Love Disarmed* are featured. The value of the all-silver server, a currently produced piece, would be approximately $275, and the individual salad fork is in the range of $75-125, depending upon the age of the piece. Note: original pieces would be more valuable than currently produced items.

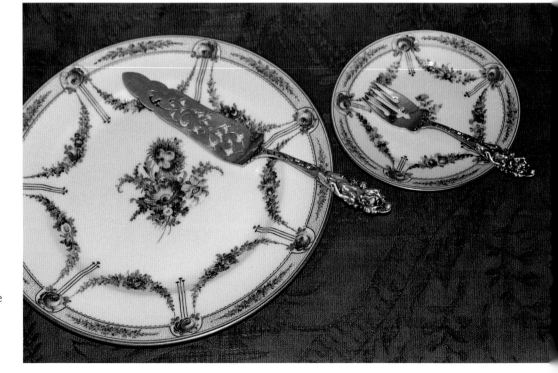

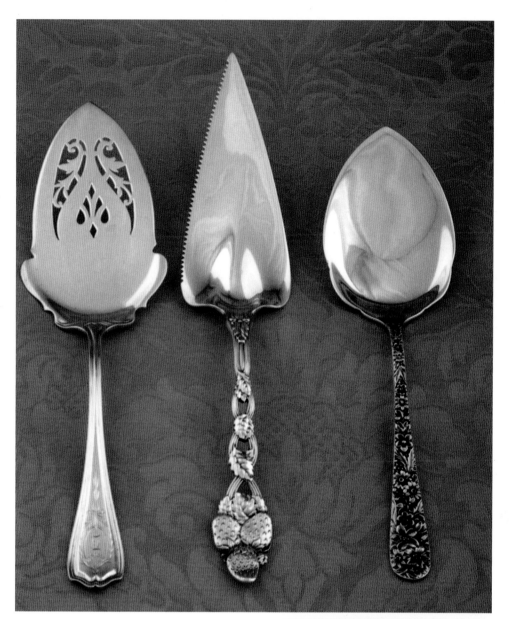

Figure 2.062. The three servers in this picture are, again, all-silver and quite differently made. The first example is a pie server from Reed and Barton in their pattern *Hepplewhite, Engraved*. This pierced piece is 10-3/8" long. The next item, by Tiffany in their *Strawberry*, is 11-3/8". The last item is by Kirk in their *Repoussé* pattern and it is 9-1/2" long. The values of these three pieces would vary greatly. The Tiffany piece would command about $995 and the other two $295-425 for older examples.

Right:
Figure 2.063. Four hollow-handled examples and one all-silver server (center). From left to right the pieces are: Reed and Barton's *Love Disarmed*; Towle's *Rambler Rose*, (measurements not available); Wallace's *Grand Colonial*, 9-3/16" (very unusual and rather rare piece); Kirk's *Repoussé* at 10-3/16"; and Wallace's *Peony* at 10-3/8". The hollow-handled pieces could range in value from $59 to over $95. The all-silver *Grand Colonial* is worth over $200, even with the monogram, due to the rarity of the item.

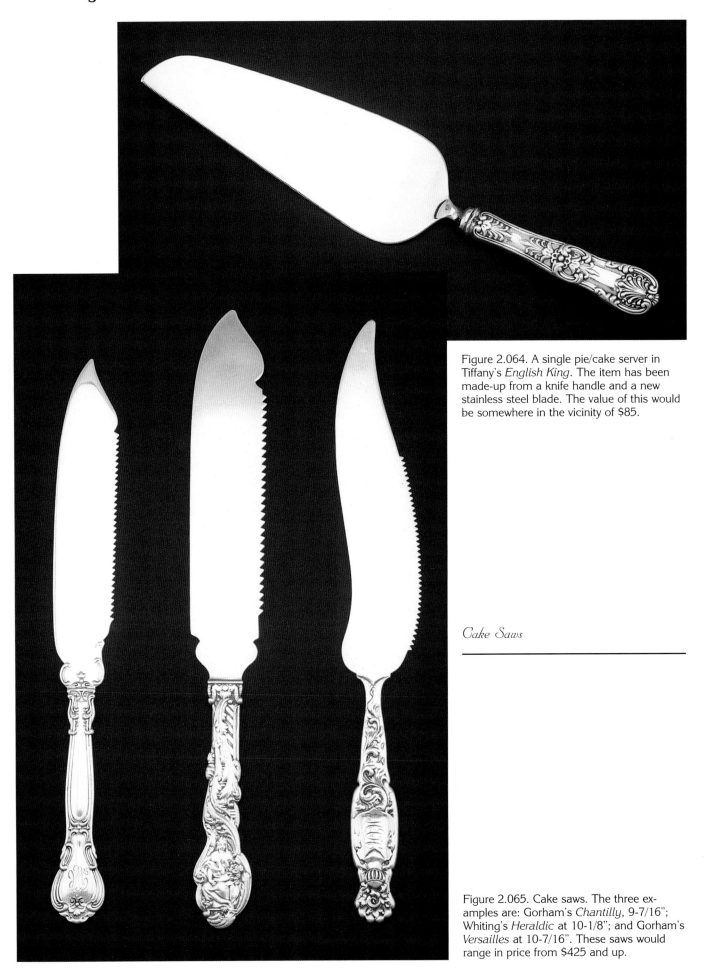

Figure 2.064. A single pie/cake server in Tiffany's *English King*. The item has been made-up from a knife handle and a new stainless steel blade. The value of this would be somewhere in the vicinity of $85.

Cake Saws

Figure 2.065. Cake saws. The three examples are: Gorham's *Chantilly*, 9-7/16"; Whiting's *Heraldic* at 10-1/8"; and Gorham's *Versailles* at 10-7/16". These saws would range in price from $425 and up.

Cheese Implements

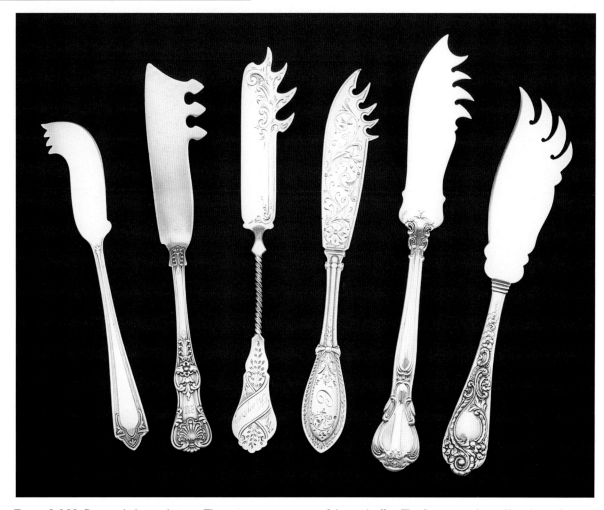

Figure 2.066. Pronged cheese knives. These items are very useful on a buffet. The first example, in Manchester's *Doric,* may be an individual piece; the clue being the manner in which the tines are pointed. This piece is 6-5/16". Beside it is Tiffany's *English King,* is 7" long. Third is a coin silver example, only marked with an "E," which it may be a strap cheese knife. It is 7-7/16" long. The next item is Whiting's *Italian,* 7-3/16" long. The fifth knife is Gorham's *Chantilly,* 8" long. The last item is marked "H & D," pattern and manufacturer both unknown and it is 7-3/8" in length. These pieces would be valued at $110 and up.

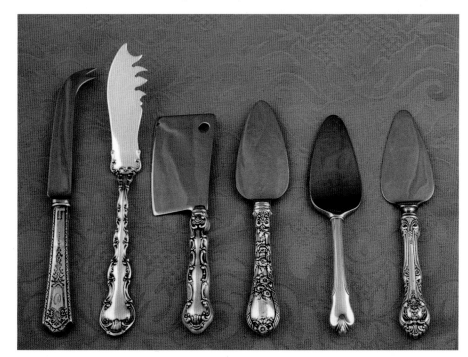

Figure 2.067. The variety of items that can be found in cheese implements is illustrated here. From the left: Manchester's *Princess,* 7-5/8" (note this has been rebladed); *Strasbourg* cheese knife by Gorham, 8"; cheese cleaver also in *Strasbourg*; Durgin's *Dauphin* (also rebladed) 6-5/8"; Wallace's *Grand Colonial,* 6-7/16"; and Gorham's *King Edward,* 6-1/2". The value of these items would range from $49 to approximately $100.

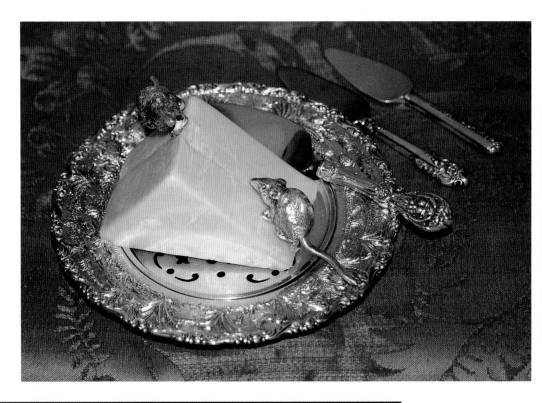

Figure 2.068. A *Repoussé* butter dish by Kirk, with a wedge of cheddar cheese. The two sterling mice inspecting the cheese, are whimsical items for the buffet table. Three cheese knives are visible in the photograph. On the plate is *Francis I* by Reed and Barton, next is Wallace's *Grand Baroque*, and last is Towle's *Rambler Rose*. The value of the knives would be $55 to 85. Measurements were not available for the items.

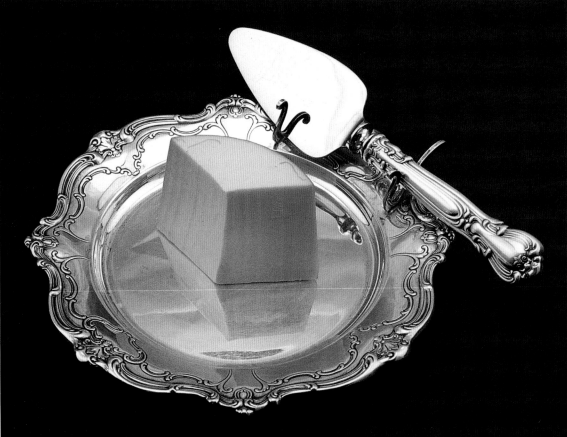

Figure 2.069. A cheese dish in Gorham's *Chantilly* with a nice Smoked Gouda. This dish has two short sterling prongs that hold the cheese serving implement. The knife would be valued at approximately $59 and up. The dish, created by Gorham from bread and butter plates, would be worth from $115 up, depending on condition. This particular item is frequently sold as a "bread and butter plate with holder" by unknowing dealers. If you are going to use the plate for cutting cheese, it is always wise to take a sterling dish like this to a shop specializing in plastics and have a clear plastic insert cut to fit in the bottom of the dish. This prevents nasty knife blade lines so often found on sterling trays. The same idea holds true for larger sterling dishes or trays where food will need to be cut before serving.

Crumb Knives (Crumbers)

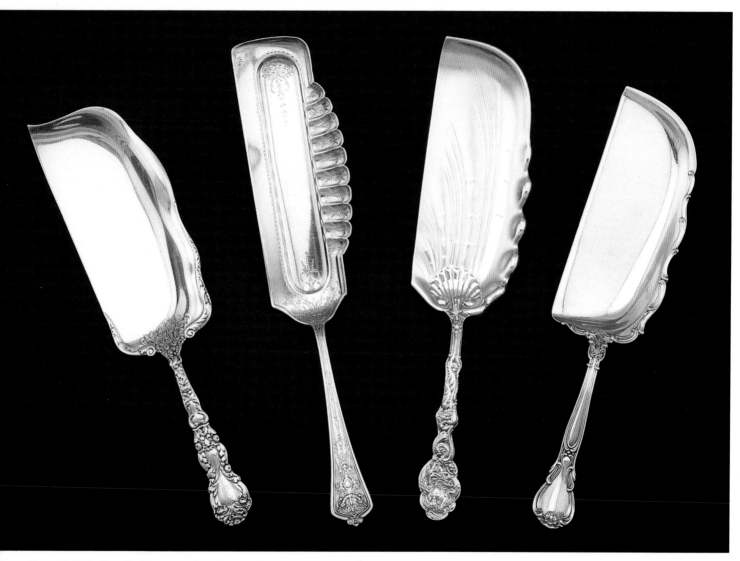

Figure 2.070. Four Gorham crumbers. These large "knives" are very useful for buffets. These work well serving stuffed crepes or enchiladas. From left to right: *Imperial Chrysanthemum*, 11-5/8"; *Lady Washington*, 12-7/8"; *Versailles*, 12-5/8"; and last, *Chantilly*, 11-11/16". The value of these items would range from $495 and up.

Figure 2.071. Tiffany's *English King* at 12-3/4". The value of this piece would be $795 and up.

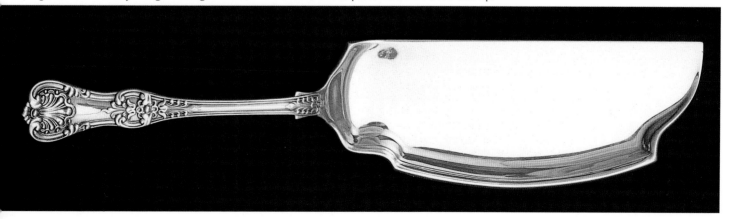

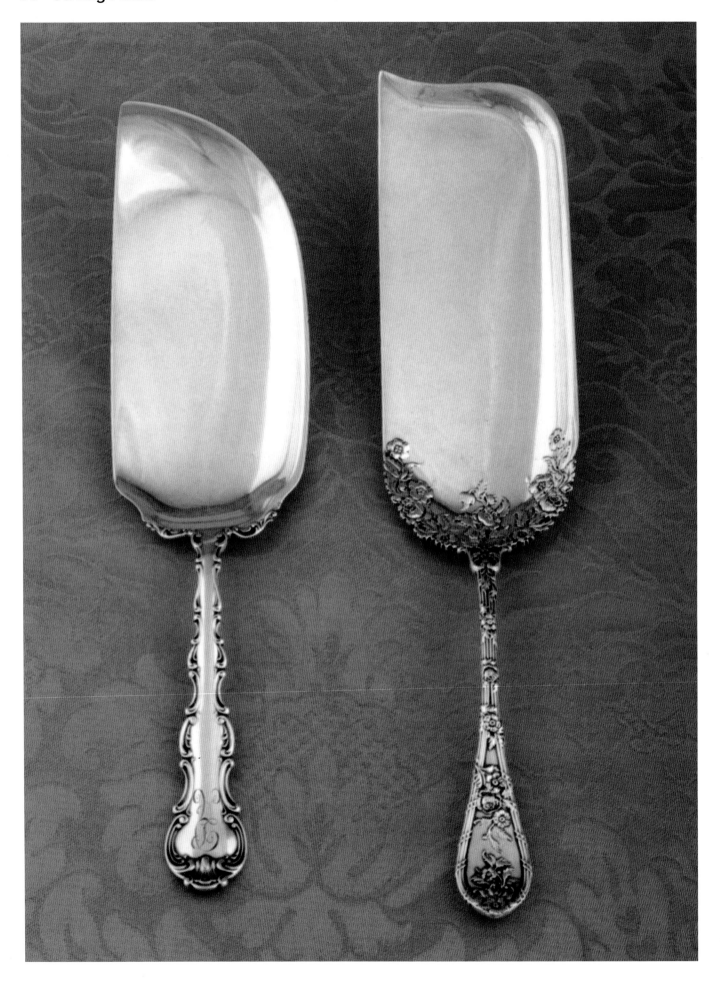

Opposite page:
Figure 2.072. Two magnificent crumbers. The left example, by Gorham in their *Strasbourg* pattern, is 11-1/2" The second crumb knife is by Durgin in their *Dauphin* pattern. It is 12-7/8" long. The value of these pieces would be $695 for the Gorham piece and approximately $995 and up for the Durgin piece.

Jelly Knives

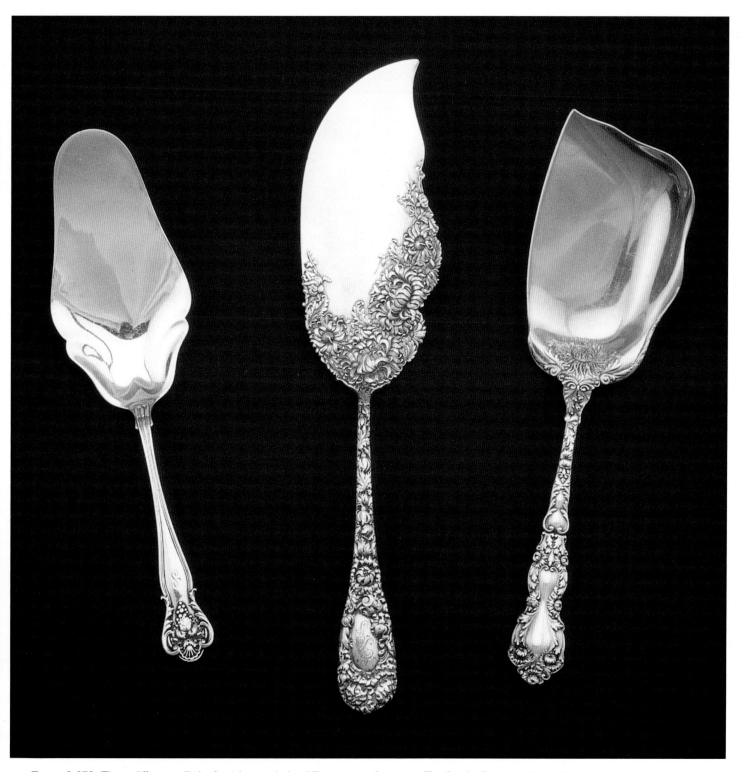

Figure 2.073. Three different jelly knife styles made by different manufacturers. The first by Durgin in their *New Vintage* pattern is 7-3/4". The second, also by Durgin in *Chrysanthemum,* is 9-11/16". The last, by Gorham in *Imperial Chrysanthemum,* is 9-3/8". The value of these items will vary from $165 to $325. There has been repair work done on the blade of the *New Vintage* piece, which would detract from its value.

Ice Cream Knives/Servers

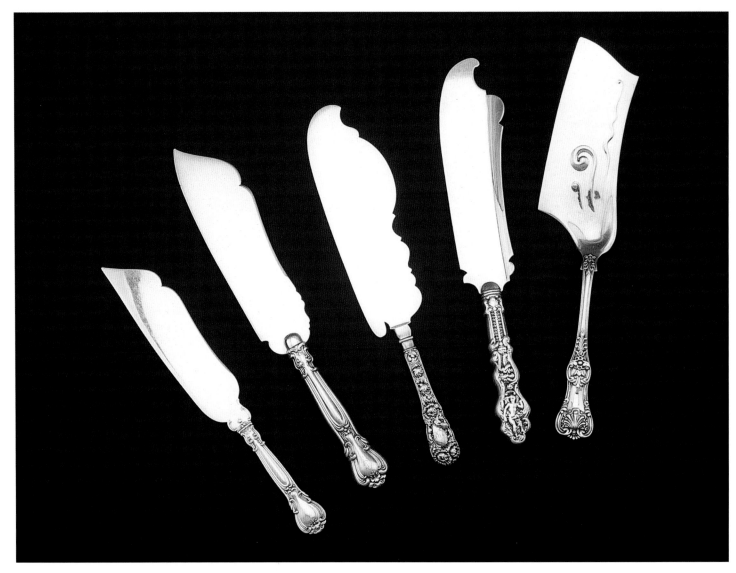

Figure 2.074. A variety of items by three manufacturers. At the left is a flat, all-silver ice cream knife in Gorham's *Chantilly*, at 10-1/4". Beside it is another *Chantilly* piece with a sterling hollow-handle, but plated blade. It is 12-3/16" long. This is frequently found with the handle at a slight angle. Due to the pressure one exerts when cutting a brick of ice cream it is possible that damage can occur. The middle piece is Durgin's all-silver *Chrysanthemum*. The beautiful 11-11/16" blade gives this piece distinction. The next, also by Gorham in *Versailles,* is hollow-handled and 12-1/4" long. The last example in this grouping is a Tiffany *English King,* at 12". Note the gold wash on the blade, along with the stamped design, giving prominence to this piece. The value of these items would be from $595 and upward.

Opposite page, top:
Figure 2.075. Two Gorham pieces and one by Tiffany. The Haviland dish was sold as an ice cream tray, but it is in reality a cookie tray. It is certainly the size for a brick of ice cream and would serve well in that capacity. The hollow handle knife at the bottom of the picture is in *Strasbourg* and is 10-1/2" long. Careful examination of the handle reveals that pressure from cutting has caused a separation between the top and bottom of the handle. The middle example, on the tray is also Gorham's, but it is in the *Buttercup* pattern and is 10" long and all-silver. The example to the right of the dish is a fabulous Tiffany example in their *Strawberry* pattern and it is 11-1/2". The *Strasbourg* item, in perfect condition would be worth approximately $69. The *Buttercup* example is worth about $225 and up. The Tiffany example is valued at $1295 and up.

Opposite page, bottom:
Figure 2.076. The Haviland items in this figure are paired with the Reed and Barton *Love Disarmed* silver. On the tray, a slicer is displayed. To the right an ice cream server is shown. An individual ice cream spoon is shown on the individual plate. The value of the items would be as follows, depending on the age of the items: ice cream slicer, $595 and up; the server $595 and up; and the individual spoon, $85.

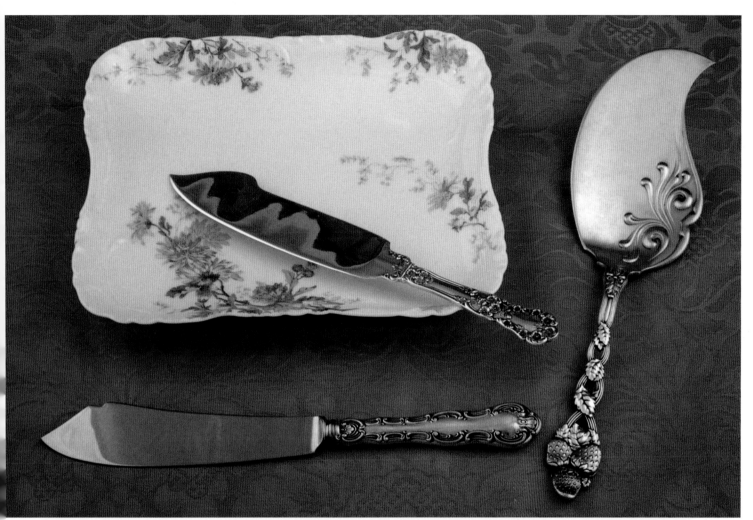

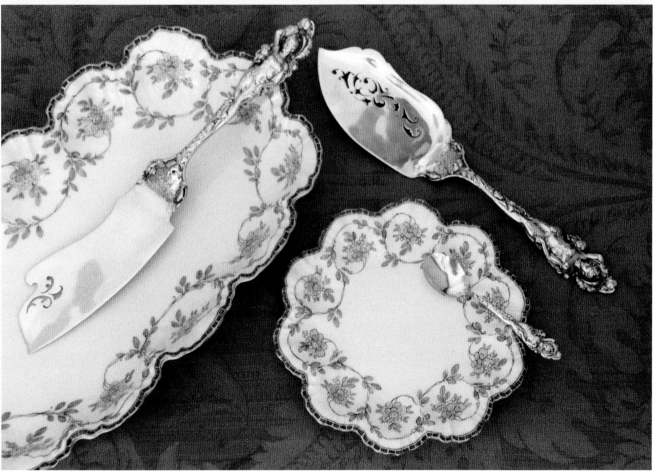

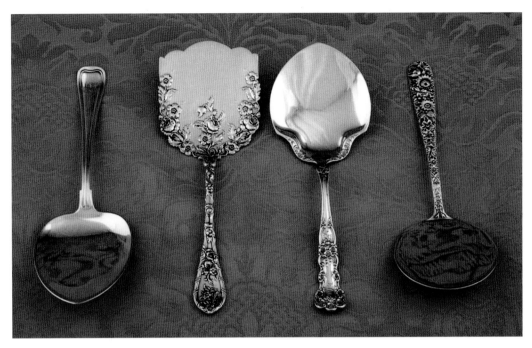

Figure 2.077. In this figure four waffle knives are featured. Left to right: Gorham's *Old French,* 7-15/16"; Durgin's *Dauphin,* 8"; Gorham's *Buttercup,* 7-13/16"; and Kirk's *Repoussé,* 7-5/8". All of these examples are fairly typical for each of the manufacturers. These items are really stunning and serve many uses. They are valued at $395 and up, depending on age.

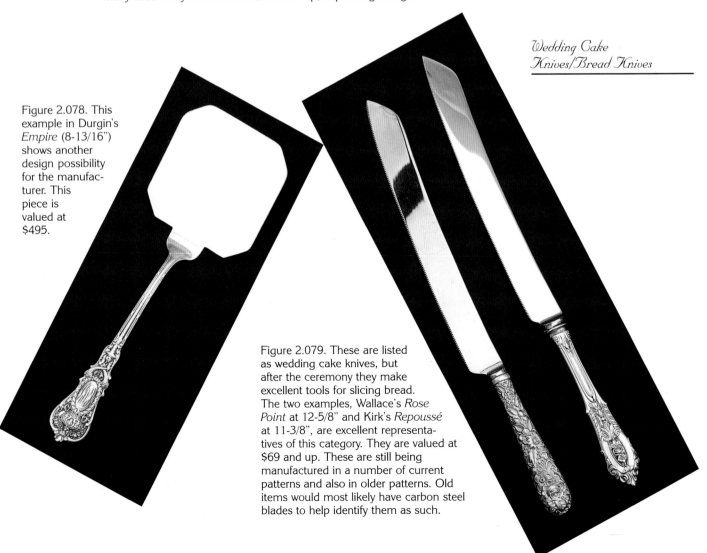

Figure 2.078. This example in Durgin's *Empire* (8-13/16") shows another design possibility for the manufacturer. This piece is valued at $495.

Figure 2.079. These are listed as wedding cake knives, but after the ceremony they make excellent tools for slicing bread. The two examples, Wallace's *Rose Point* at 12-5/8" and Kirk's *Repoussé* at 11-3/8", are excellent representatives of this category. They are valued at $69 and up. These are still being manufactured in a number of current patterns and also in older patterns. Old items would most likely have carbon steel blades to help identify them as such.

Spoons

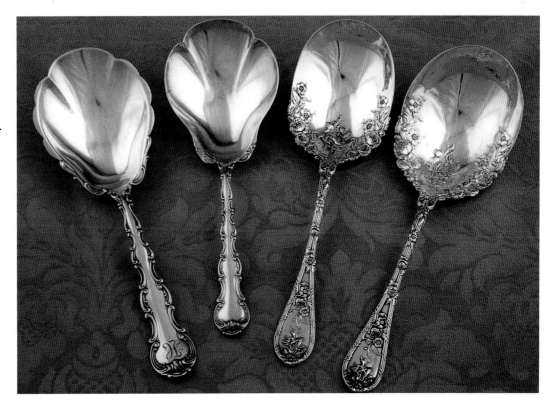

Figure 2.080. Two pairs of berry spoons in two different patterns. At the left are two spoons in Gorham's *Strasbourg* pattern. The first is 8-3/4"; the second is 7-5/8" and gold washed. The other pair, in Durgin's *Dauphin* pattern, are 8-7/8" and 9-1/8" in length. The larger spoon is gold washed. The value of these spoons would vary between $195 and 695 for the largest spoon, depending on the condition and desirability of the spoons.

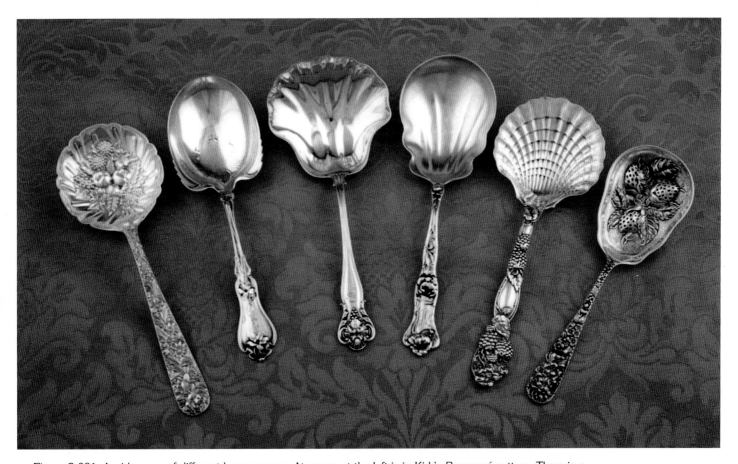

Figure 2.081. A wide array of different berry spoons. At spoon at the left is in Kirk's *Repoussé* pattern. There is a companion spoon with matches this, but it is smaller, and is not illustrated here. This is followed, left to right, by: Whiting's *Violet* spoon, 8-13/16"; Durgin's *New Vintage* with a beautiful shell shaped bowl, 8-13/16"; Wallace's *Peony*, 9"; Tiffany's *Blackberry*, 8-7/8"; and Stieff's *Rose*, 8-1/8". The value of these spoons would be from $325 to 995 for the Tiffany piece.

Figure 2.082. This figure repeats two of the spoons seen in Figure 2.081, but introduces yet another variation in the Tiffany work. From left to right: Wallace's *Peony,* 9"; Tiffany's *Blackberry,* at 8-7/8" with a conch-like bowl; Whiting's *Violet* at 8-13/16". The Tiffany piece would be valued at approximately $895. The other two pieces would vary from $395 to 450.

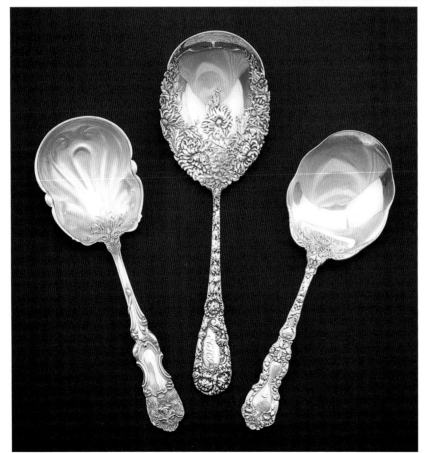

Figure 2.083. The berry spoons are (left to right): Frank Smith's *Lion* at 8-3/8"; Durgin's *Chrysanthemum* at 9-3/8"; and Gorham's *Imperial Chrysanthemum* at 8". The value of these pieces would range between $325 and $595.

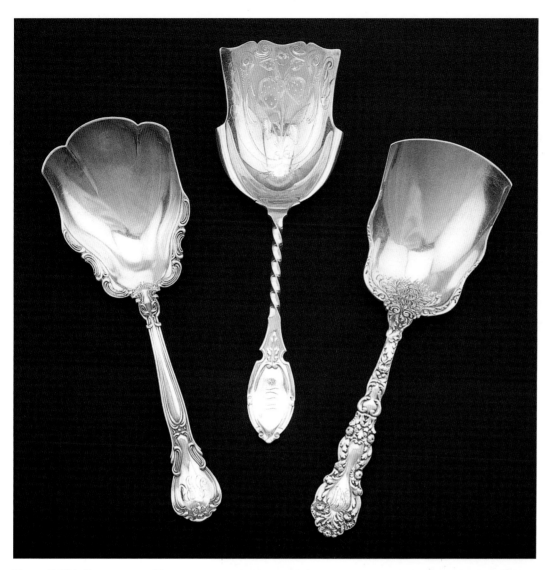

Figure 2.084. Berry scoops. The first, Gorham's *Chantilly* at 9-11/16" has an applied edge, making it from circa 1895. The next spoon is an unmarked coin spoon with a gold washed bowl and engraved strawberries. It is 8-7/8". The last scoop is again by Gorham in *Imperial Chrysanthemum* and it is 9-3/4". The value of these scoops is from $595 up.

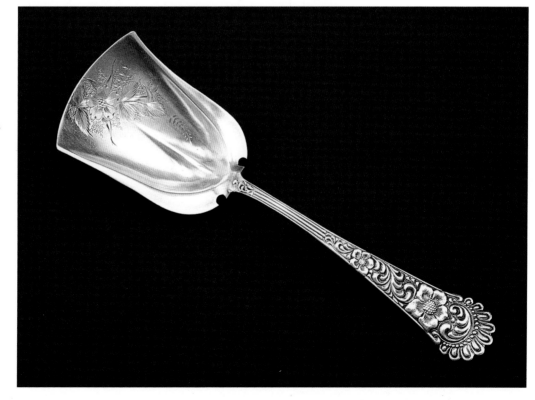

Figure 2.085. Another berry scoop, but an unknown pattern, marked H & D, 8-3/4". Value of this scoop would be approximately $375.

Figure 2.086. Four bon bon spoons or scoops. At the top left is Gorham's *Imperial Chrysanthemum* which has a scoop that pours to the left. This piece is 5-7/16". It could be a confection spoon. This particular item is not shown in any of the author's collection of design patents for Gorham's *Imperial Chrysanthemum* (*see Appendix*). Not all items manufactured are shown in every brochure, but a glimpse of a brochure helps with logical deductions. At the top center is an example of Durgin's *Chrysanthemum*. It is 5-1/8". Note the manner in which the designer has placed full blown flowers into the bowl. At the top right is a regular nut or bon bon spoon in Gorham's *Imperial Chrysanthemum*. At the bottom is an example of a scoop in Mt. Vernon Company's *Louise*, 4-7/8". The value of these items would range from about $85 and up to 175.

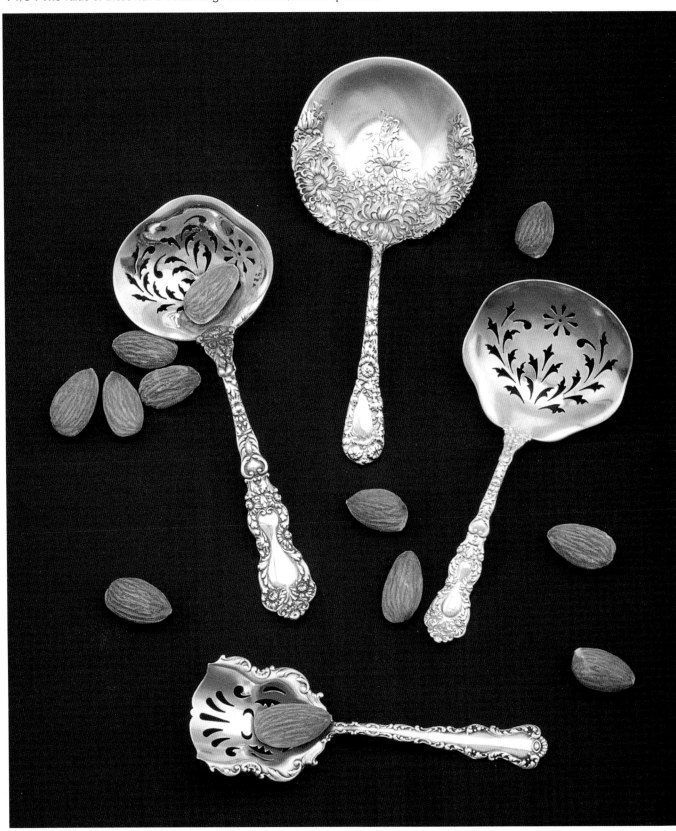

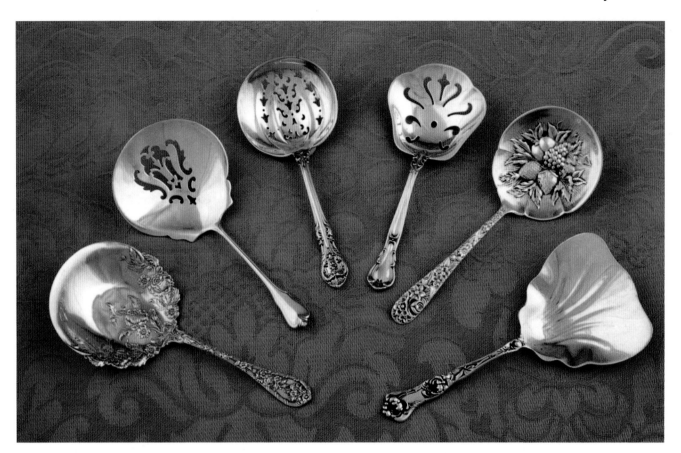

Figure 2.087. A wider variety of the shapes in bon bon spoons. From left to right: Durgin's *Dauphin* at 5-1/4";
Wallace's *Grand Colonial* at 4-15/16"; Gorham's *King Edward* at 4-15/16"; *Chantilly* at 4-3/8"; Kirk's *Repoussé*
at 5-5/8"; and Wallace's *Peony* at 5-1/8". Values for these items would range from $65 to about $195 for the
Dauphin example.

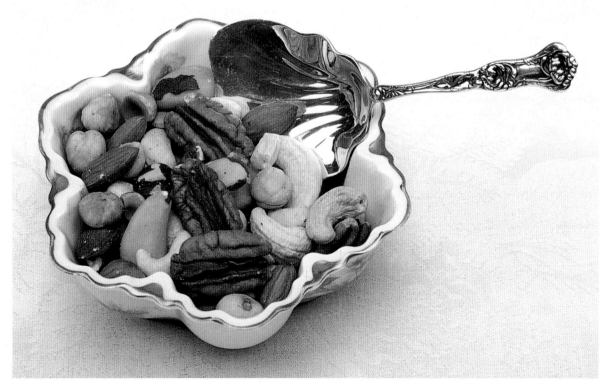

Figure 2.088. A Haviland nappy, a 6 pointed bowl in blank #1 with gold, with Wallace's *Peony* nut spoon in the
mixed nuts. The value of the silver is $95.

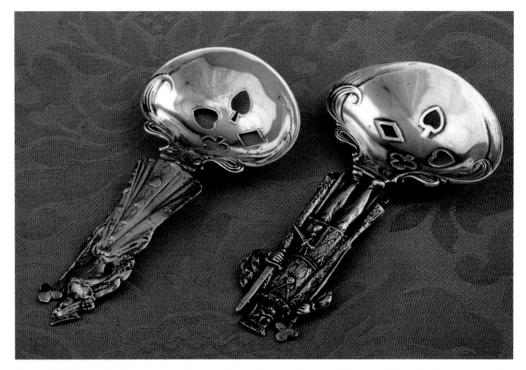

Figure 2.089. A pair of bon bon nut servers featuring the King and Queen of Hearts. These unusual items were made by the Whiting Company. They are marked, "Copy. 1901." They are valued at $275 each.

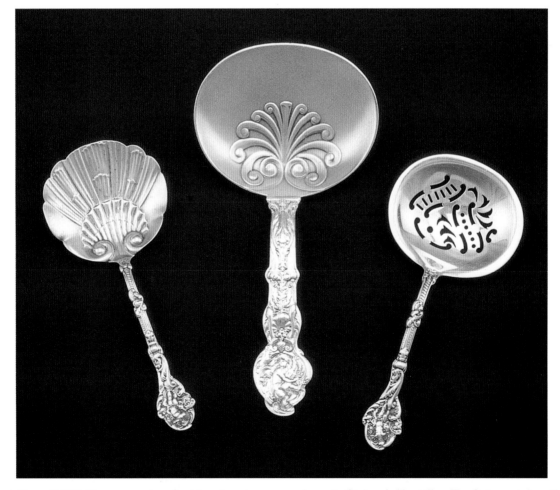

Figure 2.090. Three examples of nut/bon bon servers are shown in Gorham's *Versailles*. The first example, with a solid bowl and a shell motif, is 4-3/4". The middle example is a large solid shell and is 5-13/16". The last, pierced example is 4-7/8". The value of these items would range from $95 to over $250 for the large sample.

Right:
Figure 2.091. Schofield's *Baltimore Rose* (5-5/8") is shown with large Haviland bon bon dish marked "G. Demartine." This would be G & D Cie, Limoge, France, 1891-1900. The bon bon spoon is valued at $95 and up.

Claret Spoons

Figure 2.092. Five examples of claret spoons. The label claret "spoon" is somewhat of a misnomer, since these examples are ladle-shaped, but claret spoon is the correct designation for this category. Beginning from the bottom left, the first spoon is by Dominic and Haff in their pattern, *Number Ten (#10)*. It is 12-3/4" long. Tiffany's *English King* is next at 15-3/4", followed by two examples in Gorham's *Versailles*. The first example in *Versailles* has a plain bowl, and is 14-1/2" long. The second example, with a fancy bowl, is 14-3/8" long. The last example in Wallace's *Rose* is 13-1/4". The value of these unique spoons is $325 to $750.

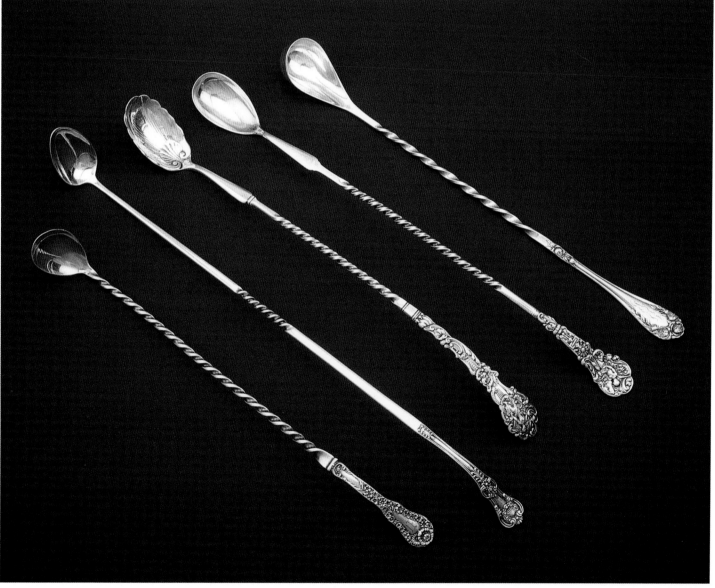

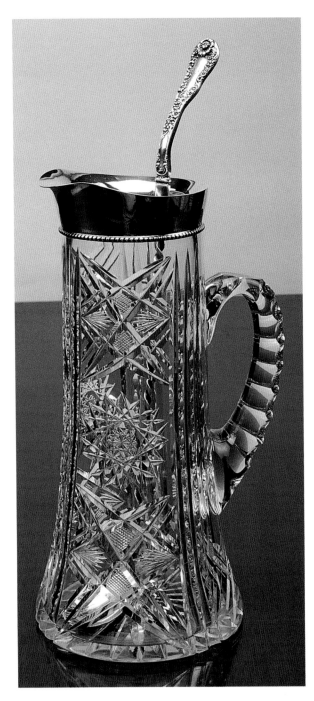

Figure 2.093. A cut glass pitcher, with Dominic and Haff's *Number Ten* claret spoon. The value of the spoon would be approximately $325 and upward.

Confection Spoons

Below:
Figure 2.094. Two examples of confection spoons. The first example is Gorham's *Chantilly* and is 5" in length. The second example is Watson's *Orchid* at 6-3/16". This category can range from $125 to well over $450 for rare examples.

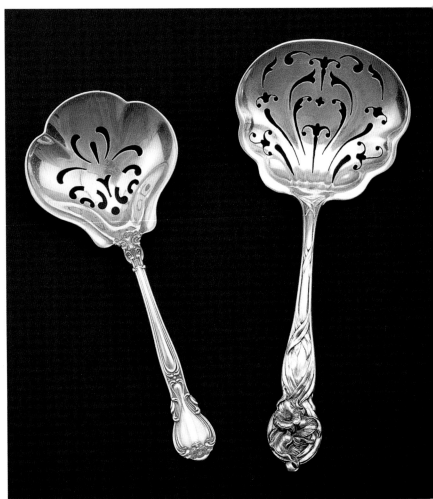

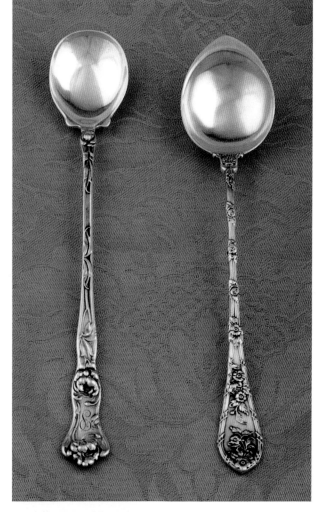

Chocolate Muddlers

Figure 2.095. Two examples of chocolate muddlers. The example on the left is Wallace's *Peony* and is 8-1/4". The example of the right is in Durgin's *Dauphin* and is 8". The value of these items would be from $225 to well over $500 in very rare patterns.

Below:
Figure 2.096. A complete set of a muddler and spoons. The pattern is *Old Colonial* by Towle. The muddler is 8-1/2" and each spoon is 4-1/4". The necessity for the spoons was that fact the chocolate was not as completely refined and had to be frequently agitated to keep the chocolate suspended. A complete set, muddler and spoons, would command a higher price. In this case a value of $650 and up would be in order.

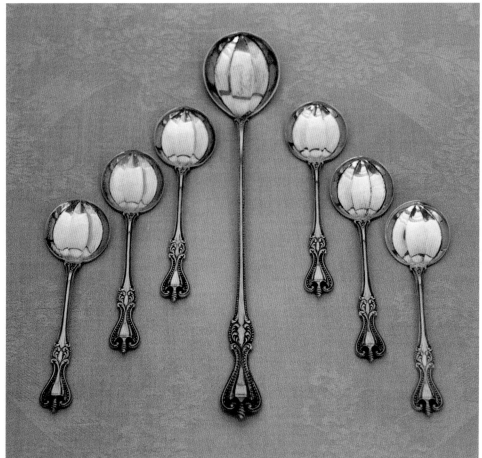

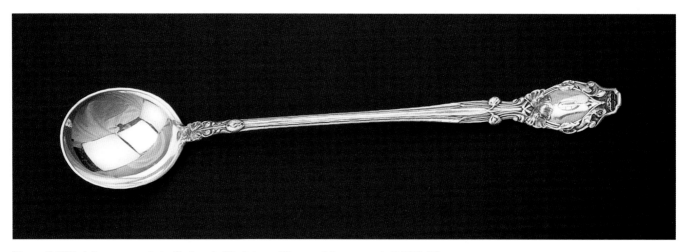

Figure 2.097. A lone example in Gorham's *Virginiana*. The muddler spoon is 9-3/8". The value of this spoon would be about $250.

Horseradish Spoons

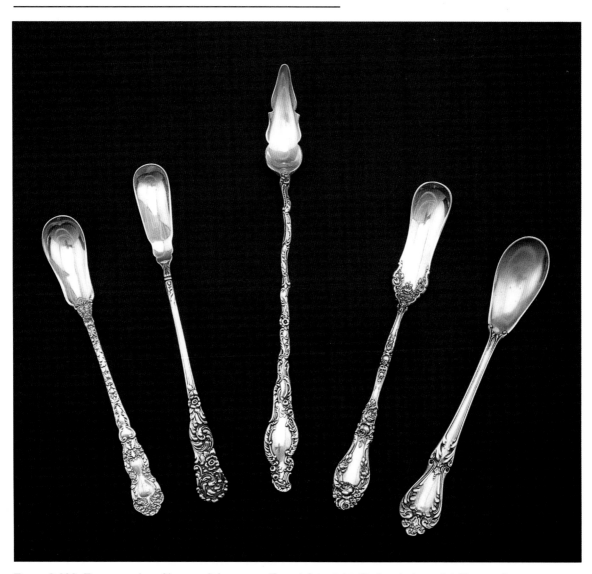

Figure 2.098. Five examples of horseradish spoons. From left to right: Gorham's *Imperial Chrysanthemum*, 5-3/4"; Reed and Barton's *Trajan*, at 6-7/16"; Durgin's *Watteau*, 8" (note the unusual bowl of this spoon); Durgin's *Marechal Niel*, 6-1/4"; and an unknown pattern by Watson, 5-15/16". The value of these items ranges from $95 to $425. Durgin made long- and short-handled horseradish spoons.

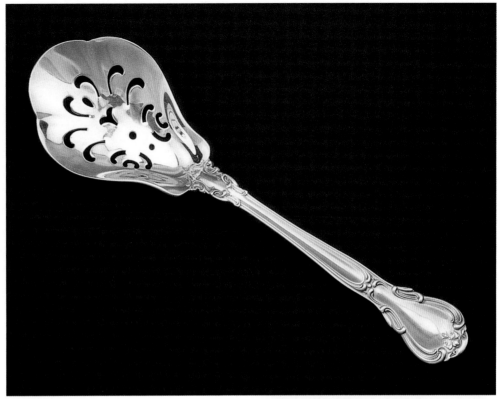

Ice Spoons

Figure 2.099. An example of an ice spoon in Gorham's *Chantilly*. Ice spoons are usually made from berry spoons, using a heavier gage of silver. These spoons are currently being remade, so locating old examples may prove difficult. This example is 9" in length. The value of examples in this category would be from $225 and upward.

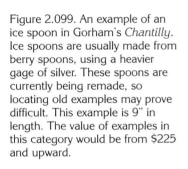

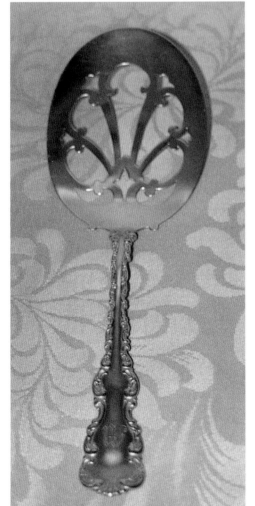

Poached Egg Server

Left:
Figure 2.100. An example of a poach egg server in Whiting's *Louis XV*. This one is 7-3/4". The value of this item would be approximately $295.

Mashed Potato Spoon

Right:
Figure 2.101. Currently Reed and Barton is featuring this spoon. It is 8-7/16" and is an excellent size to have on the dinner table to serve mashed potatoes. The value is $175 and upward.

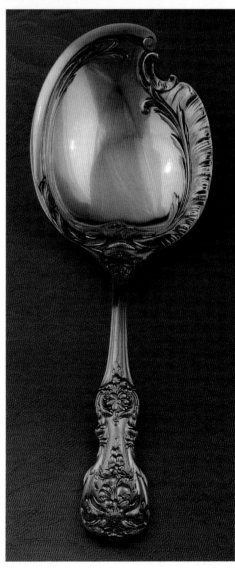

Jam/Jelly Spoons/Servers

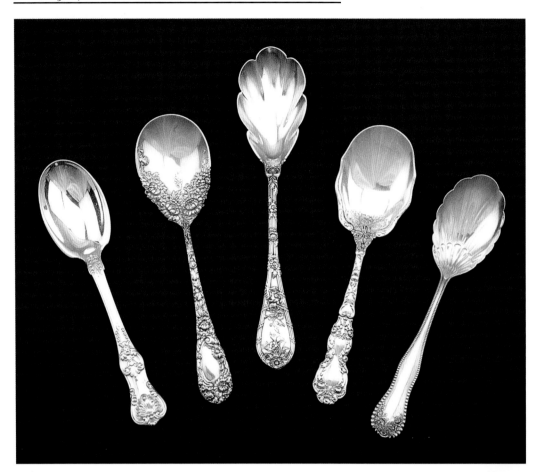

Figure 2.102. At the left is Tiffany's *English King*. This piece is 7-7/8". Continuing to the right are: Durgin's *Chrysanthemum*, at 7-1/2", and *Dauphin* at 8-3/8" [note the shell bowl]; Gorham's *Imperial Chrysanthemum* at 7-1/4", and *Lancaster*, at 7-1/8". These spoons would range from $125 to about $325.

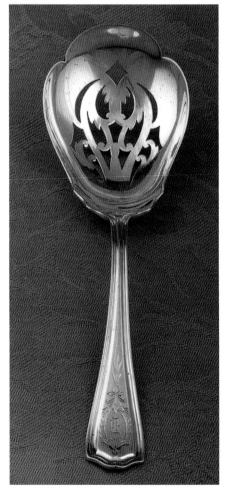

Figure 2.103. This example from Reed and Barton in their engraved *Hepplewhite* is called a pierced jelly spoon. It would be valued at $95 to $145.

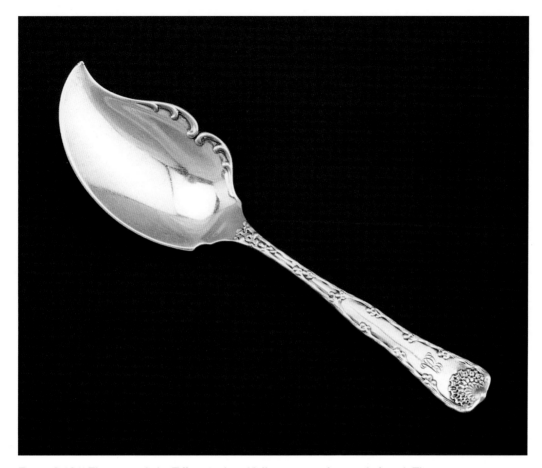

Figure 2.104. This example by Tiffany in their *Holly* pattern is frequently found. This is not a full-line pattern for Tiffany. Value would be from $225 up.

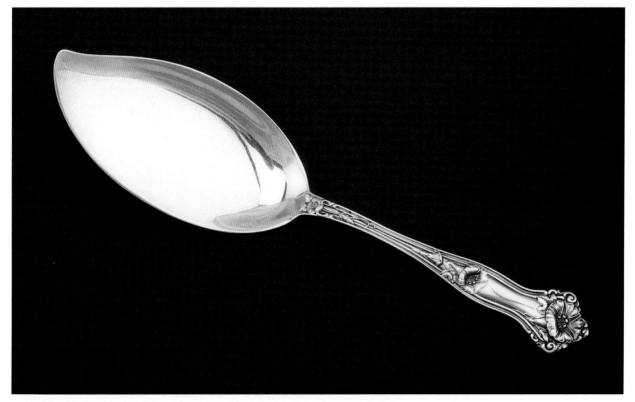

Figure 2.105. Alvin's *Morning Glory*. This piece has an unusually shaped blade and is 6-7/16". The value of this one item would range from $95 to about $150.

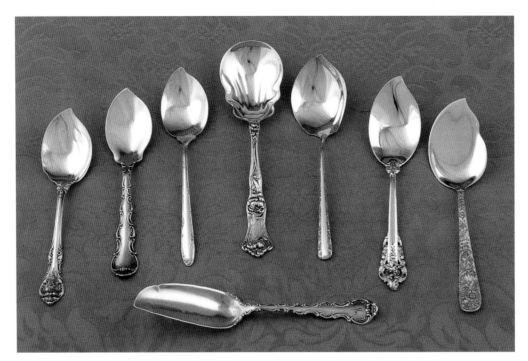

Figure 2.106. This figure shows a number of currently produced jelly servers, and two that are discontinued. From the left we find two Gorham patterns, *King Edward*, at 6-1/4" and *Strasbourg*, at 6-1/8" followed by Towle's *Madeira*, at 6-9/16". The central item is Wallace's *Peony* at 7-1/8". Many of the current Gorham patterns no longer feature a jelly spoon. Next is Towle's *Candlelight*, at 6-9/16", followed by Wallace's *Grande Baroque*, at 6-13/16". At the right is Kirk's *Repoussé*, at 6-3/4". The *Repoussé* piece has a large blade making it possible to use this item for cream cheese and other spreadables. At the bottom of Figure 2.106 is a discontinued example made by Gorham in their *Strasbourg* pattern. This item is 7-1/4". These items would be valued at $65 to $150.

Figure 2.107. Two examples in Gorham's *Chantilly*. This allows the reader to visualize the two sizes of jelly servers made in many Gorham patterns. In this figure the smaller piece is 6-1/8" and the larger one is 6-5/8". Values for these would run from $75 to about $165. The large jelly knife has not been in production for several years.

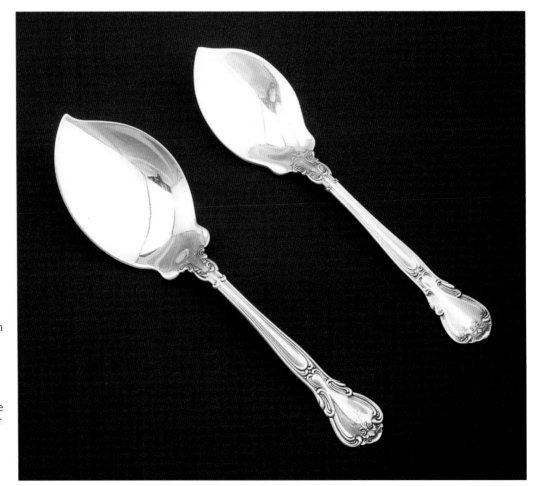

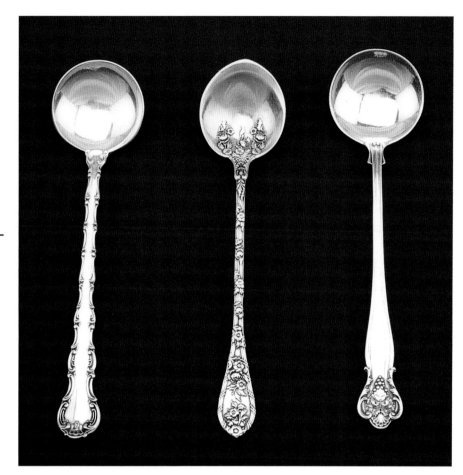

Jam Spoons

Figure 2.108. Three examples of jam spoons. They are, from left to right, Gorham's *Strasbourg,* 5-5/16"; Durgin's *Dauphin,* 5-7/16", and *New Vintage,* 5-1/2". The value of these spoons would range from $85 to $195. The spoons are also labeled long-handled chocolate spoons.

Figure 2.109. Victorians disguised just about everything. Here is a Haviland jam container that would be used over a jar of jam. It is paired with the jam spoon by Durgin in *New Vintage*. The bottom of the Haviland container has a hole allowing the jar to be pushed up and then removed when empty. The Haviland pattern is unknown, but the item is made on blank #18.

Mustard Spoons

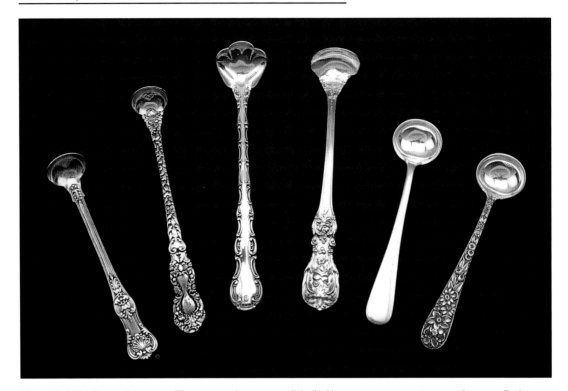

Figure 2.110. Mustard spoons. The spoons have a small ladle like appearance, yet correctly are called "mustard spoons." The first example is Tiffany's *English King*, at 3-7/8". Next is Gorham's *Imperial Chrysanthemum* at 5-3/8". This is followed by Gorham's *Strasbourg*, at 5-3/4" and Reed and Barton's *Francis I* at 4-13/16". The last two examples by Kirk have a totally different look—almost like a master salt, for which they are frequently mislabeled. The first is *Old Maryland* is 3-13/16", followed by *Repoussé* at 3-3/4". The value of these spoons would be from $95 up for the ladle form and slightly lower for the Kirk examples.

Figure 2.111. A Haviland mustard pot in Schleiger's pattern #72 is paired with a Whiting's *Lily* mustard spoon. This spoon, with only the handle visible, is 4-15/16" in length. The ladle is valued at approximately $135.

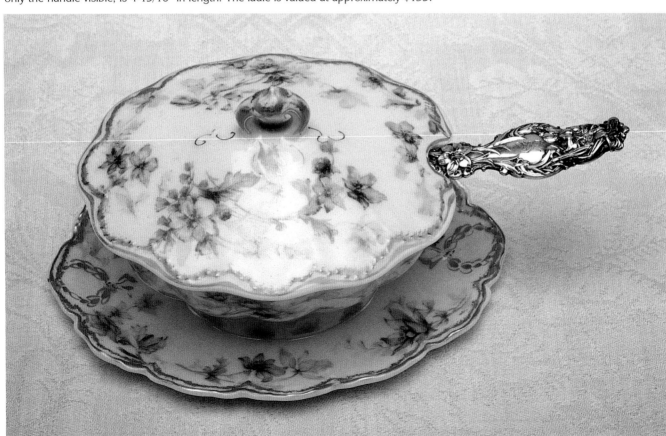

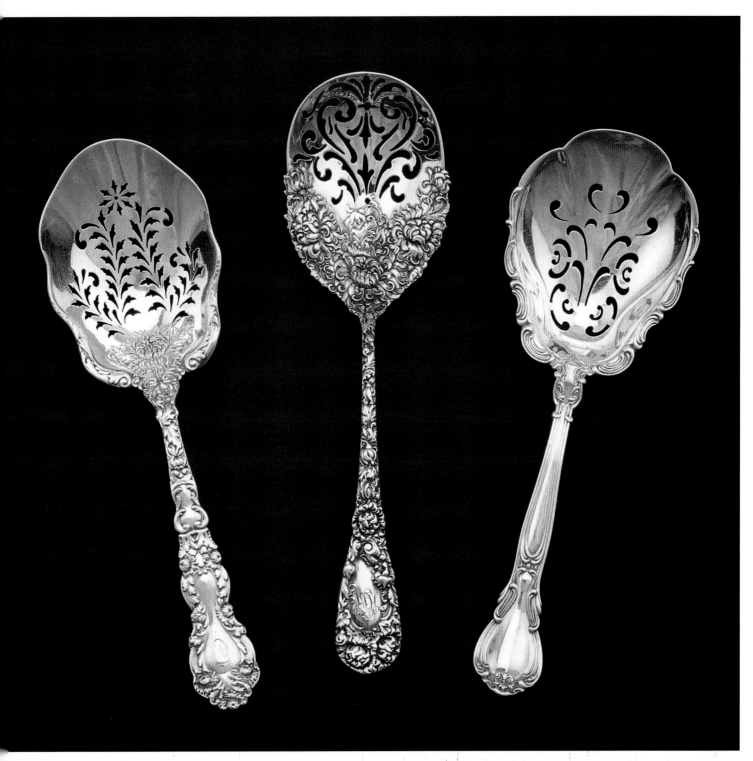

Figure 2.112. Three magnificent examples of nut spoons. On the left is Gorham's *Imperial Chrysanthemum* at 8-9/16". The middle spoon is Durgin's *Chrysanthemum* at 9". At the right is Gorham's *Chantilly* at 8-9/16". All of these have beautiful piercing in the bowl of the spoons. Note the example in Durgin *Chrysanthemum* and how the piercing is almost at the extreme end of the bowl. Supposedly these spoons were used by the butler to serve nuts to guests or for refilling small nut bowls or baskets. These spoons are rare, and difficult to locate. They range in value from $495 upwards. Comparing sizes most of these examples appear to be large berry spoons that are pierced.

Olive Spoons

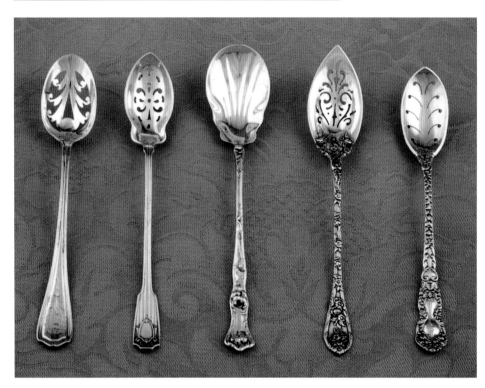

Figure 2.113. The five typical examples of olive spoons. Most were pierced, while a few were made without the piercing. Reed and Barton's *Hepplewhite* at 5-13/16" is on the left. Beside it is Gorham's *Spotswood* at 5-3/4". In the center is Wallace's *Peony* at 6-3/16". Then comes Durgin's *Dauphin* at 6-1/8", and lastly, Gorham's *Imperial Chrysanthemum* at 5-3/4". The heavy piercing in Durgin's *Dauphin* is typical of the fabulous piercing done at the Durgin plant. These pieces would range in price from $85 to well over $200 for the more rare examples.

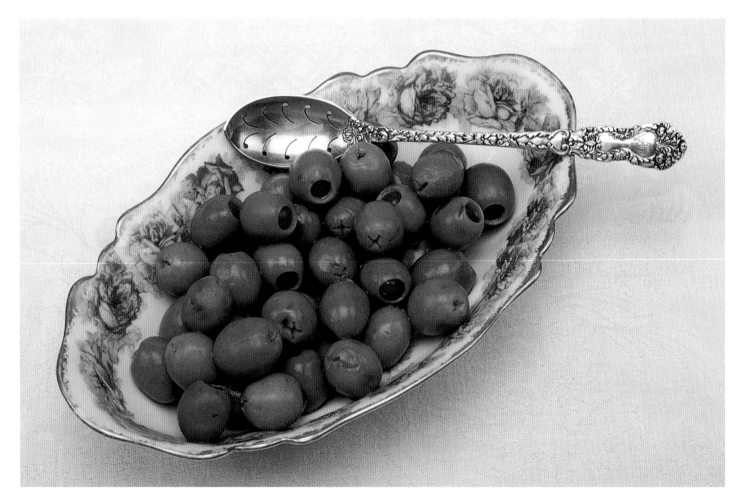

Figure 2.114. Haviland's "Drop Rose" olive dish is being used to serve olives with Gorham's *Imperial Chrysanthemum* pierced olive spoon.

Preserve Spoons

Figure 2.115. This example of a preserve spoon is by Durgin in their magnificent *Chrysanthemum* pattern. The piece is 7-5/16". The value of this spoon would be in the vicinity of $225 and up. These are frequently called "small berry spoons."

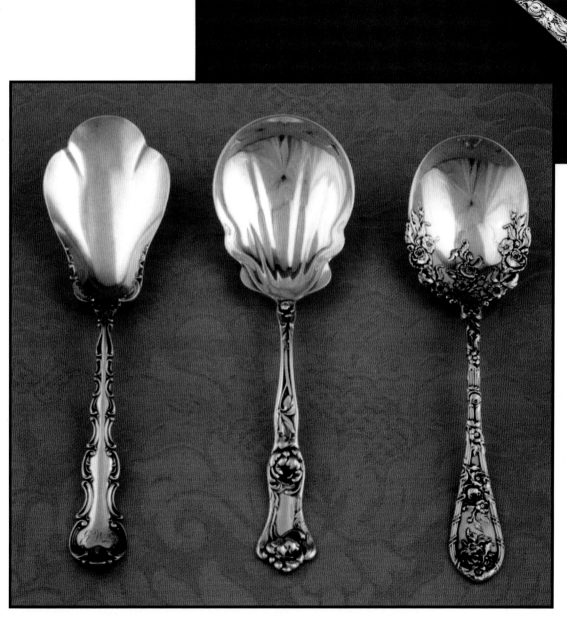

Figure 2.116. Three examples of Preserve spoons are shown in Figure 2.116. The patterns are Gorham's *Strasbourg* at 7-5/8"'; Wallace's *Peony* at 7-1/2"; and, lastly, Durgin's *Dauphin* at 7-5/16". The value of these spoons would be from $135 up to $295 for the more difficult to locate patterns.

Pea Spoons

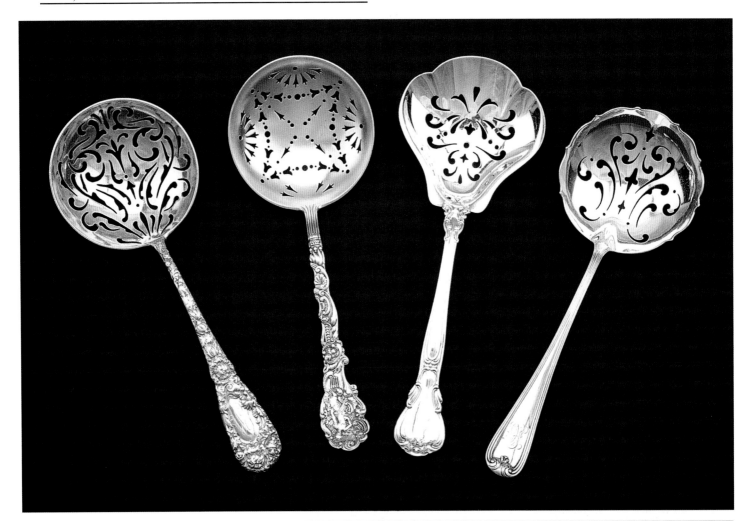

Figure 2.117. Four super examples of pea spoons. Durgin's *Chrysanthemum*, 8-1/2", is at the left. It is followed by Gorham's *Versailles* at 8-3/8". Next is *Chantilly* at 8-11/16" and at the right is Durgin's *New Standish* at 8-7/16". Note the piercing in each of these examples. Each is designed to embellish the pattern to the fullest. The value of these spoons would range from $495 up.

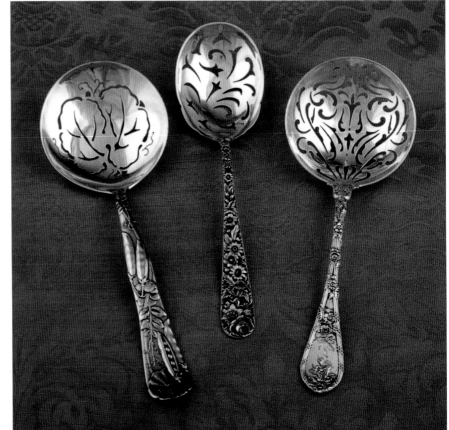

Figure 2.118. Additional examples of pea spoons. Note how, in Tiffany's *Vine* with the pea pod motif, the piercing duplicates the shape of the leaves of the pea vine/plant. Next is Kirk's *Repoussé* at 8-5/16". The last example is Durgin's *Dauphin* at 8-1/2". None of these items is easily located. The Kirk example could be valued at about $225, while the other examples are worth from $895 up.

Pudding Spoon

Figure 2.119. This Theodore Haviland pudding set in an unknown pattern is not complete. There should be a pudding bowl inside the handled liner resting on the undertray. The spoon is also an unknown pattern, but done in *Repoussé* style. It is 9-5/8" and would be valued at approximately $145.

Salt Spoons, Master

Below:
Figure 2.120. A variety of master salt spoons. From left to right they are: Gorham's *Imperial Chrysanthemum*, 3-1/2"; Gorham's *Versailles*, 3-5/8"; Reed and Barton's *Francis I*, 3-1/2"; Durgin's *Chrysanthemum*, 3-3/4"; Tiffany's *English Kings*, 3-1/2"; and Durgin's *Watteau*, 3-15/16". At the far right, Gorham's *Chantilly* is in the sterling *Chantilly* master salt cellar. These items would range from $55 up, depending on pattern, location, and rarity of the pattern.

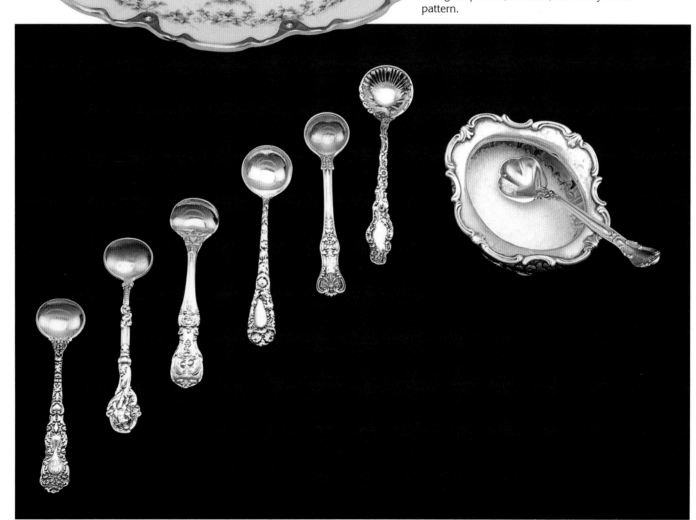

Stuffing, Platter, or Gravy Spoons

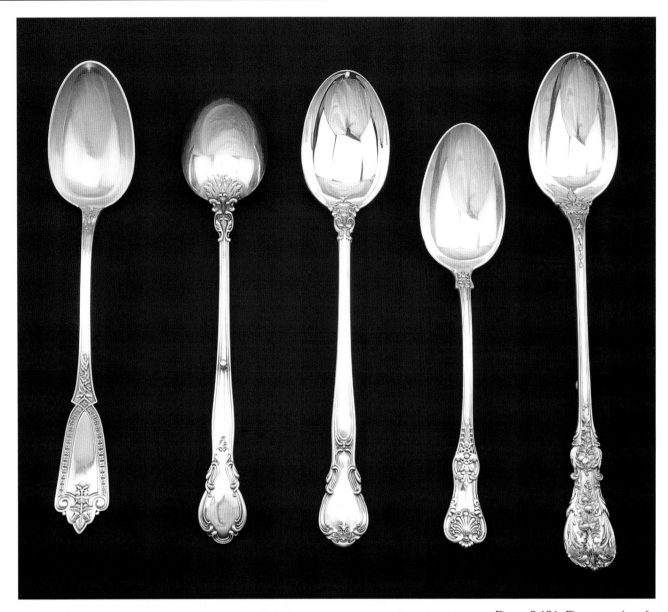

Figure 2.121. Five examples of stuffing spoons. The first is Whiting's *Ivy* at 12-1/8". Next are two examples in Gorham's *Chantilly.* The first example shows the button back on an old spoon. The old spoon is 12-5/8", while the next spoon, a newer version, is 12-3/8". A Tiffany example, *English King,* is next at 10-7/8", and the last example is a huge spoon in Reed and Barton's *Francis I,* at 13-9/16". These spoons would vary from $350 up.

Figure 2.122. The reverse side of the Whiting *Ivy* spoon has this highly detailed "button" in the shape of an acorn. Older silversmiths put much character into the pieces they made, as evidenced by this fantastic example.

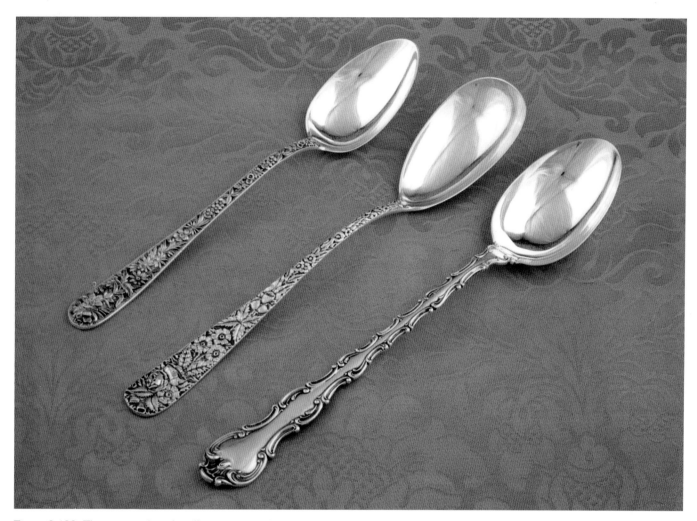

Figure 2.123. Three examples of stuffing, gravy or platter spoons are shown in Figure 2.123. Two examples are shown in Kirk's *Repoussé*. The top spoon, in *Repoussé* is 10-3/4", and the next spoon, with the ovoid bowl is 1-7/8". The middle spoon is hand done, while the first example is stamped using a die. The last example in Gorham's *Strasbourg* is 12-3/8". The value of these spoons would be from $275 up, the most valuable being the *Repoussé* spoon in the middle, because of the hand work.

Sugar Spoons/Sugar Shells

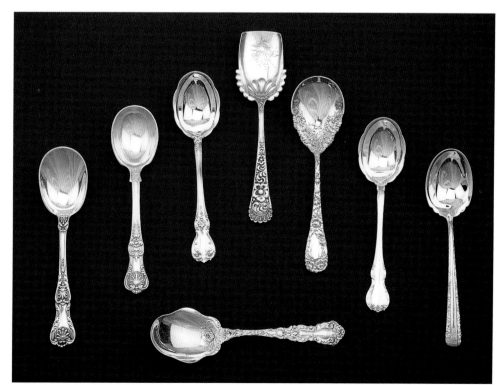

Figure 2.124. Sugar spoons surround a sugar scoop. At the top from the left are Gorham's *King George,* 5-7/8"; Tiffany's *English King,* 5-5/8"; Towle's *Old Master,* 5-3/4"; an sugar scoop in an unknown pattern, 6-1/8"; Durgin's *Chrysanthemum,* 6"; Towle's *French Provincial,* 5-3/4"; and *Candlelight,* 5-3/4". At the bottom is Gorham's *Imperial Chrysanthemum,* 5-13/16". These spoons are valued at $65 and up.

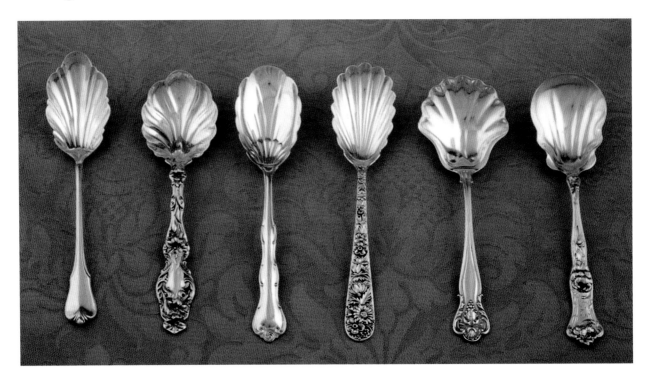

Tablespoons

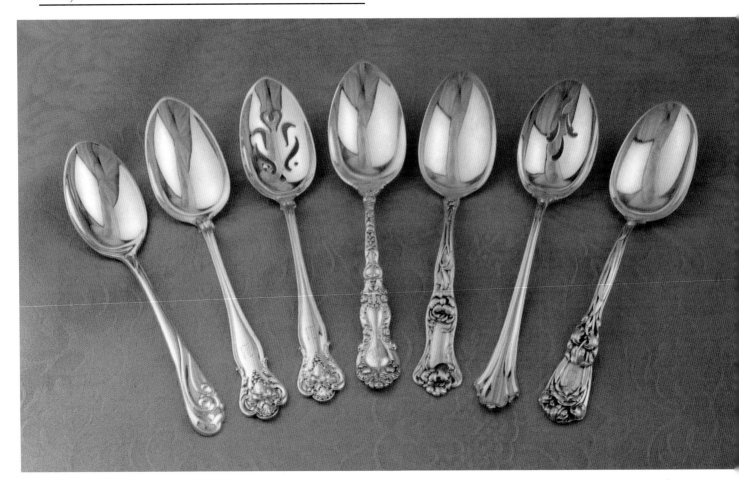

Figure 2.126. Tablespoons are a very necessary implement. They can come factory-pierced or remanufactured, meaning the piercing may not match that done by the factory. The two examples at the left are Kirk's *Surf,* at 7-7/8"; then Durgin's *New Vintage* at 8-7/16". The pierced example in *New Vintage* is a remanufactured piece. Next is Gorham's *Imperial Chrysanthemum,* at 8-3/8"; followed by Wallace's *Peony* at 8-1/4". Lunt's *Bel Chateau* is next at 8-1/2" and lastly is Durgin's *Iris* at 8-3/8". Tablespoons vary from $65-75 and up, depending upon the pattern.

Opposite page, top:
Figure 2.125. These sugar shells illustrate how the various manufacturers each interpreted the shell form for their patterns. Wallace's *Grand Colonial* is first at 6". It is followed by Whiting's *Lily*, at 5-3/4"; Gorham's *Rhondo*, at 6-1/8". Kirk's *Repoussé* at 6-1/8". and Durgin's *New Vintage* at 5-3/4". The last sugar shell is Wallace's *Peony* at 6-1/16". The *Rhondo* example has the same shaped bowl as the Gorham *Lancaster* pattern. The value of these spoons is $45 and up.

Figure 2.127. A Haviland covered vegetable in a variation of Princess, Schleiger # 57. The serving spoon is an ovoid form of *Repoussé*. It is 8-3/8" long and is valued at approximately $100.

Ladles

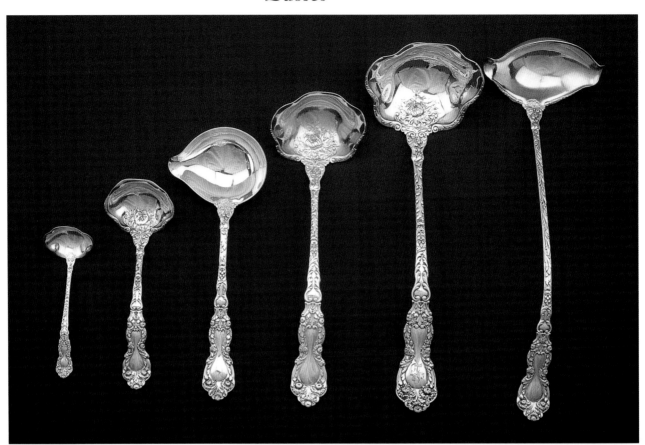

Figure 2.128. A variety of ladles in Gorham's *Imperial Chrysanthemum*. By seeing all of the ladles the reader gets an idea of the sizes (exception is the mustard spoon), minus the pierced sugar shaker, which can be found in Figure 2.137. Since these same items are seen throughout this section, values and size measurements will be found in each group.

Bouillon Ladles

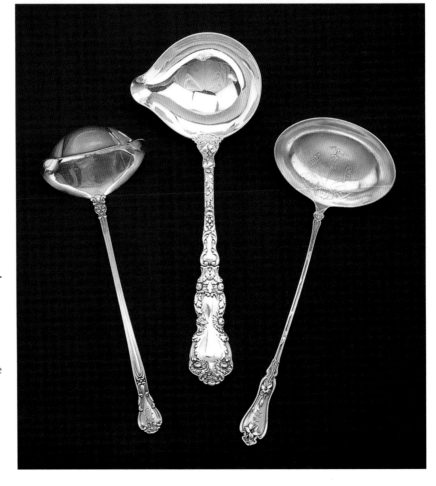

Figure 2.129. Bouillon ladles. These ladles, not frequently found today, were used for serving bouillon, a regular course in bygone days. The first example is in Gorham's *Chantilly* and it is 8". This is followed by *Imperial Chrysanthemum* with a side pouring lip, at 9-3/16". The last example is Whiting's *Violet,* at 8-3/4". The value of these ladles would be from $495 upwards to $895.

Cream Ladles

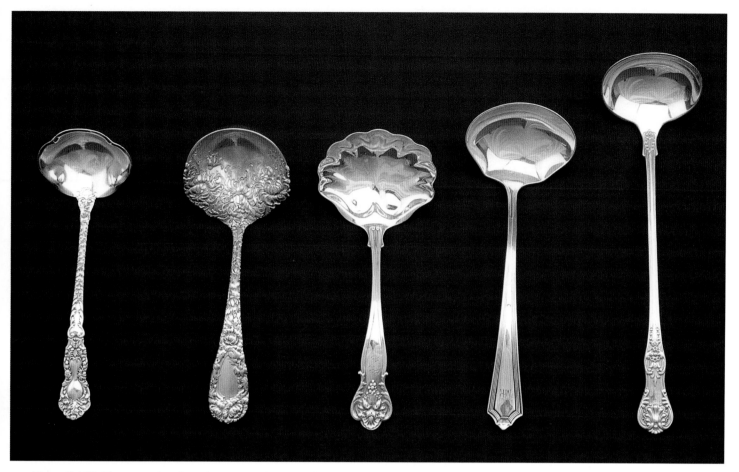

Figure 2.130. The examples show the various shapes and sizes found in cream ladles. The example at the left is Gorham's *Imperial Chrysanthemum*, at 5". It is in a shape that was called, "new style" by Gorham. For two other examples of these ladles, see Figure 2.132. Next is Durgin's *Chrysanthemum*, at 5-1/4", followed by *New Vintage*, at 5-1/4". Gorham's *Plymouth* is next, at 5-7/8", followed by Tiffany's *English King*, at 6-3/4". The values of these ladles ranges from $95 to about $295.

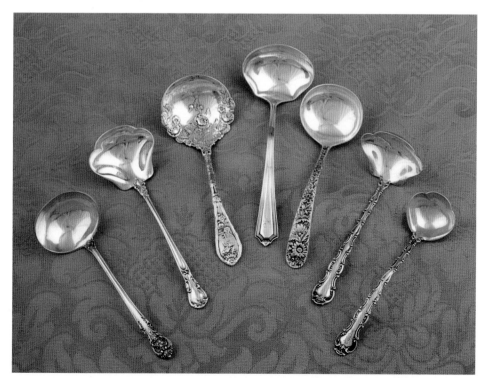

Figure 2.131. Cream ladles. At the left are two Gorham patterns, *King Edward,* at 5-5/8" and *Chantilly* at 5-11/16". The next two are Durgin's *Dauphin* at 5-9/16" followed by Gorham's, *Plymouth,* at 5-7/8". Next is Kirk's *Repoussé,* at 5-3/8", followed by two examples in Gorham's *Strasbourg.* The first is the current example at 5-1/16" which displays the new style handle. The last example is 5-1/32" and has a gold washed bowl. These examples would run from $85 up to $225.

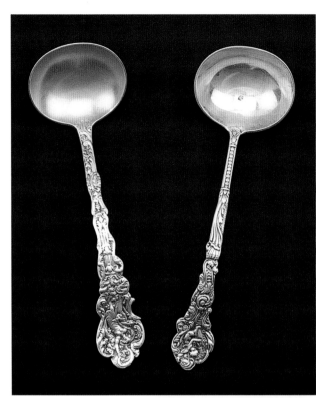

Figure 2.132. Two examples of cream ladles, new style and old. At one time Gorham made the wider style handle, and then introduced the example with the narrow handle. The were labeled, old style (O.S.), wide-handled, and new style (N.S.), narrow-handled. Both of the examples in Figure 2.132 are in Gorham's *Versailles*. The thick style (O.S) is 5-3/4" and the new style (N.S.) is 5-7/8". These examples would be worth from $175 and up.

Gravy Ladles

Below:
Figure 2.133.1. Three examples of gravy ladles. The first is Tiffany's *English King*, 7-3/8", with a shell bowl. In the center is Durgin's *Chrysanthemum* at 7-1/2" and on the right is another examples in Tiffany's *English King,* at 7-1/8". Note how the two bowls in the Tiffany examples give each a regal appearance. These gravy ladles would be worth from $295 and up.

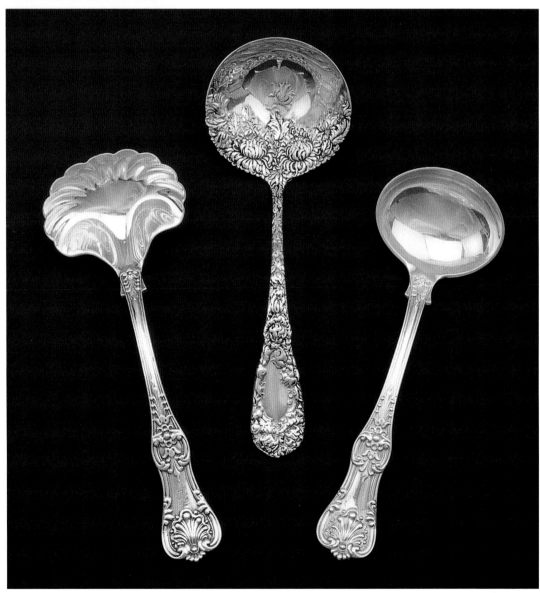

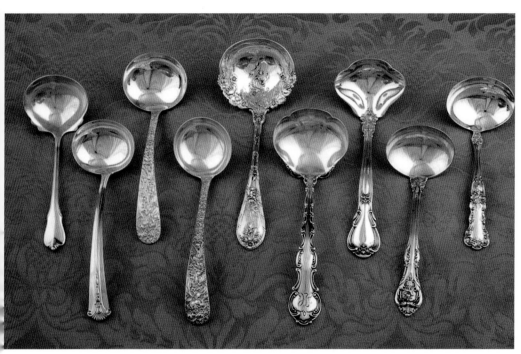

Figure 2.133.2. These nine examples represent most of the styles found in gravy ladles. In the top row (left to right) are: Wallace's *Grand Colonial*, 6-1/8"; Kirk's *Repoussé*, 6-1/8" [note this is the current gravy ladle]; Durgin's *Dauphin*, 7-3/8"; and Gorham's *Chantilly*, 7", and *Buttercup*, 5-7/8".

The bottom row includes: Kirk's *Severn*, gold trimmed, 6-7/8", and *Repoussé*, 7"; and Gorham's *Strasbourg*, 7-3/8", and *King Edward*, 6-3/8". The values of these gravy ladles ranges from $95 up.

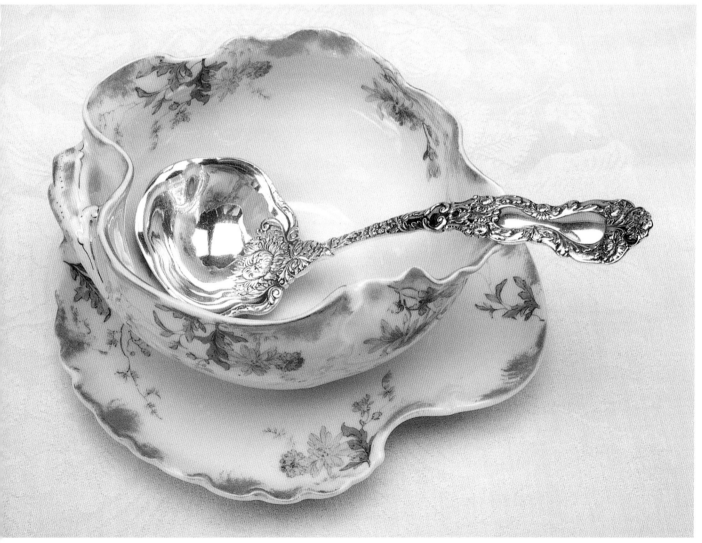

Figure 2.134. A Haviland gravy boat with attached tray, in Schleiger's #86A is featured with Gorham's *Imperial Chrysanthemum* ladle. These two patterns were introduced relatively close together. A number of chrysanthemum patterns by several companies were introduced to the public from 1880, with Tiffany's *Chrysanthemum* first introduced in 1880 and, eventually, Gorham's *Imperial Chrysanthemum* in 1894.

Oyster Ladles

Figure 2.135. Three examples of oyster ladles, showing the beauty found in this form. They can be easily used to serve soup from a smaller tureen or covered vegetable dish for a family or small group gathering. The three examples shown are the following: Durgin's *Dauphin*, at 10-1/2"; Wallace's *Peony* at 10-1/4"; and Gorham's *Strasbourg* at 10-1/2". The values of these ladles would range from $550 up.

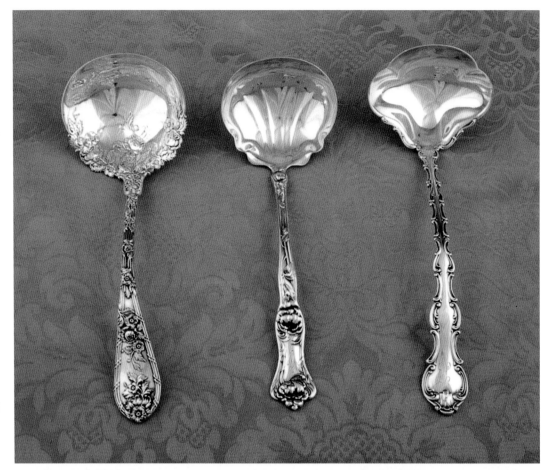

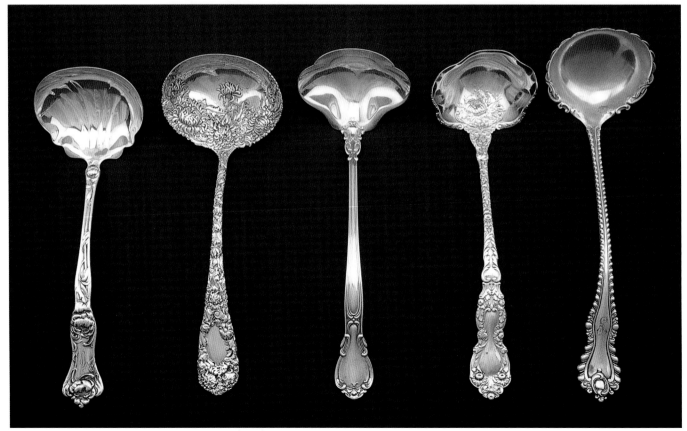

Figure 2.136. Five additional oyster ladles. From the left: Wallace's *Peony*, 10-1/4"; Durgin's *Chrysanthemum*, 10-1/2"; Gorham's *Chantilly*, 10-1/4", and *Imperial Chrysanthemum*, 10-5/8"; and Dominic and Haff's *Mazarin*, 10-5/8". The value of these oyster ladles would range from $450 up.

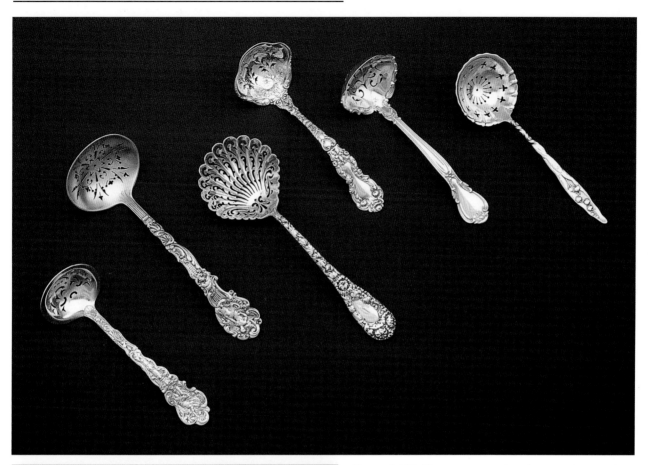

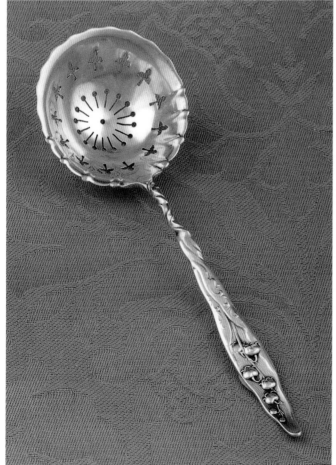

Figure 2.137. These six examples of sugar sifters typify this category. Beginning at the left, the first example is in Gorham's *Versailles* at 5-5/8", followed by another example, also in *Versailles,* at 7". Durgin's *Chrysanthemum* with the fantastic pierced bowl is next at 7-3/16". It is followed by an entirely gold washed example in Gorham's *Imperial Chrysanthemum*. The reverse of this piece indicates it was given for a golden wedding anniversary. It is 5-3/4". The next example is *Chantilly* at 5-3/4", and last is Whiting's *Lily of the Valley*, at 5-15/16". The value of these examples would be from $175 up.

Figure 2.138. Pictured singly is Whiting's *Lily of the Valley*. The beautiful piercing of this example is easily observed. The delicate gold wash applied to the bowl adds to the beauty of this example. It would be valued from $225 up.

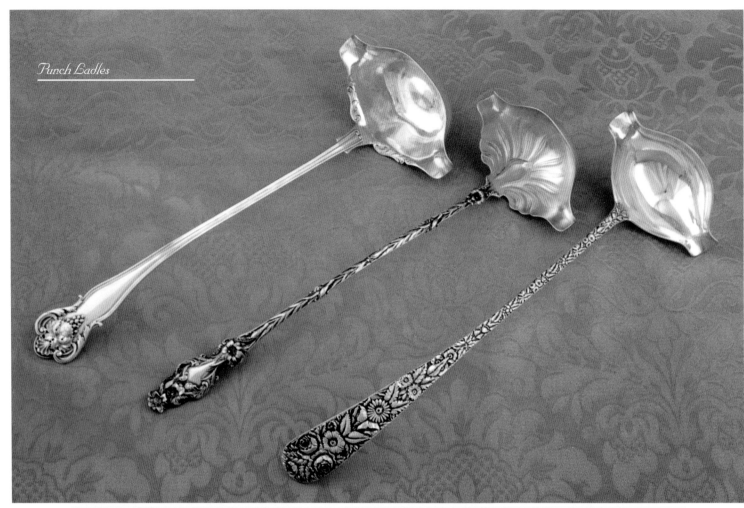

Punch Ladles

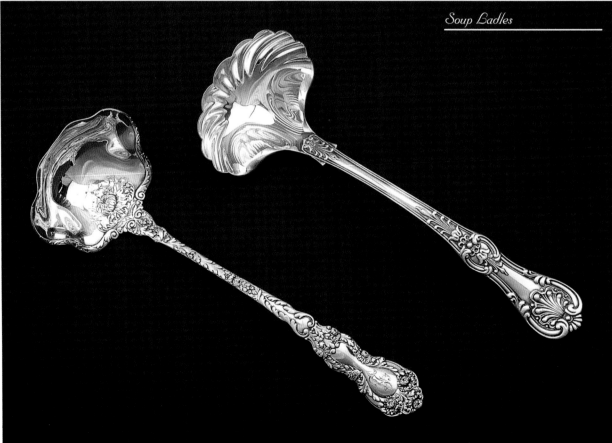

Soup Ladles

Opposite page, top:
Figure 2.139. Three examples of punch ladles. From the left the examples: Durgin's *New Vintage* at 13-1/2";
Whiting's *Lily* at 14"; and Kirk's *Repoussé*. The values of these items would range from $695 to over $1200.

Opposite page, bottom:
Figure 2.140. These two examples, Gorham's *Imperial Chrysanthemum*, left, and Tiffany's *English King*, both
at 12-1/2", typify soup ladles. The prices of these would be from $695 up.

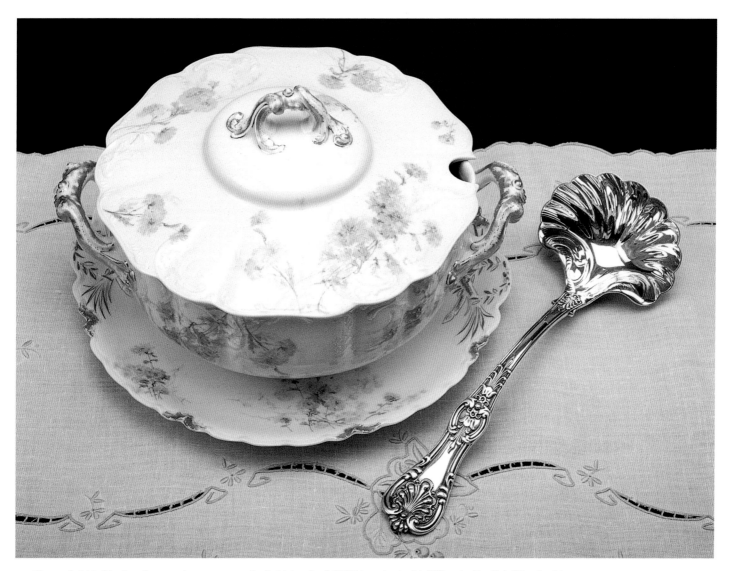

Figure 2.141. Haviland's round soup tureen in Schleiger's #664E is paired with Tiffany's *English King* in this
view. The tureen was produced between 1888 and 1896 as evidenced by the marking of H & CO on the bottom
of the tureen.

Tongs

Asparagus Tongs

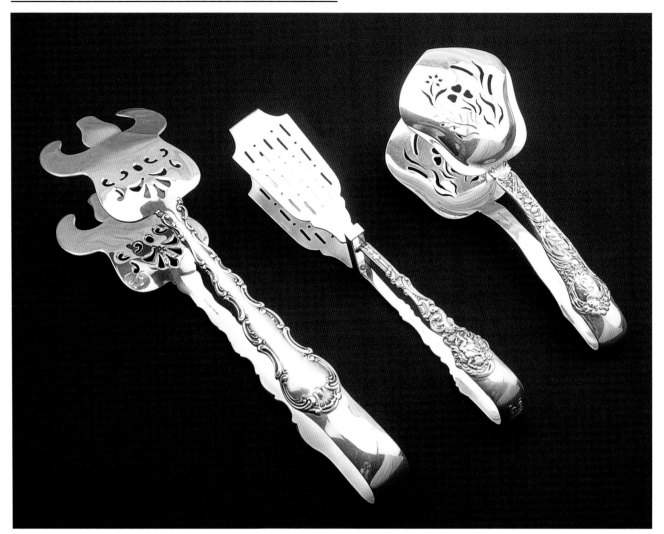

Figure 2.142. Three examples of Gorham asparagus tongs. The first example, in *Strasbourg* is 10-1/8". This particular asparagus tong was recently manufactured. The evidence comes from the Gorham logo, not the Lion, Anchor and G which would be found on older tongs. The second example is in *Meadow*. This tong is 7-1/4". Note the excellent pierced work and the array of meadow flowers on the shaft of the implement. The last example is *Versailles* at 8-5/8". What sets this example off is the fact that the entire tong is complete, that is the metal piece that prevents the tongs from being forced to accept too large a serving is intact. To see an example of a missing bar, please refer to Figure 2.001 where all three types of asparagus implements are pictured and the asparagus tong in the photograph is missing the bar. The value of these items would be from $325 up.

Ice Tongs

Figure 2.143. This group of ice tongs allows the careful observation of subtle differences between manufacturers. From the left: Wallace's *#300* [a nlp], 7-5/8"; Gorham's *Chantilly*, 7-5/8"; Durgin's *Chrysanthemum*, 7-1/4"; Gorham's *St. Dustan* [chased] at 6-9/16". The next ice tong, Wallace's *Violet*, at 6-5/8", is a fabulous example for this pattern. At the right is Gorham's *Versailles* at 7-7/16". The values of these pieces range from $225 up.

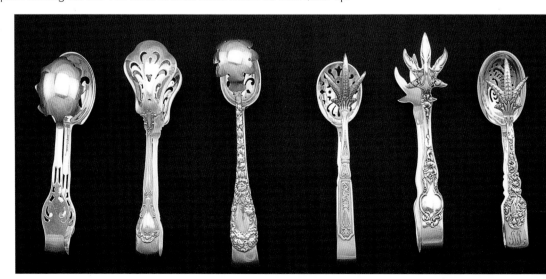

Chicken Tongs

Figure 2.144. These spectacular tongs, at 9-5/8", are only marked, "Pat'd 1878." The workmanship is remarkable. The fluted bowl is exquisitely pierced and the floral decoration on the shaft is very well done. The value of this item would be from $795 up.

Sardine and Sandwich Tongs

Figure 2.145. Two examples of sandwich tongs by Gorham. The first, in *Buttercup* is 6" in length. Note the differences between the bottom and top of this tong. The *Versailles* example is 4-7/8". The value of these items would range from $350 up.

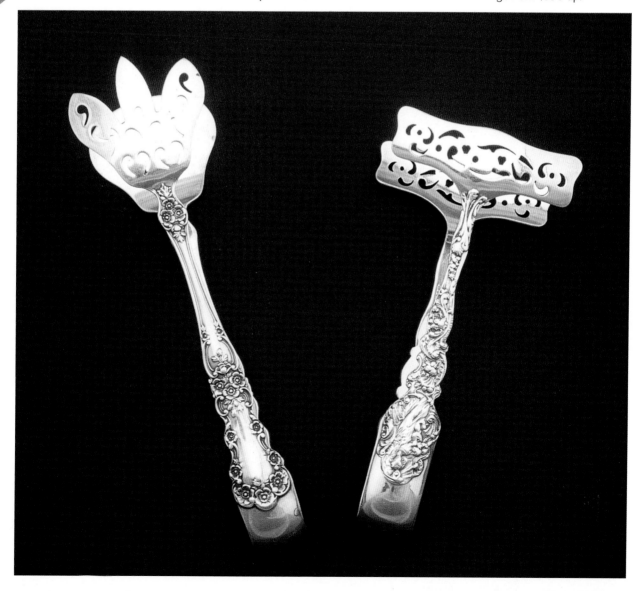

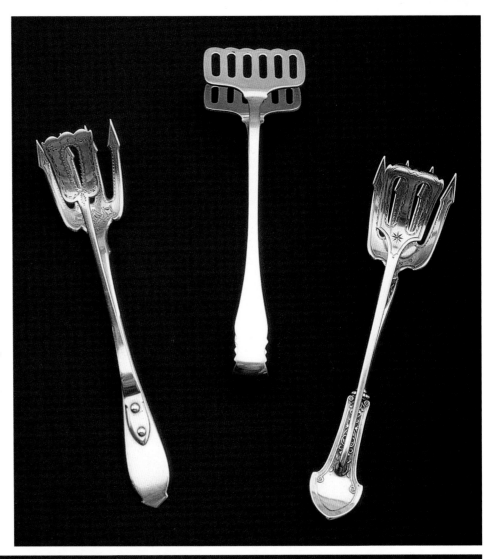

Right:
Figure 2.146. Three sardine tongs. The first is an old Gorham pattern from c. 1865 called *Italian*. It is 5-3/4". The next example is Towle's *Old Newbury*, and it is 5" in length. The last example, again by Gorham, is *Corinthian* at 5-1/2". This pattern was introduced in 1872. Note the two Gorham examples have an attached top portion to hold the sardine. The value of these tongs would be $325 up.

Sugar Tongs

Figure 2.147. Four sugar tongs. From the left: Kirk's *Repoussé*, 4"; Tiffany's *English King*, 4-1/8"; Gorham's *Imperial Chrysanthemum*, 4-1/4"; and Durgin's *New Vintage*, 4-1/2". Each of these tongs has a unique end, specifically designed for the rest of the tong. These tongs would be valued at $95 and up.

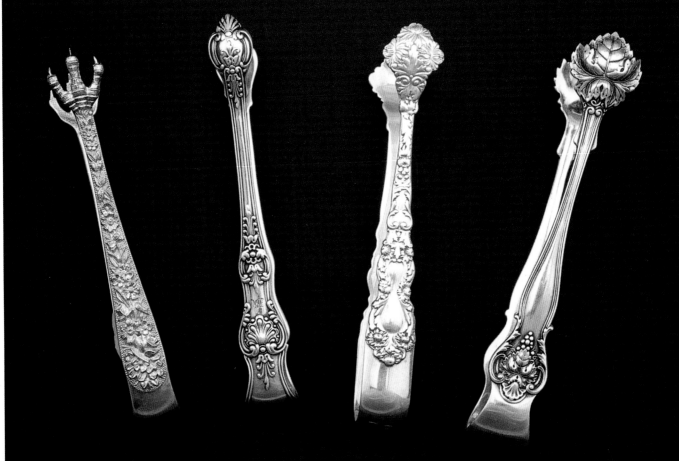

Other Serving Implements

Bon Bon Tongs

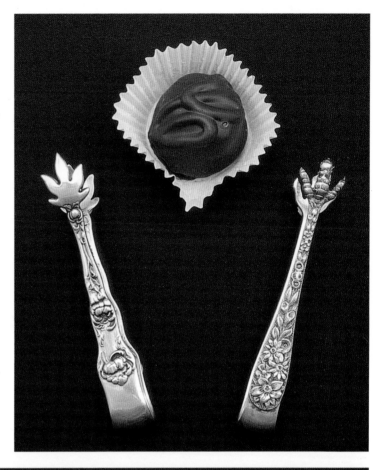

Figure 2.148. Two examples of bon bon tongs. Basically bon bon tongs are very small. The example on the left is Wallace's *Peony* at 3-1/4", and on the right is Kirk's *Repoussé* at 3-3/8". A delightful chocolate awaits some lucky person in the center of this photograph. The value of these tongs would be $75 and up.

Cake Breaker

Figure 2.149. *Eloquence* by Lunt is represented in a fine example of a cake breaker. These implements are a necessity when cutting and serving angel food cake. The value would be $89 and up.

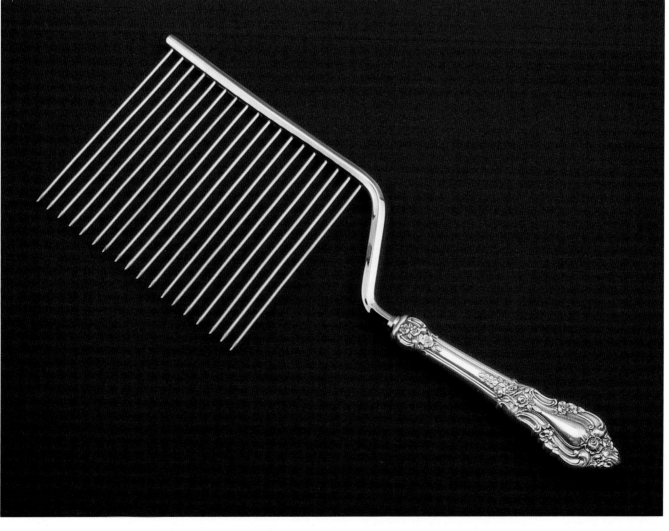

Cheese Scoops

Figure 2.150. Some of the variety on can find in cheese scoop shapes. From the left are: Gorham's *Buttercup*, at 7-11/16"; Wallace's *Peony* at 7-15/16"; Dominic and Haff's *Charles II* at 8-1/8" [note the delicate gold wash]; Durgin's *Dauphin* at 8-1/8"; and Kirk's *Repoussé*. The value of these items would range from $195 up, depending upon the pattern.

Below:
Figure 2.151. Cheese scoops. The first example is in *Empress,* an old Gorham pattern from c. 1880, at 7-11/16". Note the very open type of scoop on this item. Next is an example of a small scoop in *Versailles* at 5". Frank Smith's *Lion* is at the apex of this figure at 7". This is followed by Gorham's *Buttercup* [small] at 5-11/16"; and lastly Durgin's *Chrysanthemum* at 8-1/8". The value of these items would range from $225 up.

*Cracker Scoops/Saratoga Chip
Servers*

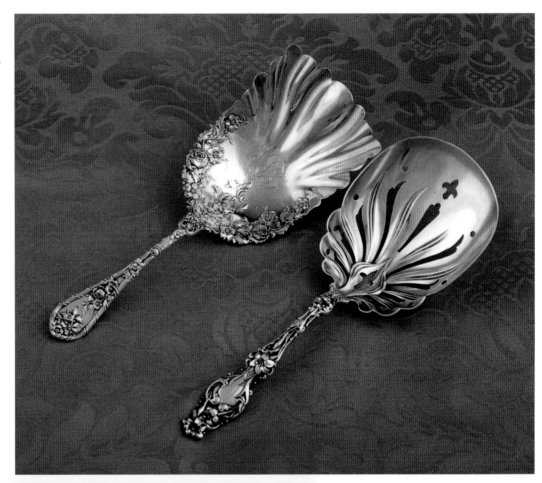

Figure 2.152. Two magnificent
cracker scoops, both in highly
desirable patterns. Durgin's
Dauphin at 8-5/8" and Whiting's
Lily at 8-1/2" are excellent
examples of the category. The
values of each would be from $995
up.

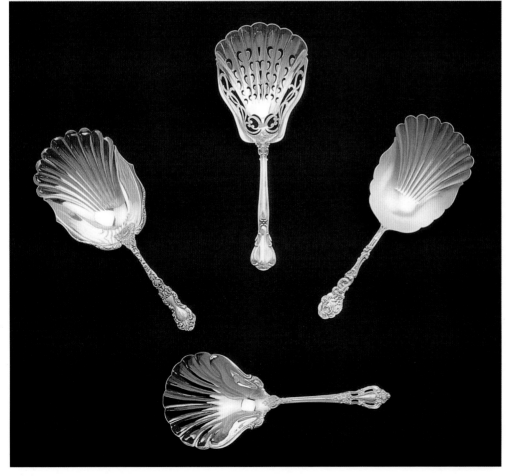

Figure 2.153. Three additional
examples of scoops. On the left
at the top is Gorham's *Imperial
Chrysanthemum* at 7-7/8". This
is followed by *Chantilly* at 9-5/8"
[note the stellar piercing of the
bowl of this piece]. At the top
right is *Versailles* at 7-7/8". These
old examples would command a
price from $495 and up, depend-
ing upon condition. The bottom
of the scoop is an example of
Lunt's *Eloquence*, which is
currently in production. This
piece would run about $200.

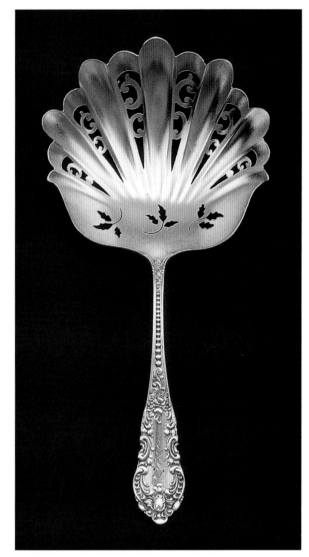

Figure 2.154.1. This lone example in Knowles *Argo,* at 6-15/16", may have been designed to serve oyster crackers. It would be valued at approximately $395 and up.

Croquette Server

Figure 2.154.2. This lone example of a croquette server attests to the rarity of the item. This example in Durgin's *Chrysanthemum* is 6-5/8". The value of this item would be $495 and up. The reader is advised to look at the portion of the original *Chrysanthemum* pattern located in Figures 1.18-1.25 and A.18-A.25 and note that Durgin made four quite different items to serve croquettes and that this is only one of those displayed.

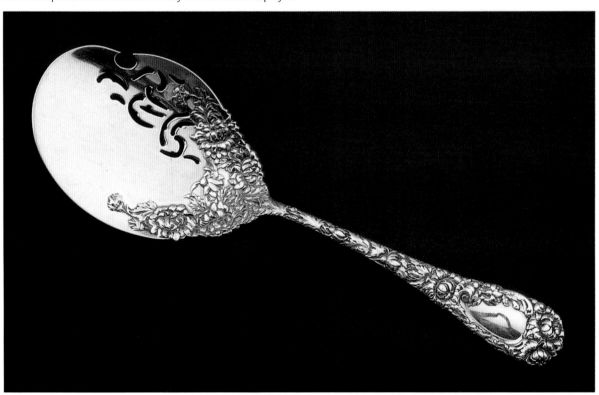

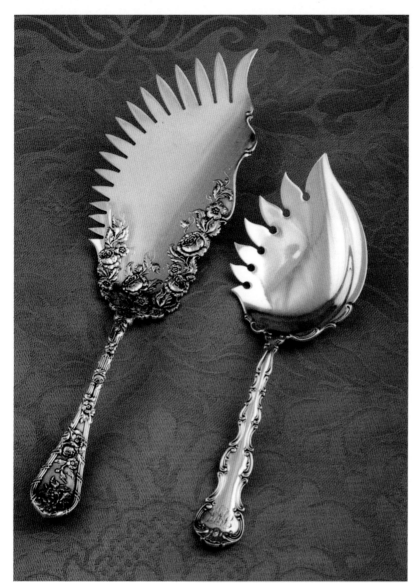

Macaroni/Entree/Fried Oyster Servers

Figure 2.155. Two very popular patterns showing an entrée server and a macaroni server. The first, in Durgin's *Dauphin* is a macaroni server. It is 10-5/8" long and would be valued at over $1500. The next example, in Gorham's *Strasbourg,* is 8-1/4" and would command a price in the vicinity of $595 and up. The reader should refer again to the partial Durgin catalog in Figures A.18-A.25 and note the similarity between a macaroni server and a tomato server in the Durgin patterns. To the best of the author's knowledge, this peculiarity is only found within Durgin Company products.

Below:
Figure 2.156. Five examples of items in this category. The first, an example by Knowles in their *Argo* pattern, is 9-1/4". Next, in Gorham *Versailles,* is an oyster server, as evidenced by the seashell design in the bowl. This piece is 9-3/8". The third example is by Dominic and Haff in their pattern *Louis XIV,* and it is 10-7/16". The next example, by Gorham in their *Virginiana* pattern, is an entrée server at 8-3/4". The last example, in Gorham's *Old French* at 9", shows the variety found even within a company. The value of these items would range from $435 up.

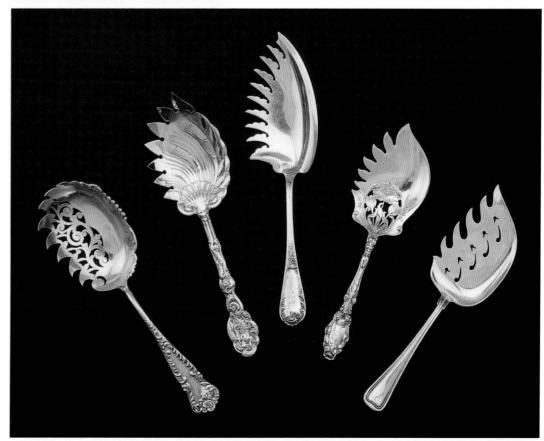

Cucumber Server

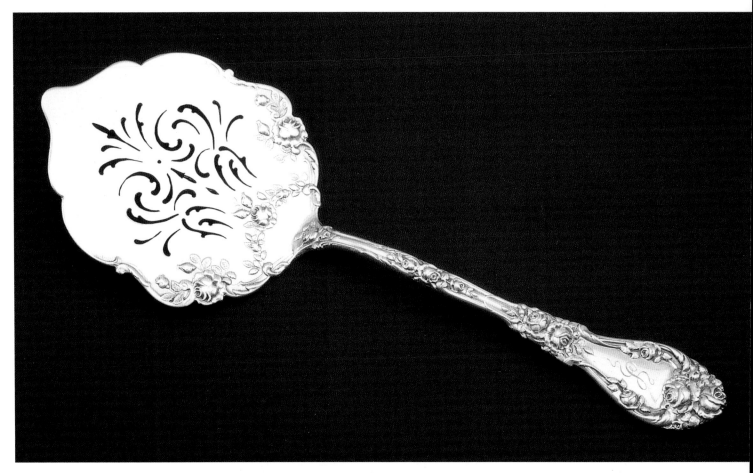

Figure 2.157. This long example by Durgin in *Marechal Niel* at 9" is also peculiar to Durgin products. It would appear to be a tomato or flat server, yet it is a cucumber server according to Durgin catalogs. The value of this piece would be approximately $425 and up.

Cucumber/Tomato Servers

Figure 2.158. Three examples of servers for tomatoes or cucumbers. The first example is Gorham's *Etruscan* at 6-1/8". It is a tomato server. The next example in Durgin's *Dauphin* is a tomato server. The small cucumber server has a different end. The last example, the toothed Gorham *Strasbourg* is a cucumber, tomato server and it is 5-7/8". Some silver companies even label this last example as a cheese server. This is why it is absolutely necessary to have, if at all possible, an old catalog to go by for more positive identification. The value of these items would be from $195 to $225 and upwards for the *Dauphin* piece.

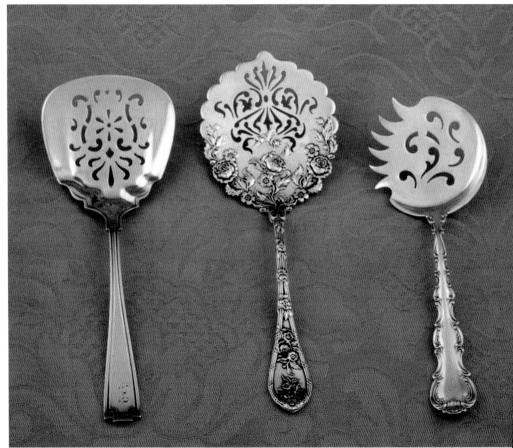

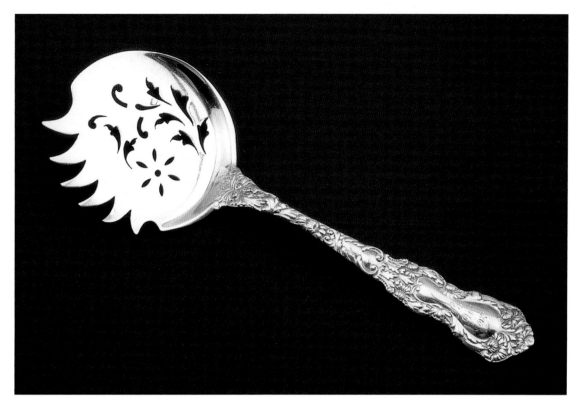

Figure 2.159. Another example of a notched cucumber/tomato/perhaps cheese server. This example is in Gorham's *Imperial Chrysanthemum*. It is 5-3/4" long. It would be valued at $225 and up. The author has an old Gorham catalog featuring *Imperial Chrysanthemum*, but this piece is not included.

Tomato Servers

Figure 2.160. It is possible to locate a variety of shapes in tomato servers and some of these are featured here. Four are rounded and three are rectangular. The first, Gorham's *Chantilly*, is 7-1/2", as is the next example in Gorham's *Strasbourg*, also at 7-1/2". The next three rectangular examples are by various of manufacturers. The first is Reed and Barton's *Marlborough* at 8-1/4", followed by Whiting's *Violet* at 7-1/4", and Whiting's *Lily* at 7-5/8". This last example with the floral design is not original to this piece. It may have been altered by use of a laser. The next two examples are the "standard" round shape. The first is Gorham's *King Edward* at 7-3/4" and followed by Wallace's *Grand Colonial* at 7-3/4". The value of these items would range from $195 upwards.

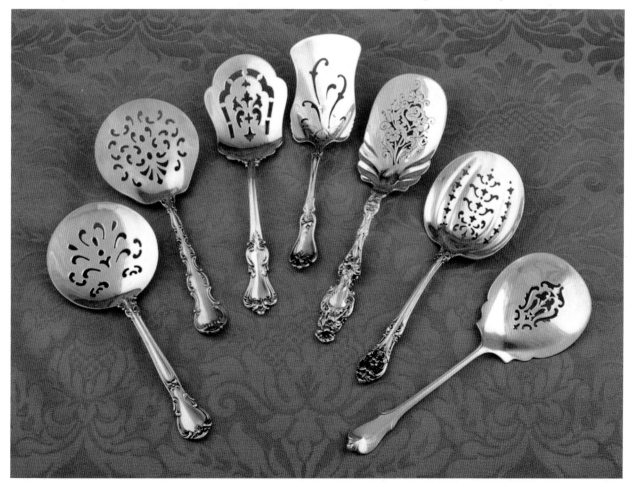

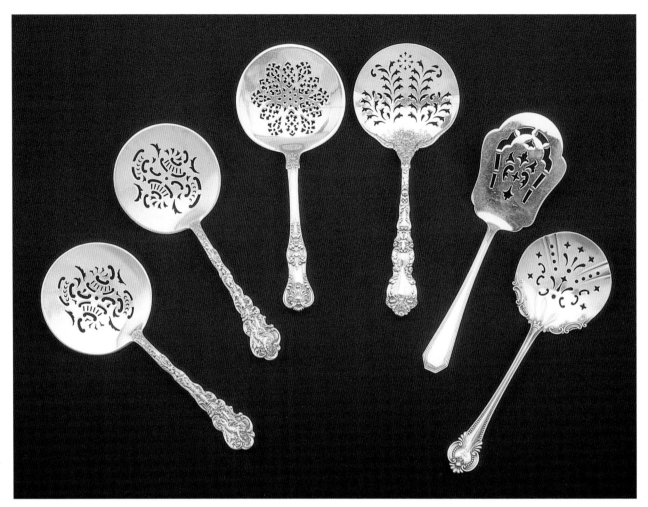

Figure 2.161. Five additional examples of tomato servers/flat servers. The first two examples, in Gorham's *Versailles*, both at 8-9/16", show the subtle variation in hand piercing. Both designs are very similar, yet vary in some of the piercing. Next is Tiffany's *English King* at 7-5/8", followed by Gorham's *Imperial Chrysanthemum* at 7-7/8". Note the beautiful piercing in these two examples. Next is Dominic and Haff's *Queen Ann, Plain* at 7-7/8". The last example is International's *Irene at* 7-3/8". The value of these items would range from $195 up.

Toast Server

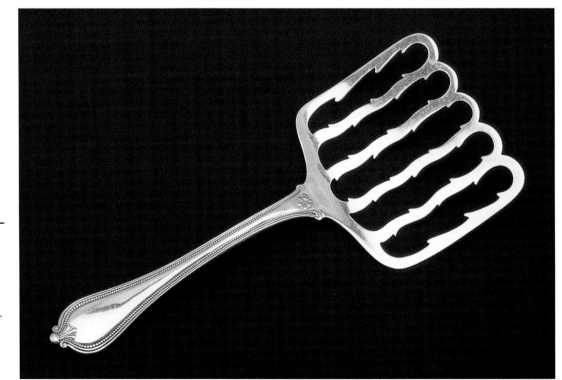

Figure 2.162. This long example of a toast server is by Towle in their *Old Newbury* pattern. The value of this item would be $395 and up.

Nut Picks/Nut Crackers

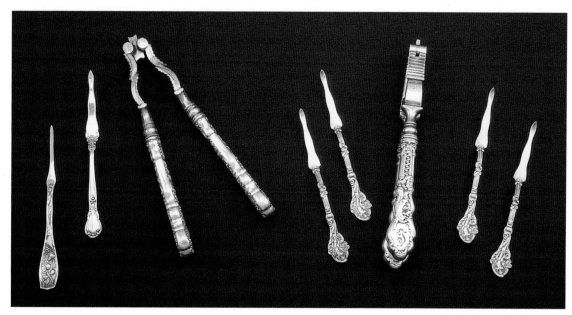

Figure 2.163. These examples exemplify the shapes that nut picks and nut crackers usually take. The nut picks are all-silver, while the crackers use hollow handles with steel fittings that are usually silverplated. In this figure, the first example, on the left, is Towle's *Pomona* at 4-5/8", followed by Gorham's *Chantilly* at 4-13/16". The nut cracker is in *Imperial Chrysanthemum* and is 6-3/4" in length. The next example is in *Versailles*. The individual nut picks are 4-5/8" and the nut cracker is 6-5/8". The value of the items would range from $145 up for the nut picks, and $425 and up for the nut crackers.

Bar Accessories

Figure 2.164. All of the items in Figure 2.164 are in Wallace's *Lion* and are currently available. The bar knife/opener is 8-13/16". The ice scoop is 9-11/16" and the jigger is 5-1/2". The value of these items is from $75 upwards.

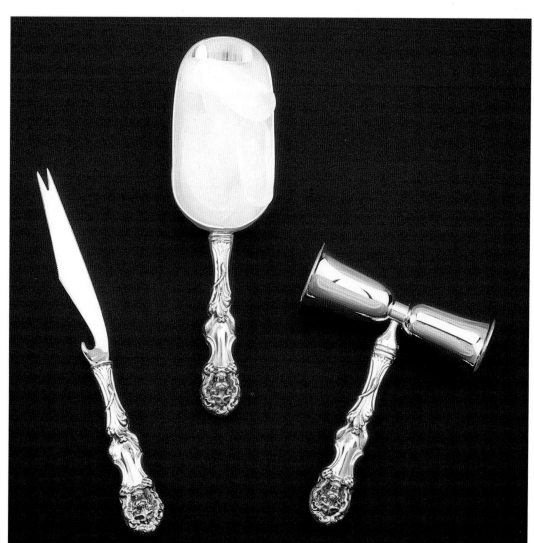

Corn Items

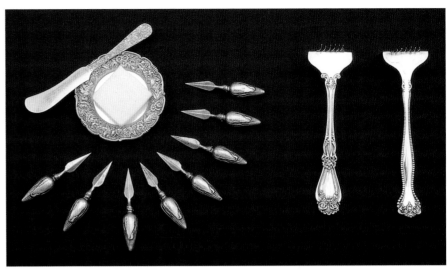

Figure 2.167. A number of items used in the serving of corn. On the left are a Kirk *Repoussé* butter pat and butter spreader along with a number of corn holders, at 2-15/16". One of these is inserted into each end of the hot ear of corn. On the right are two corn scrapers. The first, on the left, is in an unknown pattern. On the right is Alvin's *Raleigh*. The reader is also instructed to look at the individual corn fork in Figure 3.11 in Gorham's *Chantilly*.

Grape Scissors

Figure 2.165. Two examples of grape scissors. The first example on the left is only marked "Sterling," attesting to American manufacturing. It is 6-15/16". The second item is in Tiffany's *English King* and it is 6-1/8". The value of these items would run from $325 upward.

Cigar Cutter

Figure 2.166. A rare Gorham *Chantilly* cigar cutter. An Orrefors ash tray and a box of matches complete the "setting." The cutter is extremely rare, and would command top dollar; a beginning price tag of $750 and up would not be out of line.

Tea Items

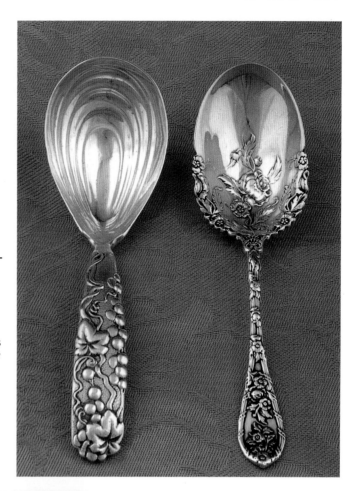

Tea Caddy Spoons

Figure 2.168. Two fabulous examples of tea caddy spoons. On the left is Tiffany's *Vine* at 5". On the right is Durgin's *Dauphin* also at 5". These spoons are relatively rare and would be priced from $450 up.

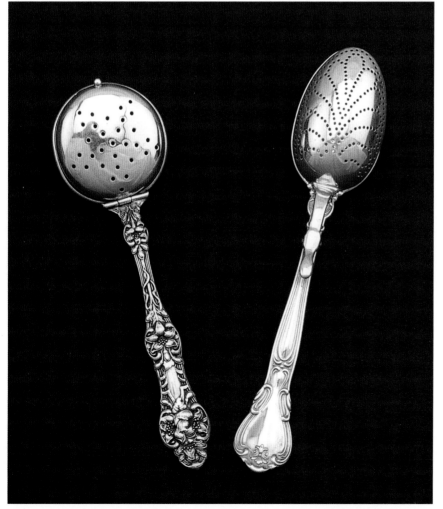

Tea Infusers

Figure 2.169. Two examples of tea infusers. Alvin's *Old Orange Blossom* is shown on the left. The round bowl of the infuser is most unusual. This item is 5-1/8". On the right is Gorham's *Chantilly* at 5-9/16". The value of these items would range from $195 up.

Tea Strainers/Tea Balls

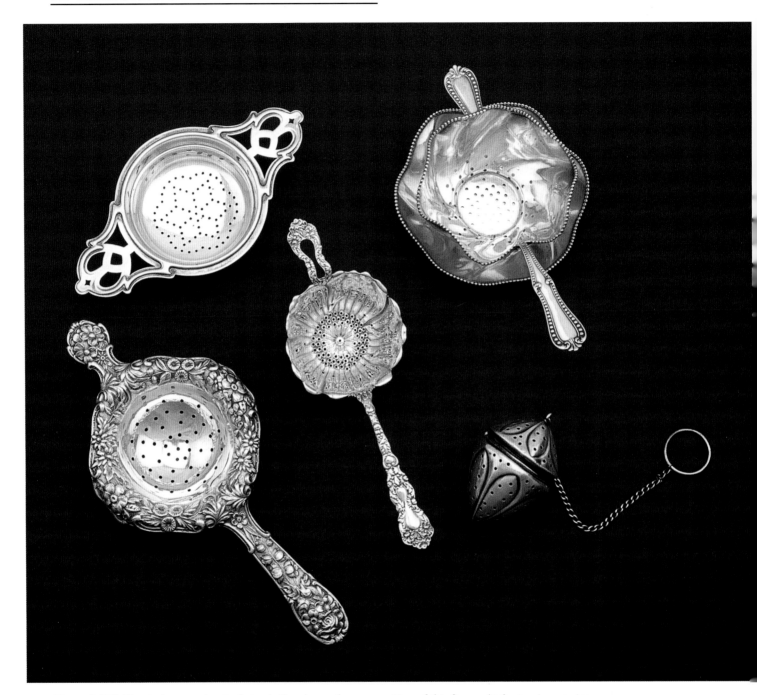

Figure 2.170. Tea strainers and a single tea ball make up the composition of this figure. At the top is a strainer with two handles by Wallace. It is 5-1/16" long. To the right is a two piece sterling strainer, only marked "sterling," with no maker. It is 6". The bottom piece acts as a reservoir for tea drippings. At the lower left is an example by Kirk in *Repoussé* at 6-7/8". In the center is another strainer made by Gorham in *Imperial Chrysanthemum*. This particular item can be found with the same center floral piece, but with handles in various Gorham patterns. This one example is unusual as it has one of the handles pierced. The next item is a tea ball, only identified by #5604 at 2-1/8". Values of these items would range from a low $95 for the unmarked two-piece set to over $400 for patterned pieces.

Manufacturer Made-Up Pieces

Many manufacturers are taking the handles from sterling place knives or sterling dinner knives and placing stainless steel findings into them thus creating serving pieces that are more reasonably priced for today's market.

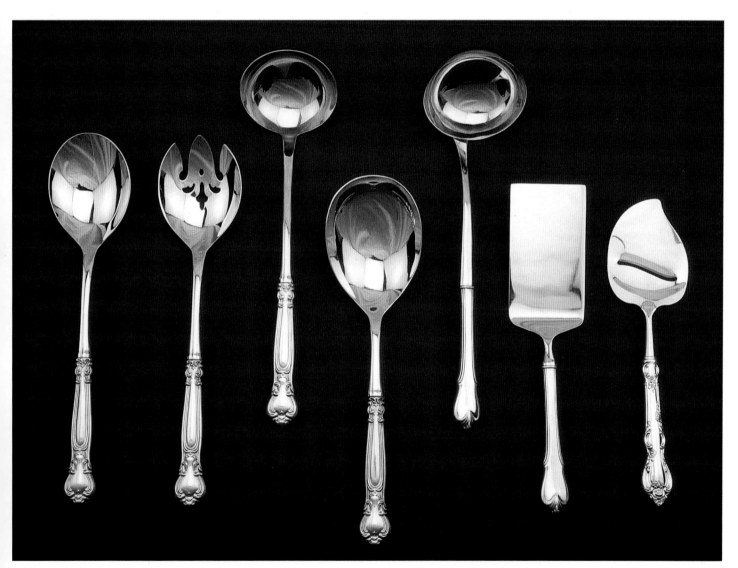

Figure 2.171. A number of manufacturer's made-up items. The first is a salad set by Gorham in their *Chantilly* pattern. The spoon is 11-3/8" and the fork is 11-1/4". Next is a soup ladle in the *Chantilly* pattern. It is 11-1/2" and is followed by a large serving spoon also in *Chantilly* at 11". Next is a soup by Wallace in their *Grand Colonial* pattern at 11-1/2". This is followed by a Lasagna server in the same pattern at 10". Last is Towle's *Spanish Provincial* cheese plane at 9-3/8". Each of these is advertised for what they are, and the prices vary from a low of $49 to approximately $79 for the soup ladles or $89 for the salad set. The stainless steel inserts are most appropriate to use at a buffet, or with large groups. If the serving piece sits in the food for an extended period, it will not be harmed.

Made Up Pieces, or Remanufactured Pieces

An area of strong contention between some dealers and their customers is characterized by items found in this category. Reading the ads placed by dealers on ebay, or in magazines/newspapers does not always give the unknowing a true picture of the item. A small cheese scoop may be just that to the unknowing. If this same customer later becomes an avid collector and discovers that the cute cheese scoop was made from a teaspoon, there may be some very difficult feelings between the customer and the dealer. The dealer who readily admits that the item is made up is to be commended for honesty, yet the question still remains—do we wish to flood the market with sterling items that are "not real?" This is a very difficult question to answer and the full disclosure is the only way to go for future customers. Some dealers have advertised their products as "Pierced Post Manufacturer." While this does signify the fact that the item was reworked, remanufactured, to the neophyte it does not. Only full disclosure will solve this problem. This is a problem that may come back to haunt the unscrupulous dealer.

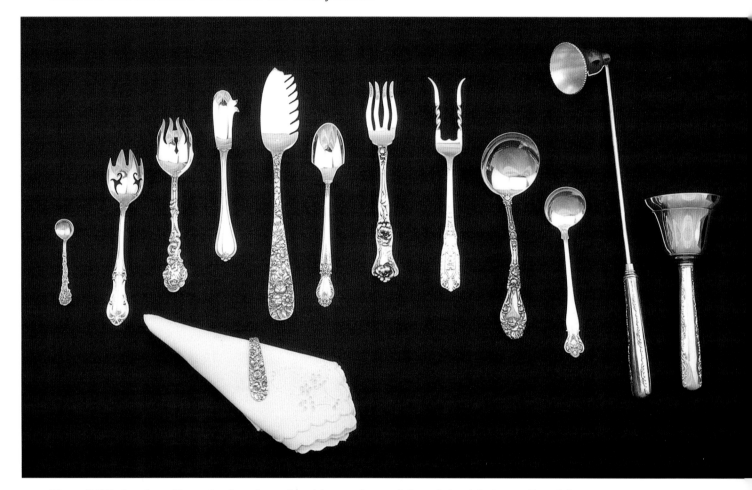

Figure 2.172. A variety of items that have been altered (remanufactured) from their original state. From left to right the items are the following: Gorham *Versailles* individual salt, 2-3/4" [most likely sand cast—hence the plain back]; International's *Joan of Arc*, ramekin/terrapin fork, 5-11/16"; *Versailles*, ramekins, 5-11/16"; Towle's *Old Newbury*, butter pick knife, 5-3/4"; Stieff's *Rose* macaroni knife, 8-9/16"; International's *Brocade*, cheese scoop, 6"; Wallace's *Peony* fish fork/large salad fork, 7-3/4" [made from a luncheon fork]; Westmoreland's *Milburn Rose* English meat fork, 7-1/4"; Durgin's *Marechal Niel*, 6-1/2" cream ladle [made from a large gumbo soup]; Durgin's *New Vintage* condiment ladle, 5-3/8" [made from a long-handled chocolate spoon]; and Towle's *Candlelight* candle snuffer, 13-1/2" (fully extended) and dinner bell, 7". At the bottom is a napkin clip made from a Stieff's *Rose* teaspoon. Since some of these items began life as a lonely teaspoon, being remade into a serving piece commands a larger price. The items found here were priced from $35 up.

Part 3

Place Pieces

This portion of the book begins the presentation of place pieces in sterling silver. Each of the following items was made for individual place settings. Some are extremely rare, and others are currently being manufactured. The section begins with a discussion of forks, then knives and spoons. The section then goes on to children's silver, and ends with a discussion of unusual place pieces.

The basic fork we know today was not introduced until approximately 1361 in Florence, Italy. When Catherine de Medici married into the French monarchy in 1533, she brought a number of forks with her to France. There the fork began to make its way onto the tables of the elite. Its acceptance in England, however, was very slow. The English did not take well to influences from France, and since the fork was seen as a French idea, it development and acceptance in England met great resistance. According to Giblin, not until 1650 did forks become evident throughout England. In the Old World the style of eating changed with the introduction and acceptance of the fork during the period between 1650 and 1750.

In this country the introduction was still later, and not until the early 1800s did forks become commonplace. In America, it seems, British ideas were not easily accepted due to the Revolution. The development of silverplating in the 1840s readily made for cheap forks and hence their rapid acceptance.

With the introduction of forks, spoons also began to change. They began to be defined by their purpose, which dictated the size proportions of the spoon. Large spoons became tablespoons, and smaller ones teaspoons. The teaspoon was necessary to stir sugar and/ or cream into the tea. Tea itself was very well accepted. Other variations in spoons followed developments in china and food introductions.

Knives have been commonplace forever. Early examples are very rare as the constant sharpening of the blade soon caused the knife to become worn out. The result was the many early knives were simply thrown out when they could no longer be sharpened. In the 1200s wealthy people carried their own utensils with them as inns did not furnish implements for eating..

The shape of the knife blade has changed over time due to a multitude of reasons. Some of the lore of knives includes the story that Cardinal Richelieu ordered that knives used at his table must be blunt, and not sharp. One version of this story concludes that the Cardinal was disgusted with a guest who picked his teeth with his knife. Another version states that with flaring tempers at the dinner table it was very dangerous to have sharp knives available. Louis XIV passed a law making it illegal to carry pointed knives.

Other changes were because of style and history. For many years manufacturers wanted to find a metal that would not wear out and expose the underlying material, as happened with silverplated blades. Stainless steel was experimented with for many years, and Gorham developed the Latima blade. Other companies had similar examples, yet none of these were without problems, as evidenced by the many knives that can be found with broken blades. Stainless steel blades as we know them today were perfected after World War II. The shape of the blade may sometimes give the clue as to the age of the knife, unless it has been rebladed.

Forks

Dinner Forks

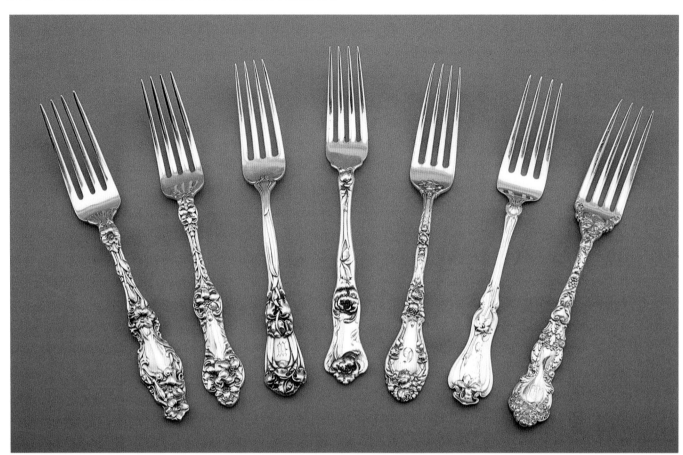

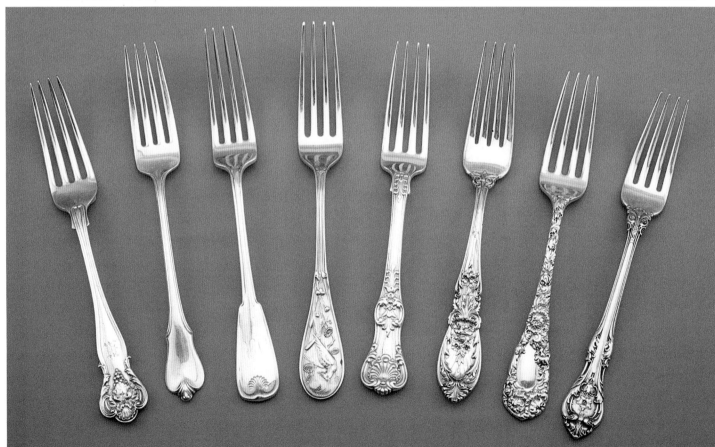

Opposite page, top:
Figure 3.001. A number of examples of dinner forks. From left to right the forks are: Whiting's *Lily*, 7-5/8"; Alvin's *Old Orange Blossom*, 7-9/16"; Durgin's *Iris*, 7-5/8"; Wallace's *Peony*, 7-5/8"; Durgin's *Marechal Niel*, 7-5/8"; Whiting's *Violet*, 7-1/2"; and, last, Gorham's *Imperial Chrysanthemum*, 7-1/2". The values of these forks would be from $85 up.

Opposite page, bottom:
Figure 3.002. Eight dinner forks. At the left are: Durgin's *New Vintage*, 7-5/8", and Wallace's *Grand Colonial*, 7-3/4". These are followed by three Tiffany patterns, *Palm*, 8", *Audubon*, 8-1/2", and *English King*, 7-5/8". Next are International's *Richeleau*, 7-3/4"; Durgin's *Chrysanthemum*, 7-1/2"; and, last, Gorham's *King Edward*, 7-5/8". The value of these individual forks would be from $75 up.

Place Forks

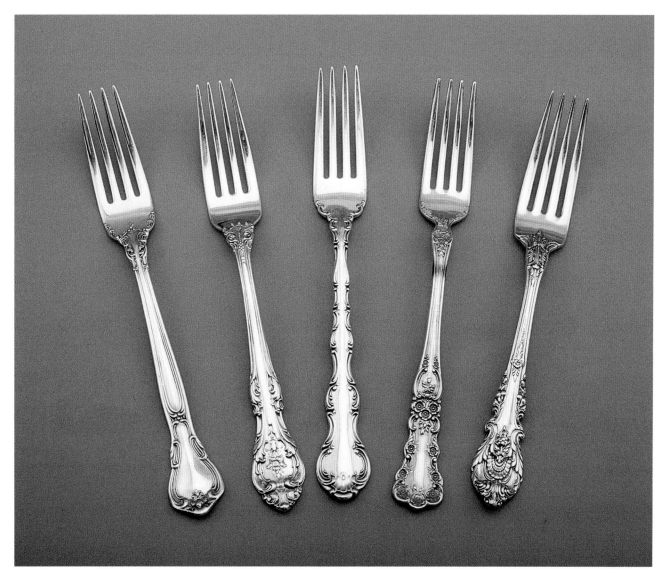

Figure 3.003. Five examples of place forks by two manufacturers. Originally these forks were created to fill a need for a fork smaller than a dinner fork and larger than a luncheon fork. They appeared on the marketplace shortly after World War II. The four at the left are from Gorham: *Buttercup*, 7-1/2"; *King Edward*, 7-1/2"; *Strasbourg*, 7-1/2"; and *Chantilly*, 7-1/2". The last example is Wallace's *Sir Christopher*, 7-1/4". The value of these forks would be from $65 up.

Luncheon/Dessert Forks

Figure 3.004. Luncheon forks were made long before salad forks, and it is not uncommon to find old sets with double or triple the number of dessert forks, as salad forks were not introduced before 1885 (Turner). There are eleven examples from seven different manufacturers. From left to right: Durgin's *Fairfax*, 7-1/4"; *Iris*, 7-1/16"; *New Vintage*, 7"; and *Marechal Niel*, 7-1/16"; Whiting's *Lily*, 6-3/4", and *Violet*, 6-11/16"; Wallace's *Peony*, 7-3/16"; Gorham's *Imperial Chrysanthemum*, 6-3/4"; Alvin's *Old Orange Blossom*, 6-11/16"; Tiffany's *Palm*, 7"; and Frank Smith's *Lion*, 7". The value of these forks would vary, but the beginning price would be somewhere around $75 to 80 dollars.

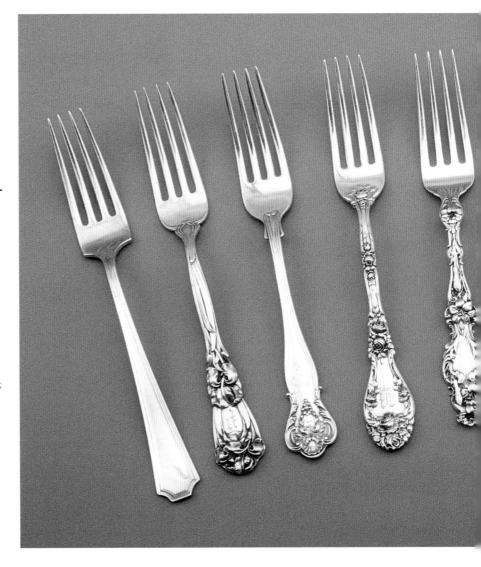

Salad Forks, Large

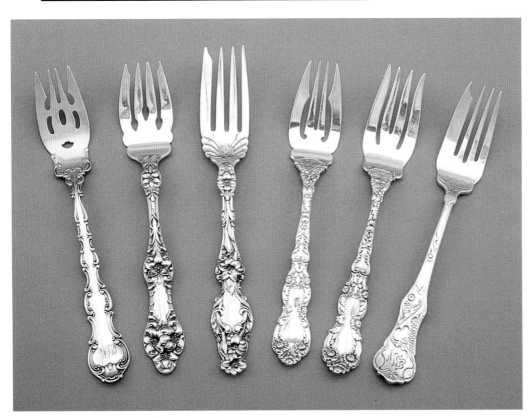

Figure 3.005. Large salad forks. These were most likely designed to be used with the dinner forks, to make a more aesthetically pleasing statement—size wise. The first is Gorham's *Strasbourg*, 6-13/16". It is followed by two forks in the Masterpiece Collection by Gorham, Alvin's *Old Orange Blossom*, 6-3/4", and Whiting's *Lily*, 6-3/4". Both of these forks are even large for salad forks, but when inspecting old catalogs they turn up as "fish forks, large." Next come two examples in *Imperial Chrysanthemum*. The regular size is 6-5/8", while the differently tined example, similar to *Buckingham*, is 6-7/8" Why the different tine style is a mystery, yet there must be other examples. Last in this figure is an unknown King/Queen's pattern. The older patterns like the *Strasbourg* would be valued at approximately $135 and up, while the two examples in the Masterpiece Collection would be from $75 to 95. The *Imperial Chrysanthemum* examples would be worth from $95 to around 135 each.

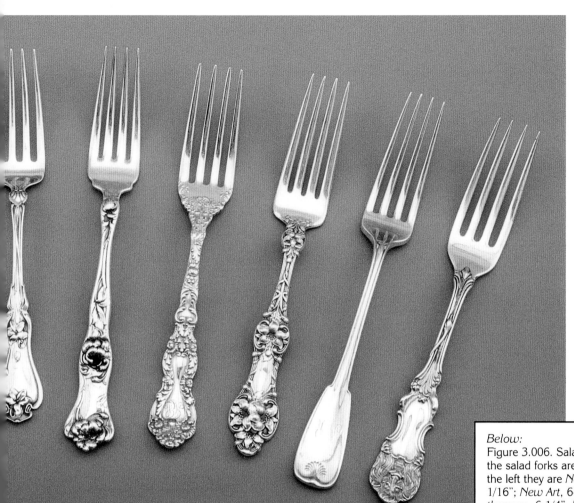

Below:
Figure 3.006. Salad forks. In this figure all the salad forks are by Durgin Company. From the left they are *New Vintage,* 6"; *Fairfax,* 6-1/16"; *New Art,* 6-1/4"; *Iris,* 6-1/4"; *Chrysanthemum,* 6-1/4"; *Marechal Niel,* 6-1/4"; and *Watteau,* 6-1/16". These examples by Durgin would command prices from $85 up. The floral patterns, *Iris, New Art* and *Chrysanthemum* would command slightly more.

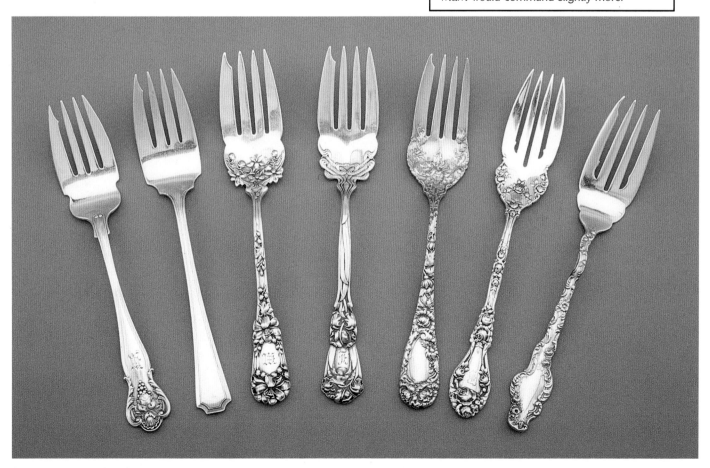

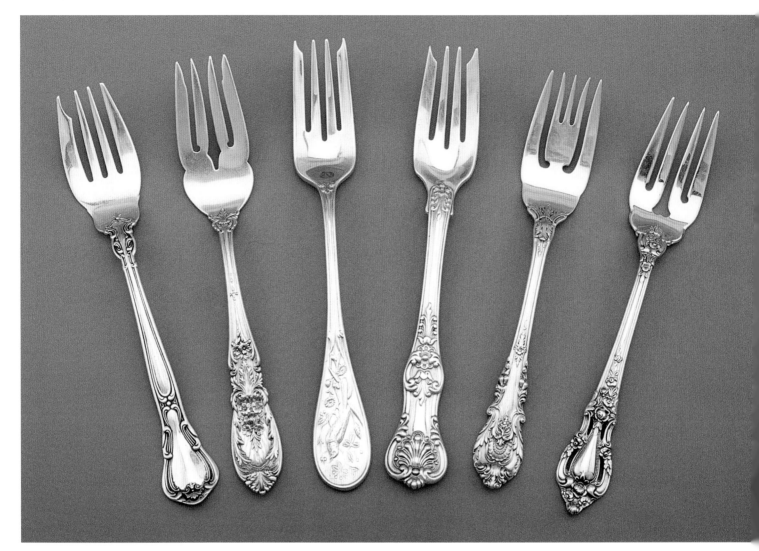

Figure 3.007. Additional examples of salad forks. From the left they are: Gorham's *Chantilly*, 6-1/2"; International's *Richeleau*, 6-1/2"; Tiffany's *Audubon*, 6-7/8", and *English King*, 6-3/4"; Wallace's *Sir Christopher*, 6-3/8"; and Lunt's *Eloquence*, 6-3/8". The values of these forks would be from $65 up. The Tiffany examples would command prices over $125.

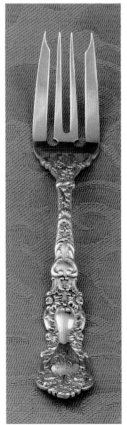

Left:
Figure 3.008. The salad fork made in Gorham's *Imperial Chrysanthemum*. This particular fork is not frequently found; instead the small pastry fork found in Figure 3.013 is often substituted for the salad fork. There may be several reasons for this problem. One is, salad forks, according to Turner, were not introduced until after 1885, and since this pattern was made the large salad/fish fork (See Figure 3.005) may have sufficed for many and few were manufactured. Another explanation could be that the public preferred the pastry fork/fish fork with the pierced design below the tines. Yet another explanation is that Gorham was late in introducing this particular style, and the buying public had substituted other items for the salad. Again, the only way to know for sure what particular fork is what, is to have a copy of the original patent design or a brochure featuring the pattern. The value of this fork would be approximately $95.

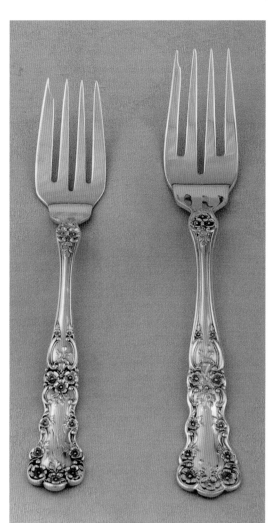

Figure 3.009. Two examples of salad forks in Gorham's *Buttercup*. The example on the left shows the older style, and the example on the right is the newer version, called place size. This particular piece has the letter "P" placed within a diamond on the reverse. Having both sizes would allow the hostess to use one for salad, and the second fork for dessert, thus saving time washing forks between courses. These would be valued at about $65 for the newer version, while the older version would be worth from $75 up. Gorham's *King Edward* pattern also has the two different sizes.

Below:
Figure 3.010. Five additional examples of salad forks. The first example, Whiting's *Lily,* is 6". This particular fork is old, as born out by the old marks, the engraving, and the slight wear. Other examples that have been seen were sand cast and are very rough to the touch. The second example is Whiting's *Violet,* 6-1/8". The next is an example in Alvin's *Old Orange Blossom*, 6-7/8". Note the bars on this example. Following this is another Whiting *Violet* sample that is three tined. It is also made of heavier gauge silver than is usually found in this pattern. It is 6-3/16". The last piece is Wallace's *Peony,* 6-1/8". Placing values on this particular group is very difficult. The *Lily* examples are being restruck by Gorham, and this may affect the price. The *Violet* examples are very difficult to locate and prices over $100 would not be unusual. The *Peony* examples are extremely difficult to find. An entire set was purchased in order to obtain these examples. The values of these forks would be well over $100 each.

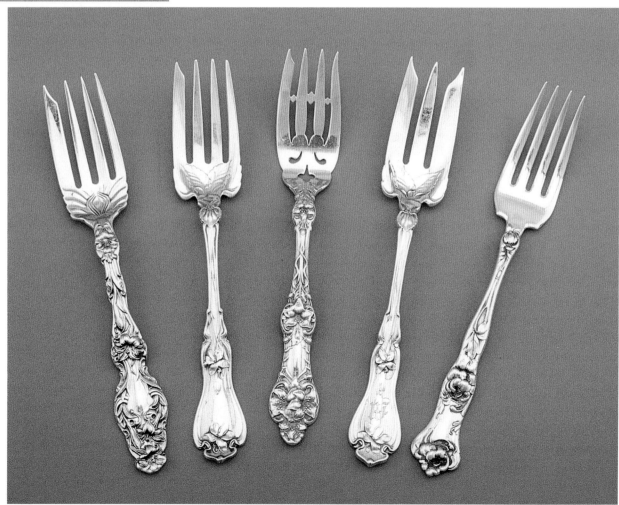

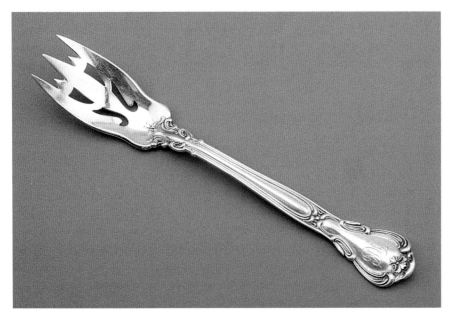

Figure 3.011. One of the most elusive and rare items is the corn fork. In this example, Gorham's *Chantilly,* the heavy, pointed cutting tines would be useful in removing the kernels from the cob. Seldom do many of these forks emerge. They should be valued at around $400 to $500. Gorham made corn forks in few patterns; only *Chantilly* and *Old French* have been seen to date. The forks are 6-11/16" in length.

Fish Forks, Large _____

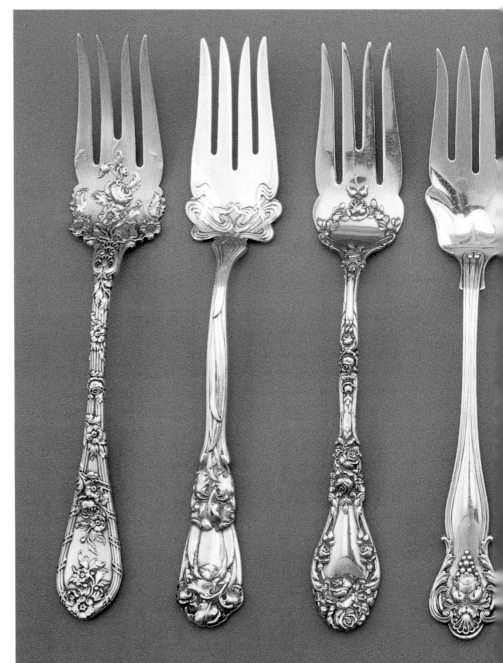

Figure 3.012. Large fish forks. The first five are from Durgin and Company. They are as follows: *Dauphin,* 7-5/16"; *Iris,* 7-1/2"; *Marechal Niel,* 7-3/8"; *New Vintage,* 7-3/8"; and *Chrysanthemum,* 7-3/8". All of the Durgin forks are also sold as "cold meat forks, small." They are very large for fish or salad forks, even though they are labeled as "large." The value of these forks would be from $95 to about $150 each, depending upon rarity, monogramming, and "need." The next examples are by Gorham: *Strasbourg,* 6-13/16"; *Imperial Chrysanthemum,* 6-5/8"; and *Chantilly,* 6-3/4". These forks would be valued from $95 to over $135. The last two examples are in Tiffany patterns. The first is *Palm,* 6-5/8", and the second is *English King,* 6-3/4". The Tiffany examples would be worth from $145 up depending upon the number available, and if there were fish knives to go with each fork.

Fish/Salad Forks, small

Figure 3.013. Two examples of fish/salad forks. The example on the top in Durgin's *New Vintage* is 6-1/16". The second one is in Gorham's *Imperial Chrysanthemum*, 5-15/16". The value of these forks varies from $85 to over a hundred dollars. Both are more frequently seen than other small salad forks in either of these two patterns.

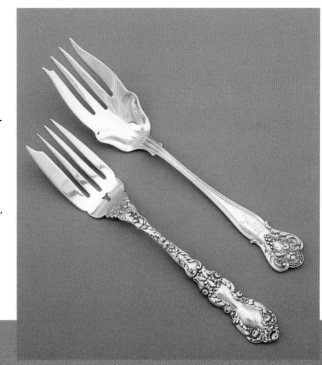

Figure 3.014. An individual Haviland fish plate with an accompanying fish fork and large butter knife, serving as a fish knife. The fork is also found in the last section, under "remanufactured" forks. This fork was fashioned from a luncheon fork, in the form of the fish serving fork. The value of this fork is not more than a luncheon fork, but since it was made up, the most it should command from a customer well aware of its condition and structure, would be $55., well under the cost of the fork and the labor for making it. The knife, untouched, would be worth from $125 up to $150.

Pastry/Dessert Forks

Figure 3.015. Five examples of pastry/dessert forks are featured in this figure. The first example is Knowles *Crescent,* at 6-1/4". This is followed by Durgin's *Dauphin,* 6-1/8"; Whiting's *Lily of the Valley,* 6-1/8" [note the bar in this example and the next two examples]; unknown manufacturer, *Queens,* 6-1/16"; and Alvin's *Old Orange Blossom,* 5-15/16".

Pie Fork, Large

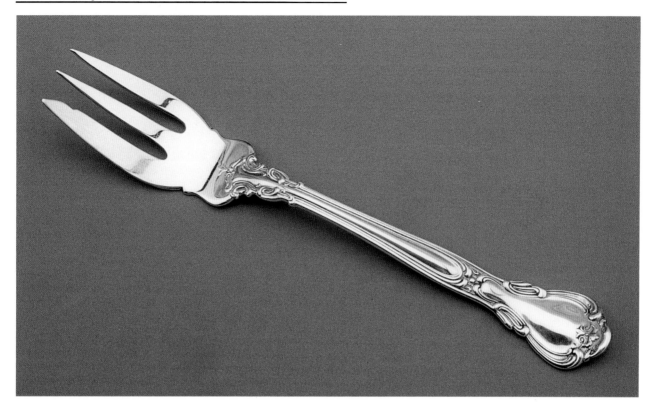

Figure 3.016. An example of a large pie fork featuring Gorham's *Chantilly* at 6-7/8". Pie forks were made before salad forks, and in some older patterns they are the only item available. This example is highly collectable and would be worth about $135.

Pie Forks, Small

Figure 3.017. Five examples of small pie forks. The first two are by Gorham: *Imperial Chrysanthemum*, 5-13/16", and *Versailles*, 5-15/16". In the center is Whiting's *Lily*, 5-3/8", followed by Gorham's *Strasbourg*, 5-7/8", and *Chantilly,* 5-7/8". These forks would be worth from $110 to about $150, which is the price the author paid for the example in *Imperial Chrysanthemum*, which I HAD to HAVE to use as an example for this figure. These same forks also can be labeled as "pickle forks" and then paired with a pickle knife.

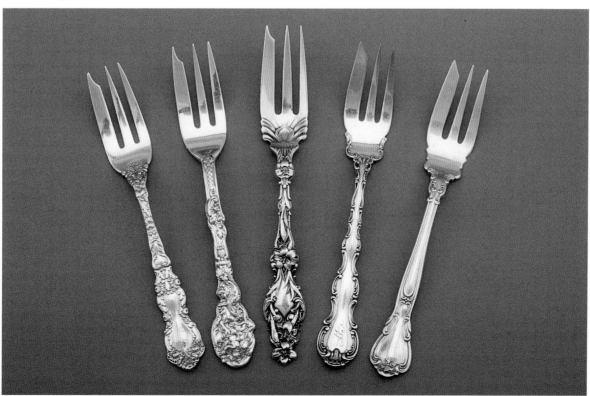

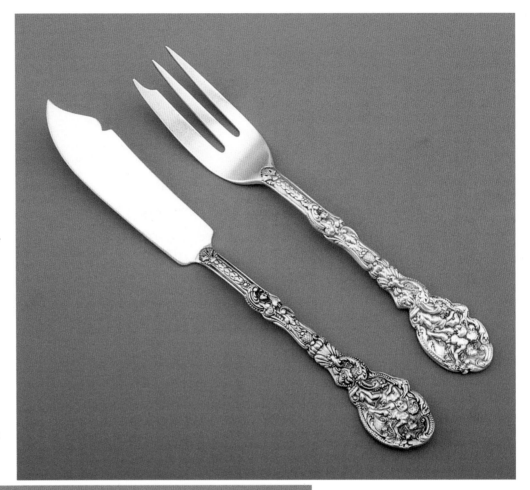

Pickle Fork/Pickle Knife

Figure 3.018. An example of a pickle fork and a pickle knife. Individually these would be worth about $125-150 each, and about $325 for the set, provided they were not put together to form a set. Checking the monogram will ascertain this for the reader.

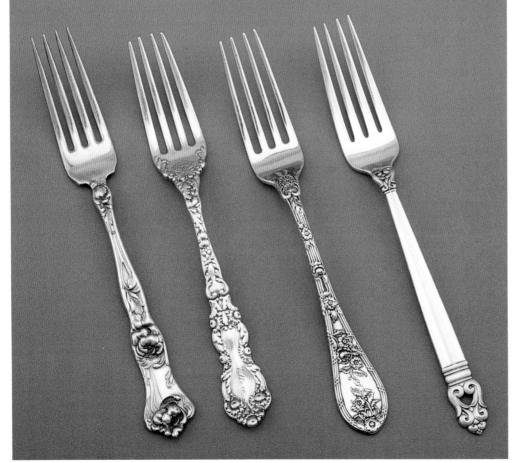

Junior Forks/Tea Forks/ Breakfast Forks

Figure 3.019. This category has a number of names for the same pieces. They are the forks one gives young children who cannot handle a luncheon size fork/knife; they double for breakfast sets for adults and/or they are used for tea. These items are really usable and having a selection of different patterns allows for an interesting table conversation. The four examples in Figure 3.19 are as follows: Wallace's *Peony*, 6-1/8"; Gorham's *Imperial Chrysanthemum*, 5-15/16"; Durgin's *Dauphin*, 6-1/8"; and International's *Royal Danish*, 6-5/16". These forks would be valued at $35 to $60 separately, but worth more when in a set, consisting of a fork, knife, and spoon.

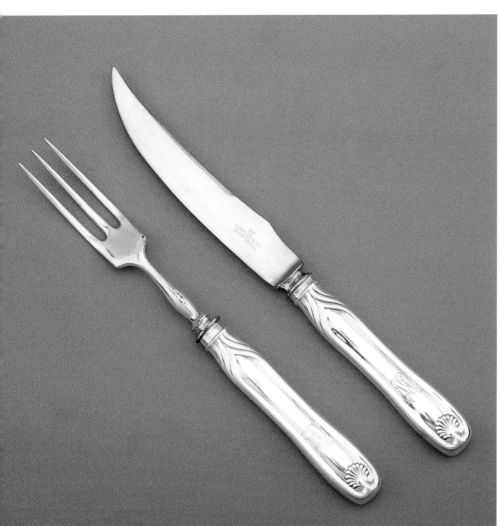

Bird Forks/Bird Knives

Figure 3.020. An example of a bird knife and a bird fork in Tiffany's *Palm*. The knife is 7-1/4" and the fork is 7-1/4". The value of the set would be approximately $265 and up, depending on the pattern and condition of the knife blades and the fork inserts. Finding a full set would be a very rare occurrence.

Ice Cream Forks, Large

Below:
Figure 3.021. An array of large ice cream forks. The first fork, in Gorham's *Versailles* was purchased as a parfait spoon. Judging from Figure 3.022.1 featuring small forks, and zeroing in on the *Imperial Chrysanthemum* fork, for which there is a design patent sheet, it would appear that this is indeed a long-handled ice cream fork. The second fork is Kirk's *Repoussé*, 5-15/16". It is followed by four Durgin patterns: *Chrysanthemum*, 5-3/4", *New Vintage*, 5-11/16", *Iris,* at 5-3/4", and *Dauphin,* 5-13/16". The values of these forks would be from $85 for the *Repoussé* fork to $125 to $150 for the other forks. The *Dauphin* has a very poor monogram removal and some of the design is missing, hence the low appraisal.

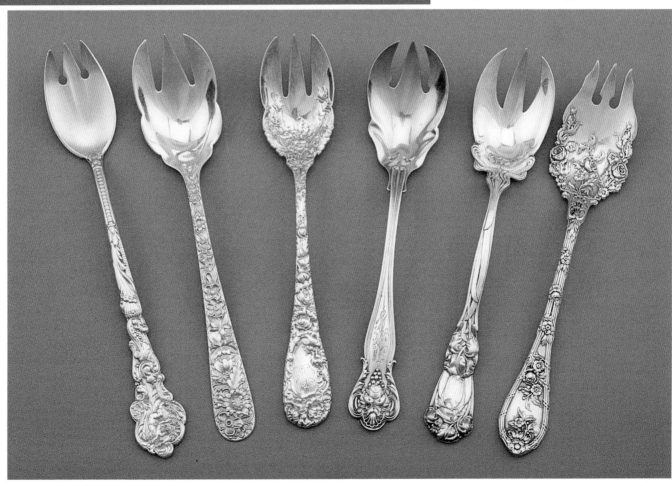

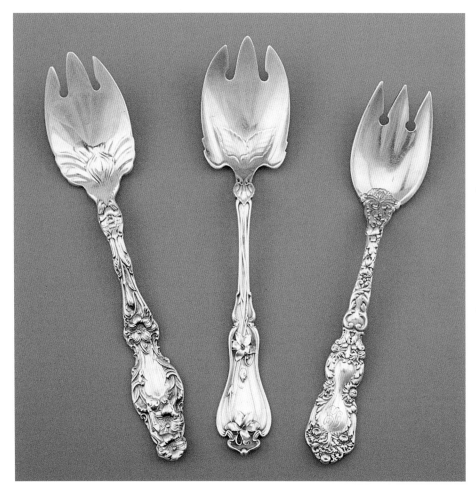

Ice Cream Forks, Small

Figure 3.022.1. Three examples of small ice cream forks. The first examples is Whiting's *Lily*, 5-1/8". Next is *Violet*, 5-1/8", followed by *Imperial Chrysanthemum*, 4-3/4". These small forks sell from $75 to over $110.

Fruit Fork

Below:
Figure 3.022.2. The lone example of a fruit fork is in Gorham's *Albermarle*. This fork is 6-1/16" long and it would have been possible to purchase an all-silver or a hollow-handled fruit knife to accompany it for the eating of fruit at the end of a meal. This particular fork being a lone example, while unusual, would be worth approximately $80.

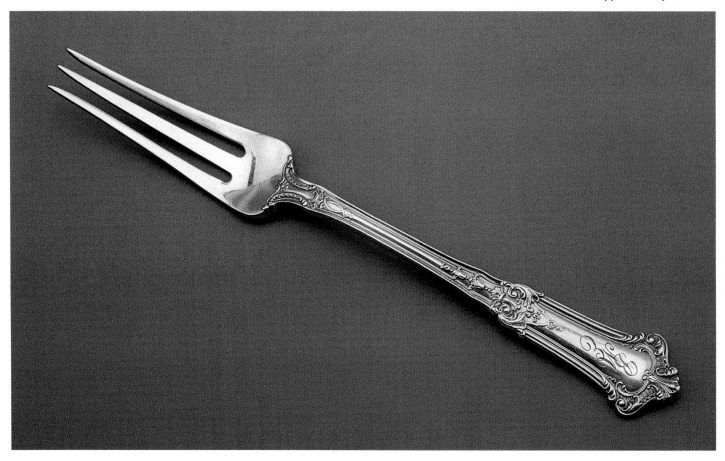

Fruit Cocktail Fork

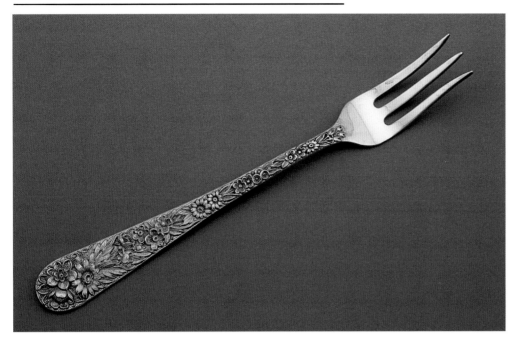

Figure 3.023. Kirk's *Repoussé* is known for a large number of place pieces, perhaps due to the long life of the pattern. This piece, at 5-3/16" can easily substitute for a cocktail fork, when needed. The value of these forks would be very similar to the price of a cocktail fork. They would be worth about $55-75 each.

Cocktail Forks

Figure 3.024. A very useful fork for eating crab, shrimp, and other shellfish is the cocktail fork. Its use is not limited to seafood; it is adaptable to a wide range of uses. It is excellent to use at a cocktail table, and when paired with a butter server allows each individual to serve themselves and to cut the items for use. At the left is Gorham's *Imperial Chrysanthemum*, 5-7/16". It is followed by: Alvin's *Old Orange Blossom*, 5-11/16"; Wallace's *Peony*, 5-15/16"; and Whiting's *Violet*, 5-7/8". Note the cut out violet leaf on this item. Next is Whiting's *Lily*, 5-7/8", followed by Gorham's *Chantilly*, 5-1/2". The value of these forks would range from $55 to upwards of $75, or more for difficult to find patterns like Wallace's *Peony*.

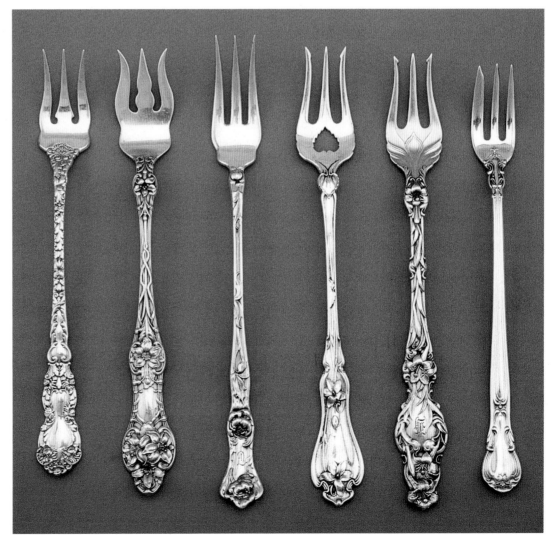

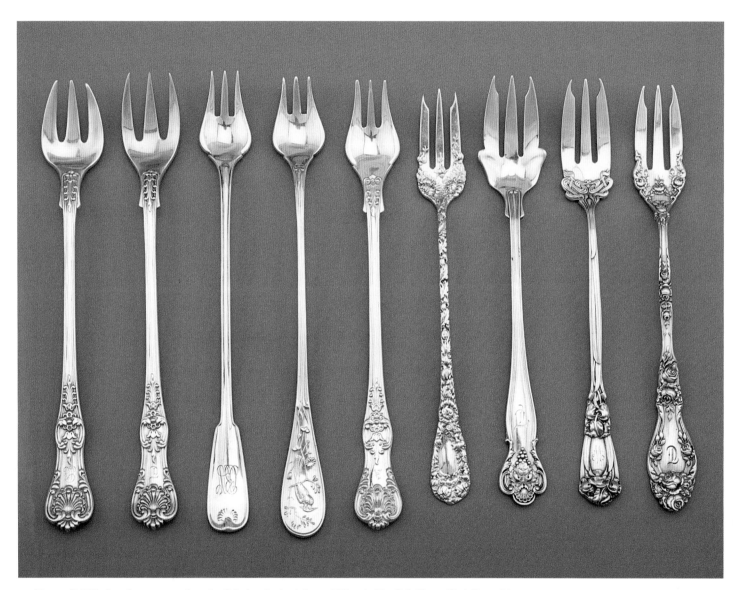

Figure 3.025. Another group of cocktail forks. At the left are Tiffany's *English King*, 6", followed by an oyster fork in the same pattern, also 6". A Tiffany seafood in *Palm* is 6-1/8"; followed by Tiffany's *Audubon*, 6-1/8". At the right are four Durgin patterns: *Chrysanthemum*, 5-9/16"; *New Vintage*, 5-11/16"; *Iris*, 5-11/16"; and *Marechal Niel*, 5-3/4". The value of these forks would be around $65 for the Durgin examples and $75 and up for the Tiffany examples.

Cherry/Canape Fork

Figure 3.026. Two examples of Cherry or Canape forks. The first example is in Reed and Barton's *Francis I*, 4-3/8". The second example is in Gorham's *Versailles* and is also 4-3/8". Note the differences in the tines in these two examples. Each of these items would be worth approximately $75 and up.

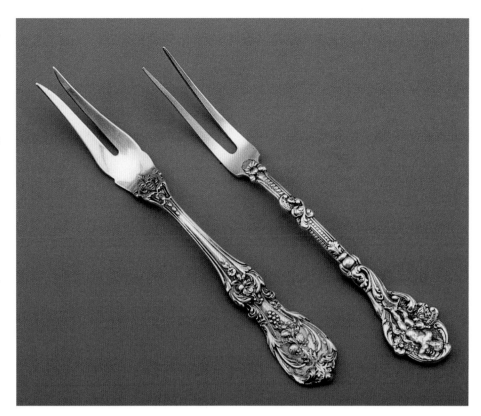

Terrapin Forks

Below:
Figure 3.027. An array of Terrapin Forks. These forks are in the following patterns: Durgin's *Dauphin*, 5-1/2", and *New Art*, 5-1/2"; Schofield's *Baltimore Rose*, 6-5/8"; Gorham's *Versailles*, 5"; and Durgin's *Iris*, 5-9/16". These forks are valued at $135 and up.

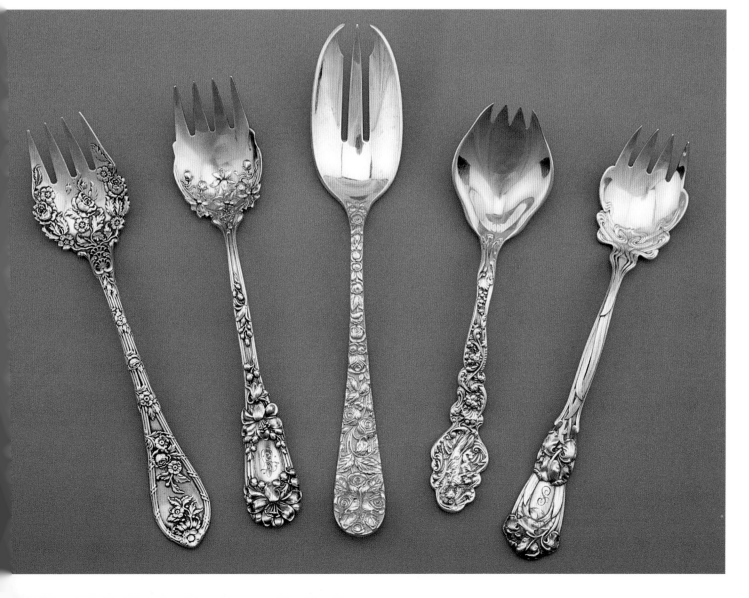

Figure 3.028. A Meissen soup bowl is featured with a Durgin
Dauphin terrapin fork.

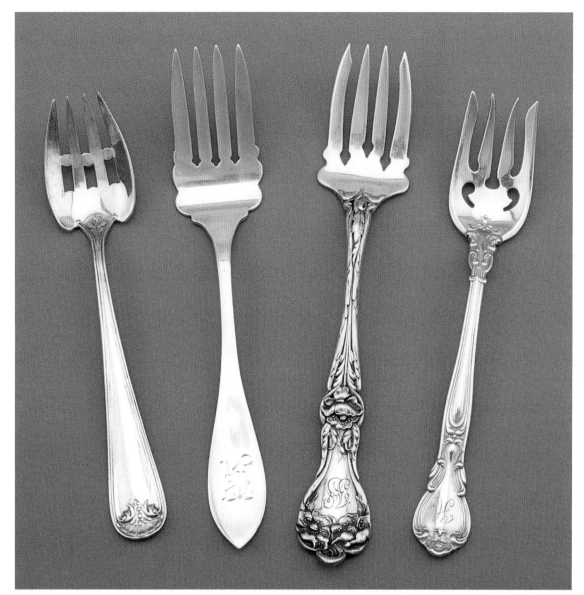

Figure 3.029. Ramekin forks. These small diminutive forks are perfectly teamed with Haviland ramekins and underplates. The forks shown in the figure are as follows: Watson's *Bunker Hill*, 4-5/8"; *Old Colony,* 5-1/8"; Alvin's *Majestic,* 4-3/8"; and Gorham's *Chantilly,* 4-3/4". The value of these forks varies mainly because of design and availability. Each fork would be worth from $55 up for the Watson forks, to $75 and more for the other two forks.

Right:
Figure 3.030. A single Ramekin fork, placed with a Haviland ramekin cup and plate.

Strawberry Forks

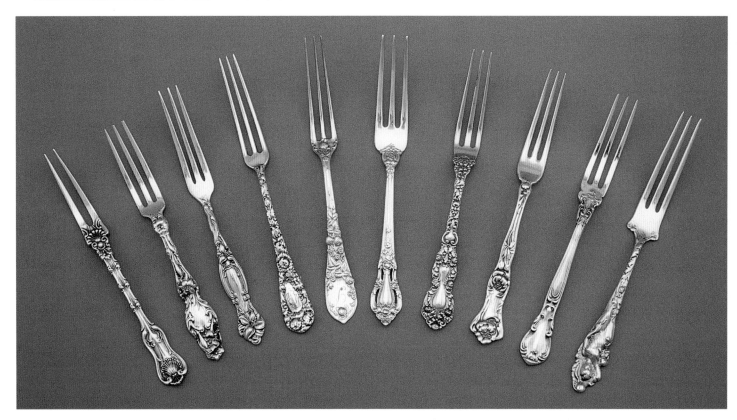

Figure 3.031. The variety that can be found in the shapes of strawberry forks. On the left is Whiting's *Imperial Queen*, 4-1/2" [note that this fork has two tines]. This is followed by Whiting's *Lily*, 4-5/16"; International's *Frontenac*, 4-9/16"; Durgin's *Chrysanthemum*, 4-13/16", and *Strawberry, 4-3/4"; Lunt's* Eloquence, 4-13/16"; Gorham's *Imperial Chrysanthemum*, 4-5/16"; Wallace's *Peony*, 4-11/16"; Gorham's *Chantilly*, 4-3/4"; and Reed and Barton's *Love Disarmed*, 4-7/8". The value of these forks will vary due to some being new, even though the pattern is old, and others being old forks. Old forks, would be worth from $55 up, while new forks should be valued about $45 up to $65, again depending on the pattern and its desirability.

Figure 3.032. A single example of a strawberry fork in Tiffany's. This fork is 4-3/8" long and is valued at approximately $95.

Mango Fork

Figure 3.033. A solitary mango fork is pictured in Reed and Barton's *Amaryllis*. The fork is 7-1/16" long and is valued at $95.

Lobster Fork/Pick

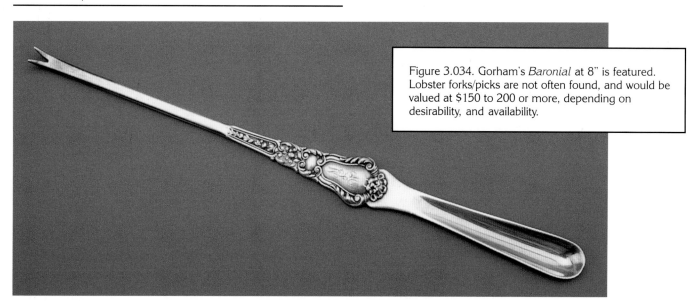

Figure 3.034. Gorham's *Baronial* at 8" is featured. Lobster forks/picks are not often found, and would be valued at $150 to 200 or more, depending on desirability, and availability.

Knives

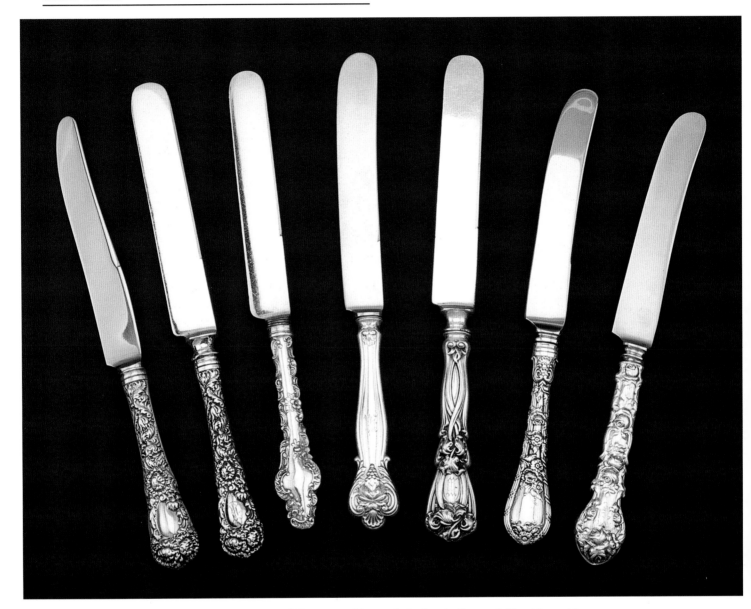

Figure 3.035. Knives manufactured by Durgin and Company, either at their plant in Concord, New Hampshire, or in Gorham's plant in Providence, Rhode Island. The patterns are as follows: *Chrysanthemum*, 9-3/4" [original size from Durgin]; *Chrysanthemum*, 9-1/2" [ordered from Gorham during a made-to-order sale]; *Watteau*, 9-7/16"; *New Vintage*, 9-3/4"; *Iris*, 10"; *Dauphin*, 9-7/16" [from Gorham's Masterpiece Collection]; and *Marechal Niel*, 9-1/2" [rebladed]. The knives, in original condition are worth $85-100 each, while newer versions are worth somewhat less.

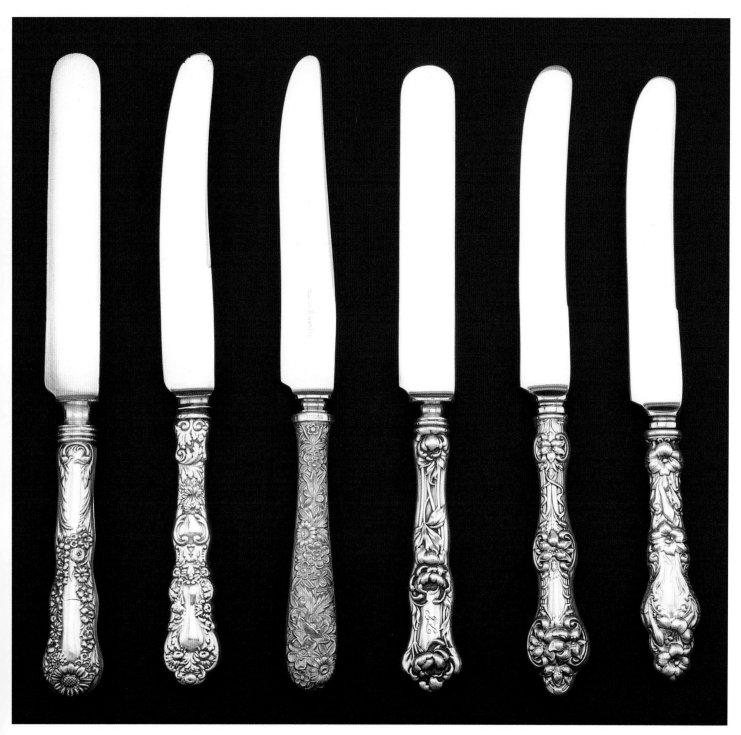

Figure 3.036. Knives from a number of manufacturers. From the left they are: Dominic and Hall's *Number Ten*, 9-3/4"; Gorham's *Imperial Chrysanthemum*, 9-5/8" [rebladed]; Kirk's *Repoussé*, 9-3/4"; Wallace's *Peony*, 9-9/16" [original blade]; Alvin's *Old Orange Blossom*, 9-3/4" [Masterpiece Collection]; and Whiting's *Lily*, 9-1/4" [Masterpiece Collection]. The value of these knives, in original condition, would be, again, approximately $85. Knives that are rebladed using a different blade [example: *Imperial Chrysanthemum*] would be valued at $65-75. The knives in the Masterpiece Collection would be valued around $75.

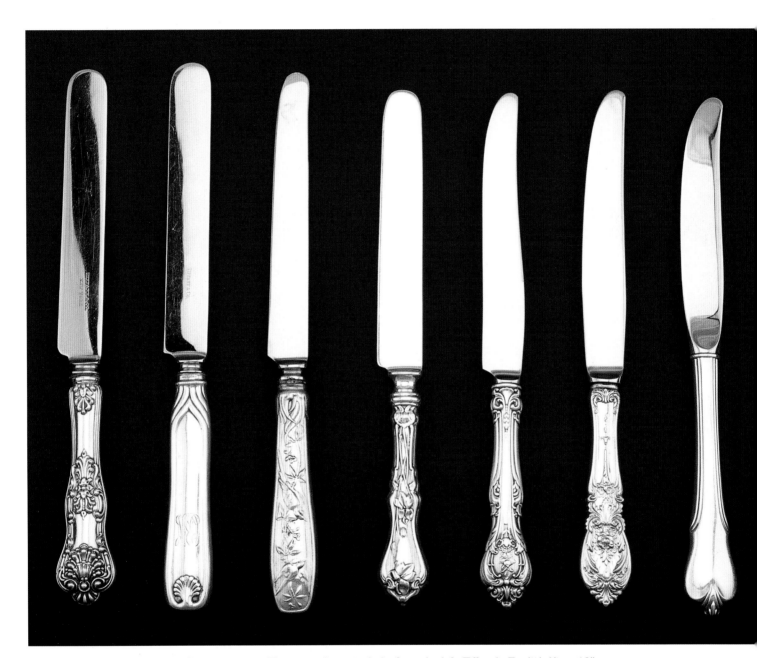

Figure 3.037. A number of great patterns. The items shown include, from the left: Tiffany's *English King*, 10",
Palm, 10-1/4", and *Audubon, 10*-1/8"; Whiting's *Violet, 9-5/8*" [note, this original blade has been resilvered];
Gorham's *King Edward*, 9-5/8"; International's *Richeleau*, 9-3/4"; and Wallace's *Grand Colonial*, 9-3/4". The
value of these knives would vary. The Tiffany patterns would command the highest price, followed by Whiting's
Violet. These knives would be worth from $95 up to $120; the other knives, would be worth about $75 each.

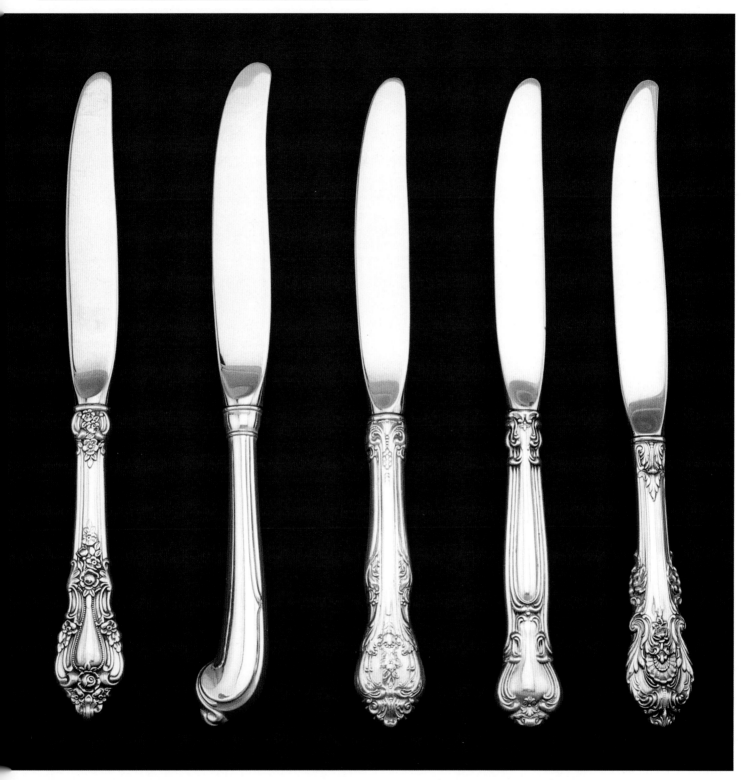

Figure 3.038. Place knives, the currently produced product by many firms, were introduced just after World War II. The examples found in Figure 3.038 include the following: Lunt's *Eloquence*, 9-1/8"; Wallace's *Grand Colonial*, 9-3/8" [pistol grip knife handle]; Gorham's *King Edward*, 9-1/8", and *Chantilly*, 9-1/8"; and Wallace's *Sir Christopher*, 9-1/4". The value of these knives would be from $45 up to 65.

Luncheon/Dessert Knives

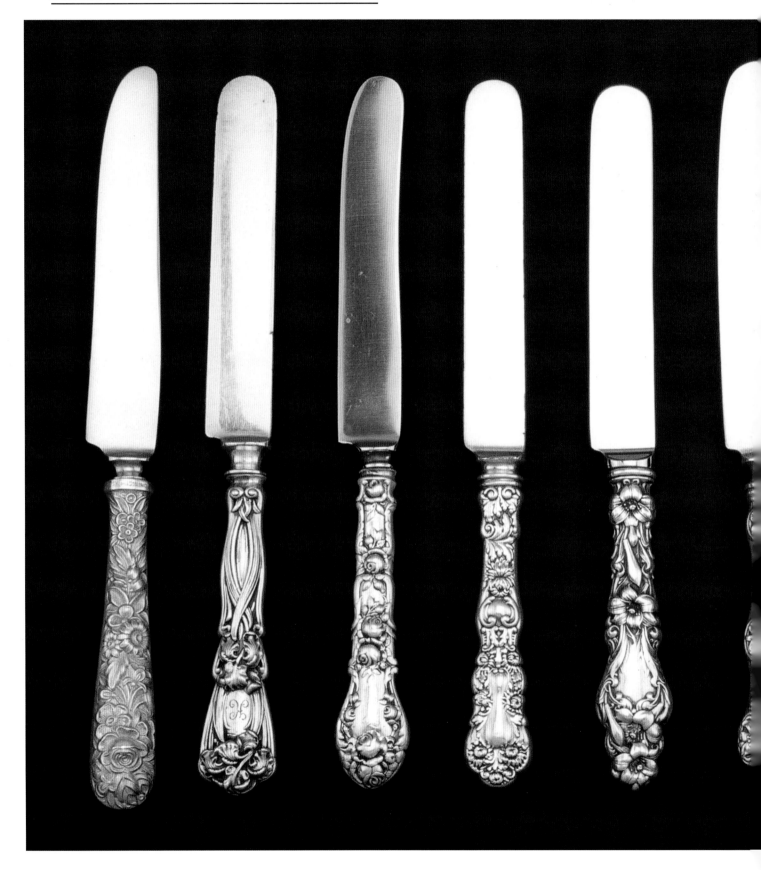

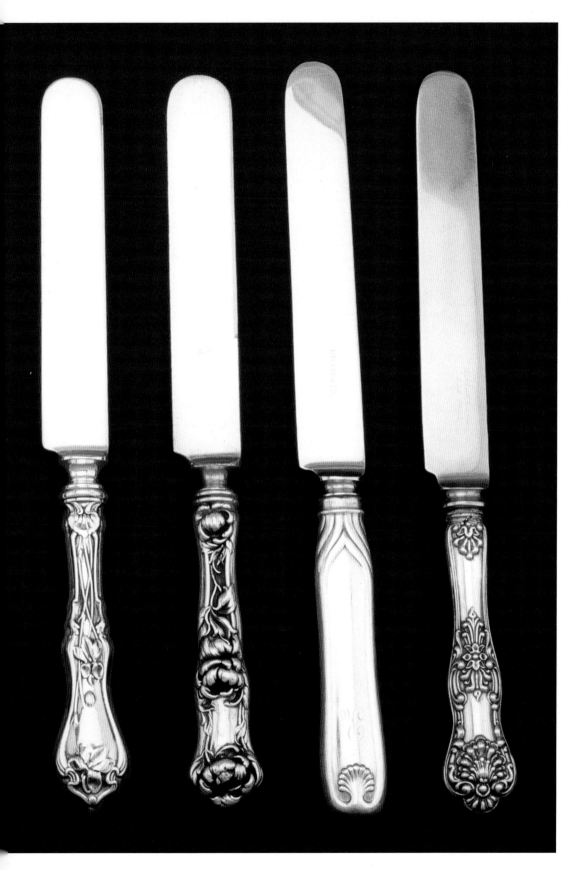

Figure 3.039. Ten different examples of luncheon/ dessert knives from a variety of manufacturers. From the left: Kirk's *Repoussé*, 9"; Durgin's *Iris*, 8-3/4", and *Marechal Niel*, 8-1/2" [note reblading]; Gorham's *Imperial Chrysanthemum*, 8-1/2"; Whiting's *Lily*, 8-1/2"; Alvin's *Old Orange Blossom*, 9" [original blade]; Whiting's *Violet*, 8-15/16" [resilvered original blade]; Wallace's *Peony*, 9" [original blade]; Tiffany's *Palm*, 9-1/8", and *English King*, 9-1/8". The value of these knives would run from $45 to about $95. Condition would be very important.

Dessert/Tea/Breakfast Knives, All–Silver

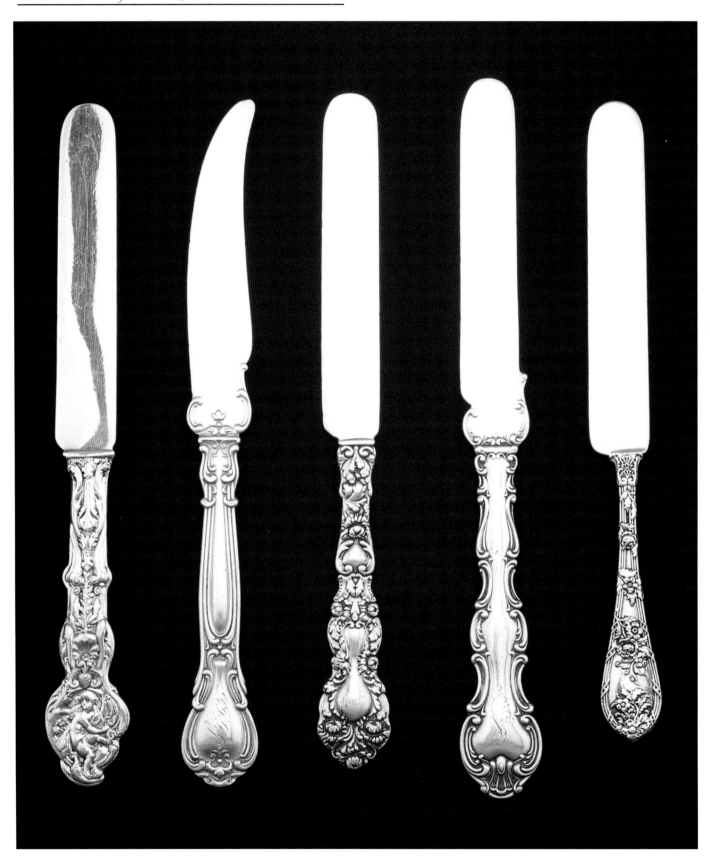

Figure 3.040. Five all-silver examples of dessert/tea/breakfast knives. The blades show a variety of shapes. The first four knives are by Gorham: *Versailles*, 7-3/8"; *Chantilly*, 7-1/2" [note the very unusual style and turn of the blade]; *Imperial Chrysanthemum*, 7-3/8"; and *Strasbourg*, 8-7/8". The last knife is Durgin's *Dauphin, 7*". The value of these knives, all of which are relatively rare, would run from a low of $75 and up. Should the knife be a part of a set, then as a set it would command a higher price.

Steak Knives

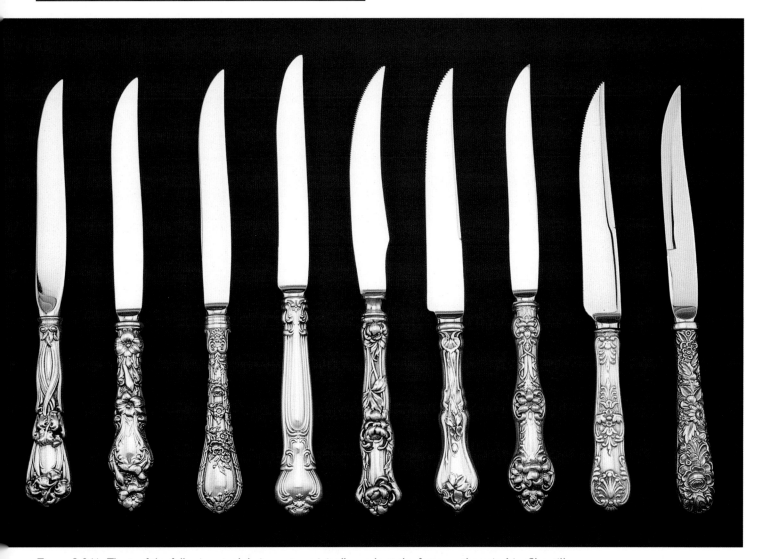

Figure 3.041. Three of the following steak knives were originally made at the factory—those in *Iris, Chantilly,* and *Repoussé* are all original. The other knives were rebladed with a variety of blades at different times. From the left the knives are: Durgin's *Iris,* 8-11/16"; Whiting's *Lily,* 9-3/4"; Durgin's *Dauphin,* 9"; Gorham's *Chantilly,* 9-3/8"; Wallace's *Peony* 9-1/16" [note the unusual form of the blade]; Whiting's *Violet,* 9-1/16"; Alvin's *Old Orange Blossom,* 9-1/4"; Tiffany's *English King,* 8-3/4"; and Kirk's *Repoussé,* 8-3/4". The value of these knives would run from $55 to about $85.

Fish Knives

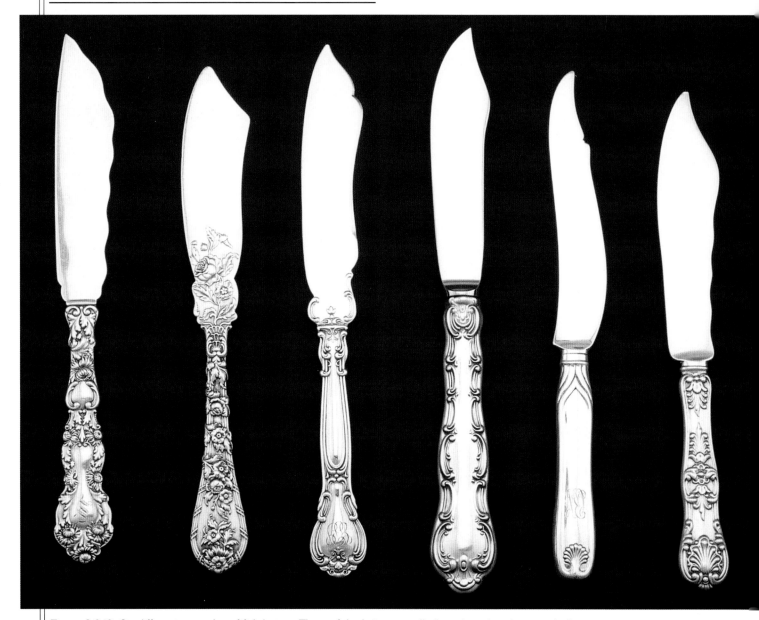

Figure 3.042. Six different examples of fish knives. Three of the knives are all-silver, the other three are hollow-handled. The first example is Gorham's *Imperial Chrysanthemum* at 8". Note the wavy edge. This was also made in a smaller version. Next is Durgin's *Dauphin*, 7-11/16". Durgin also made a master butter knife with the same shape; the difference between the two is the lack of design on the blade of the butter knife. Then follows: Gorham's *Chantilly*, 8-1/8", and *Strasbourg*, 8-5/16"; and Tiffany's *Palm*, 7-3/4", and *English King*, 7-1/2". The value of these knives would reflect three different situations. The all-silver versions would be worth approximately $185 and up, the Tiffany examples would be in about the same category, while the *Strasbourg* example would run about $65 to 85 each.

Junior/Tea/Breakfast Knives

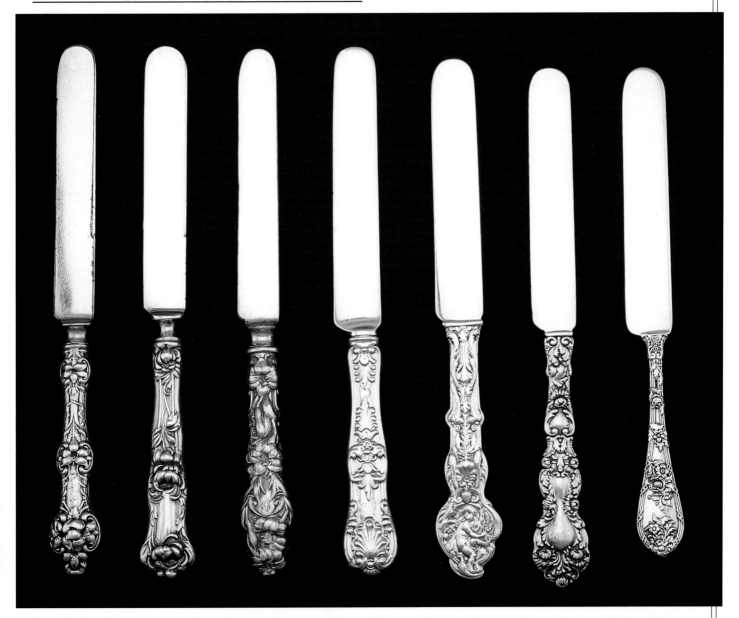

Figure 3.043. Seven examples of junior/tea/breakfast knives. Three of the examples are hollow-handled, and four are all-silver. The first three examples are of the hollow-handled variety. They are as follows: Alvin's *Old Orange Blossom*, 7-9/16"; Wallace's *Peony*, 7-9/16"; and Whiting's *Lily* at 7-1/2". The value of these hollow-handled knives would be from $50-65, depending upon the condition of the knife blade, and the amount of wear on the sterling handle . The next four examples are all-silver: Tiffany's *English King*, 7-1/2"; Gorham's *Versailles*, 7-3/8", and *Imperial Chrysanthemum*, 7-3/8"; and Durgin's *Dauphin,* 7". The value of these all-silver examples would vary from $75 up, depending upon rarity and demand.

Fruit Knives

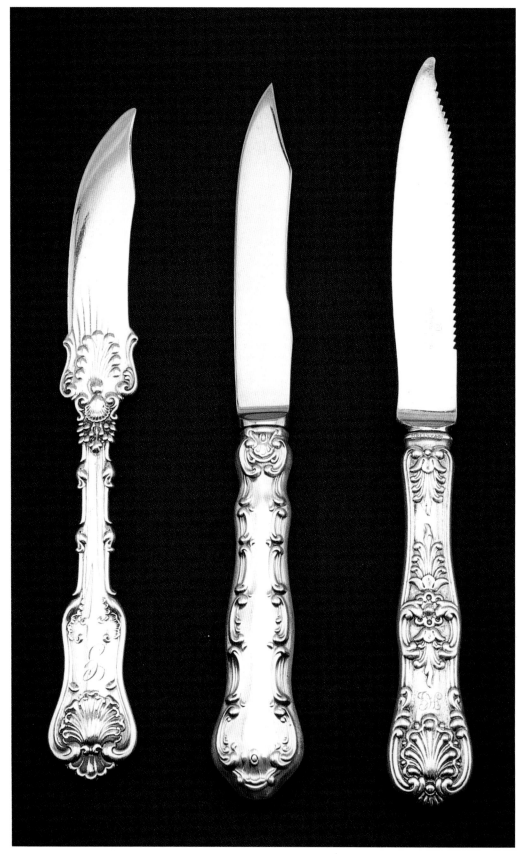

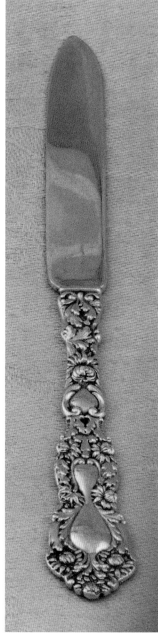

Figure 3.045. A single fruit knife in Gorham's *Imperial Chrysanthemum*. This knife is gold washed and is 6-3/8". The value would be approximately $75.

Figure 3.044. Three different fruit knives. The first, Whiting's *Imperial Queen*, is 6-3/8" and is all-silver. The next is Gorham's *Strasbourg*, 6-13/16", with a hollow sterling handle. Last is Tiffany's *English King*, 7". The value of these knives would run from $59 for the *Strasbourg* example, to $75 and up for the other examples.

Orange Knives

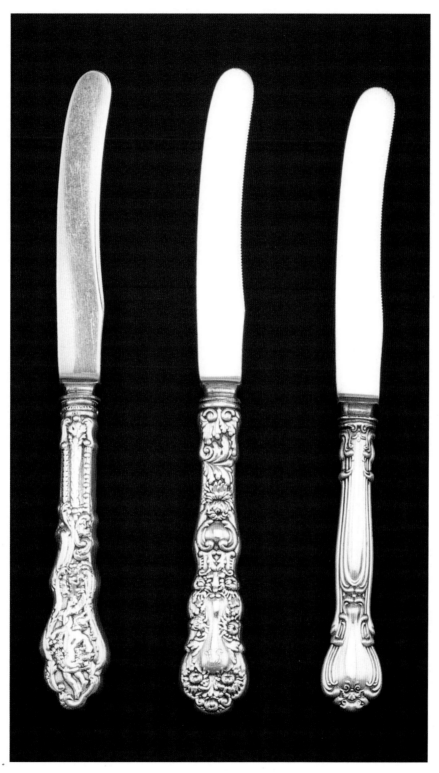

Figure 3.046. Three examples of orange knives by Gorham. All of the examples are 7-3/8" and have a partially serrated blade. The examples are *Versailles, Imperial Chrysanthemum*, and *Chantilly*. These individual items would be worth $65 and up, depending upon condition.

Butter Spreaders, Hollow–Handled

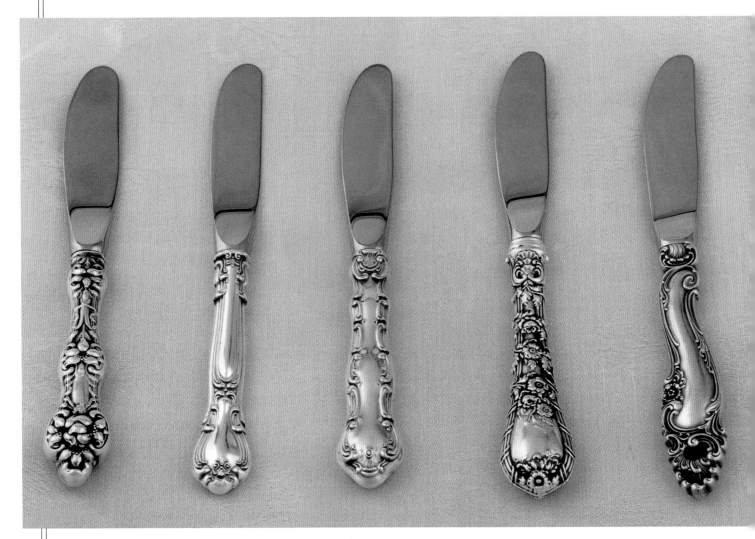

Figure 3.047. Five different patterns of hollow-handled butter knives. They are, from left to right: Alvin's *Old Orange Blossom*, 6-1/8"; Gorham's *Chantilly*, 6-1/4", and *Strasbourg*, 6-3/16"; Durgin's *Dauphin*, 6-1/2"; and Gorham's *Décor*, 6-5/16". The values of these spreaders would range from $45 up to about $65 for the *Dauphin* example.

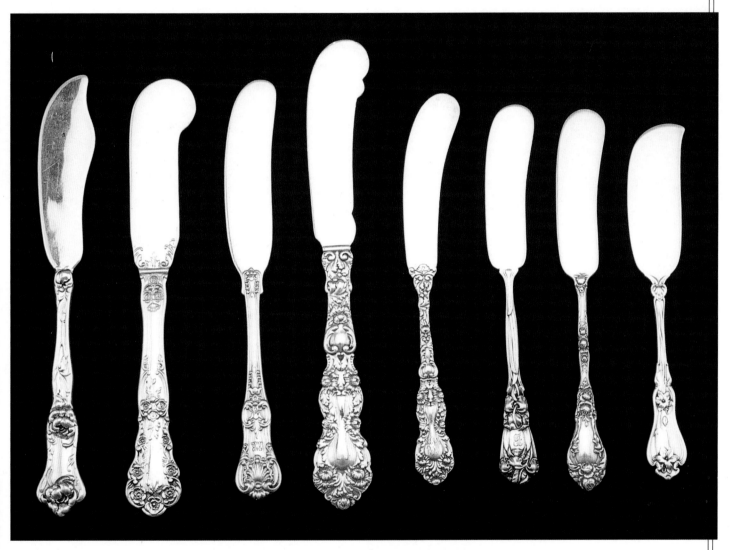

Figure 3.048. A variety of all-silver butter knives in three sizes. From the left we find Wallace's *Peony,* 6-1/16";
Gorham's *Buttercup,* 6"; and Tiffany's *King,* 5-3/4". Next are two samples in Gorham's *Imperial Chrysanthe-
mum.* The first, sample is 6-7/16", and the second sample 5-1/4". The large butter spreader is more in propor-
tion to the dinner size service. Next are two Durgin patterns, *Iris,* 5-1/4", followed by *Marechal Niel,* 5-1/4". The
last sample is Whiting's *Violet,* 4-7/8". The value of these spreaders would vary from $45 to about 65.

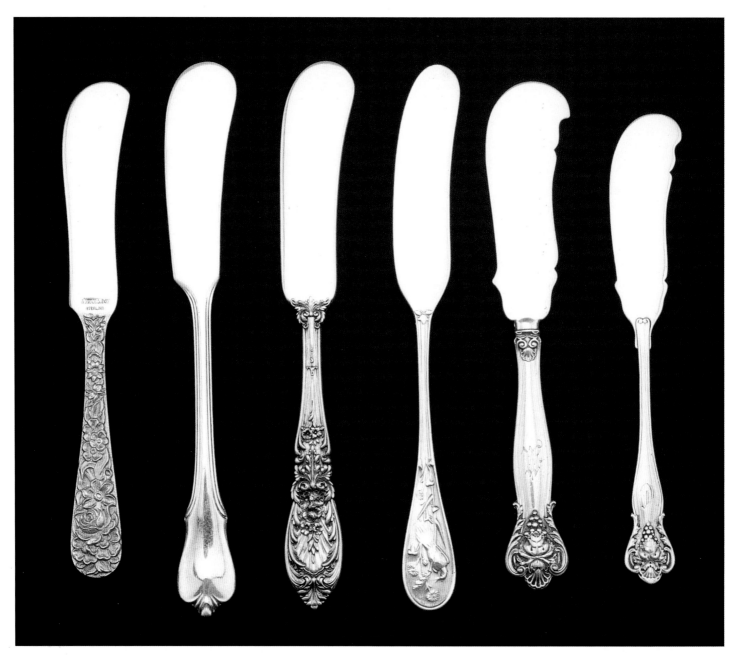

Figure 3.049. Additional flat, all-silver butter spreaders. The first example is in Kirk's *Repoussé*, 5-3/8"; followed by Wallace's *Grand Colonial*, 6-1/16"; International's *Richeleau*, 6"; and Tiffany's *Audubon*, 6". The last two examples are in Durgin's *New Vintage*. Their placement together allows the reader to compare sizes of the spreaders. The large one is 5-1/2" and the smaller is 5-1/8". The values of these spreaders would vary from a low of $40 to approximately $75 and up for the Tiffany examples.

Caviar Spade

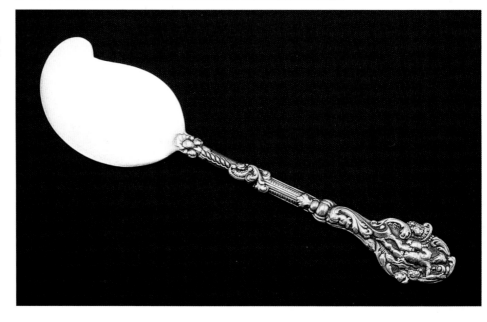

Figure 3.050. A lone example of a caviar spade in Gorham's *Versailles*. This is a very rare example, and would command a price of $150 and up per piece.

Spoons

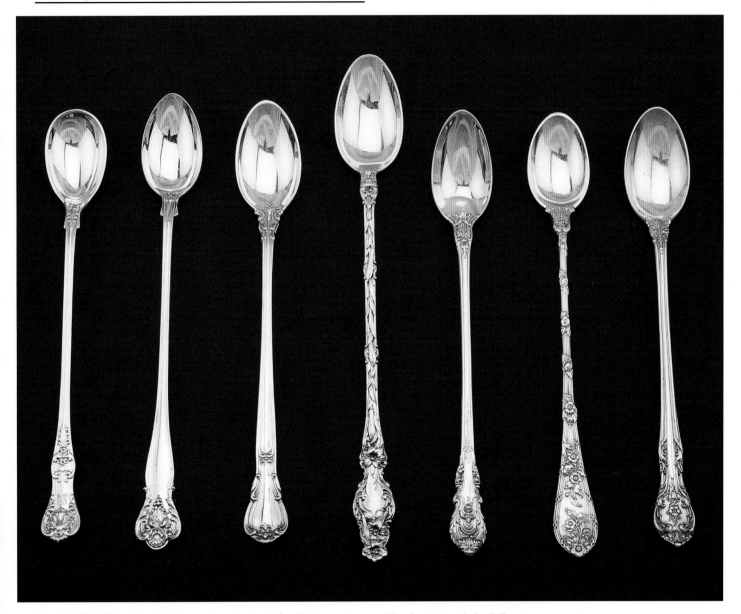

Figure 3.051. The range of shapes that can be found in ice teaspoons. The first example by Tiffany is representative of the shape they used for ice teaspoons. This example, in *English King,* is 7-3/8". The next spoon, in Durgin's *New Vintage*, is 7-3/4"; followed by Gorham's *Chantilly* at 7-9/16". Whiting's *Lily*, an extra long spoon is 8-3/4". Whiting made their spoons in two sizes, small and large. This is an example of the large size. Wallace's *Sir Christopher* is next at 7-1/2"; followed by Durgin's *Dauphin,* at 7-5/8"; followed by Gorham's *King Edward*, at 7-1/2". The value of these spoons would range from around $55 for the basic spoons, to $100 or more for the Tiffany and During's *Dauphin*, because of rarity.

Dessert Spoons

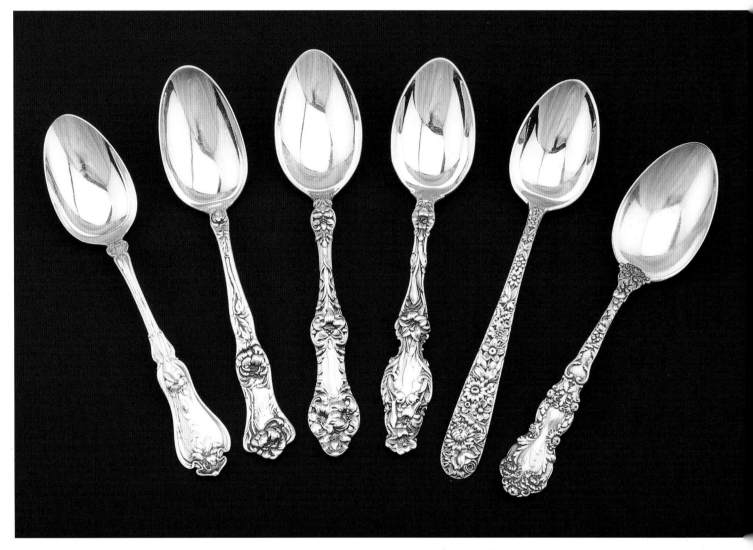

Figure 3.052. Dessert spoons. From the left: Whiting's *Violet*, 6-7/8"; Wallace's *Peony*, 7"; Alvin's *Old Orange Blossom*, 7-1/4"; Whiting's *Lily*, 7"; Kirk's *Repoussé*, 7-1/4"; and Gorham's *Imperial Chrysanthemum*, 6-15/16". The values for these spoons would be from $65 up.

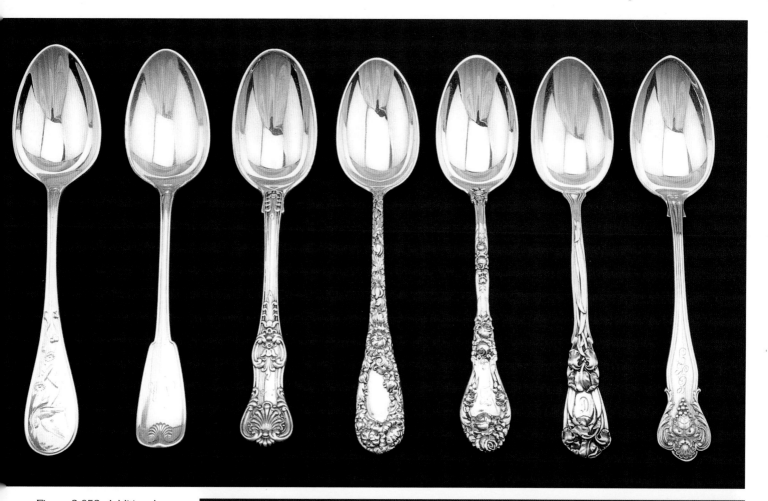

Figure 3.053. Additional dessert spoons. From the left we find: Tiffany's *Audubon*, 7-1/4", *Palm*, 7-1/8", and *English King*, 7-1/8". These are followed by Durgin's *Chrysanthemum*, 7-1/8", *Marechal Niel*, 7-1/16", *Iris*, 7-1/8" and *New Vintage*, 7-3/16". The value of these spoons would be somewhere around $75 for many of the Durgin spoons, and somewhat higher for the Tiffany examples.

Right:
Figure 3.054. Two large formal soups in Tiffany patterns *English King* and *Palm*. These are also the same size as a tablespoon and are used on a very formal table for soup. They would be valued at approximately $125 and up.

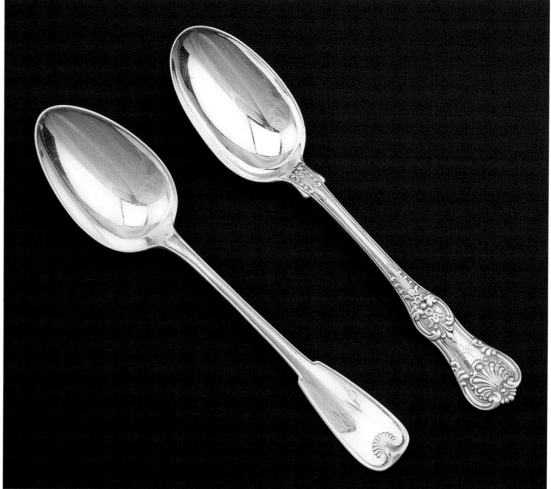

Place Spoons

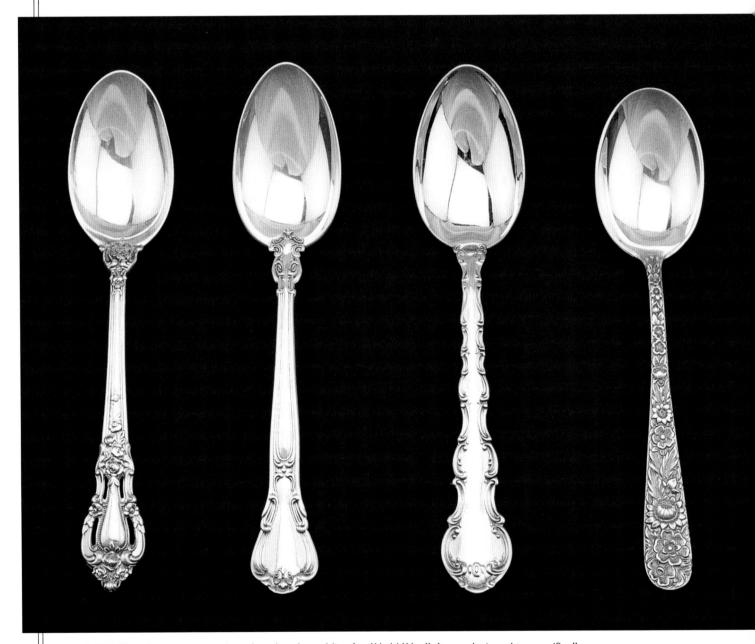

Figure 3.055. The place spoon was introduced to the public after World War II. It was designed to specifically take the place of a gumbo and /or cream soup, and a dessert spoon. This was an attempt by the silver manufacturers to cut down on the number of items in a pattern. The four examples are: Lunt's *Eloquence*, 6-5/8";
Gorham's *Chantilly* 6-3/4", and *Strasbourg* at 6-5/8"; and Kirk's *Repoussé, 6-3/8".* The value of these spoons would be from $60.

Gumbo/Chowder Spoons

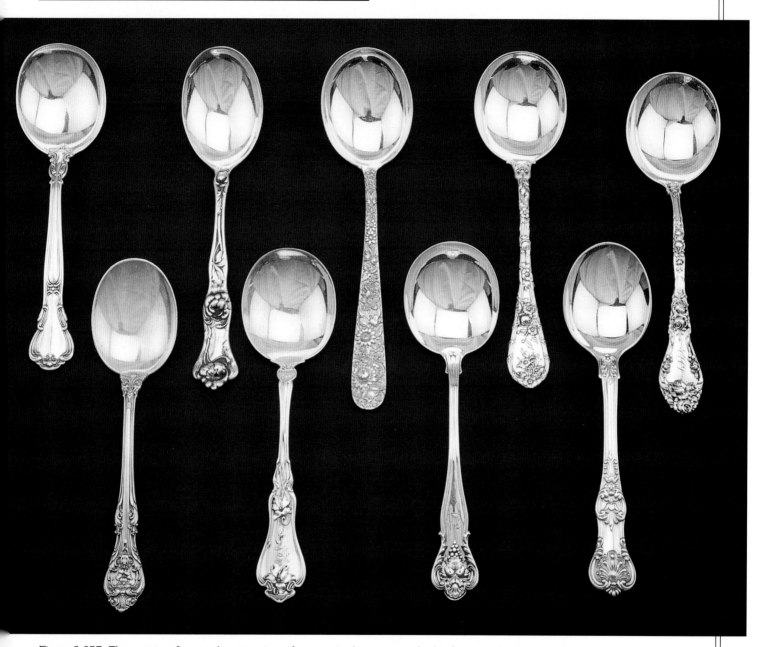

Figure 3.057. The next two figures show a variety of spoons in this category. In this figure on the top row are: Gorham's *Chantilly*, 6-11/16"; Wallace's *Peony*, 6-15/16" [note the unusual shape of the bowl which is repeated in some of the other spoon bowls]; Kirk's *Repoussé*, 7-1/4"; and Durgin's *Dauphin*, 6-7/8", and *Marechal Niel*, 6-15/16". The bottom row features: Gorham's *King Edward*, 6-3/4"; Whiting's *Violet*, 6-3/4"; Durgin's *New Vintage*, 6-3/4"; and Tiffany's *English King*, 7-7/8". The value of these spoons would range from about $75 and up for the Tiffany examples.

Figure 3.058. This figure shows four spoons, two are Gorham products in the same pattern, and the other two are by Tiffany in two different patterns. The Tiffany spoons are on the left, with *Palm,* 8", followed by *English King,* 7-7/8". The two examples by Gorham in their pattern, *Versailles,* are quite different. The longer one is 7" and the shorter one is 6-5/8". There are different scenes and of course the difference in length perhaps indicating an abrupt change during the "life" of the pattern when it was active. Another explanation could be that one was ordered much later in a Gorham remake promotion, and a spoon bowl was tied to a different handle in the manufacturing process. The value of the Tiffany spoons would be approximately $125, while the Gorham items would range around $85 and up.

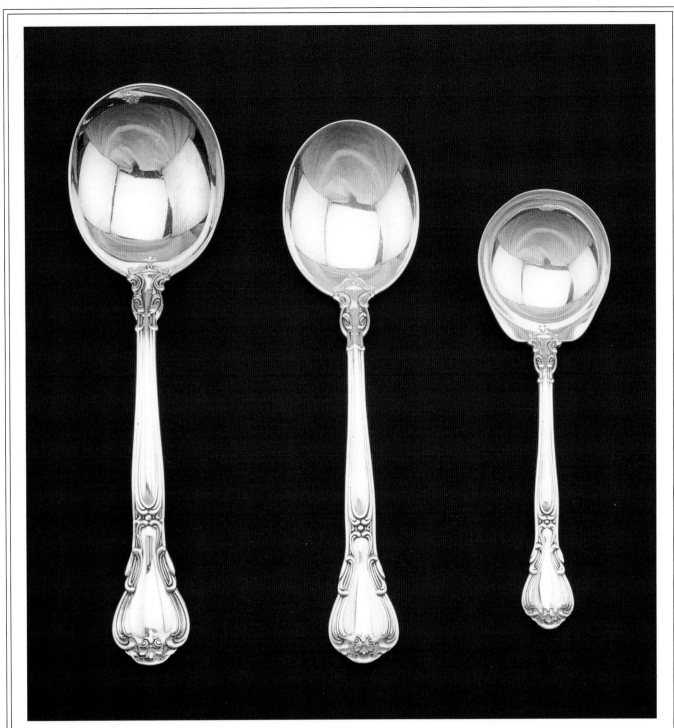

Figure 3.059. Three examples of soup spoons in Gorham's *Chantilly*. The first is a gumbo soup, 6-11/16",; followed by a cream soup spoon, 6-1/4", and a bouillon spoon, 5-1/16". The value of the spoons would range from $65 and up.

Cream Soups

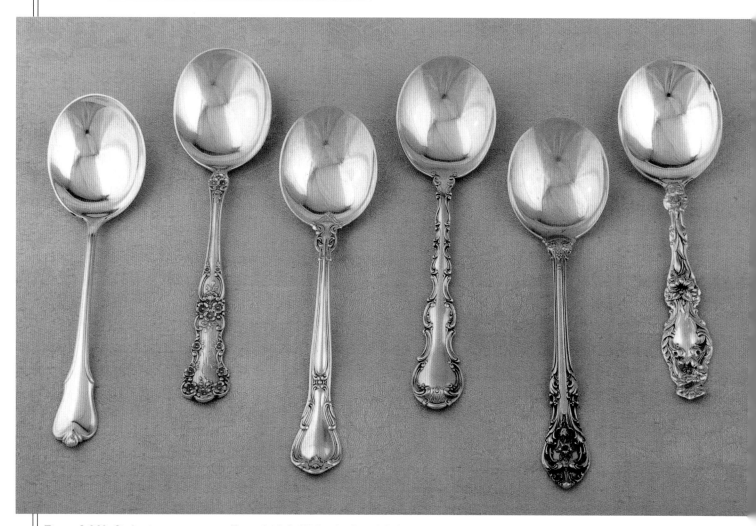

Figure 3.060. Six basic cream soups. From the left: Wallace's *Grand Colonial,* 6-15/16"; Gorham's *Buttercup,* 6-1/4", *Chantilly,* 6-1/4", *Strasbourg,* 6-1/4", and *King Edward,* 6-1/4"; and Whiting's *Lily,* 6-13/16". The values of these spoons, all of which are currently in production, would range from a low of about $55 upward.

Bouillon Spoons

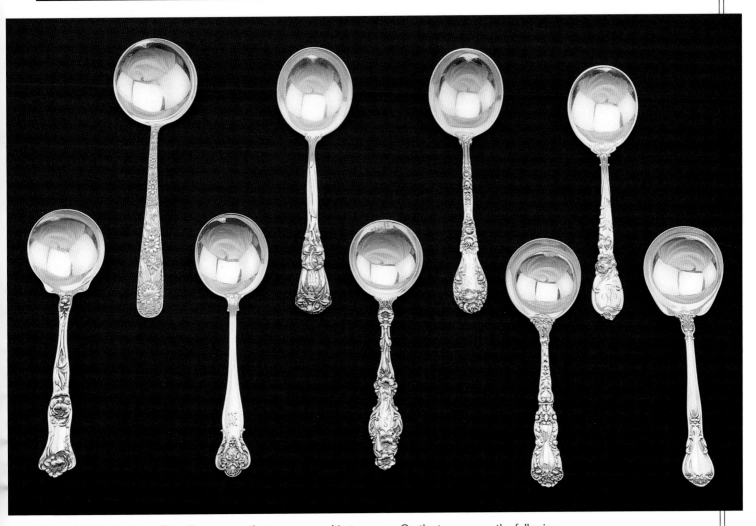

Figure 3.061. A variety of bouillon spoons that are arranged in two rows. On the top row are the following examples: Kirk's *Repoussé*, 5-7/8"; Durgin's *Iris*, 5-9/16", and *Marechal Niel*, 5-9/16"; and Reed and Barton's *La Parisienne*, 5-3/8". The second row consists of examples of: Wallace's *Peony*, 5-5/16"; Durgin's *New Vintage*, 5-1/4"; Whiting's *Lily*, 5-15/16"; and Gorham's *Imperial Chrysanthemum*, 5-13/16", and *Chantilly*, 5-1/16". The value of these spoons would be from $55 and up, depending on rarity, and demand.

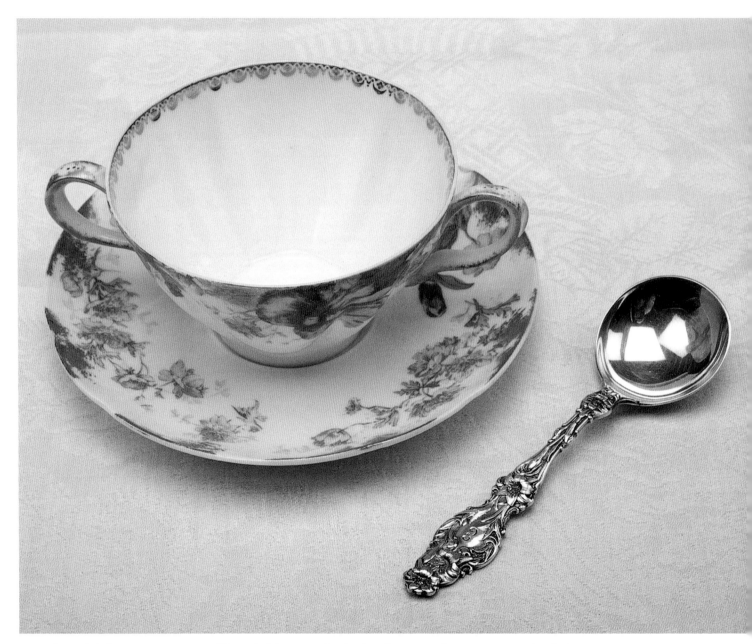

Figure 3.062. A bouillon spoon in Whiting's *Lily* is paired with a bouillon cup and saucer in an unidentified Haviland and Company pattern on a ruffled Ransom blank, which was retailed by Gumps in San Francisco, according to the backstamp on the china.

Sorbet Spoons

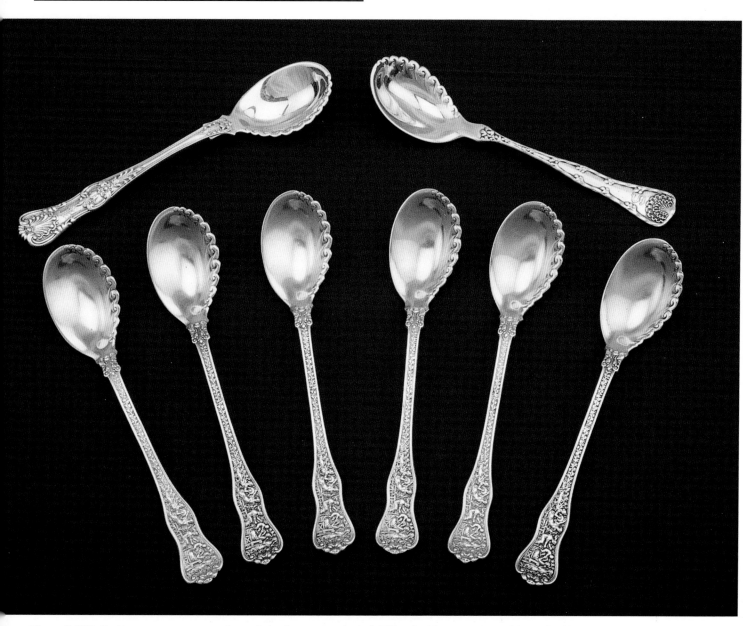

Figure 3.063. Sorbet spoons appear to be an item that was exclusively Tiffany's. The examples in Figure 3.063 feature six spoons in their *Olympian* pattern. On the top right is their *Wave Edge* pattern, and on the top left is an example in *English King*. All examples are 5-3/8". Note the gold wash on the *Olympian* examples and the fluting on the top of the spoon, if held in the right hand. These spoons are valued at approximately $85 each.

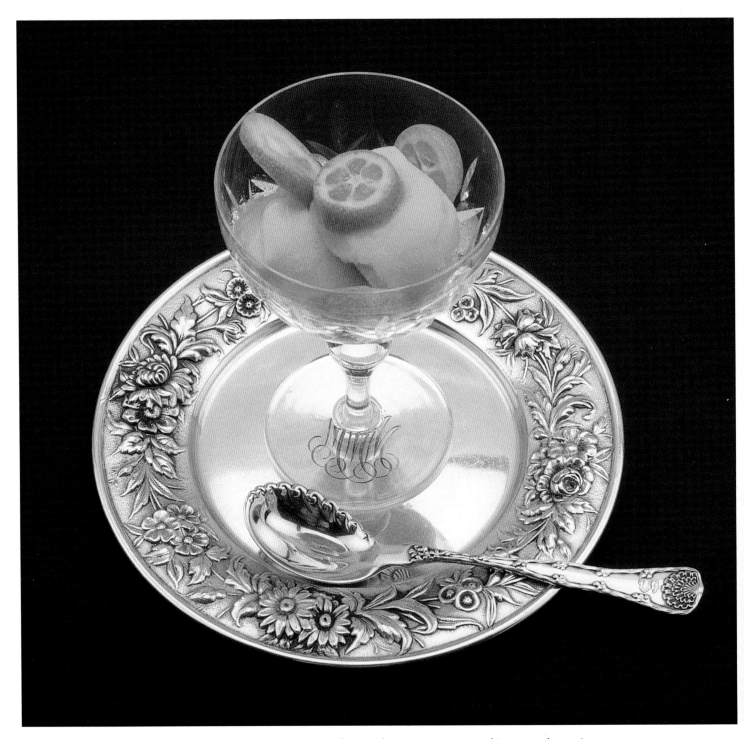

Figure 3.064. Two small scoops of sorbet, complemented with sweet kumquats are pictured in a crystal stem in *Regent* by Stuart, placed upon a sterling bread and butter in Kirk's *Repoussé,* ready to cleanse the palate between courses.

Parfait Spoons

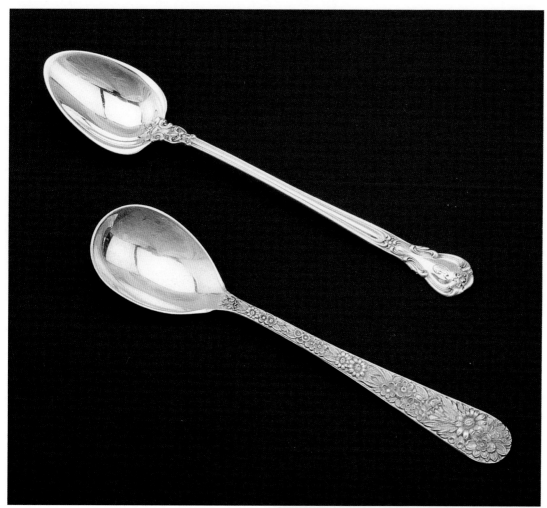

Figure 3.065. Two examples of parfait spoons. The top example, in Gorham's *Chantilly,* is 5-3/4". The lower example is by Kirk in their *Repoussé* pattern and it is 5-3/8" long. The value of these spoons is approximately $85.

Sherbet Spoons

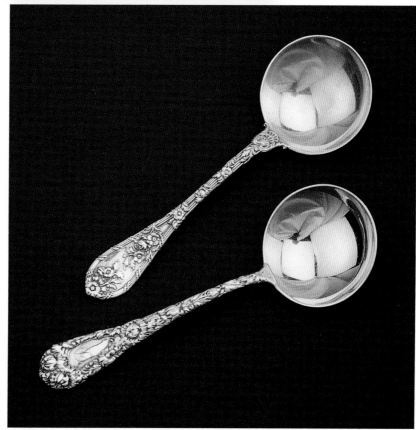

Figure 3.066. Examples of sherbet spoons are not often found. These two examples are both manufactured by Durgin and gold washed. The top example is in *Dauphin* and the bottom example is in *Chrysanthemum.* Both of these are 4-1/4". Whiting was another company that made sherbet spoons. The value of these spoons would be approximately $85.

Ice Cream Spoons, Large

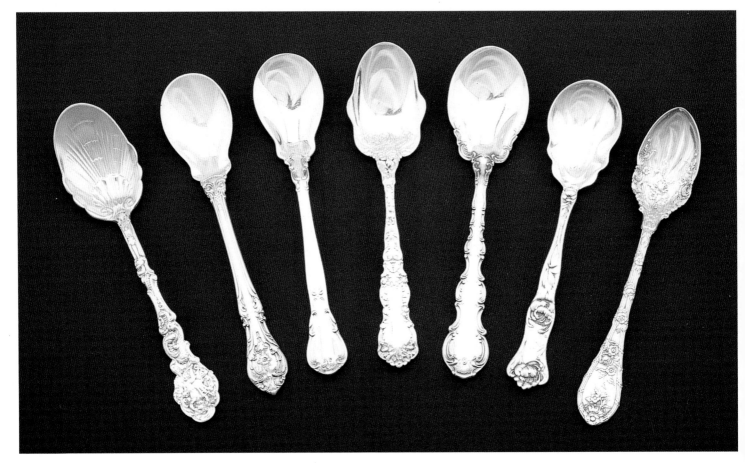

Figure 3.067. Ice cream spoons come in basically two sizes and the larger size is pictured here. The first five examples are by Gorham: *Versailles*, 5-7/8"; *King Edward*, 5-13/16"; *Chantilly*, 5-3/4"; *Imperial Chrysanthemum*, 5-5/8"; and *Strasbourg*, 5-13/16". These are followed by Wallace's *Peony*, 5-1/2"; and Durgin's *Dauphin*, 5-3/4". The value of these spoons would range from $65 to approximately $125 or more for the *Dauphin* examples.

Ice Cream Spoons, Small

Opposite page:
Figure 3.068. Two examples of small ice cream spoons. On the left is Whiting's *Lily*, 5-3/16". The other example is Gorham's *Strasbourg*, 5-1/4". The value of these spoons would be approximately $65-80 each.

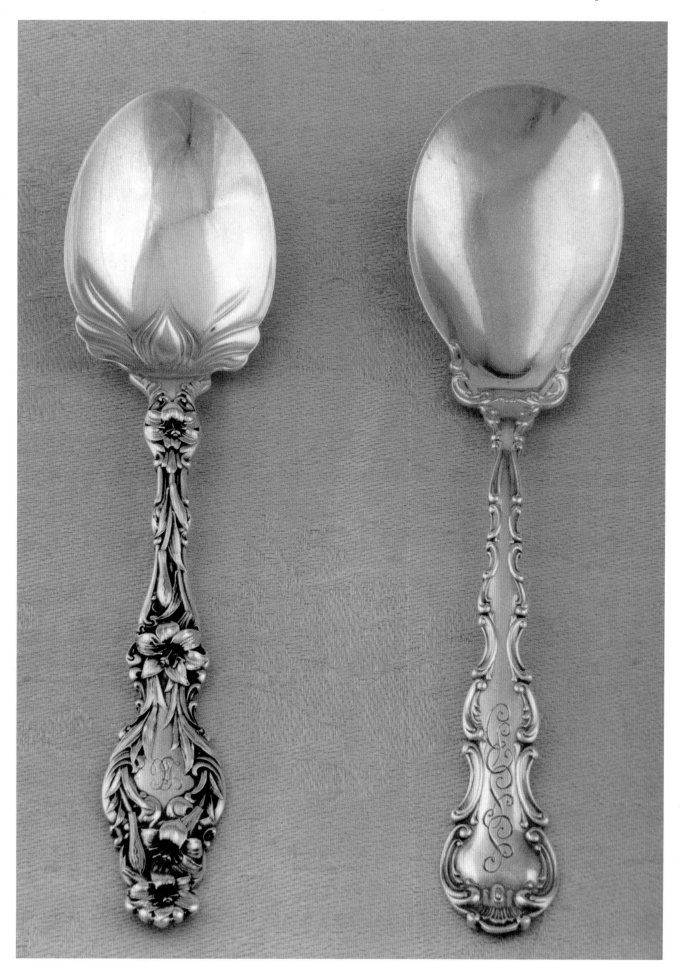

Demitasse Spoons

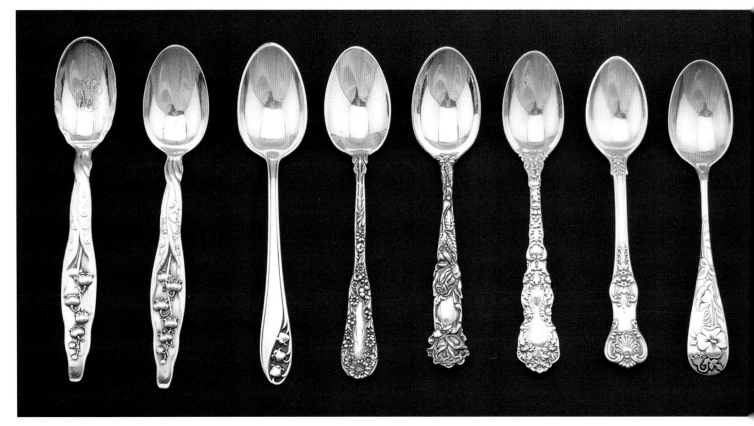

Figure 3.069. Eight demitasse spoons. The first two examples are in Whiting's *Lily of the Valley*. Both of these examples are 4-5/16", but the first example has a ruffled bowl. These are followed by Gorham's *Lily of the Valley*,-5/16"; Dominic and Haff's, *Number Ten*, 5-1/4"; Alvin's *Bridal Rose*, 4"; Gorham's *Imperial Chrysanthemum*, 4-1/8"; Tiffany's *English King*, 4"; and an unknown pattern, only marked "Sterling," 4". The value of these small spoons ranges from $20 up to $45 for especially difficult to locate patterns. They make interesting collectibles.

Egg Spoons

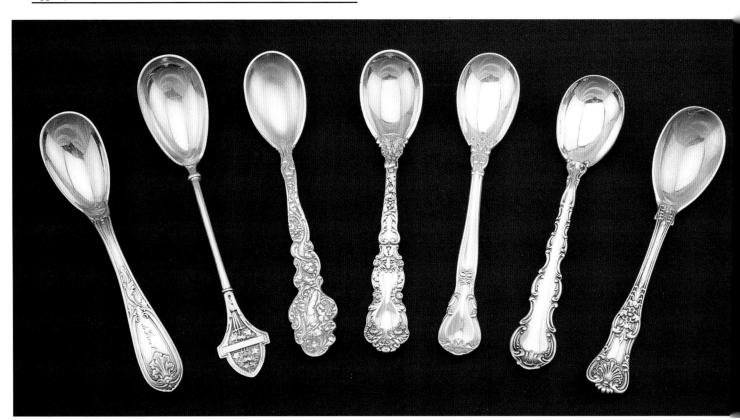

Opposite page, bottom:
Figure 3.070. Egg spoons, when paired with china egg cups were extremely popular in Victorian times. The examples in Figure 3.070 begin with an unknown Wood and Hughes pattern, 4-1/2", followed by Gorham's *Ivy*, 5"; *Versailles*, 4-3/4"; *Imperial Chrysanthemum*, 4-5/8"; *Chantilly*, 4-3/4"; *Strasbourg*, 4-11/16"; and Tiffany's *English King*, at 4-1/2". The value of these spoons ranges from approximately $50 upwards.

Orange Spoons

Figure 3.071. Two examples of orange spoons. Both were manufactured by Gorham. The spoon at the top is *Strasbourg*, 5-7/8", and the lower spoon is in *Chantilly*, also 5-7/8". The 1914 Chantilly catalog shows that Gorham made a distinction between orange spoons and grapefruit/melon spoons. The value of these spoons would be approximately $65 each.

Toddy/Muddler Spoon

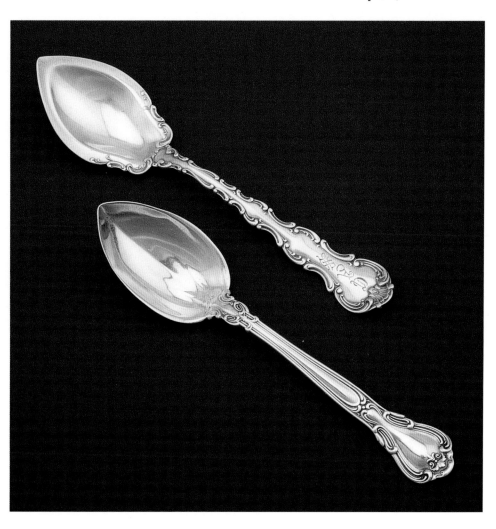

Figure 3.072. This lone example of a toddy/muddler spoon in Kirk's *Wadefield* is rare. Supposedly Tiffany also made these spoons, but examples have not been located, according to William P. Hood, Jr., in *Tiffany Silver Flatware*. This example is 6" long and is valued at about $165.

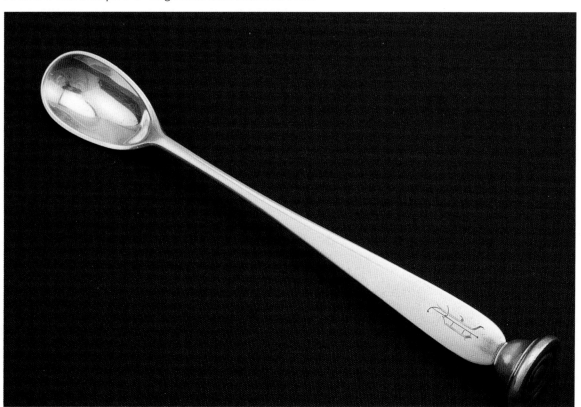

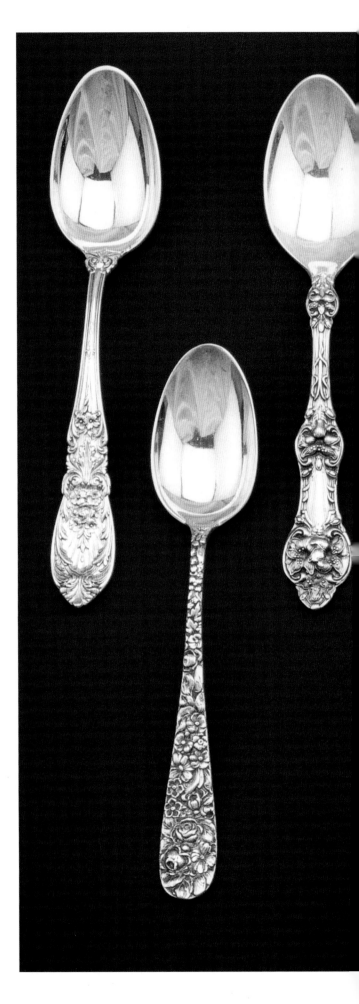

Teaspoons

Figure 3.073. Perhaps the first sterling item many people purchase is the teaspoon. Here is a variety of teaspoons, in two rows. The top row, from left to right, includes: International's *Richleau*, 6"; Alvin's *Old Orange Blossom*, 5-7/8"; and Tiffany's *English King*, 5-7/8", *Palm* 6", and *Audubon*. 6-1/4". The bottom row includes: Stieff's *Rose*, 5-15/16"; Wallace's *Sir Christopher*, 5-15/16", and *Peony,* 5-7/8"; and Durgin's *Iris*, 5-13/16". The value of teaspoons varies from a low of about $30 upwards for examples in exclusive patterns.

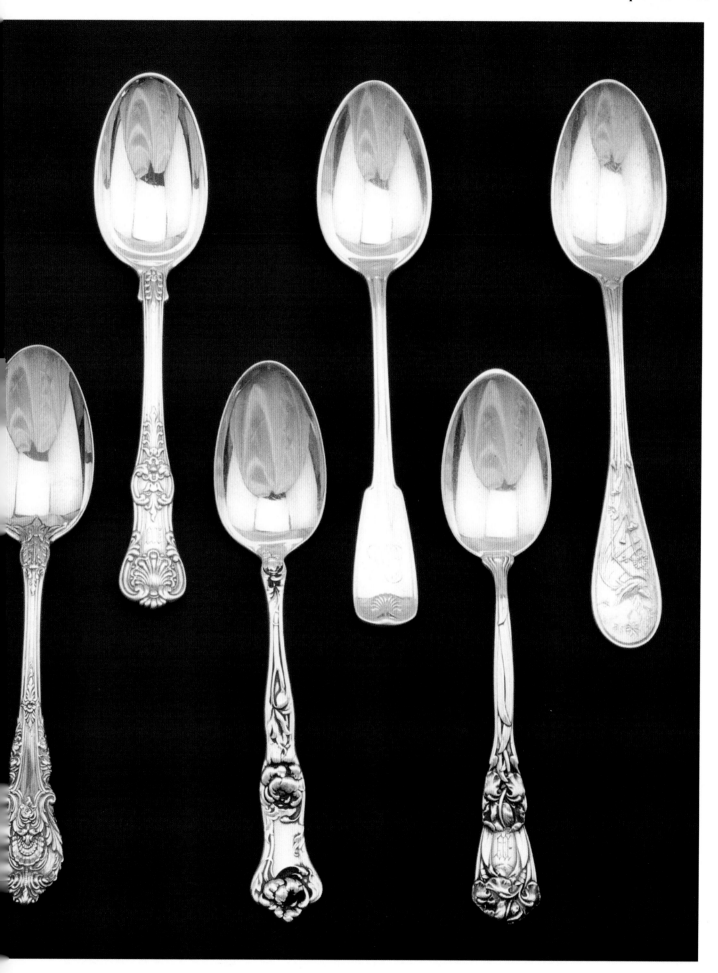

Grapefruit/Melon Spoons

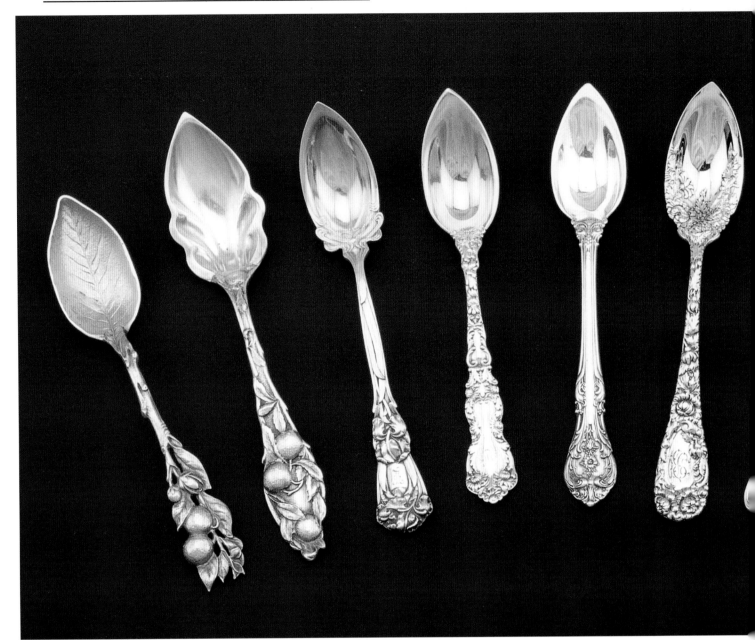

Figure 3.074. Grapefruit spoons. The first example is a Gorham product, and it is gilded. The pattern name is unknown, and the spoon is 5-3/4". The next item is an unknown pattern by Watson, 6-1/4". The third example is by Durgin in their *Iris*, at 5-3/4". This is followed by Gorham's *Imperial Chrysanthemum*, 5-9/16", and *King Edward*, 5-13/16"; Durgin's *Chrysanthemum*, 5-11/16"; Gorham's *Chantilly*, 5-11/16"; Alvin's *Old Orange Blossom*, 5-13/16"; Stieff's *Orchid*; 6"; and Gorham's *Versailles*, 5-3/4". The value of these spoons would be from $75 up.

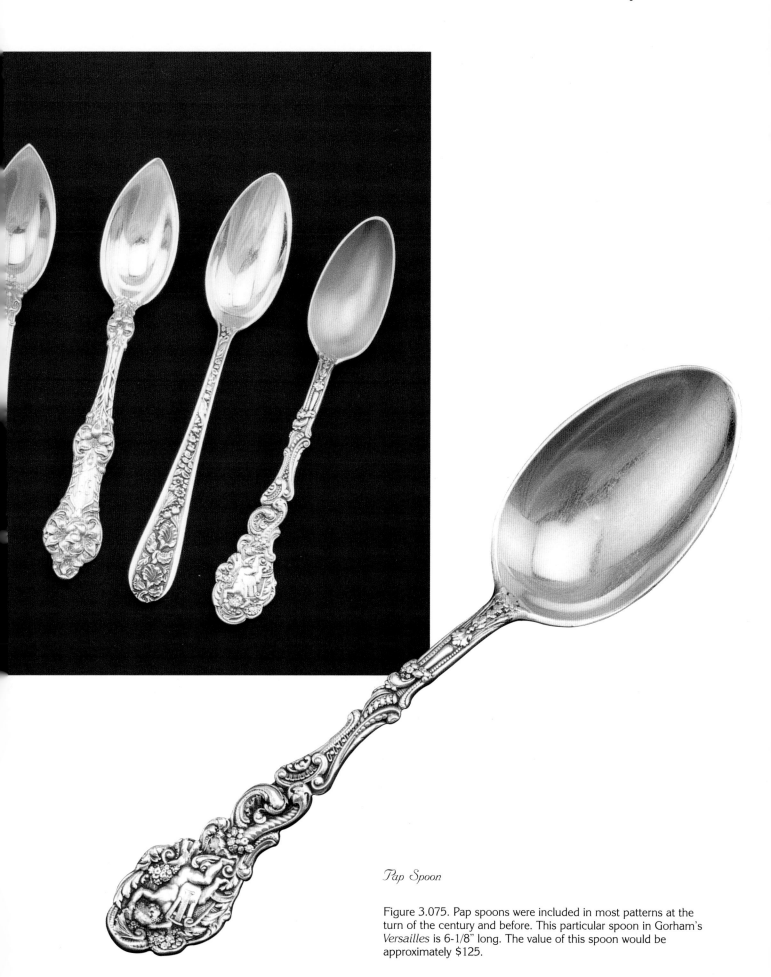

Pap Spoon

Figure 3.075. Pap spoons were included in most patterns at the turn of the century and before. This particular spoon in Gorham's *Versailles* is 6-1/8" long. The value of this spoon would be approximately $125.

Chocolate Spoons

Figure 3.076. Two long-handled chocolate spoons. The first, Durgin's *New Vintage,* is 5-1/2", and the second, in Gorham's *Strasbourg,* is 5-7/16". Frequently these spoons are sold as jam spoons by the factory. The value of these spoons would be approximately $65.

Figure 3.077. Three examples of short chocolate spoons. The first, in Gorham's *Chantilly* is 4-9/16", followed by Wallace's *Peony,* 4-1/8", and *Rose,* at 4". Note that the bowl of the *Peony* example mimics the shape of the gumbo soup in this same pattern. The designers continued the motif throughout the pattern. The value of these spoons would be about $45 for the Wallace examples, and about $55 and up for the *Chantilly* examples.

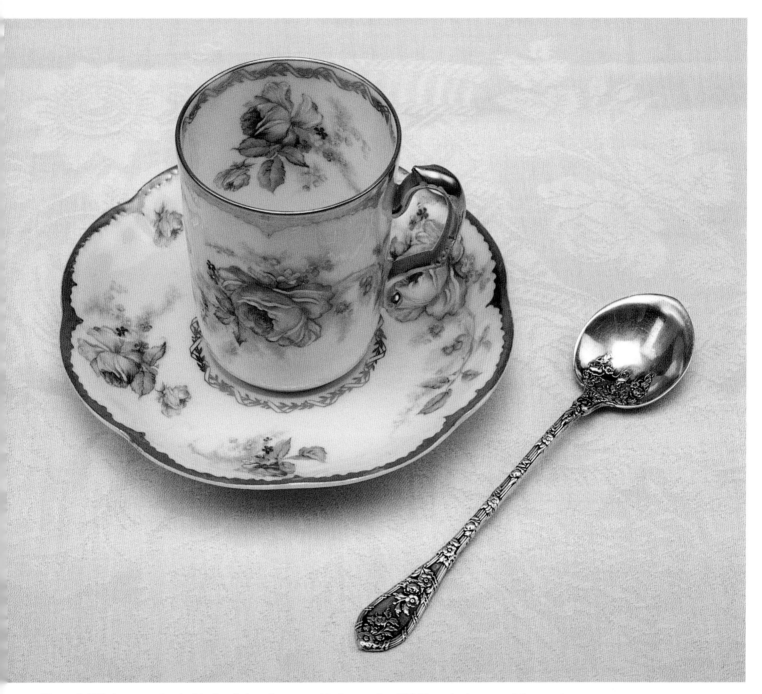

Figure 3.078. An example of a Haviland chocolate cup with the number 22241 on the bottom of the cup, is shown here. The number on the cup designates the factory information to those interested about the pattern. The cup is accompanied by a long-handled spoon in Durgin's *Dauphin*, 5-7/16". The roses on both patterns compliment each other. The value of this spoon would be about $125 and up.

Five O'clock

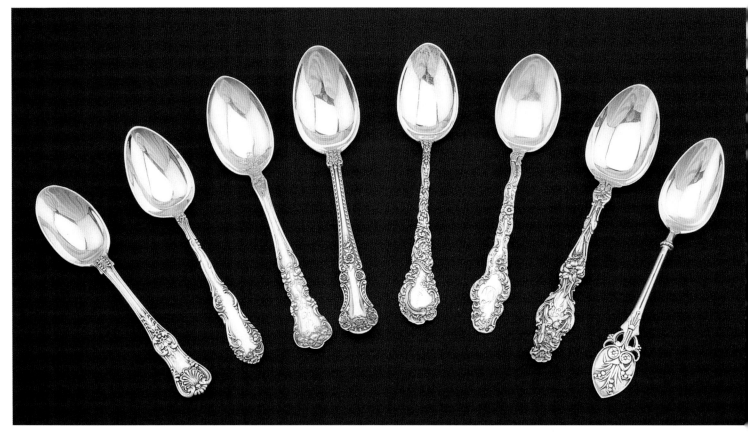

Figure 3.079. Eight examples of five o'clock spoons, named for their use with afternoon tea or coffee. This was a chance for the housewife to rest before the rigors of a formal dinner began. The first example may be a four o'clock spoon in Tiffany's *English King*, 4-5/8". The second, Towle's *Old English*, is 4-13/16". These are followed by International's *Pansy*, 5-5/16"; Gorham's *Cambridge*, 5-3/8"; Wallace's *Louvre*, 5-1/4"; Durgin's *Watteau*, 5-1/4"; Whiting's *Lily*, 5-3/8"; and, last, an old Gorham pattern (c. 1870) called *Lily*, 5-1/8". The values of these spoons would be approximately $30 to $45.

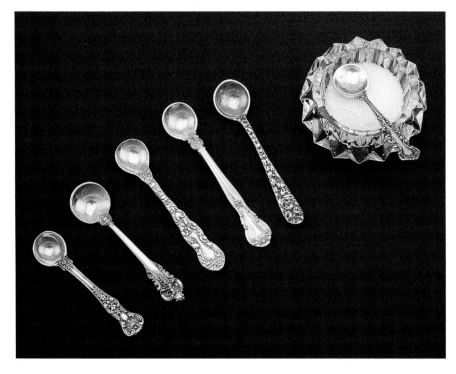

Salt Spoons Individual

Figure 3.080. Salt spoons for each individual place setting were very common. In this collection the first is Tiffany's *English King*, 2-1/4", followed by: Wallace's *Grand Baroque*, 2-1/2"; Gorham's *Imperial Chrysanthemum*, 2-5/8", and *Chantilly*, 2-5/8"; Schofield's *Baltimore Rose*, 2-5/8"; and an unknown pattern in the cut glass salt cellar. The value of these spoons runs from a low of $15 up to around $30.

Children's Silver

Baby Sets, Two Piece

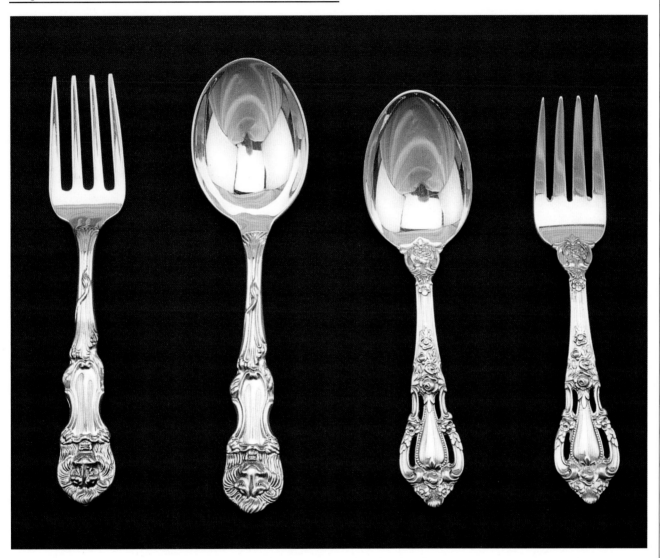

Figure 3.081. Two examples of baby sets. The first is Wallace's *Lion,* with a fork, 4-9/16", and the spoon, 4-3/4". The second example is in Lunt's *Eloquence.* The fork and spoon in this set have the same 4-1/4" measurements. The value of these sets is approximately $65 to $80 apiece.

Infant Feeding Spoons

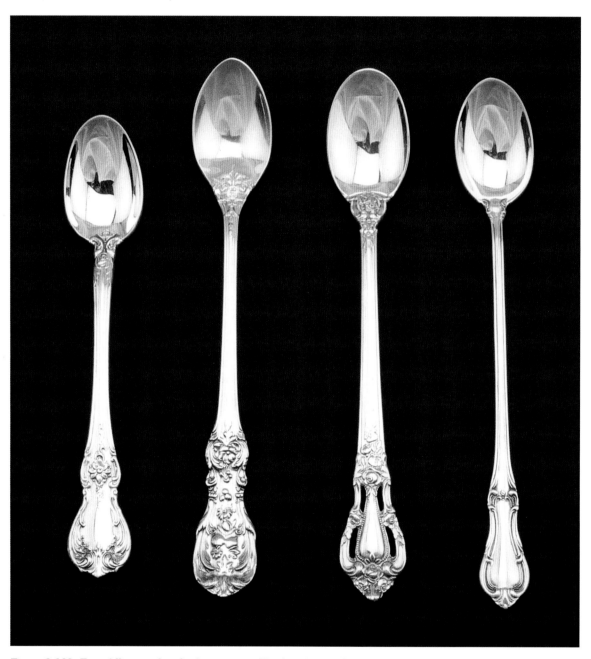

Figure 3.082. Four different infant feeding spoons. The first, Lunt's *Old Master*, is 4-13/16". The second is by Reed and Barton in their *Francis I* and it is 5-5/8". The third example is by Lunt in their *Eloquence* patterns at 5-9/16". The last example, by International is in their *Joan of Arc* pattern. It is 5-1/2". The value of these spoons is from $35 to $50. When infant feeding time ends, these items make excellent spoons to use for relish trays and for olive spoons.

Food Pushers

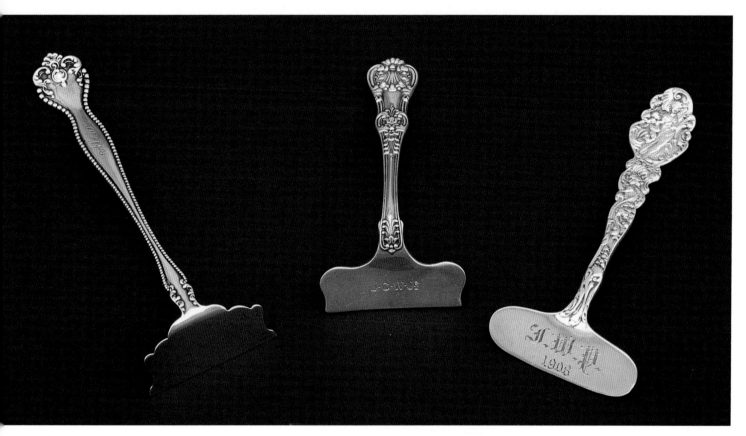

Figure 3.083. Food pushers are highly collectable. They were developed to help children get food onto their forks by pushing the food to the fork. These three examples are: Alvin's *Raleigh*, 4-5/8"; Tiffany's *English King*, 3-3/8"; and Gorham's *Versailles*, 4". The value of these implements would range from $65 for the *Raleigh* example to $125 and up for the other two samples.

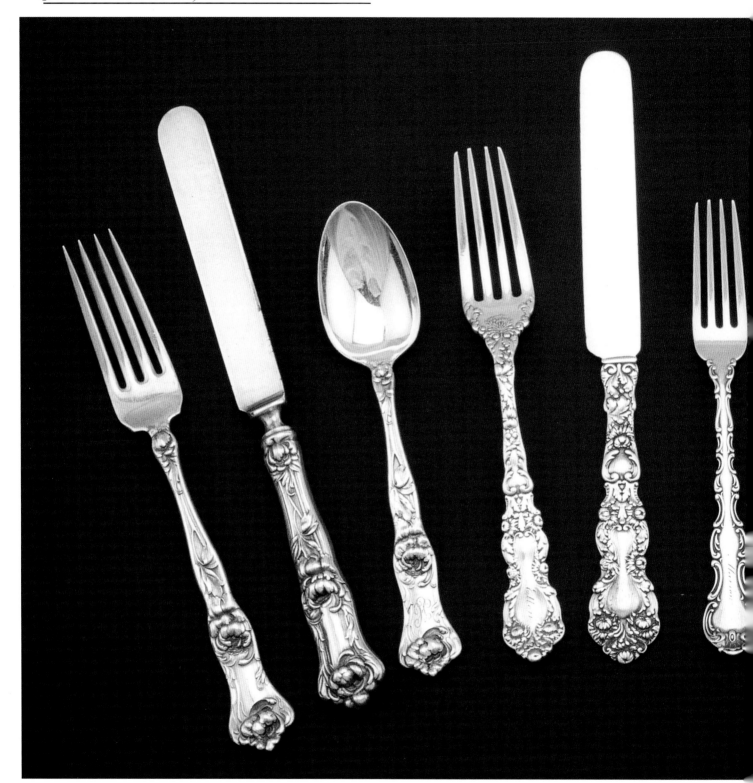

Figure 3.084. Samples of youth sets, tea sets, or breakfast sets. The first three piece set is in Wallace's *Peony*. The fork is 6-1/8", the knife is 7-5/8", and the spoon is 5-1/2". The next set is a partial set in Gorham's *Imperial Chrysanthemum*. The fork is 5-5/16" and the solid silver knife is 7-3/8". The third set, in Gorham's *Strasbourg*, is definitely a child/youth set because of the diminutive size. This set is half way between the regular 3 piece sets and the baby sets. The sale for this size may have been so small that Gorham discontinued manufacturing it. The fork is 5-1/4" and the knife is 6-3/4". The last example, in Durgin's *Dauphin* is rare. The fork is 6-1/8", the knife is 7" and the spoon is 5-3/4". The value of the three piece set in *Peony* would be approximately $125, and the *Dauphin* example would be much higher. The *Imperial Chrysanthemum* set, while missing the spoon would command a price of about $110. The last example, in *Strasbourg* would be valued at about $85.

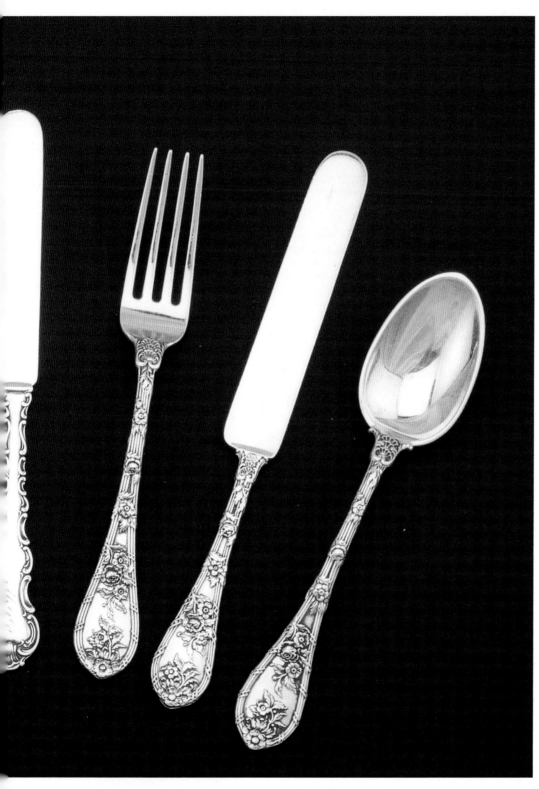

Youth Spoon

Below:
Figure 3.085. This lone example of a most unusual youth spoon is in Durgin's *Watteau*. The spoon is 7-7/8" and has an unusual engraving in the bowl of the spoon. The value of this spoon would be approximately $75.

Unusual Place Pieces

Individual Asparagus Tongs

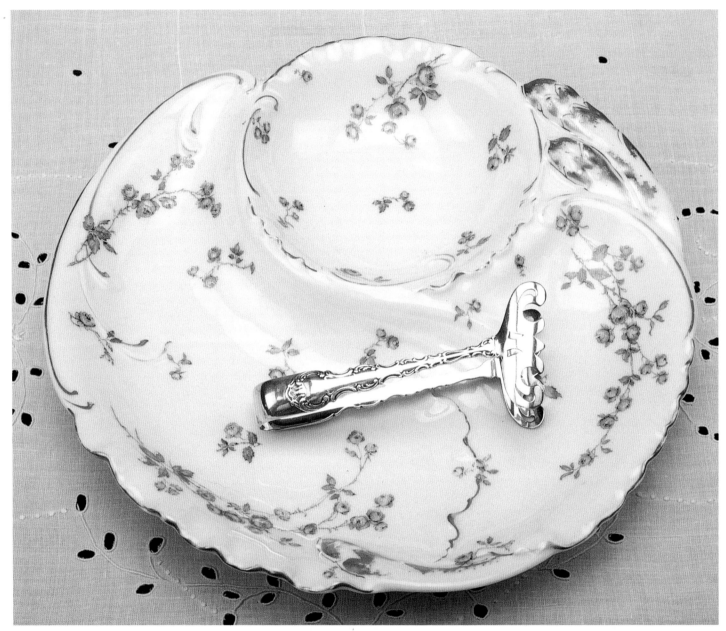

Figure 3.086. Individual asparagus tongs in Gorham's *Strasbourg* are paired with an individual Haviland asparagus plate in the "Dresden" pattern, # 679D. The tongs are 4" in length. The value of the tongs is approximately $145 each.

Individual Ice Tongs

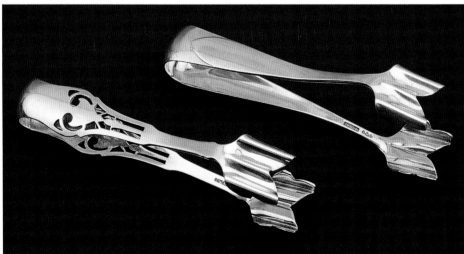

Figure 3.087. Two samples of individual ice tongs are found in Figure 3.087. Both of the tongs were manufactured by Watson, and both are 4-3/4". The two patterns are *Putnam* on the left and *Old Colony* on the right. The value of these tongs would be approximately $175 each.

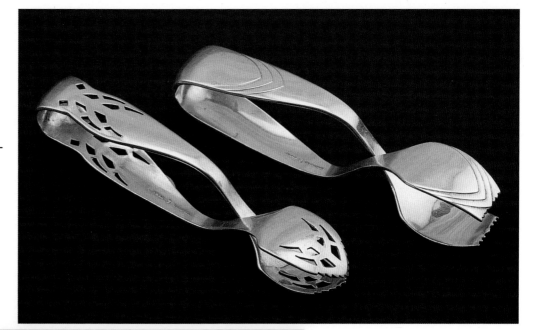

Figure 3.088. Both escargot tongs were manufactured by International. They are unknown patterns. The pierced example is 4-7/8" and the second is 4-3/4". The value of these tongs would be approximately $175.

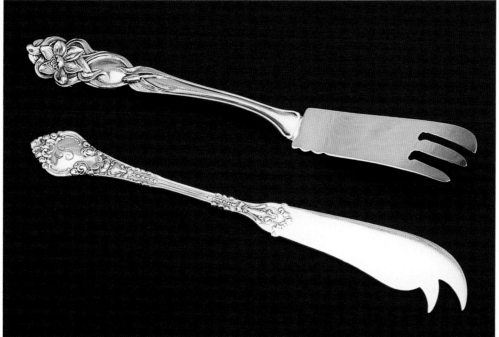

Individual Cheese Knives/ Picks

Figure 3.089. Two examples of individual cheese knives/picks are found in this picture. The top example is by Fessendon in their pattern, *Narcissus*. It is 5-1/2". The second example, on the bottom is an unknown pattern and is 5-3/8". The value of these items would be approximately $65.

Butter Pat Lifter

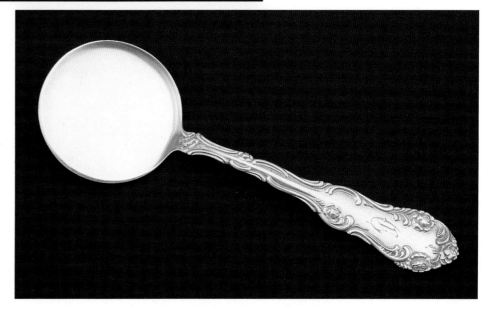

Figure 3.090. This lone example by Towle in their *Old English* pattern, is a butter pat lifter. This is a most unusual item and unique. The value of this item would be approximately $125 and up.

Individual Place Settings

Using beautiful china, silver, glass, and linen in delightful settings makes entertaining a wonderful experience for the collector. This is what the author has attempted to show in this section by pulling some of the silver items for each individual place setting, and teaming these with china, linen, and crystal to present a total picture. All of the photographs were taken in the author's dining room where he has attempted to "marry" the china and silver—at least with some of the floral designed sterling flatware.

Entertaining is something that one either totally embraces or abhors. It takes planning to pull off a meal—formal or informal. Most of the meals in the dining room are more formal, while the breakfast room tends to use similar items, but the informality is distinct.

When planning a dinner party, the author usually makes a guest list, and then sets the table . Setting the table first may be in direct conflict with "rules," but it does work for him. Next comes the menu, and a trip to the grocery story and to the farmer's market. After seeing what is in season, the menu is refined, and the table is inspected for changes necessary for the menu to be served. This also is a time to use those unusual place pieces—china or silver and to work these into the menu. Years ago an article entitled, "Confessions of a Dish Collector," had far reaching implications for the author. Little did he realize that someday he too would be faced with storage difficulties because of his collections, which continue to grow and expand.

The author keeps a book in which the table setting, photos of the settings, menu, and guest list are kept. This way a record is kept, and the next invitation will hopefully feature good food, different accoutrements, and yet another stellar food presentation.

In this section, various settings will feature various patterns of flatware. A picture of each place setting will be shown first, and some of the flatware will be pictured in greater detail. The place setting will be shown first and in some instances, no further dialog will be neces-sary, as only basic place settings exist with the collector of this pattern.

Imperial Chrysanthemum by Gorham

This pattern was first introduced to the public in 1894. At the time there were some very successful patterns featuring the chrysanthemum . Tiffany had first introduced a chrysanthemum pattern in 1880, naming it *Indian Chrysanthemum,* which was later changed to *Chrysanthemum.* This pattern was very well accepted, and represented a major change in the design of flatware. While not the first floral pattern, the American public quickly became enamored with the design, and Tiffany supplied the pattern in hollowware as well.

Other manufacturers also made designs incorporating the chrysanthemum. Durgin introduced their pattern, *Chrysanthemum,* in 1893, and a Gorham pattern by the same name, *Chrysanthemum,* arrived c. 1885. It was an engraved pattern, featuring chrysanthemum flowers. In 1894 they introduced their *Imperial Chrysanthemum* pattern, which like the Tiffany pattern and Durgin's pattern, featured the chrysanthemum flower and leaves in stunning relief, displayed with a vast array of implements for the individual place setting and also for pieces for serving the food at the dining table or buffet.. It became an instant success and the pattern today is still popular.

Haviland introduced their Pattern 86 and 86A shortly after the Marseille blank, #9, was introduced, c. 1889, according to Dr. Wallace Tomasini, a noted Haviland expert. The two patterns, one in china and one in silver, complement each other, and add an elegance to the table setting. With the exception of Tiffany's *Chrysanthemum,* most previous flower designs had been stamped or etched into the front of the item but were rarely decorated on the reverse side. By decorated the reverse with the back of a plant Gorham gave the observer a view of both sides of the chrysanthemum.

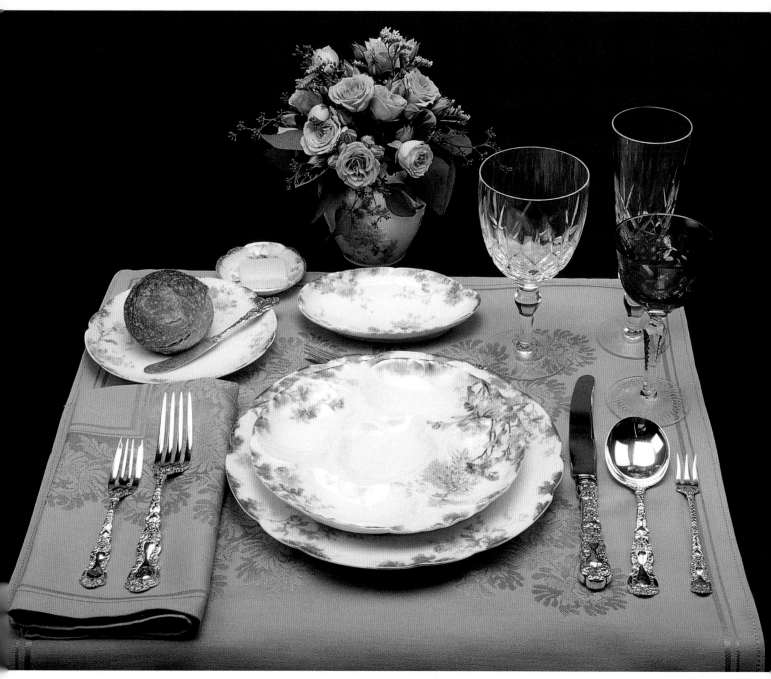

Figure 4.001. The silver consists of the salad fork, the dinner fork, dinner knife, gumbo/chowder spoon, cocktail fork, small butter knife, and a pastry fork atop the dinner table fork, all in Gorham's *Imperial Chrysanthemum*.

The china is Haviland's 86A, which is exactly like the pattern 86, but this one has gold daubs around the edge. The china consists of the following pieces, dinner plate, 9-5/8"; oyster plate, 8-1/4"; bread and butter plate, 6-1/8"; bone dish. 6" and butter pat, 3-1/8". The floral arrangement features the bottom portion of a tea caddy.

The menu would start off with oysters, and the cocktail/oyster fork, the only fork to be placed on the right side of the plate, begins the dinner service. Soup would be served next, in rim soup bowls, salad next, and the entrée would come last. Dessert would consist of pie/pastry and the fork at the top of the plate would be used for this. Some etiquette books call for dessert silver to be brought in with the dessert course. In this case, since there are no servers other than the host, he finds it is easier to place all the silver on the table before beginning dinner and to move through the courses without having to take time to reset the table.

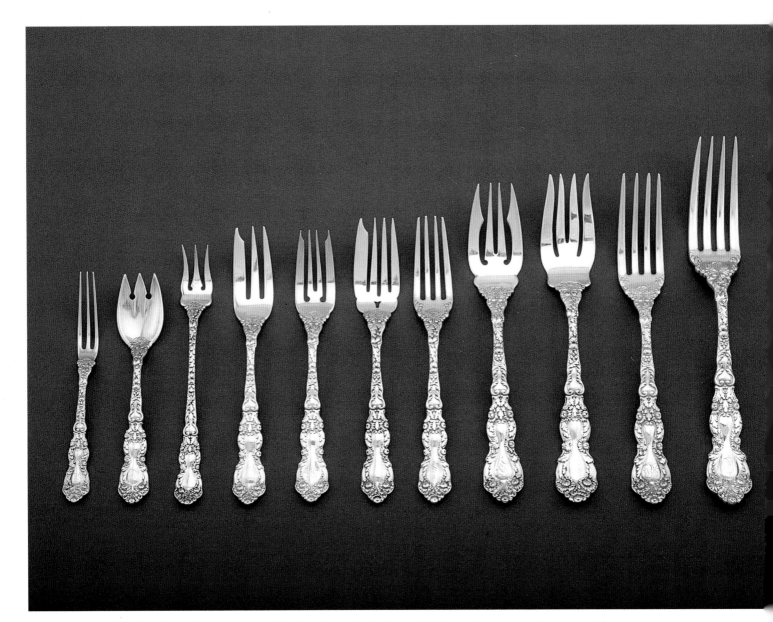

Figure 4.002. This picture features some of the forks found in the *Imperial Chrysanthemum* pattern. From left to right: strawberry fork, 4-3/4"; ice cream fork, 4-3/4"; cocktail fork, 5-3/8"; pickle fork, 5-13/16"; salad fork, 5-5/8"; pastry fork, 5-3/8"; tea fork, 5-15/16"; fish/salad fork, Large [regular style], 6-9/16"; fish/salad fork, large, 6-3/4" [note the differences in the tines in these last two forks]; luncheon fork, 6 9 16"; and the dinner fork, 7-1/8".

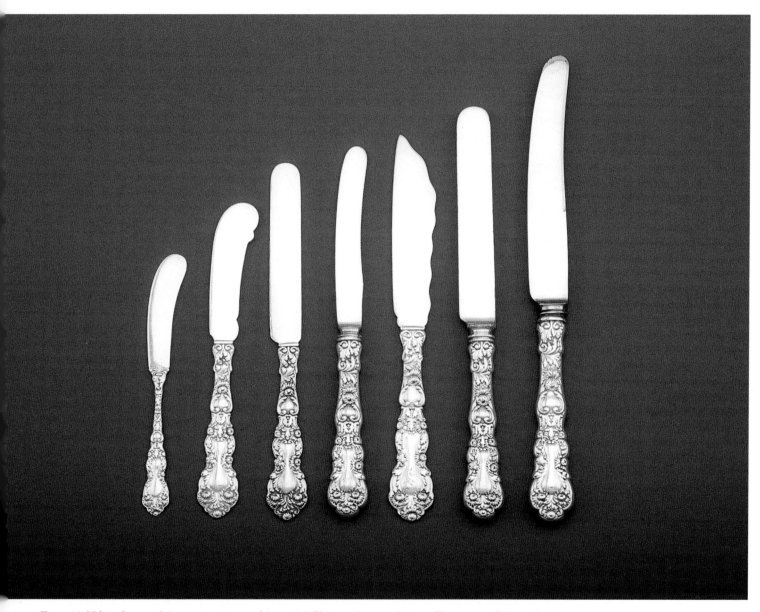

Figure 4.002.1. Some of the various types of *Imperial Chrysanthemum* knives. They are as follows: butter spreader, all-silver, small, 5-5/8"; butter spreader, all-silver, large, 6-1/2"; tea knife, all-silver, 7-3/8"; orange knife, 7-3/4"; all-silver fish knife, large, 8"; luncheon knife, 8-1/2"; and dinner knife, 9-5/8".

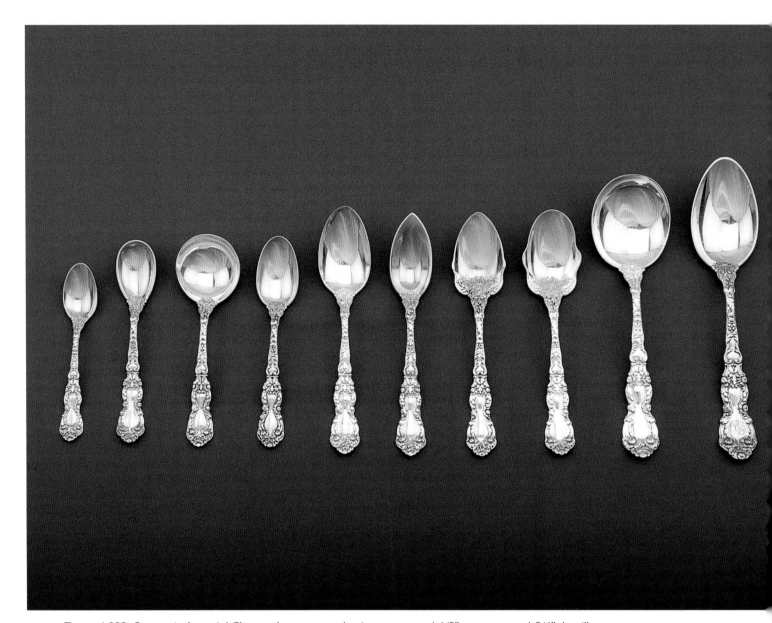

Figure 4.003. Spoons in *Imperial Chrysanthemum* are: demitasse spoon, 4-1/8"; egg spoon. 4-3/4"; bouillon spoon, 4-13/16"; five o'clock spoon, 4-15/16"; teaspoon, 5-11/16"; citrus/melon spoon, 5-5/8" orange spoon, 5-5/8"; ice cream spoon, 5-11/16"; gumbo/chowder spoon, 6-1/2"; and the dessert spoon, 7".

English King by Tiffany

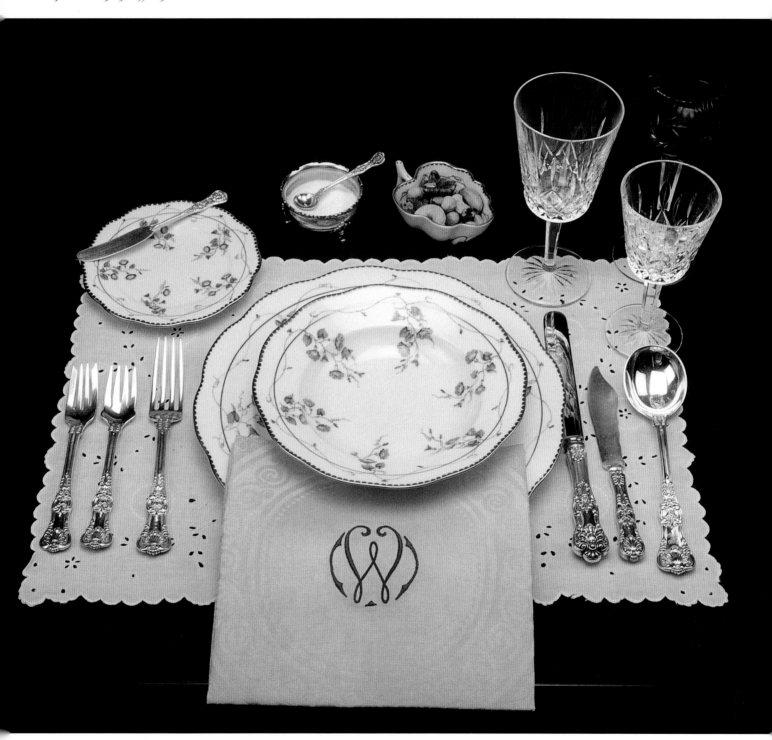

Figure 4.004. *English King* was introduced to the public in 1885, and is still in production. There was for a short time during World War II when the pattern not in production. In Figure 4.4 the silver is teamed with Herend's *Morning Glory*, and Waterford's *Lismore*. The china, *Morning Glory* is not sold in the United States, and the items shown in the figure were purchased in Bermuda. The silver setting in Tiffany's *English King* features the salad fork, 6-3/4"; the fish fork, 6-7/16", the dinner fork, 7-5/8", the dinner knife at 10-1/16", the hollow-handled all-silver fish knife; 7-7/16"; and the chowder spoon, 8-7/8". At the top, on the bread and butter plate, is a butter spreader at 5-3/4". Other items featured in this picture are a leaf dish holding nuts, and a sterling silver master salt and salt spoon also in Tiffany's *English King*.

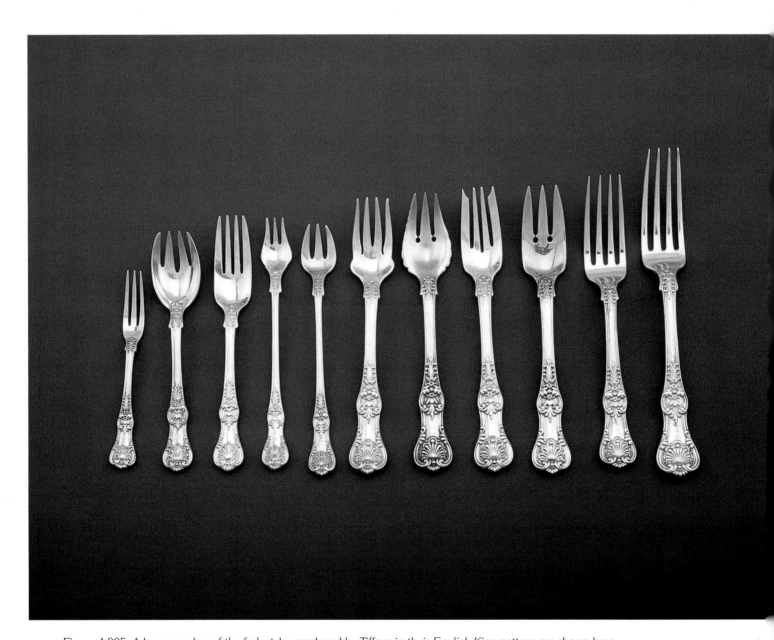

Figure 4.005. A large number of the fork styles produced by Tiffany in their *English King* pattern are shown here. From left to right are the: strawberry fork, 4-5/8"; ice cream fork, 5-9/16"; tea fork, 6-7/16"; oyster fork, 6"; oyster fork, 6" (variation); fish fork, 6-7/16"; pastry fork, 6-9/16"; salad fork, 6-3/4"; luncheon fork, 6-13/16"; and dinner fork, 7-5/8".

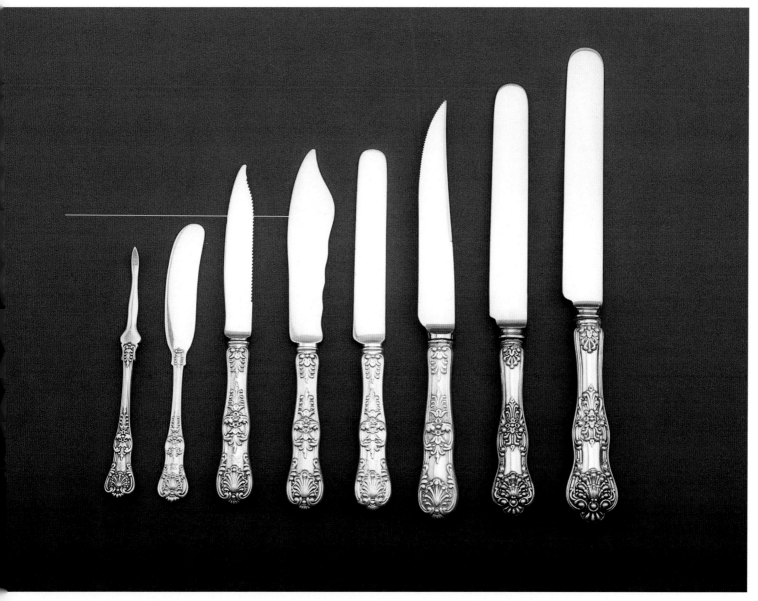

Figure 4.006. With the exception of the nut pick at the left, these are the knives in the *English King* pattern. Not wishing to introduce another category, the nut picks were grouped with knives. From left to right: nut pick, 5-1/8"; butter spreader, 5-3/4"; fruit knife (serrated blade) 7-1/8"; hollow-handled all-silver fish knife, 7-7/16"; tea knife 7-5/8"; steak knife (note: this is a rebladed item, not factory made), 6-11/16"; luncheon knife, 9-1/8"; and dinner knife, 10-1/16".

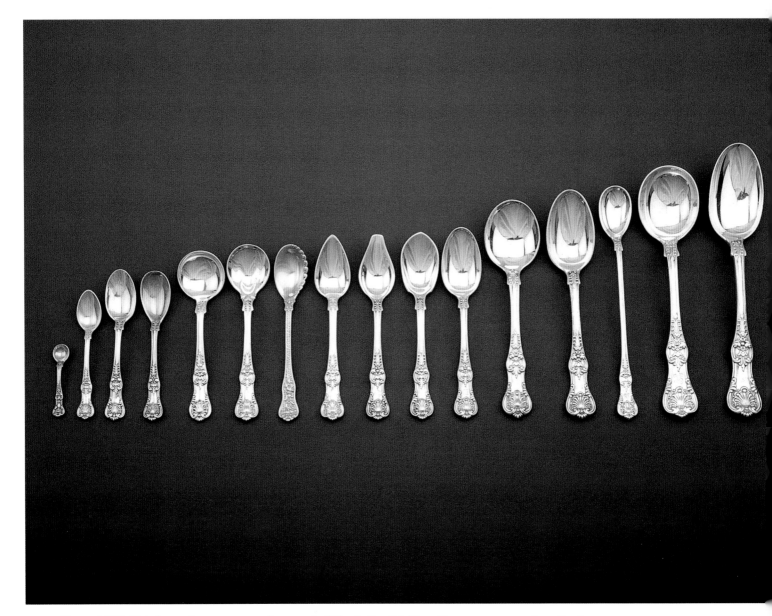

Figure 4.007. This figure shows an array of spoons in Tiffany's *English King*. The spoons range from the tiny individual salt to the tablespoon, a fixture in Continental settings. From the left: the salt spoon, 2-3/16"; demi-tasse spoon, 4"; five o'clock spoon, 4-5/8"; egg spoon 4-9/16"; bouillon spoon 5-3/16"; ice cream spoon, 5-7/16"; sorbet spoon, 5-3/8"; orange spoon, 5-11/16"; grapefruit spoon 5-11/16"; ice cream spoon, 5-3/4"; teaspoon, 5-7/8"; cream soup, 6-3/4"; dessert spoon, 7-1/16"; iced tea spoon, 7-3/8"; chowder/gumbo spoon, 8-7/8"; and the tablespoon, 9-5/8".

Chantilly by Gorham

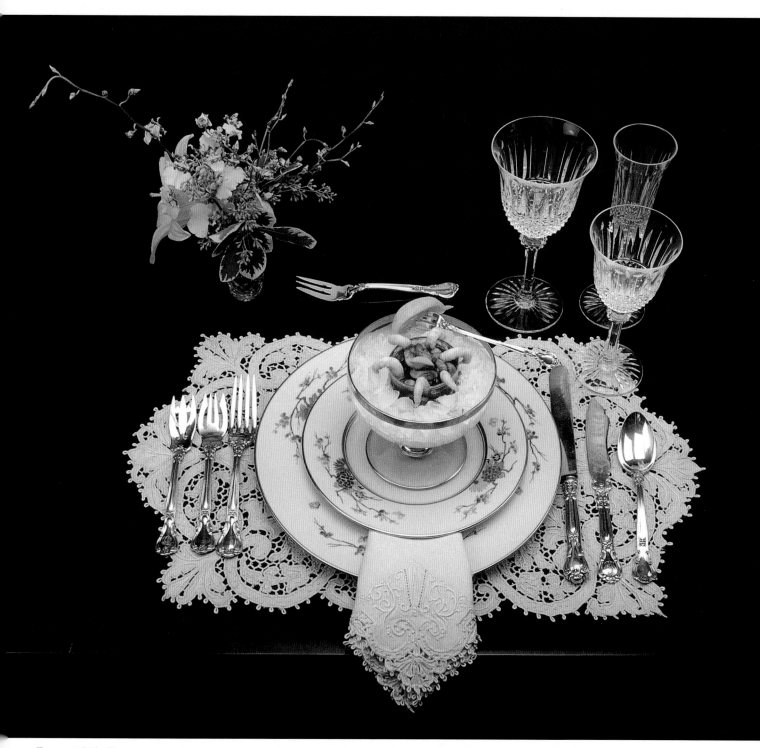

Figure 4.008. The most popular sterling silver pattern ever designed is Gorham's *Chantilly*. This pattern was first introduced in 1895, and at the time was not too well received. The pattern was reordered by customers, but Gorham's 1902 biennial catalog shows the pattern had been dropped. Gorham reintroduced the pattern with modification in 1904, and since then the pattern has always been in the top ten of sterling silver patterns. The reintroduced pattern had been simplified, and the rest of the story, is, as they say, history. The *Chantilly* pattern goes with almost everything.

 Here *Chantilly* is teamed with Lenox's *Mandarin*, and St. Louis's, *Tommy*. *Mandarin* was introduced by Lenox in 1917. The silver at each place setting consists of the following: a corn fork, 6-11/16"; a fish fork/large, 6-3/4"; a dinner fork, 7-1/2"; a dinner knife, 9-9/16"; all-silver fish knife, 8-1/16"; and a place spoon, 6-3/4". The cocktail fork, 5-1/2", spears a lemon wedge in the shrimp cocktail. The large pie fork, 7-7/8", rests above the setting for dessert.

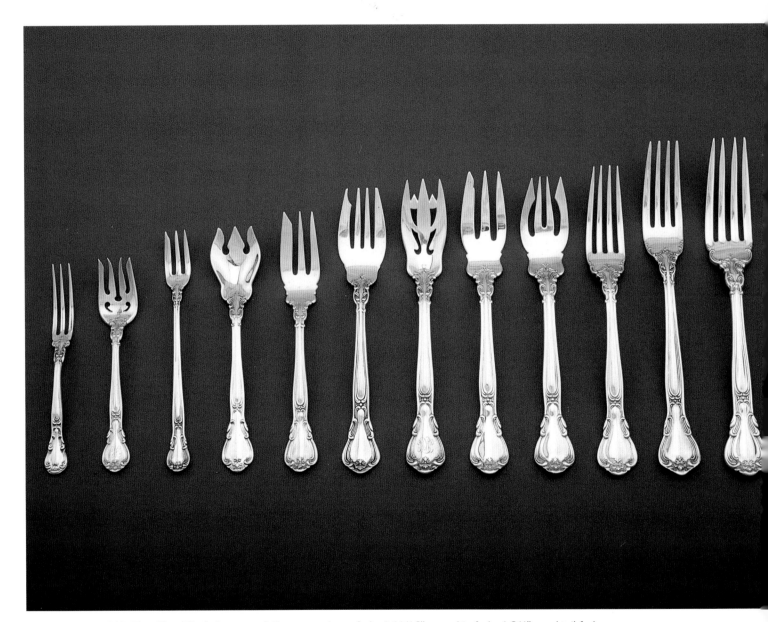

Figure 4.009. The *Chantilly* forks are as follows: strawberry fork, 4-11/16"; ramekin fork. 4-3/4"; cocktail fork, 5-1/2"; ice cream fork, 5-9/16"; small pie/pickle fork, 5-7/8"; large fish fork, 6-3/4"; luncheon fork, 7-3/8"; place fork, 7-1/2"; and dinner fork, 7-1/2".

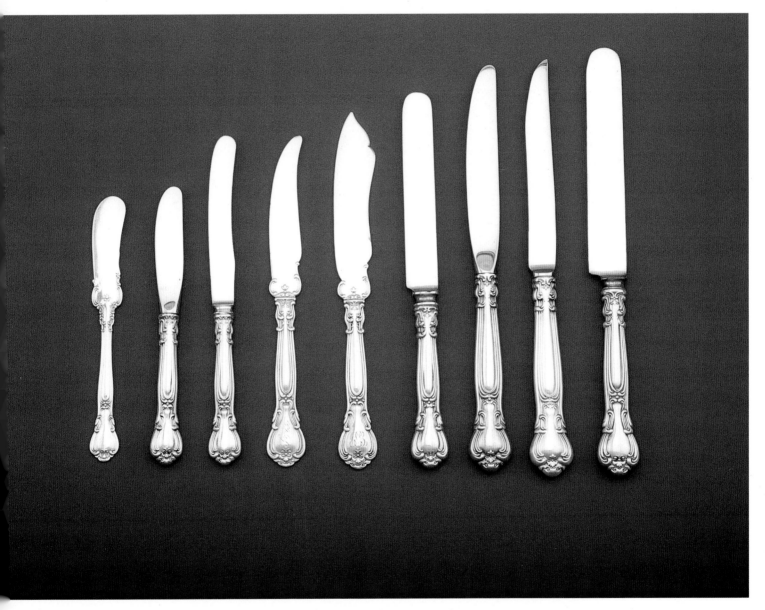

Figure 4.010. The knives in the *Chantilly* pattern are the following: flat butter spreader, 5-7/8"; hollow-handled butter spreader, 6-3/8"; ornage knife 7-5/16" (note the serration on part of the blade); all-silver tea knife, 7-1/2"; all-silver fish knife, 8-1/16"; luncheon knife, 8-7/16"; place knife, 9-1/8"; steak knife, 9-3/8"; and dinner knife, 9-9/16".

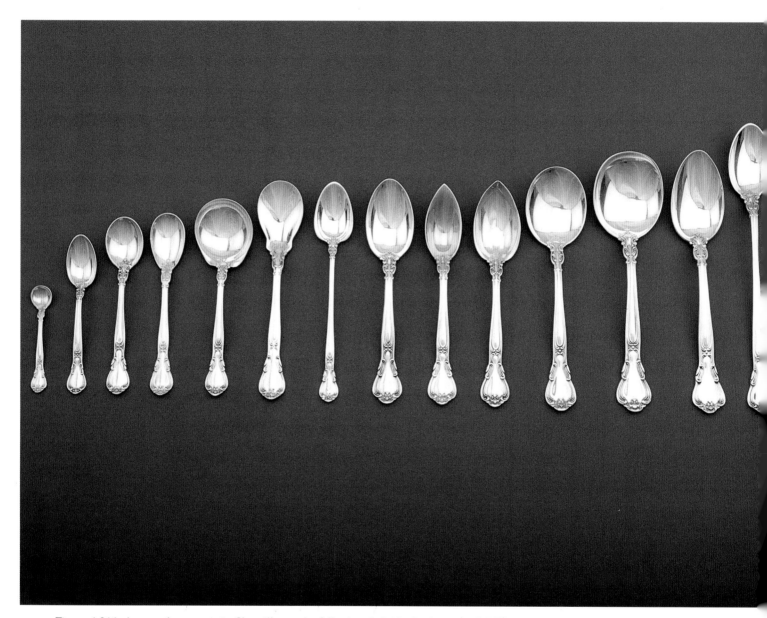

Figure 4.011. Among the spoons in *Chantilly* are the following: individual salt spoon, 2-5/8"; demitasse spoon, 4-1/16"; chocolate spoon, 4-9/16"; egg spoon, 5-3/4"; bouillon spoon, 5-1/16"; ice cream spoon, 5-3/4"; parfait spoon, 5-3/4"; teaspoon, 5-13/16"; grapefruit/melon spoon, 5-3/4"; orange spoon, 5-11/16"; cream soup, 6-1/4"; gumbo soup 6-11/16"; place spoon, 6-3/4"; and iced teaspoon, 7-5/8".

Figure 4.012. An original 1895 Gorham silver chest is shown intact with the original *Chantilly* silver.

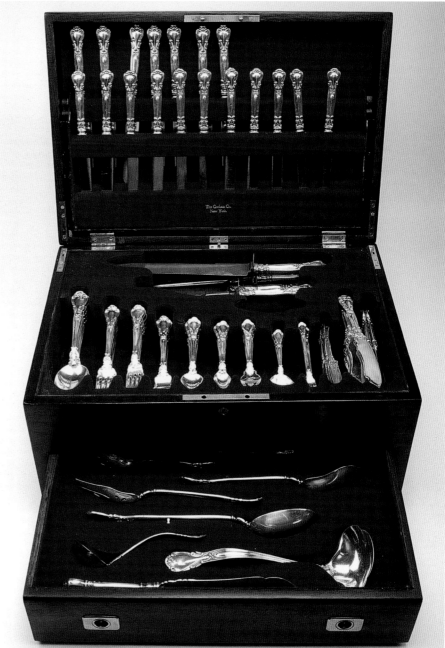

Figure 4.013. The interior of the original *Chantilly* set showing the contents. Carving accessories are located in the top, along with twelve tablespoons and the remainder of the place pieces. The drawer contains two large serving spoons, a small fish set—fork and spoon, a long-handled salad set, a dressing spoon with button back, a gravy ladle, an oyster ladle, and a large hollow-handled ice cream slice. The red interior of the top and the bottom are original to the chest. It would appear that Gorham manufactured the interior to "fit" the specific order being placed.

Ivy by Whiting

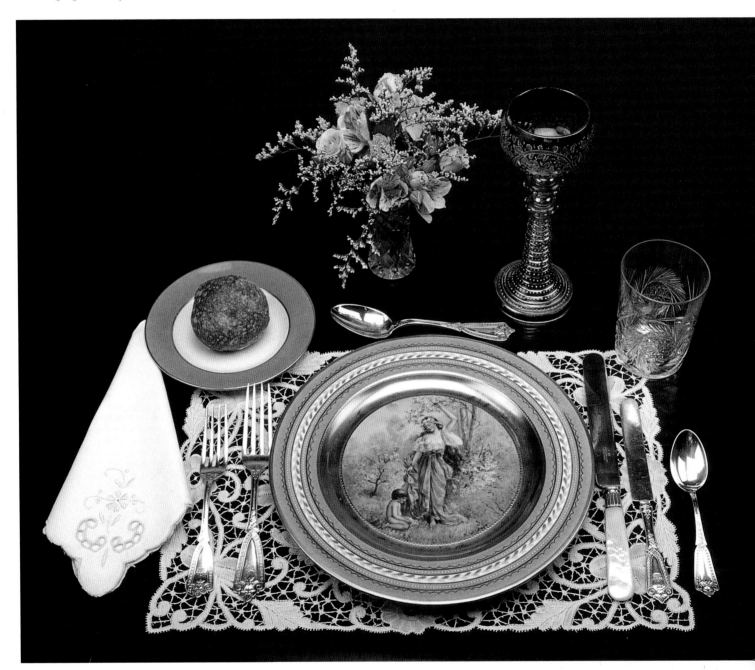

Figure 4.014. This setting features Whiting's *Ivy*, c. 1880. The pattern is noted as "n.l.p." in the *Jeweler's Keystone*, meaning that the manufacturer, in this case Whiting, did not make everything available in the set. The owner of this set has over 200 pieces, but no dinner or luncheon knives, or salad forks. Salad forks were introduced about 1885, according to Turner, and this was a direct result of improved lettuce varieties and refrigerated railroad cars, and may explain why there are no salad forks to be found in this pattern. In Figure 4.14 the service plates are Bavarian, the bread and butter is an early Lenox piece, the cranberry Rhine wine is signed Mosher, and the cut glass tumbler is by Hawkes. The silver consists of: a luncheon fork, 7"; a dinner fork, 7-7/8"; a pearl-handled Tiffany dinner knife, 10-1/4"; Whiting's all-silver tea/dessert knife being used for fish, 8"; a teaspoon, 5-13/16"; and a dessert spoon, 6-7/8", at the top of the plate for dessert.

Audubon by Tiffany

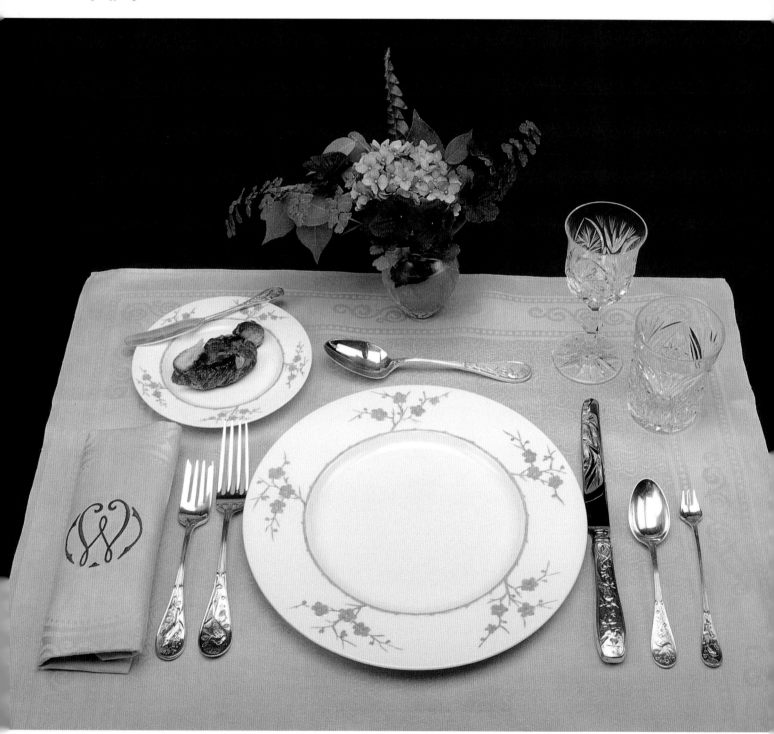

Figure 4.015. Tiffany *Audubon* sterling, Spode's *Blue Geisha* on the *Blanche de Chine* shape, and a recent cut glass wine and a tumbler signed by Hawkes comprise this setting. The Tiffany sterling is of recent manufacture and consists of: a salad fork, 6-5/8"; a dinner fork, 8-1/2"; a dinner knife, 10-1/8"; a teaspoon, 6-1/4"; a cocktail fork, 6-1/4"; a place spoon, 7-1/4"; and a butter spreader, 6".

Violet by Whiting

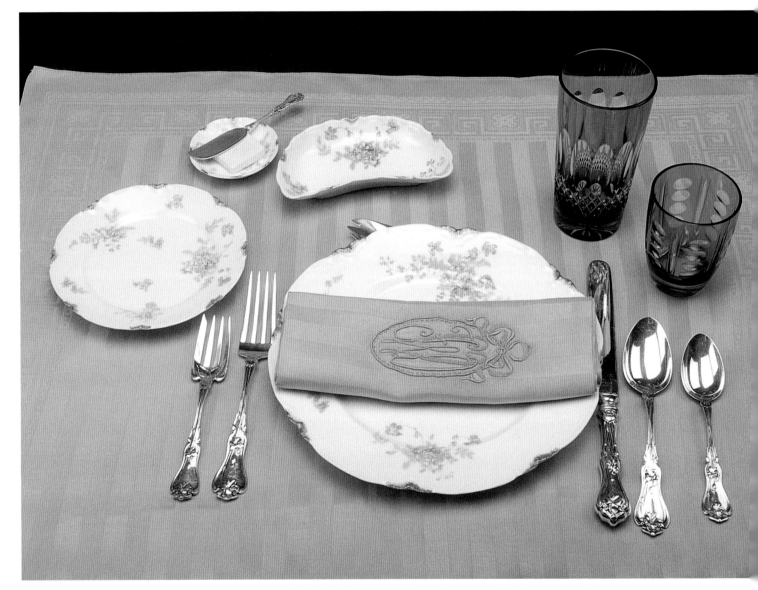

Figure 4.016. A setting in Whiting's *Violet*, paired with Haviland's 52A china, and green overlay glass cut to clear atop an apple green linen place mat. The silver shown in the photograph consists of: a four-tined salad fork, 6-1/16"; a dinner fork, 7-9/16"; blunt-bladed dinner knife, 9-5/8"; a dessert spoon, 6-7/8"; teaspoon, 5-7/8"; an ice cream fork, 5-1/8", above the dinner plate; and a butter spreader on the bread and butter plate, 4-7/8".

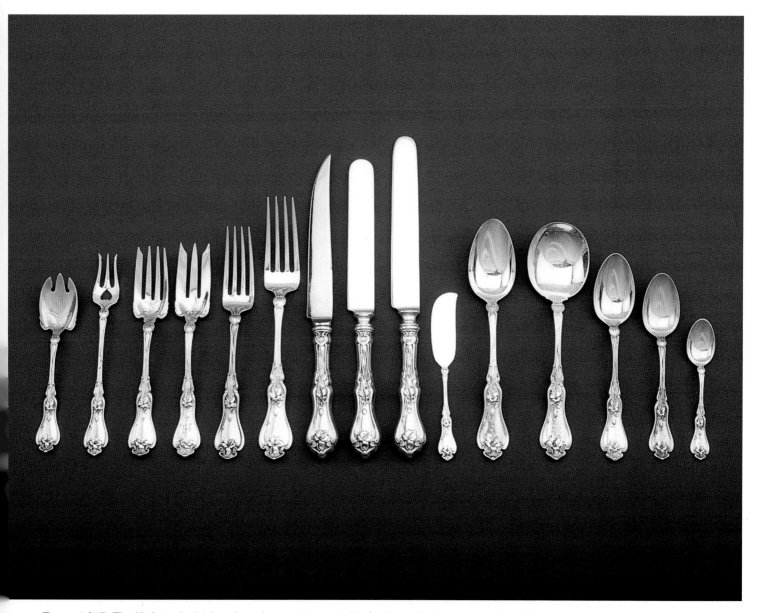

Figure 4.017. The *Violet* individual sterling place setting available for this collector consists of the following: ice cream fork, 5-1/8"; oyster fork, 5-7/8"; four-tined salad fork, 5-13/16"; three-tined salad fork, 6-1/8"; luncheon fork, 6-11/16"; dinner fork, 7-9/16"; steak knife (newly rebladed) 9-1/16"; luncheon knife, 8-7/8"; dinner knife, 9-5/8"; butter spreader 4-7/8"; 5 o'clock teaspoon, 5-5/8"; demitasse spoon, 4".

Versailles by Gorham

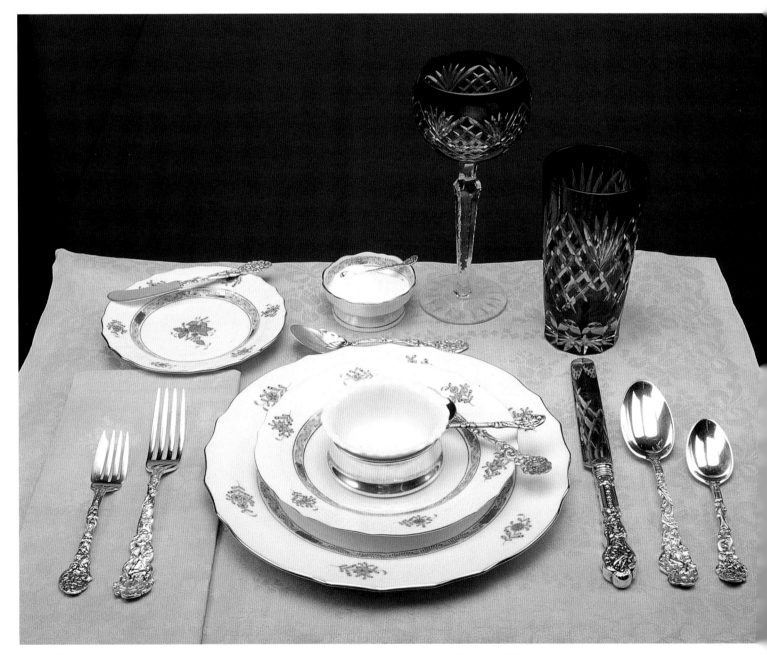

Figure 4.018. A stunning example of fabulous sterling, linen, china, and crystal, all "married." The heavily exuberant *Versailles* sterling by Gorham teams perfectly with Herend's *Chinese Blue Flowers*. The slight touches of gold on some of the sterling pieces elegantly enhance the delicate china. The sterling setting is composed of: a salad fork, 6"; a dinner fork 7-3/4"; sterling ramekin holder with a Haviland ramekin cup in the Ransom pattern and a ramekin fork, 4-3/4"; dinner knife, 9-5/8"; a place spoon, 7-1/2"; ice cream spoon 5-7/8"; and butter spreader, 5-7/8"; and master salt spoon, 3-5/8", placed with a Herend salt cellar. First introduced in 1888 and designed by Antoine Heller, Gorham's *Versailles* is truly a magnificent sterling pattern. The glassware, blue cut to clear, is relatively new and inexpensive, yet fits regally with this setting.

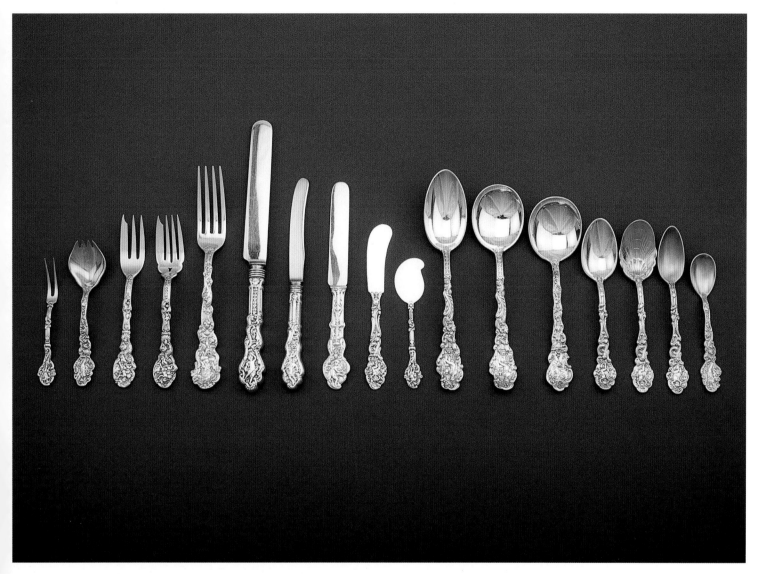

Figure 4.019. The sterling items in Gorham's *Versailles* are the following: cherry/canape fork, 4-3/8"; terrapin fork, 5"; pickle/small pie fork, 5-5/16"; salad fork, 6-3/8"; dinner fork, 8-7/8"; orange knife, 7-3/8"; all-silver tea knife, 7-3/8"; butter spreader, 6-1/2"; caviar spreader, 4-1/2"; dessert spoon, 7-3/8"; two gumbo soups of slightly different size, one 6-5/8"; and the other 6-1/2"; teaspoon, 6": ice cream spoon, 5-7/8"; demitasse spoon, 4-1/4"; and egg spoon, 4-3/4".

Fairfax by Durgin and Gorham

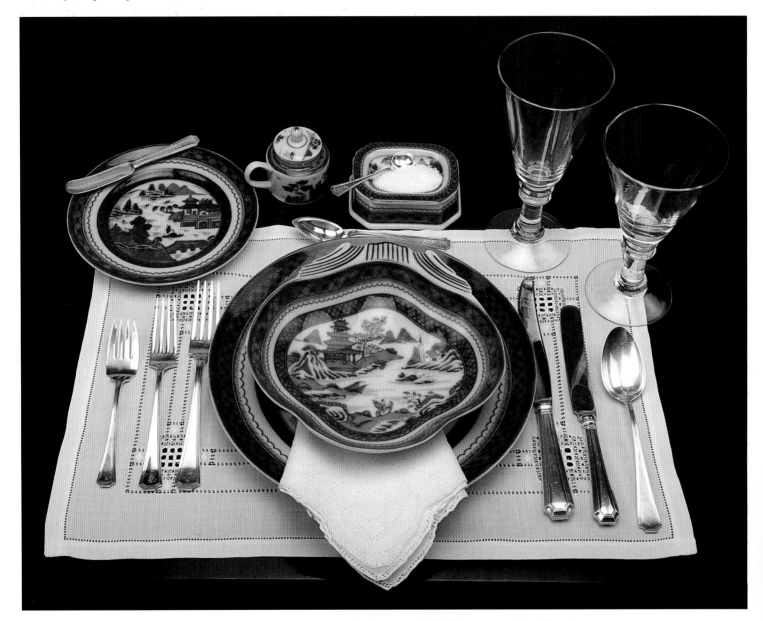

Figure 4.020. The sterling pattern *Fairfax* was first introduced by Durgin in 1910. The company had already been purchased by Gorham (1905) yet remained in Concord, New Hampshire until 1931, when it was moved to Providence, Rhode Island, home of Gorham. *Fairfax* was one of the most popular patterns for Durgin. When the Durgin logo no longer was used, Gorham as successor applied their name to the product. Some purists collect only *Fairfax* flatware with the Durgin "D," and others prefer the newer Gorham product. Each has its appeal, but the pattern itself is truly a giant in the Colonial Revival period.

Figure 4.020 Shows *Fairfax* teamed with Mottahedeh's *Blue Canton* and Williamsburg glassware. The china consists of an extra large dinner plate, a shell-scallop serving bowl for soup, and a bread and butter plate. A mustard pot and master salt complete the setting. The silver used is as follows: salad fork, 6-1/16"; luncheon fork, 7-1/4"; dinner fork, 7-7/8"; dinner knife, 9-5/8"; place knife, 8-7/8"; Place Spoon, 8-1/2"; teaspoon, 5-3/4"; grapefruit/melon spoon, 5-3/4"; and flat butter spreader, 5-1/2". The master salt is also in *Fairfax* and it is 3-3/4".

Figure 4.021. *Sir Christopher* by Wallace was introduced in 1936 and was designed by William S. Warren, a top designer for Wallace. The sterling is paired with Wedgwood's *Bianca*, a Williamsburg design, which is no longer in production, and assorted cranberry glasses and a mustard pot. The silver used consists of: a salad fork, 6-3/8"; a place/luncheon fork, 7-1/4"; a place/luncheon knife, 9-1/8"; and a teaspoon, 5-15/16". The glassware, all by different manufacturers, has a rhine wine, a tall water glass, and a Bohemian sherry glass.

Sir Christopher by Wallace

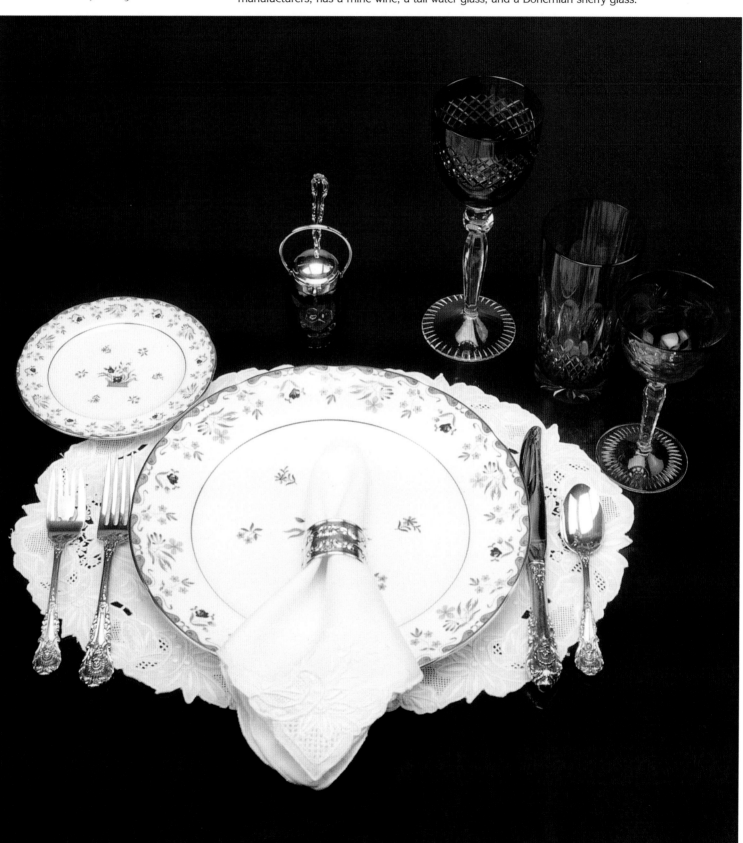

King Edward by Gorham

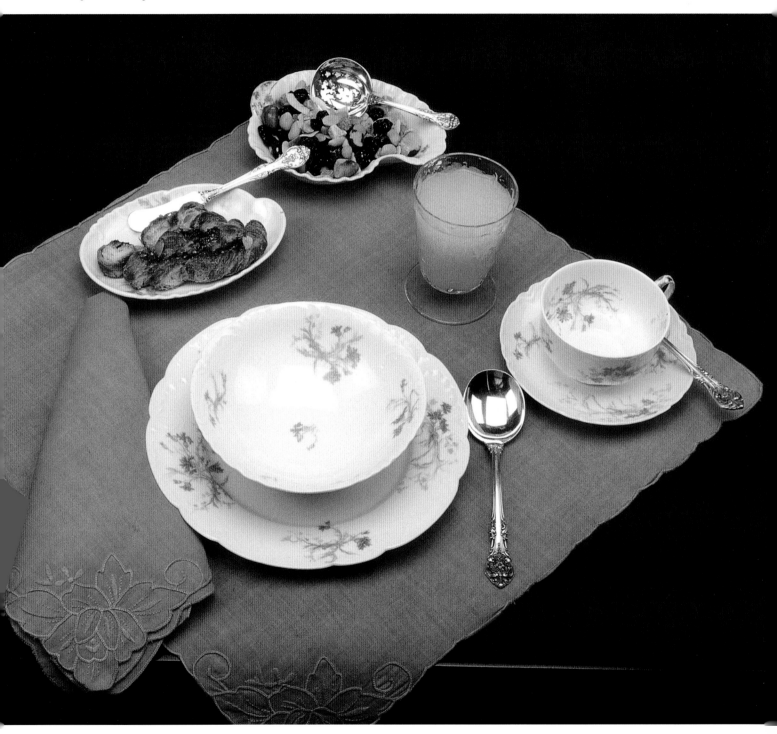

Figure 4.022. Gorham's *King Edward* was introduced in 1936, and was supposedly timed to coordinate with the investiture of the future King Edward VII of England. Even though Edward VII did not go on to become king, the sterling pattern has been very popular with Gorham.

The sterling in Figure 4.21 is paired with Haviland's *St. Lazare* pattern, #70C, and Bryce crystal. The St. Lazare pattern is one of few Haviland patterns with a factory name on most pieces, thus enabling easy, quick identification. The setting is for breakfast, and features an oatmeal bowl atop a luncheon plate with: a cream soup spoon, 6-1/4"; a teaspoon, 5-15/16"; a tea cup and saucer; a flat spreader, 5-13/16"; and the nut spoon or bon bon, 4-15/16", being used to put granola on warm oatmeal.

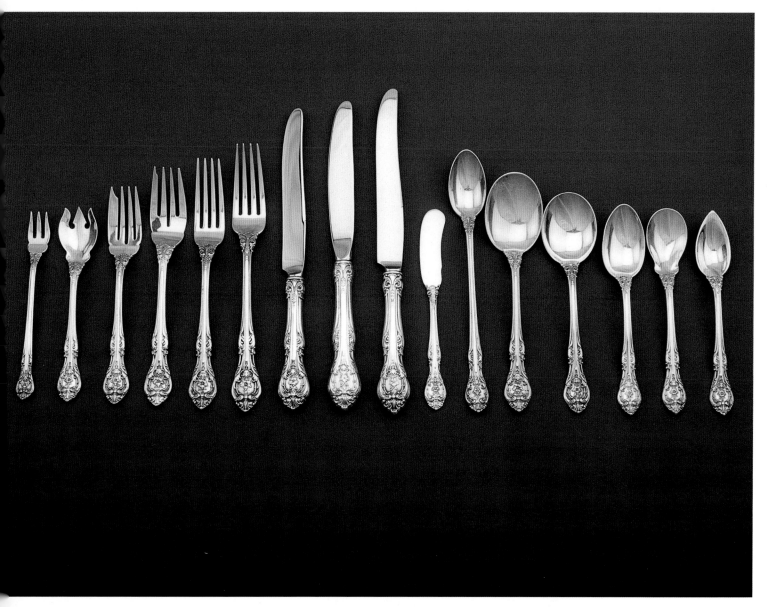

Figure 4.023. An extensive collection of *King Edward* is on viewed in this figure. Among the many pieces of this sterling pattern are the following: cocktail fork, 5-3/8"; ice cream fork, 5-9/16"; salad fork, 6-3/8"; salad fork, place size, 6-3/4"; luncheon fork, 7-1/8"; place fork, 7-1/2"; luncheon knife, 8-15/16"; place knife, 9-1/16"; dinner knife, 9-1/2"; flat-handled butter spreader, 5-13/16"; iced teaspoon, 7-1/2"; chowder/gumbo soup spoon, 6-13/16"; cream soup, 6-1/4"; teaspoon, 5-15/16"; ice cream spoon, 5-7/8"; and grapefruit/melon spoon, 5-13/16".

Palm by Tiffany

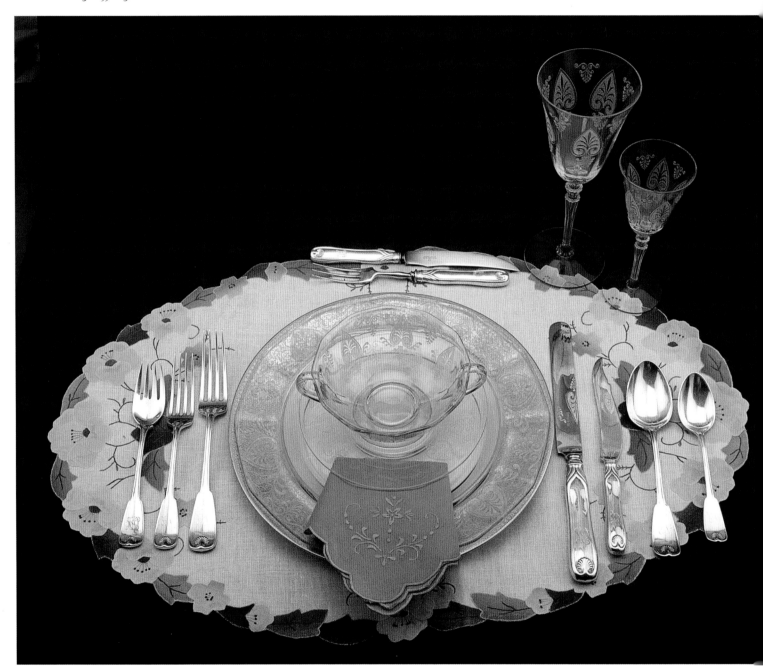

Figure 4.024. Tiffany's *Palm* is paired with a German gold-banded charger and Fostoria's *Trojan* crystal. There have been some liberties taken with the exact usage of the sterling pieces here. Occasionally in an older set as this, salad forks were not made or very few were made. Finding a set to use is next to impossible so one learns to improvise. In this setting, the fish fork, 6-5/8", is being used as a salad fork. Next to it is the luncheon knife, 7", then the dinner fork, 8". On the opposite side of the charger is: a dinner knife, 10-1/4"; fish knife, 7-3/4", being used as a salad knife; a dessert/soup spoon, 7-1/8"; and the teaspoon, 6". At the top of the plate are the game fork and game knife, which are being used in this setting as a fruit fork and fruit knife. Both of these items are 7-1/4" in length.

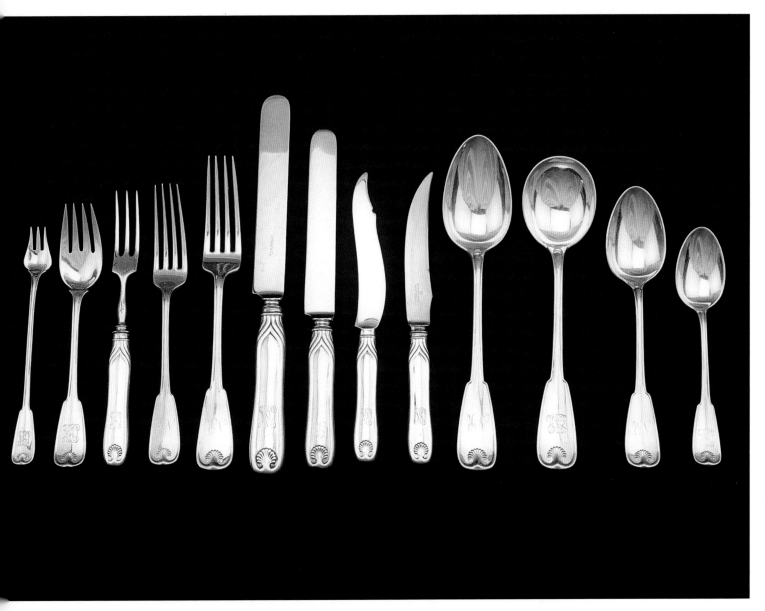

Figure 4.025. The complete setting available in Tiffany's *Palm* is as follows: cocktail fork, 6-1/8"; fish fork, 6-5/8"; hollow-handled game fork, 7-1/4"; luncheon fork, 7"; dinner fork, 8"; dinner knife, 10-1/4"; fish knife, 7-3/4"; hollow-handled game knife, 7-1/4"; tablespoon, 8-1/16"; chowder/gumbo soup spoon, 8"; dessert spoon, 7-1/8"; and teaspoon, 6".

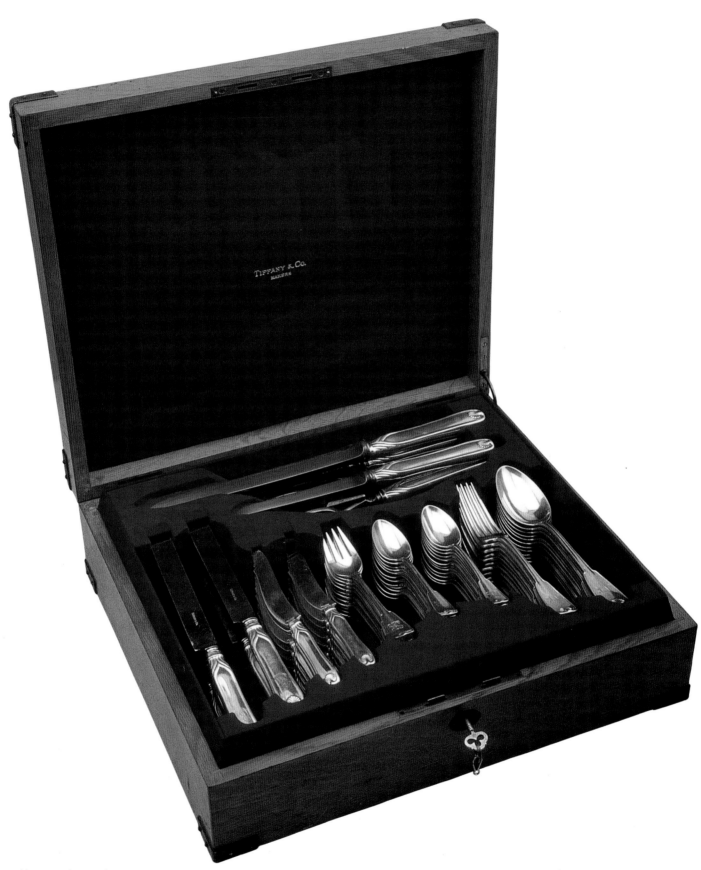

Above and opposite page:
Figure 4.026 and 4.027. The entire set of Tiffany *Palm* is displayed in its original boxes in these photographs. Finding a set in its original box is rare, and a set of this magnitude in two boxes is extremely rare. The set was located by a dealer who was bringing his collection to the photographic session for this book. On the way he made a stop and purchased the set from the last survivor of the family who had purchased the set beginning in 1901.

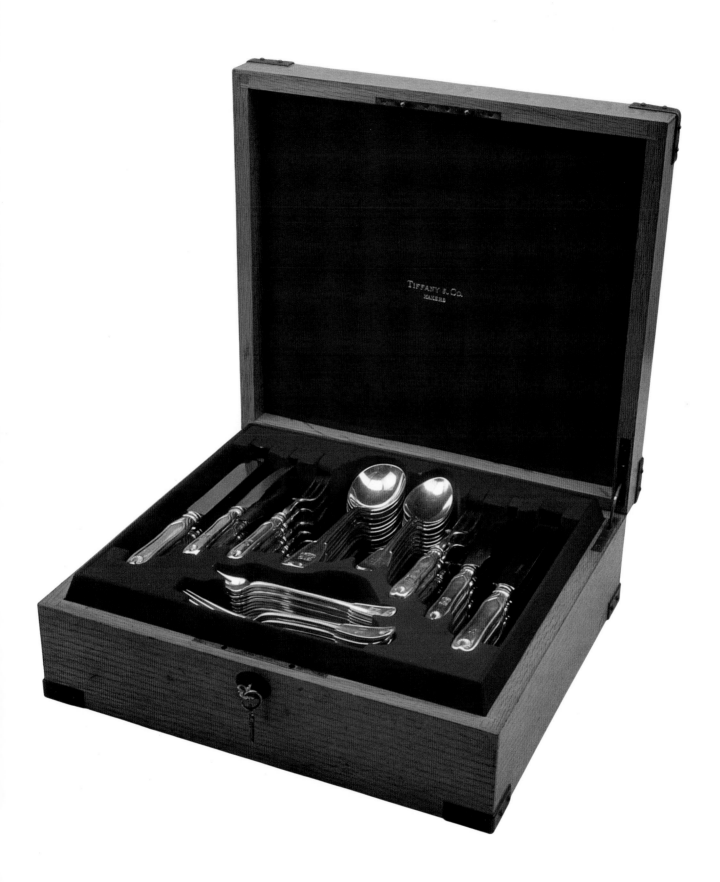

Marechal Niel/by Durgin

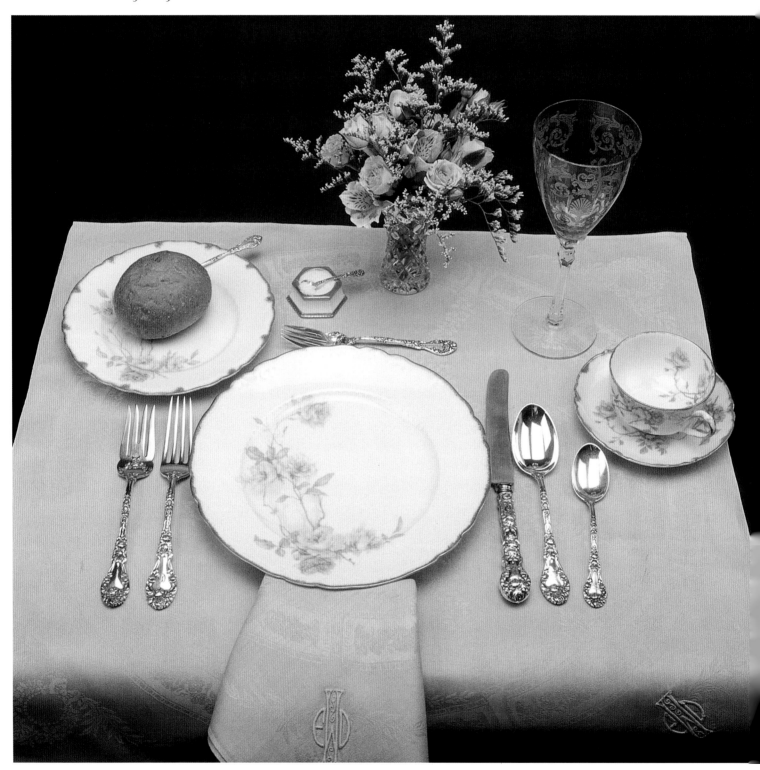

Figure 4.028. Durgin's *Marechal Niel* is teamed with Haviland's *Baltimore Rose* on Blank 8, ,Fostoria's *Versailles,* and Cambridge's *Cleo. Baltimore Rose* is one of the most highly collectible Haviland patterns. Durgin's *Marechal Niel*, first introduced in 1896 is a fabulous rose pattern that teams with the china to make a most memorable presentation. This most beautiful floral pattern is represented in this setting with: a fish fork, 7-3/8"; dinner fork, 7-5/8"; dinner knife, 9-9/16"; dessert spoon, 7-1/8"; teaspoon, 5-3/4"; flat butter spreader, 5-1/4"; and the salad fork above the dinner plate being used for pastry. A Haviland salt dip with an unidentified salt spoon rests above the individual dinner plate and to the left of the bread and butter plate. A covered bouillon cup rests atop the dinner plate.

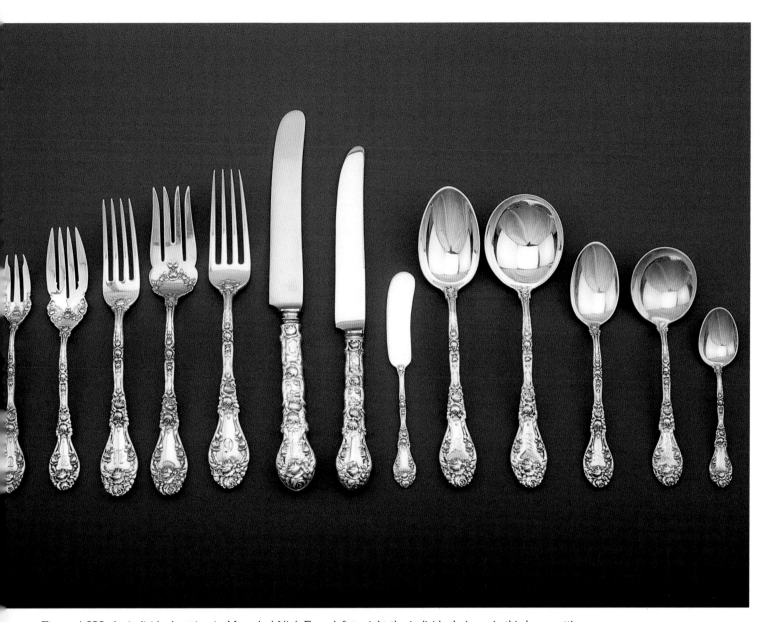

Figure 4.029. An individual setting in *Marechal Niel*. From left to right the individual pieces in this huge setting are the following: cocktail fork, 5-5/8"; salad fork, 6-1/4"; luncheon fork, 7-1/8"; fish/salad fork large, 7-3/8"; dinner fork, 7-5/8"; luncheon knife, 8-1/2"; butter spreader, 5-1/4"; place spoon, 7-1/8"; chowder/gumbo spoon, 6-15/16"; teaspoon, 5-3/4"; bouillon spoon, 5-9/16"; and a demitasse spoon, 4-3/16".

New Vintage by Durgin

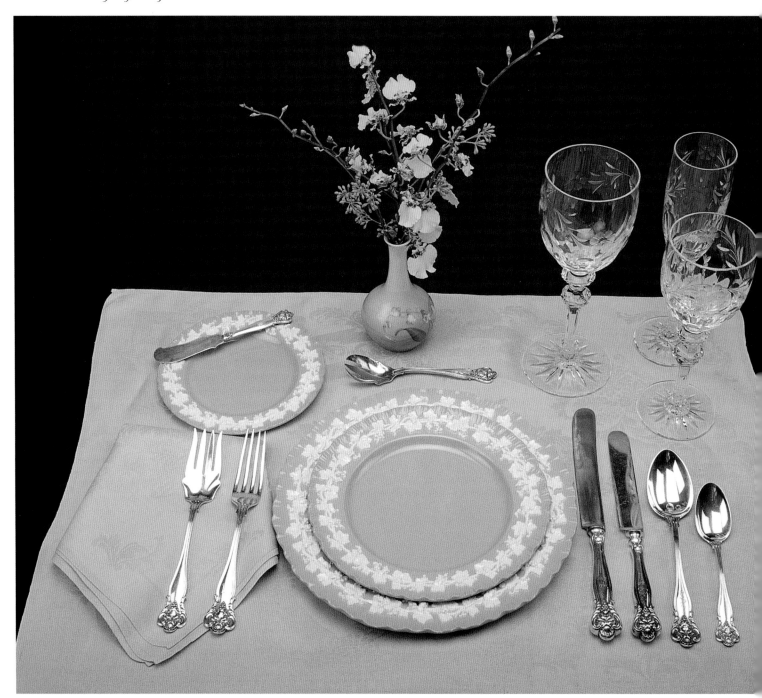

Figure 4.030. Durgin's *New Vintage*, introduced in 1904, when the grape motif was approaching its zenith, is featured in Figure 4.36, along with Wedgwood's White on Lavender with a shell edge, and Miller Rogaska crystal. Grapes as a theme on silver, china, crystal, and even linen have been a recurring theme for many years and the public still searches for additional grape items. This place setting features the following silverware: fish fork, large, 7-3/8"; dinner fork, 7-5/8"; dinner knife, 9-5/8"; luncheon knife (being used as a fish knife), 8-3/4"; dessert spoon, 7-1/4"; teaspoon, 5-13/16"; butter spreader, large, 5-9/16"; and ice cream fork, 5-11/16". A Bing and Grundal bud vase bearing a sprig of yellow orchids and greens harmonizes with the setting. The large yellow linen napkin being used as a placemat also serves as a tremendous backdrop for all the china, silver, and crystal.

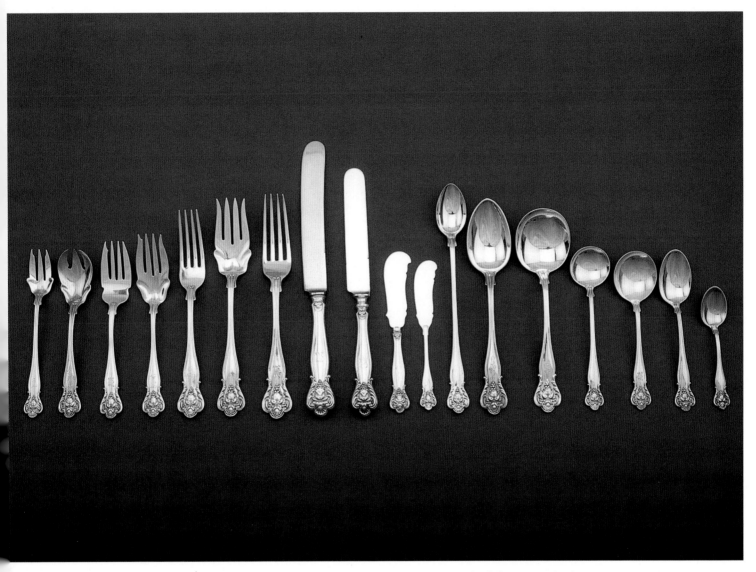

Figure 4.031. The various pieces collected in Durgin's *New Vintage* as shown include the following: cocktail fork, 5-3/4"; ice cream fork, 5-11/16"; salad fork, 5-15/16"; fish fork, small, 6-1/8"; luncheon fork, 7"; fish fork, large, 7-3/8"; dinner fork, 7-5/8"; dinner knife, 9-5/8"; luncheon knife, 8-3/4"; butter spreader, large, 5-9/16"; butter spreader 5-1/8"; iced teaspoon, 7-13/16"; dessert spoon, 7-1/4"; chowder/gumbo spoon, 6-13/16"; long-handled chocolate spoon, 5-1/2"; bouillon spoon, 5-5/16"; 5 o'clock spoon, 5-7/16"; and demitasse spoon, 4-1/16".

Dauphin by Durgin

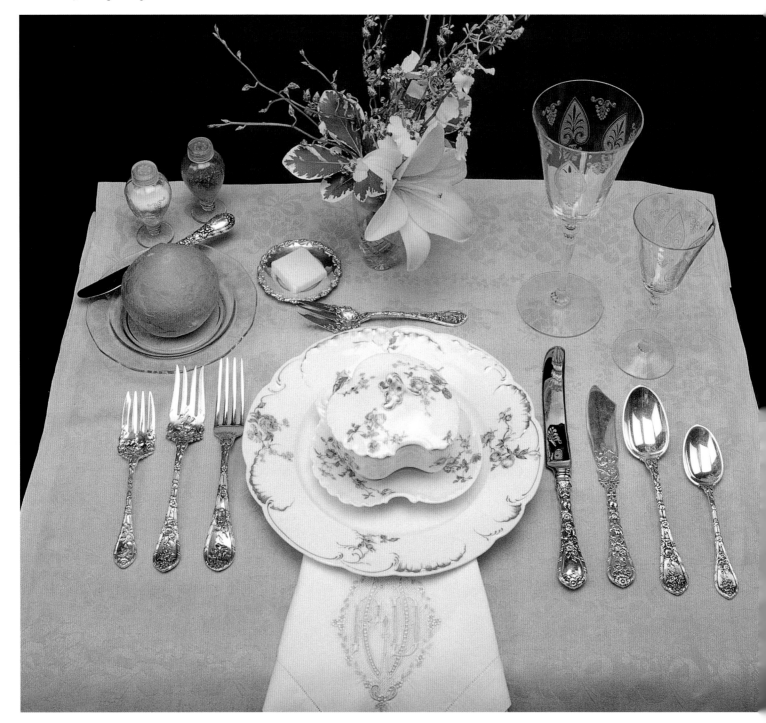

Figure 4.032. Durgin introduced their floral pattern, Dauphin, in 1897. Today, well over a hundred years later, Durgin's successor, the Gorham Company has wisely chosen to reintroduce the pattern in a collection known as the Masterpiece Collection, which is composed of a number of patterns from the past that are still memorable, and have become highly collectible. The company has wisely removed the "D" for the Durgin trademark and on the reverse has placed in small letters, "Gorham Sterling" in the area that was reserved for a monogram. This helps one readily distinguish old from new. Monograms are seldom found on new sterling. Figure 4.32 shows *Dauphin* teamed with Haviland's #266 (yellow roses with blue flowers) and #422 gold trim, and Fostoria's Trojan Crystal.

The individual setting features the following sterling items: salad fork 6-1/4"; fish fork, 7-5/16"; dinner fork, 7-5/8"; dinner knife, 9-3/8", all-silver fish knife, 7-5/8"; dessert/formal soup spoon, 7-1/8"; teaspoon, 5-13/16"; hollow-handled butter spreader, 6-1/2"; pastry/dessert fork at the top of the plate, 6-1/8". In addition, the butter pat is also sterling.

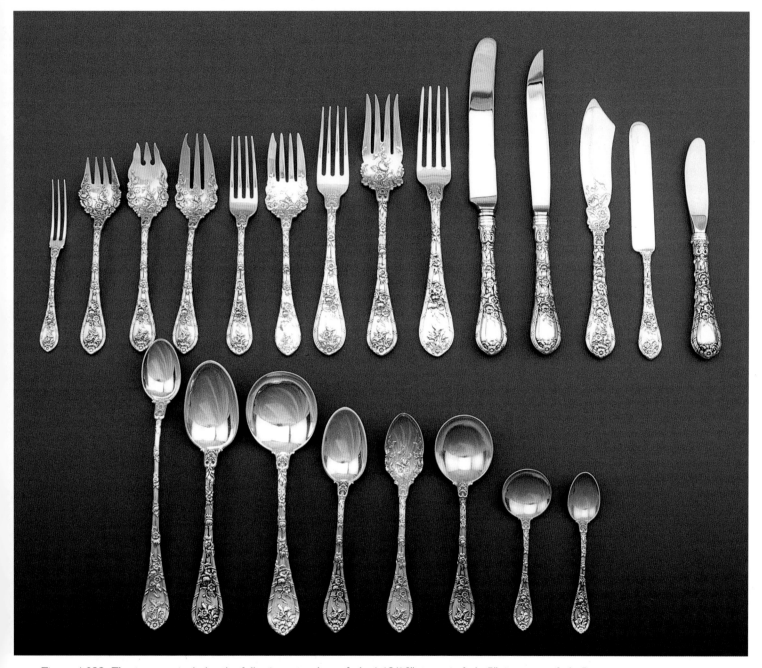

Figure 4.033. **The top row** includes the following: strawberry fork, 4-13/16"; terrapin fork, 5"; ice cream fork, 5-13/16"; pastry fork, 6-1/8"; tea fork, 6-1/8"; salad fork, 6-1/4"; luncheon fork, 6-15/16"; fish fork, 7-5/16"; dinner fork, 7-5/8"; dinner knife, 9-3/8"; steak knife, 9" (rebladed, not original); all-silver fish knife, 7 5./8"; tea knife, 7"; and hollow-handled butter spreader, 6-1/2". Missing was the luncheon knife at 7-9/16".

The bottom row includes the following spoons: iced teaspoon, 7-5/8"; dessert spoon, 7-1/8"; chowder/gumbo spoon, 6-7/8"; teaspoon, 5-13/16"; ice cream spoon, 5-3/4"; bouillon spoon, 5-5/8"; sherbet spoon, 4-1/4"; and the demitasse spoon, 4-1/4". Also missing from the photograph is the grapefruit/melon spoon, 5-3/4", and the 5 o'clock spoon, 5-3/4".

Lily by Whiting

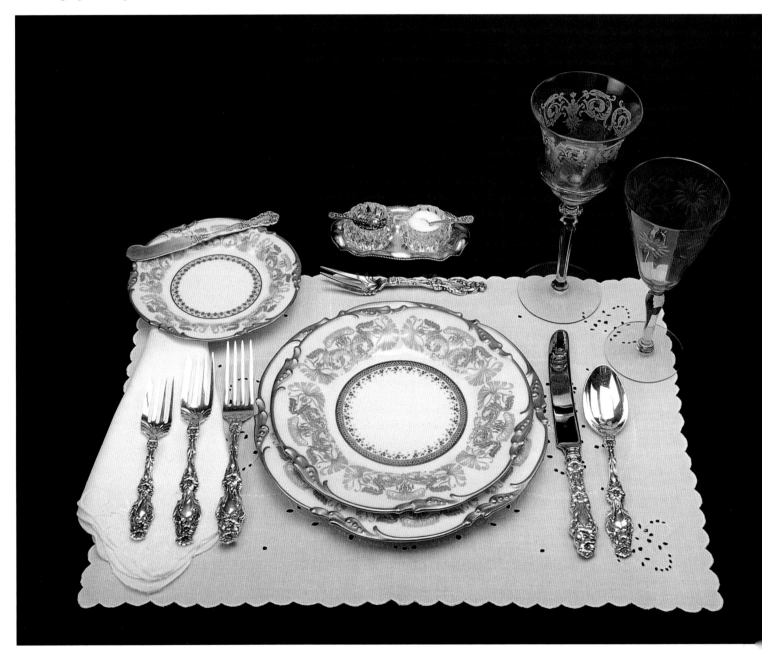

Figure 4.034. *Lily* sterling by Whiting is paired with French Limoge china purchased from Wanamaker's in Philadelphia, marked "J. Pouyat Limoge, Pat 1/23/06" The pattern is unknown, but has a heavy application of gold trim. Pink Depression glass is used with the setting matching the pale pink found in the design of the china.

A number of pieces of flatware are used in the setting. These include the following: salad fork, 6-3/16"; fish fork, 7-1/8" (this is the current salad fork in the Masterpiece Collection), dinner fork, 7-5/8"; dinner knife, 9-1/4"; and place spoon, 7". At the top of the setting a pie fork, 6-3/16", awaits dessert.

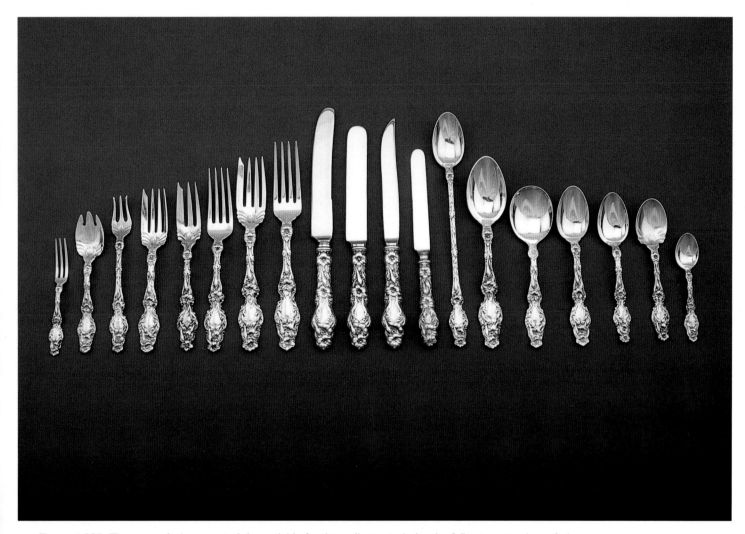

Figure 4.035. The array of silverware in *Lily* available for this collector includes the following: strawberry fork, 4-1/4"; ice cream fork, 5-1/8"; cocktail fork, 5-3/4"; salad fork, 6-3/16"; pie fork, 6-3/16"; luncheon fork, 6-3/4"; fish fork, 7-1/8"; dinner fork, 7-5/8"; dinner knife, 9-1/4"; luncheon knife, 8-1/2"; steak knife, 8-3/4" (rebladed); tea knife, 7-1/2"; iced tea, long, 8-3/4"; dessert spoon, 7"; cream soup, 5-7/8"; teaspoon, 5-13/16"; 5 o'clock, 5-7/16"; ice cream spoon, 5-3/16"; and a demitasse spoon, 3-7/8".

Peony by Wallace

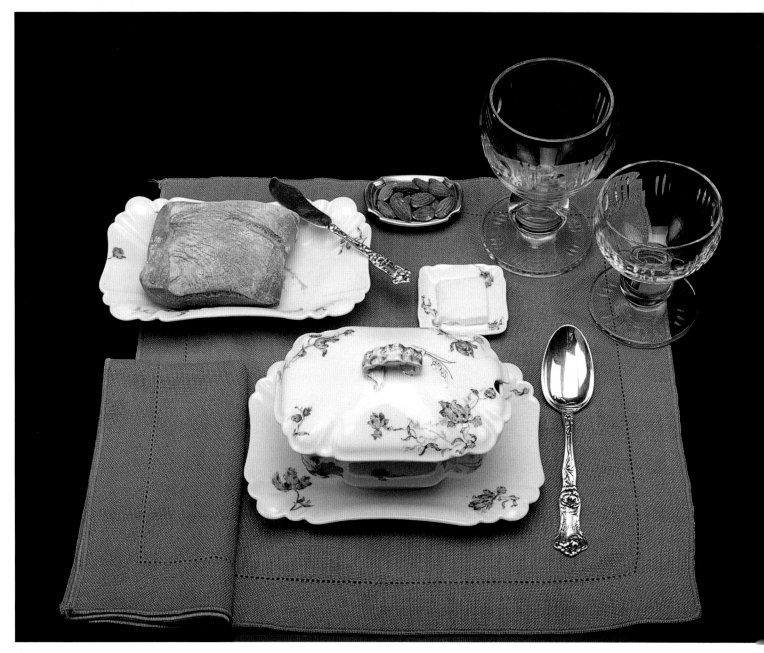

Figure 4.036. *Peony* was first introduced by Wallace in 1906, at the height of the Art Nouveau movement. No other sterling companies have put forth a design using peonies in them, so the pattern is distinctive and truly a Wallace original.

In this place setting the silver is paired with Haviland's #234, with peony/tulip-like flowers, plus glassware from Tiffany that is unnamed. All of the china rests on a Vera napkin serving as a placemat. The china uses a small covered sauce tureen to serve soup, and uses a dessert spoon in *Peony* that is 7" in length. The flat-handled butter spreader is 6-1/8", and the roll rests on a relish plate in this pattern. The square butter pat helps bring all this together..

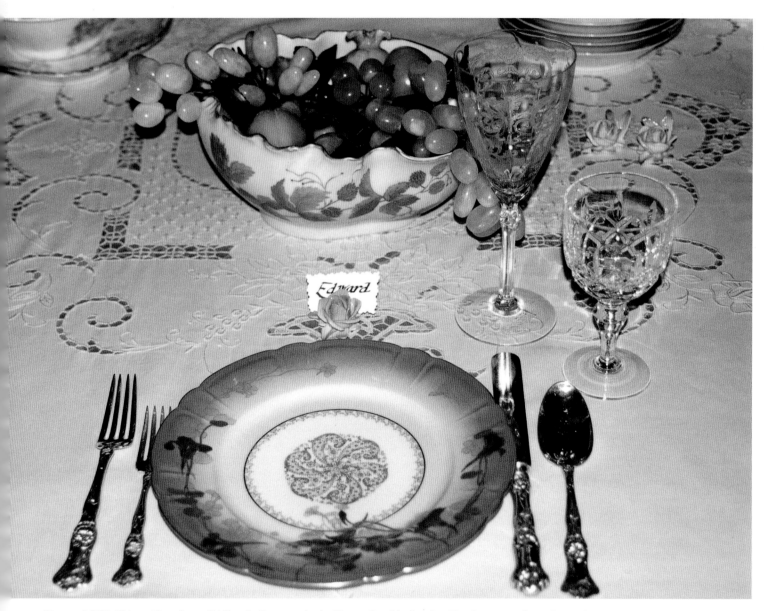

Figure 4.037. This setting shows Wallace's *Peony* paired with another Haviland setting in a more formal mood. The service plate is a Damose-decorated plate on a Diana blank. The crystal is Fostoria's *Versailles* and Stuart's *Regent*.

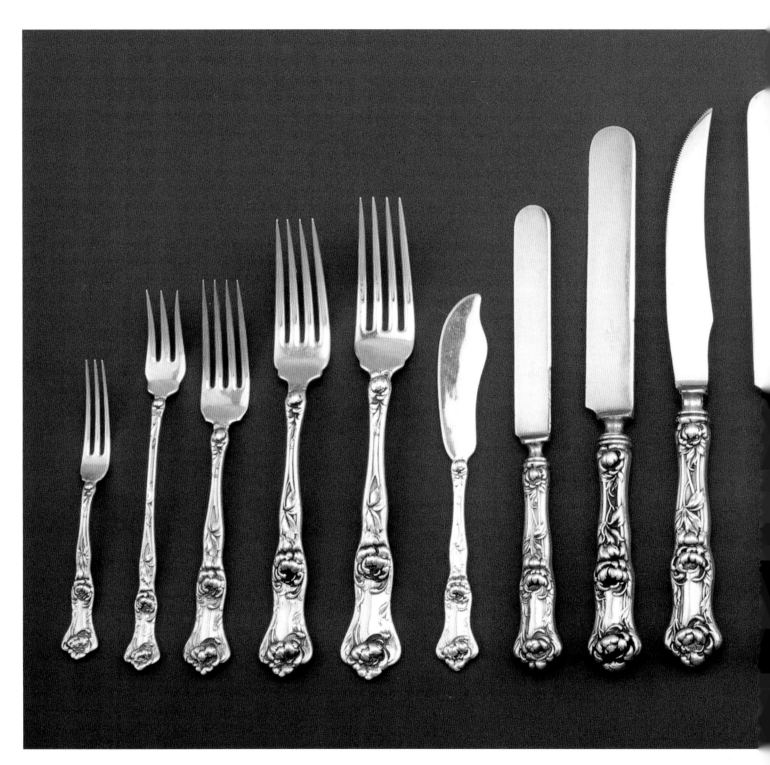

Figure 4.038. A number of items available in Wallace's *Peony*. Among these are the following: strawberry fork, 4-11/16"; cocktail fork, 5-15/16"; salad fork, 6-1/8"; tea fork, 6-1/8"; luncheon fork, 7-3/16"; dinner fork, 7-5/8"; flat-handled butter, 6-1/16"; tea knife, 7-9/16"; luncheon knife, 8-15/16"; steak knife, 9-1/8" (rebladed); dinner knife, 9-1/2"; dessert spoon, 7"; chowder spoon, 6-15/16"; teaspoon, 5-7/8"; ice cream spoon, 5-9/16"; 5 o'clock spoon, 5-7/16"; bouillon spoon 5-5/16"; demitasse spoon, 4-1/4"; and chocolate spoon, 4-1/16".

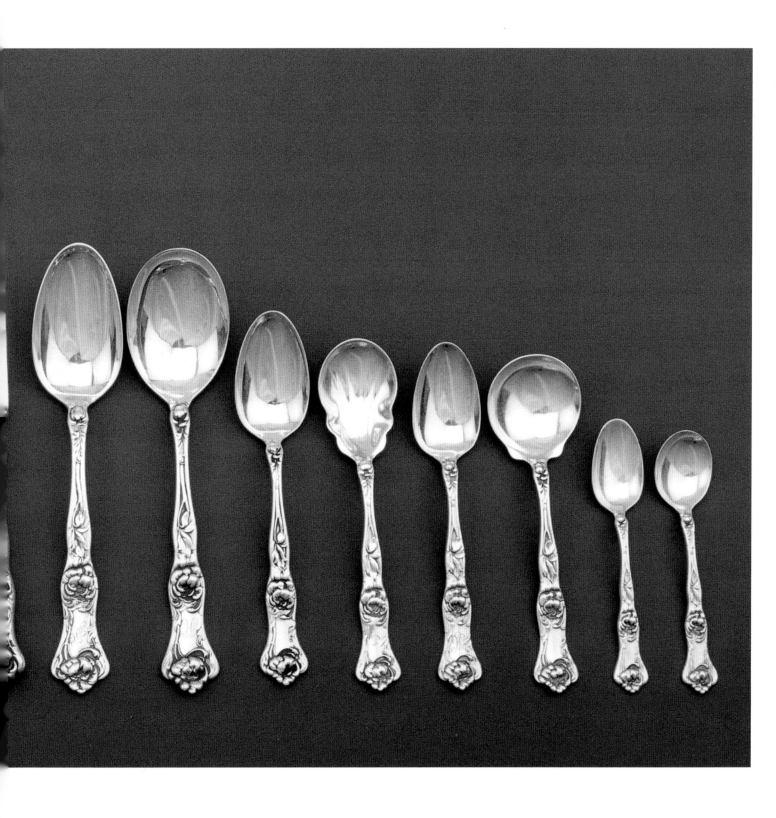

Iris by Durgin

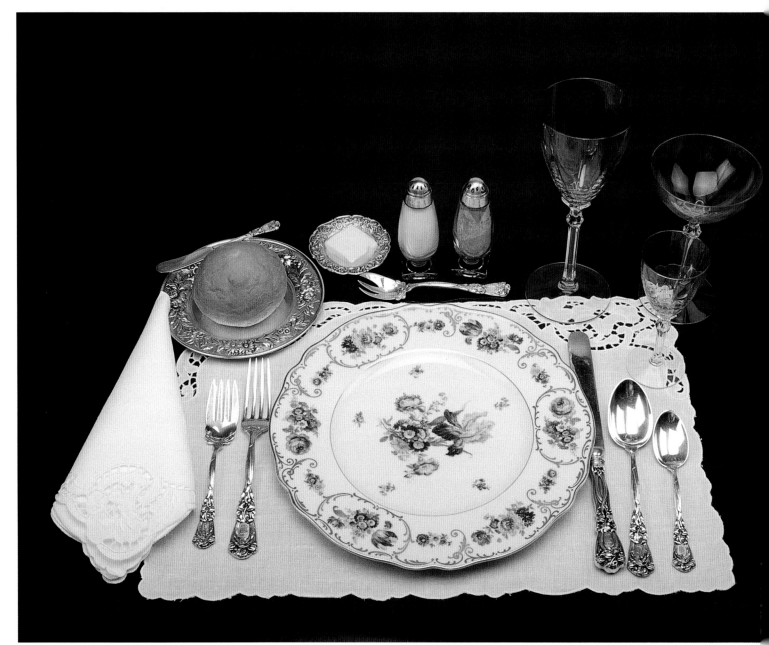

Figure 4.039. Durgin's *Iris*, Bavarian China in the *Franconia* pattern, and Fostoria's glassware complete this setting. The bread and butter plate, and the butter plate are sterling and in Kirk's *Repoussé*.

The setting includes the following silver: salad fork, 6-1/4"; dinner fork, 7-5/8"; dinner knife, 9-15/16"; dessert spoon, 7-1/8"; teaspoon, 5-13/16"; flat-handled butter knife, 5-1/4"; and an ice cream fork, 5-13/16", above the plate.

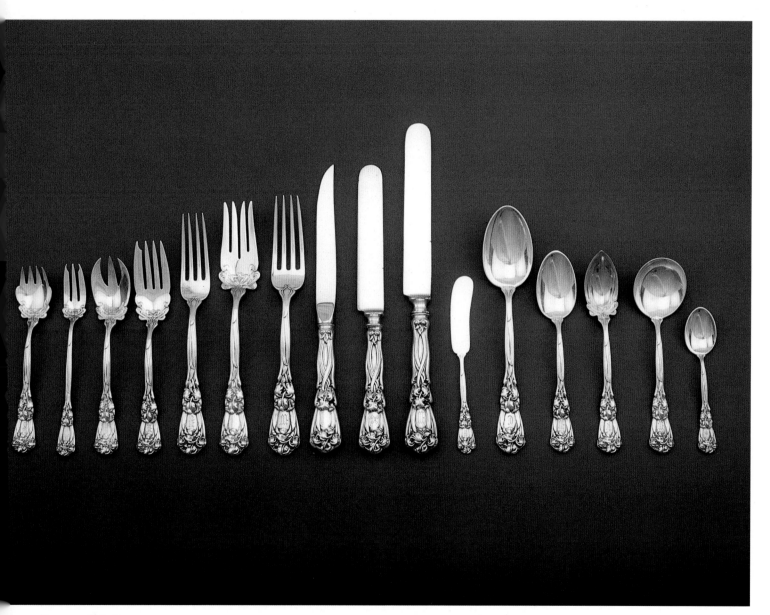

Figure 4.040. The *Iris* pattern in the following forms: terrapin fork, 5-1/2"; cocktail fork, 5-11/16"; ice cream fork, 5-13/16"; salad fork, 6-1/4"; luncheon fork, 7-1/16"; fish/salad fork, large, 7-7/16"; dinner fork, 7-5/8"; steak knife 8-5/8" (factory item); luncheon knife, 8-5/8"; dinner knife, 9-15/16"; all-silver butter knife, 5-1/4"; dessert spoon, 7-1/8"; teaspoon, 5-13/16"; grapefruit spoon, 5-13/16"; bouillon spoon, 5-9/16"; and demitasse spoon, 4-3/16".

Rose (1893) by Stieff

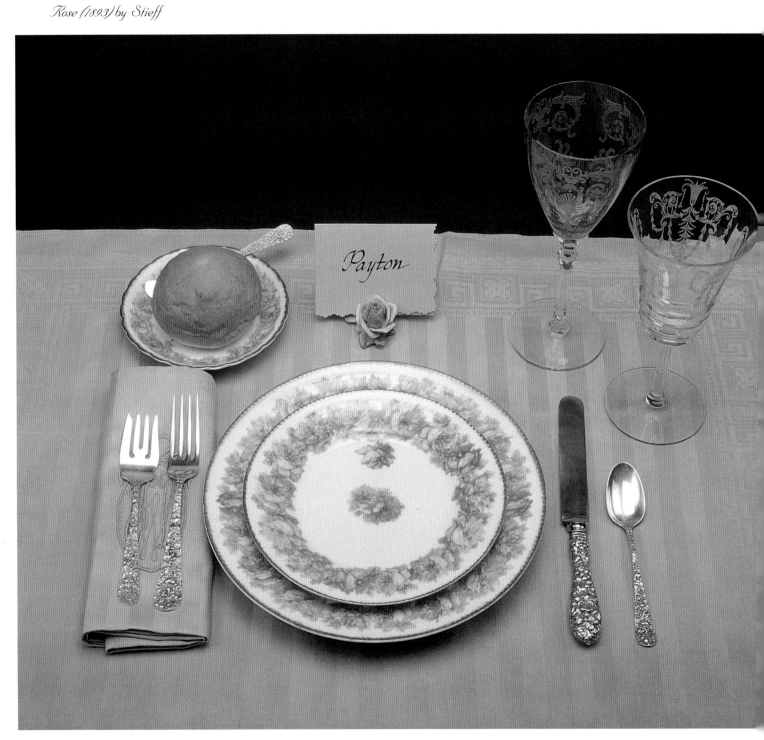

Figure 4.041. Roses in china and silver. Stieff's *Rose*, Haviland's *Drop Rose* china #55 on Blank 6 with Gold (Mark I, 1894-1931) and pink etched Fostoria complete the setting. The sterling setting consists of: a salad fork, 6-1/8"; a luncheon fork, 6-7/8"; a luncheon knife, 8-13/16"; and a teaspoon, 5-13/16". A butter spreader, 5-1/4", in Kirk's *Repoussé* is on the bread and butter plate.b

Richeleau by International

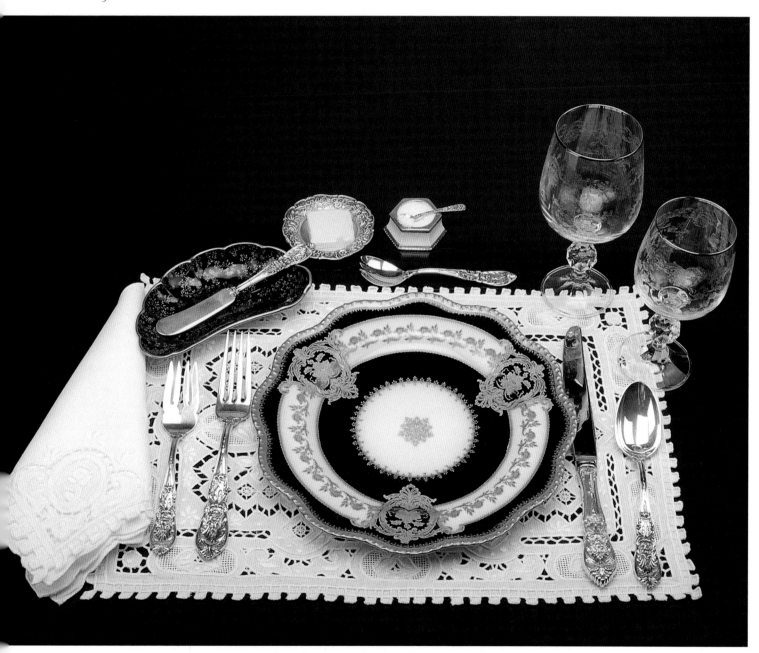

Figure 4.042. *Richeleau*, by International was truly a break from the plain art deco patterns that dominated the late 1920s and continued well into the 1930s. Here the silver is combined with a Haviland's salesman's sample (#21870) in Regal Cobalt Blue and Gold, and Rosenthal crystal. The silver consists of the following: salad fork, 6-1/2"; dinner fork, 7-11/16"; dinner knives, 9-5/8"; place spoon, 6-3/4"; all-silver flat butter spreader, 6"; and an ice cream fork, 5-5/16", to complete the place setting. Butter is presented on a Kirk *Repoussé* butter pat, and salt is served in individual salt dips with a salt spoon by Schofield in their *Baltimore Rose* pattern.

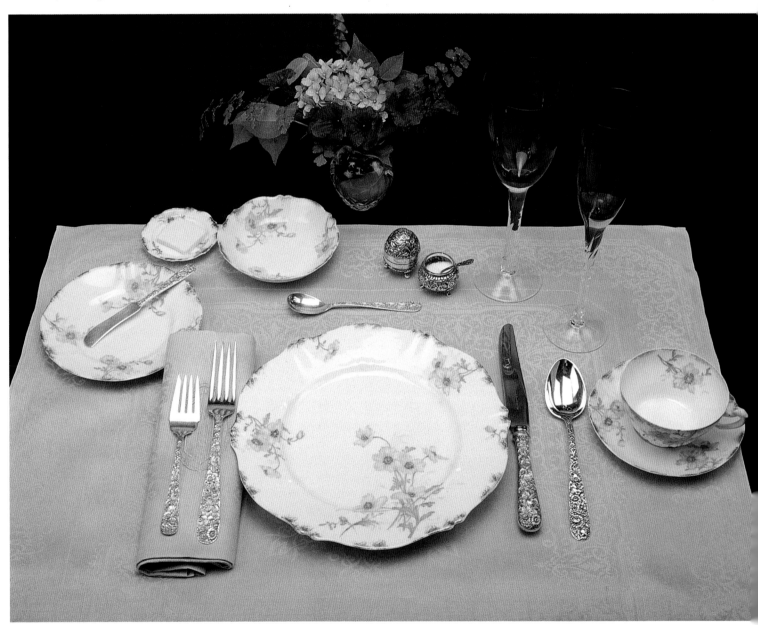

Figure 4.043. Theodore Haviland's china, 1893, #1039 on Blank 116 (St. Cloud) with gold daubs, #820 is paired with Kirk's *Repoussé* in this figure. The lavender of the china is further enhanced by inexpensive goblets and flutes in a complementing color. The sterling shown has the following items: salad fork, 6-5/8"; dinner fork, 7-7/8"; dinner knife, 9-11/16"; dessert spoon, 7-1/4"; flat-handled butter spreader, 5-1/4"; and a parfait spoon, 5-3/8", above the dinner plate.

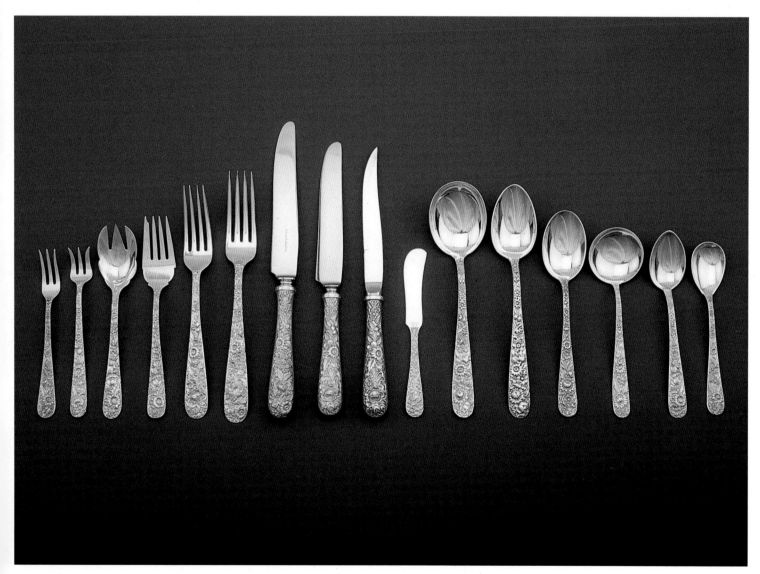

Figure 4.044. A collection of Kirk's *Repoussé*. The items are as follows: fruit cocktail, 5-1/4"; cocktail fork, 5-5/16"; ice cream fork, 6"; salad fork, 6-5/8"; luncheon fork, 7-1/4"; dinner fork, 7-7/8"; dinner knife, 9-11/16"; luncheon knife, 8-7/8"; steak knife, 8-3/4"; flat-handled butter spreader, 5-1/4"; chowder/gumbo soup, 6-7/8"; dessert spoon, 7-1/4"; place spoon, 6-3/8"; cream soup, 5-7/8"; teaspoon, 5-13/16"; and parfait/sorbet spoon, 5-3/8".

Old Orange Blossom by Alvin

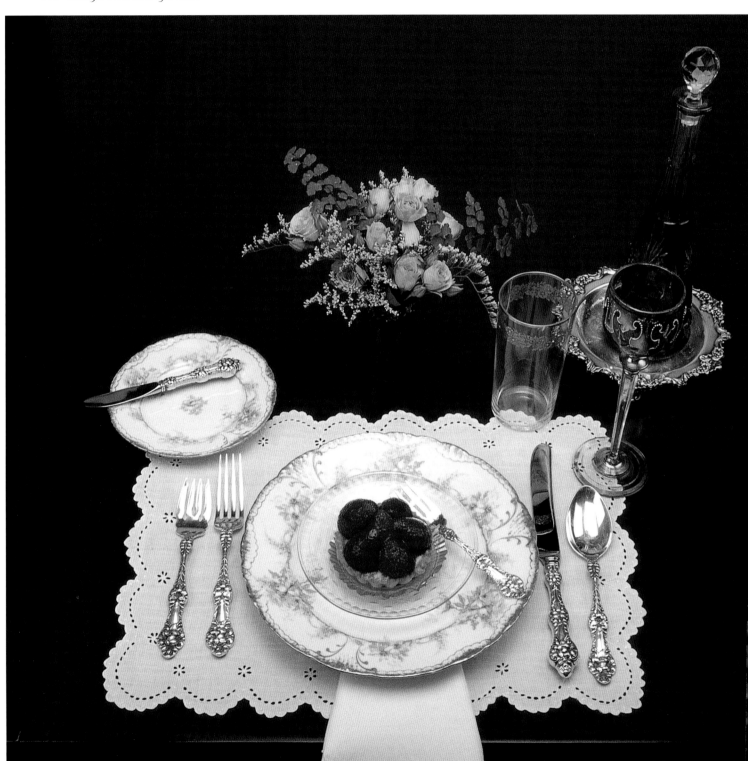

Figure 4.045. Alvin's *Old Orange Blossom* is paired with Theodore Haviland's unidentified American Rose pattern on blank 133, and a variety of crystal, one clear tumbler, and one cranberry hock, with a raspberry colored decanter. The silver consists of: a fish fork, 6-3/4"; a dinner fork, 7-1/2"; a dinner knife, 9-11/16"; a dessert spoon, 7-1/4"; and a hollow-handled butter spreader, 6-1/16" all from Gorham's current Masterpiece Collection. The salad/pastry fork with the fruit tart is from the original patent.

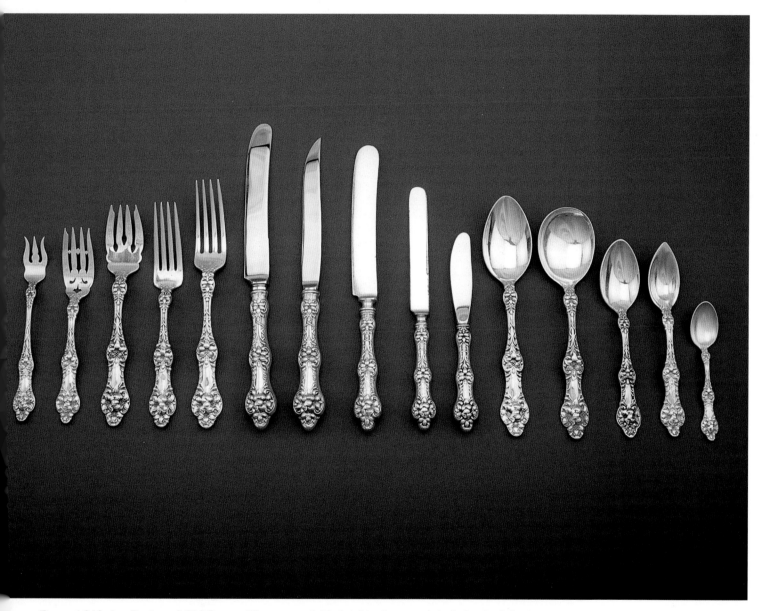

Figure 4.046. A collection of *Old Orange Blossom* available for this photograph includes the following items:
cocktail fork, 5-11/16"; pastry/salad fork, old, 5-15/16"; luncheon fork, 6-3/4"; dinner fork, 7-1/2"; dinner knife,
9-11/16"; steak knife (rebladed), 9-1/4"; luncheon knife, 8-15/16"; tea knife, 7-9/16"; hollow-handled butter
spreader, 6-1/16"; dessert spoon, 7-1/4"; chowder/gumbo soup, 6-15/16"; teaspoon, 5-7/8"; citrus spoon,
5-3/4"; and demitasse spoon, 4-1/8".

Strasbourg by Gorham

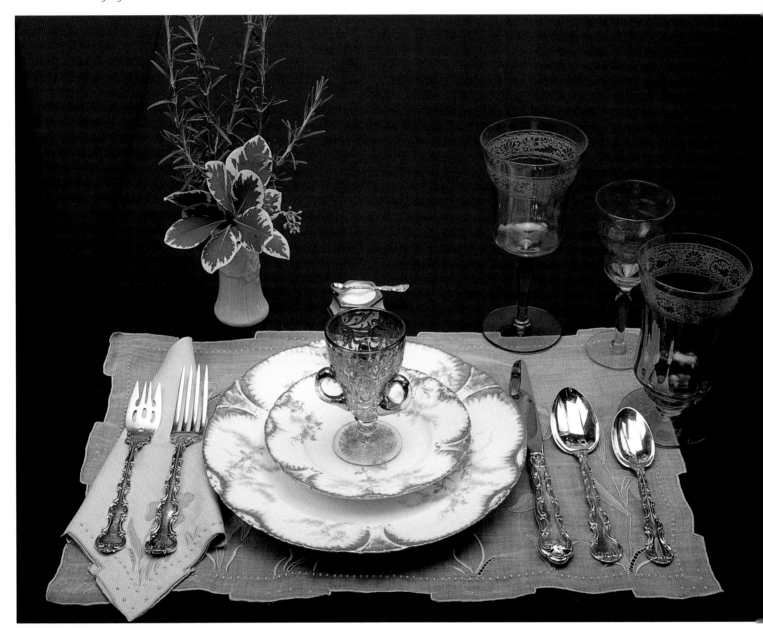

Figure 4.047. *Strasbourg* was introduced in 1897 by the Gorham Company. It is still in production today and represents a gay, informal pattern from the time of Louis XV, inspired by scrolls and shells for balance on the handles of the pieces. The back of this sterling also features a shell design, and so, for continental settings, this pattern can be used with forks and spoons turned upside down. Here the *Strasbourg* sterling is teamed with Theodore Haviland's unidentified pattern with a variation of gold on blank 133, and two pieces of Fostoria's *Royal* and a Depression wine glass. A piece of Mosher glass is resting on the bread and butter plate awaiting the seafood that it will hold, along with a cocktail fork. A small Beleek vase holds greens and sprigs of Rosemary for each setting. The linen is from the Philippines and carries out the green theme of the china and glassware. The silver at each place setting consists of the following: fish/large salad fork, 6-7/8"; dinner fork, 7-9/16"; place knife, 9-1/4"; place spoon, 6-3/4"; teaspoon, 5-15/16"; and a salt spoon 2-13/16", in a salt dish at the top of the figure.

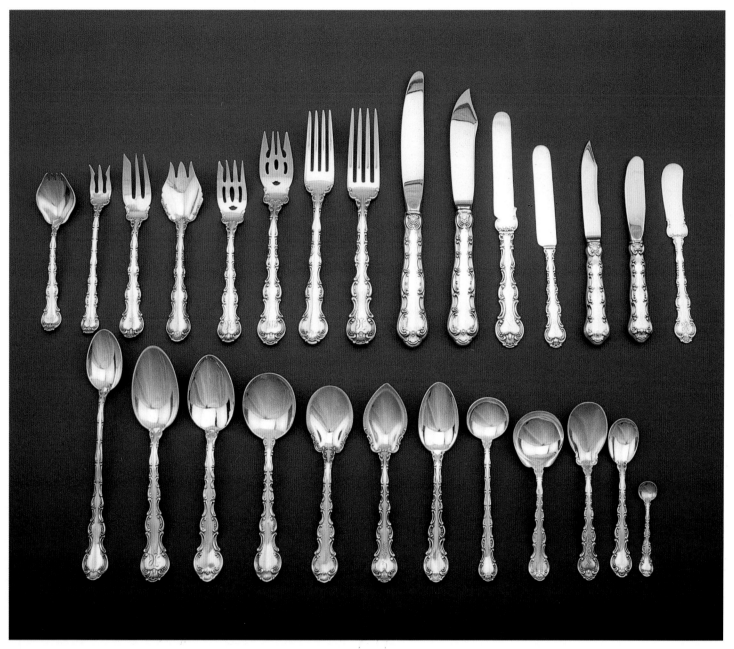

Figure 4.048. The *Strasbourg* pieces available to this collector.
Top row: terrapin fork, 5-1/32" cocktail fork 5-1/2"; pie fork, 5-7/8"; ice cream fork, large, 5-3/4"; salad/pastry fork, 5-7/8"; fish/salad fork, large, 6-7/8"; place fork, 7-5/8"; dinner fork, 7-7/8"; place knife, 9-1/4"; fish knife, 8-5/8"; all-silver tea knife, 7-27/32"; child's junior all-silver knife, 7-7/8"; hollow-handled spreader, 6-1/4"; flat-handled spreader, 6".
Bottom row: iced teaspoon, 7-5/8"; dessert spoon, 7-5/8"; place spoon, 6-3/4"; cream soup spoon, 6-1/8"; ice cream spoon, large, 5-13/16"; orange spoon, 5-7/8"; teaspoon, 5-15/16"; long-handled chocolate spoon, 5-3/8"; bouillon spoon, 5-1/8"; ice cream spoon, small, 5-1/8"; egg spoon, 4-11/16"; and individual salt spoon, 2-13/16".

Prelude by International

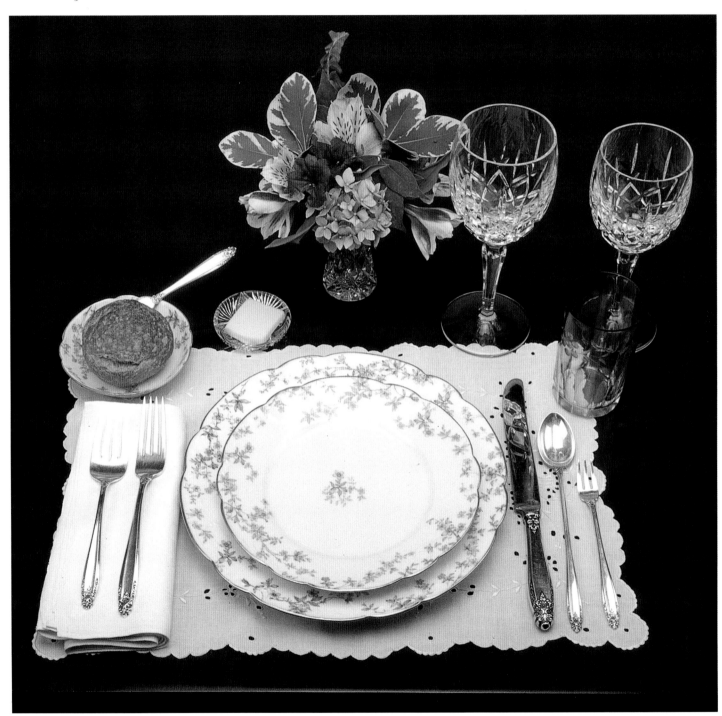

Figure 4.049. *Prelude*, a pattern introduced in 1939 has been a consistently good selling item for International. International produced sterling hollow ware in a wide variety of items to match the flatware. *Prelude* is viewed with Haviland's #81A on Blank 9 along with Gorham's *Queen Ann* stemware. A pale lavender-colored tumbler is also included. The silver shown in this figure consists of the following: a salad fork, 6-9/16"; a luncheon fork, 7-7/32"; a luncheon knife, 9-1/16"; an iced tea spoon, 7-5/16"; a cocktail fork, 5-1/2"; and a flat-handled butter spreader, 5-13/16".

Chrysanthemum by Durgin

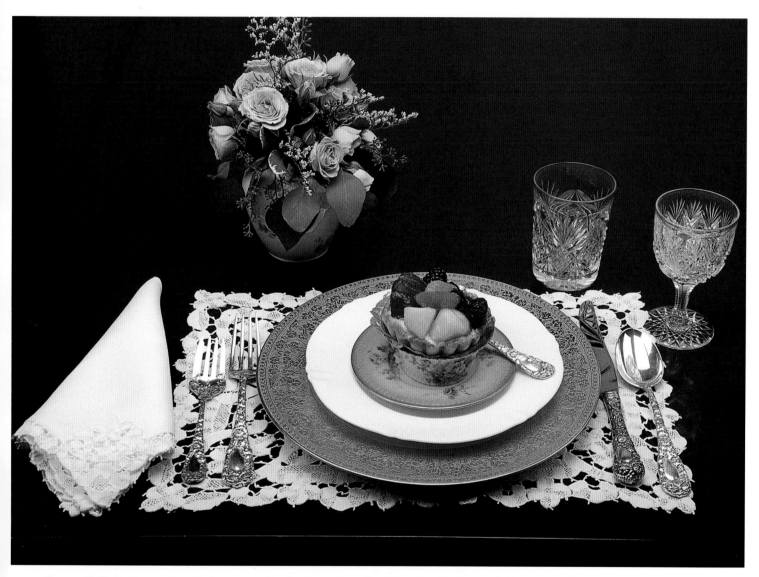

Figure 4.050. Resting on a gold charger is a Haviland ramekin with a Theodore Haviland salad beneath it. A cut glass tumbler by Clark and a superb brilliant period cut glass wine glass are all teamed with Durgin's *Chrysanthemum*. The pink in the Haviland ramekin is complemented by the pink roses in the floral arrangement. The silver consists of: a salad fork, 6-1/4"; a dinner fork, 7-1/2"; a dinner knife, 9-3/4"; a place spoon, 7-1/8"; and a cocktail fork, 5-9/16".

The Collector's Ultimate Dining Room

The last three pictures in this chapter feature three different views of a dining room set to receive some very fortunate guests. The lovely old pink-banded Lenox is paired with Gorham's *Dauphin* from the Masterpiece Collection, signed Mosher goblets, and a Sevres centerpiece with matching candlesticks, all resting atop an Italian lace tablecloth. This is a dream dining room every consummate collector hopes to someday achieve.

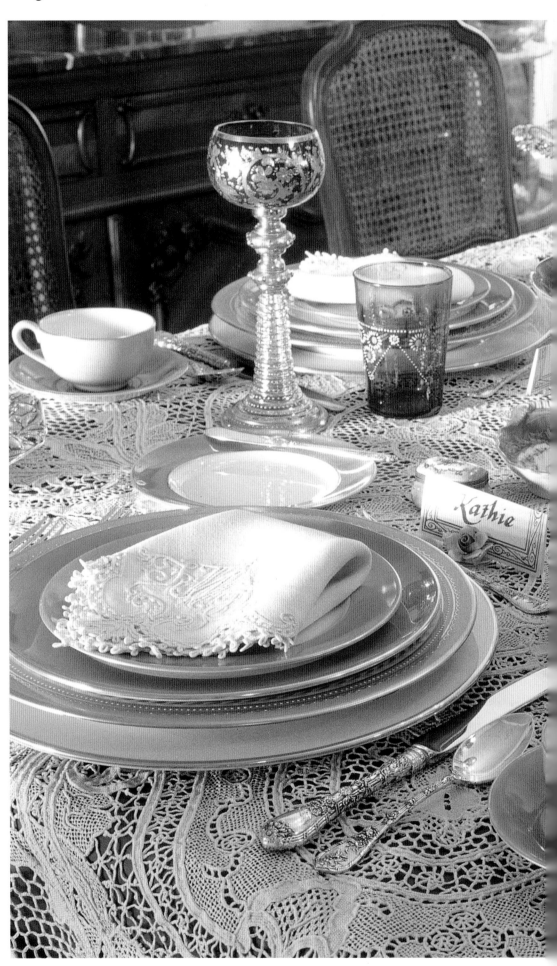

Figure 4.051.

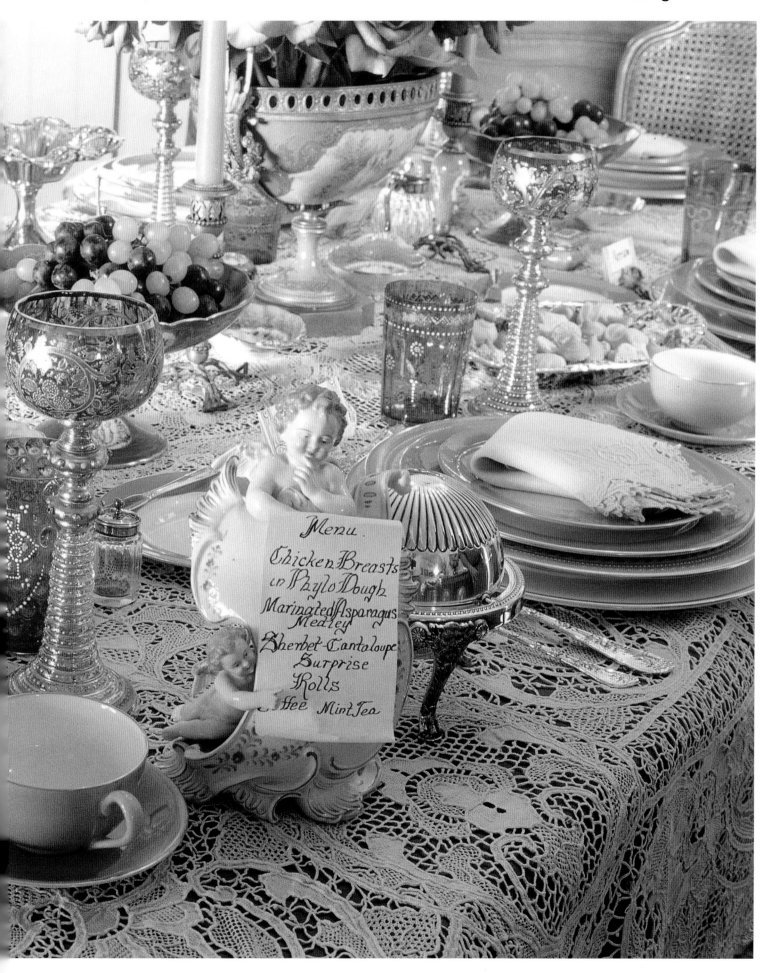

Menu.
Chicken Breasts
in Phylo Dough
Marinated Asparagus
Medley
Sherbet Cantaloupe
Surprise
Rolls
Coffee Mint Tea

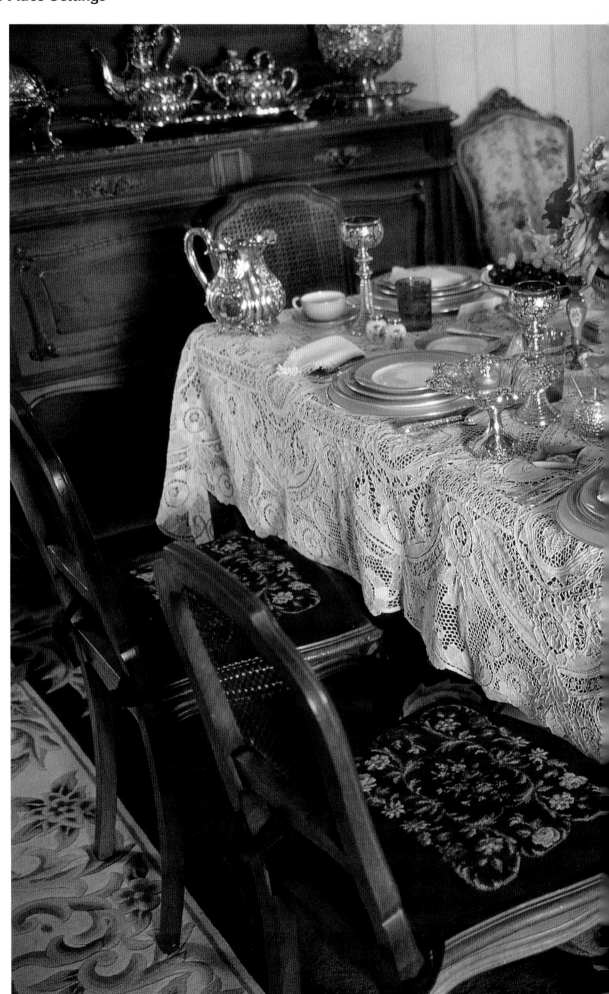

Figure 4.052.

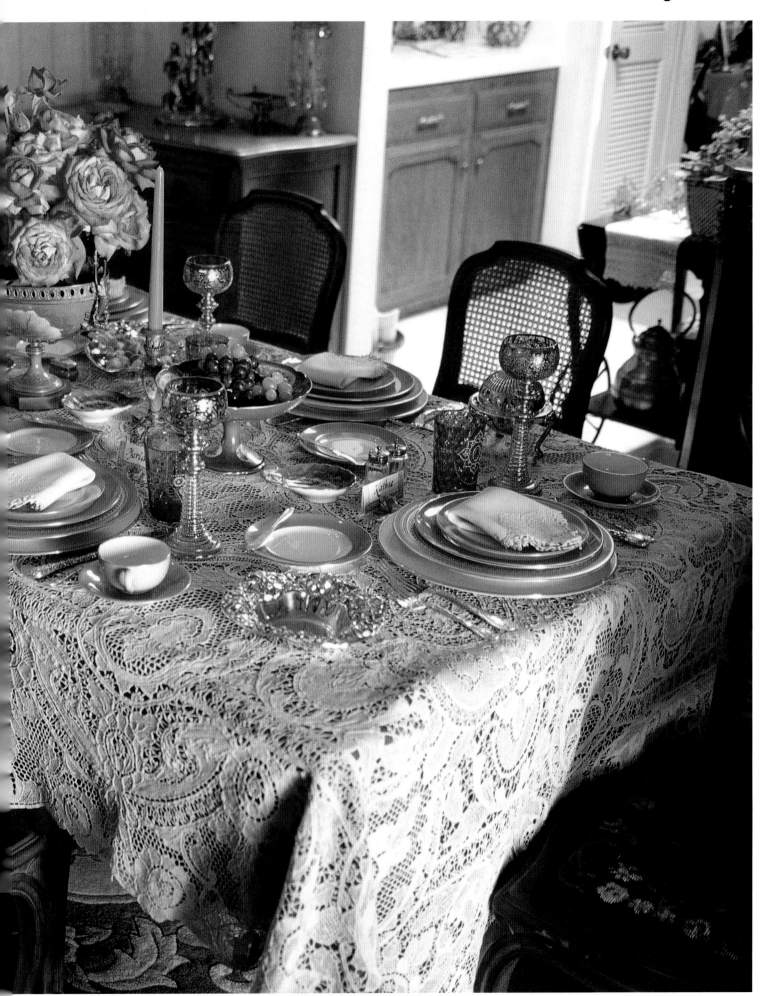

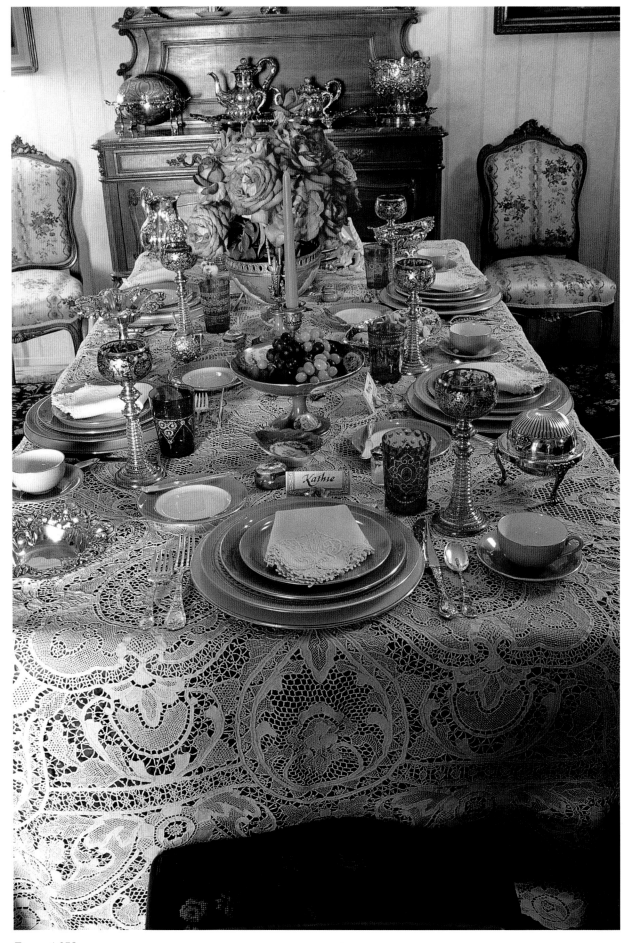

Figure 4.053.

Appendix 1
Flatware Catalog Excerpts

This section of this book contains examples of catalogs and reprints of original catalogs from a number of silver manufacturers. The value of these items makes each catalog a necessity to the collector, be they new to silver or well established. While a collection of catalogs for each silver pattern would be impossible to assemble, even if a catalog had been available for each of the patterns, when they do exist, they make identification simpler for the collector.

Throughout this text and previous books by this author the reader has been advised to attempt to locate a catalog, at least by the same manufacturer, to ease in the identification of unusual items. In the past the author managed to locate examples from customers, from silver friends, and others who also collected the same pattern. Photocopies were swapped, and the collection of information began.

Many times a missing catalog called for approximating the exact identification, thus allowing error to occur. In this same vein, some jewelry companies must have had an agreement to allow them to apply something completely different to the handle provided by the manufacturer, creating a whole new item. The west coast jeweler, Shreve and Company, and Vanderslice and Company are two places where this practice occurred. Had a catalog been available with exact definitions of the pieces, the "made-up" examples would have easily been identified as such, and not oddities from the original manufacturer.

Looking for the catalogs that identify, show, and provide assistance to the collector has been greatly helped by the items available from The Eden Sterling Company, 7672 Montgomery Rd. #244, Cincinnati, Ohio, 45236. This company provided a number of catalogs for preparation of this section, some of which are shown in the following examples. A few are from the author's collection and were obtained from customers and other collectors. Orders may be placed by calling 800-385-3336.

A listing of available catalogues from Eden Sterling Company

Manufacturer	Pattern
Durgin	Chatham , DuBarry, Fairfax, Lenox
Durgin/Gorham	Colfax
Gorham	Baronial, Old (two versions), Buckingham, Cambridge, Cinderella, Cromwell, Etruscan, Fleury,Florentine, Hamilton, Jefferson, King Albert, King Edward, King George, La Modele, Lancaster, Mothers, Mythologique (two versions), Newcastle, Norfolk, Old French, Portsmith, Royal Oak, St. Cloud, Tuileries, Versailles, Wreath.
International	Georgian M aid, Pantheon, Theseum, and Trianon
Georg Jensen	Acorn
Kirk	Repousse (three versions)
Lunt	See Rogers, Lunt and Bowlen
Reed and Barton	Miscellaneous, Oxford
Rogers, Lunt and Bowlen	Chateau Thierry
Stieff	Rose (three versions)
Towle	Benjamin Franklin, Canterbury, Cordova, Gerogian (two versions), Lady Constance, Lafayette (two versions), Loving Cups, Mary Chilton, Miscellaneous, Newbury, Old English, Paul Revere
Watson	Miscellaneous
Wallace	Grande Baroque, Grande Colonial, Rhyuthm, Rose Point, and Stradivari

The Historical Catalogue Series

See us on the web at:
www.edensterling.com

The Historical Catalogue Series is a collection of professionally reprinted silver trade catalogues from the late 19th century and the early 20th century.

The series was started to make research and reference material more easily available to a greater number of people. Most of the original catalogues in this series can only be found in museums or private collections and are not readily accessible to most individuals.

These old catalogues will be of interest to museum curators, appraisers, historians and antique dealers. Scholars will find them a necessity. Collectors will especially find them useful in determining the use and names of certain lesser-known pieces of sterling.

There are currently 9 different catalogues in the Historical Catalogue Series. 1) 1896 Whiting Manufacturing Company, 2) 1888 Gorham Manufacturing Company, 3) 1901 Daniel Low & Company, 4) 1910 Gorham Buttercup, 5) 1910 Gorham Strasbourg, 6) 1898 Towle Old Colonial, 7) 1910 Towle Old Colonial, 8) 1904 Unger Bros. 9) 1905-1906 Unger Bros. Supplement.

1896 Whiting Manufacturing Company

This 60-page catalogue illustrates over 700 different pieces of flatware, holloware and other miscellaneous items in many of Whiting's most desirable patterns. Included are Louis XV (185 pieces), Heraldic (55 pieces), Imperial Queen (156 pieces), Lily of the Valley (3 pieces), Hyperion (43 pieces), Oval Twist (61 pieces), Empire (125 pieces), Ivory (25 pieces), Dresden (5 pieces) and Bead (81 pieces). See fried egg servers, glove stretchers, coffee & tea sets, bookmarks, egg spoons, sardine tongs, paper cutters, dresser sets, cheese forks, and much more. This is the earliest known Whiting catalogue. Indexed. (ISBN 0-9656139-2-5) $24.95 postage paid.

1888 Gorham Manufacturing Company

This 40-page catalogue shows some of the classic Victorian flatware produced by the Gorham Manufacturing Company in the 19th century. Patterns illustrated are Versailles (16 pieces), Old Medici (8 pieces), Cluny (14 pieces), Old Masters (10 pieces), Colonial (20 pieces), St. Cloud (18 pieces), Jac Rose (9 pieces) as well as others. This catalogue shows the early differences between many pieces such as the salad and fish forks. Additionally, it shows a broad overview of what was available across many different lines in a time of great opulence. Indexed. $19.95 postage paid.

Visit us on the web at www.edensterling.com

Call 1-800-385-3336 to place your order today!

Figure A.01. The Historical Catalog Series

1901 Daniel Low & Company

This 168-page catalogue beautifully illustrates over 2,000 different items. This Salem, Massachusetts company is perhaps best know for starting the souvenir spoon craze in America in the 1890's with their Salem Witch souvenir spoon. They were also retailers of brooches, pendants, pins, cuff links, pocket watches, flatware, chatelaine bags and purses, match safes, sewing items, bookmarks, golf articles and other novelties in sterling and gold from some of the best known manufacturing firms such as Gorham, Durgin, Towle, Unger Bros., Shiebler and more.

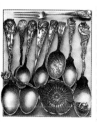
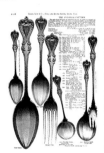

Within this catalogue are 40 pages of sterling flatware and holloware, including Towle's Old Colonial (31 pieces), Canterbury (5 pieces), Old English (3 pieces), Georgian (5 pieces) and Newbury (19 pieces); Whiting's Louis XV (24 pieces); Durgin's Dauphin (32 pieces) and Madame Royale (25 pieces); Gorham's Lancaster (27 pieces) and Strasburg (4 pieces); Dominick & Haff's Labors of Cupid (6 pieces) and New Kings (5 pieces); Shiebler's American Beauty (5 pieces) and Gothic (1 piece); Unger Bros.' Narcissus (5 pieces); Mount Vernon's Josephine (29 pieces) and Apollo (10 pieces); Howard Sterling Co.'s York (5 pieces); and Frank W. Smith's Countess (25 pieces).

1910 Gorham Buttercup

This 12-page catalogue illustrates 59 different pieces in this popular pattern, such as the ramekin fork, chips server, relish fork, chocolate spoon, ice cream fork and vegetable spoon. Many of the pieces illustrated in the 1910 Gorham Strasbourg Catalogue were also made in Buttercup. Indexed. $8.95 postage paid.

1910 Gorham Strasbourg

This 12-page catalogue illustrates 69 different pieces in this pattern originally patented in 1897. Some of the more unusual items illustrated are the tea maker, butter pick, sandwich tongs and terrapin fork. Many of the pieces illustrated in the 1910 Gorham Buttercup Catalogue were also made in Strasbourg. Indexed. $8.95 postage paid.

If you have any questions, please call 1-800-385-3336

Figure A.02. The Historical Catalog Series

1898 & 1910 Towle Old Colonial

The 1898 Old Colonial Catalogue is the earliest known catalogue for this pattern that was first manufactured in 1895. There are 108 different pieces of flatware illustrated in the 1898 catalogue and over 150 different pieces of flatware and holloware in the 1910 catalogue. Towle changed the design of several pieces early on in addition to adding many new pieces to their Old Colonial line between 1898 and 1910.

1898 Catalogue	$8.95
1910 Catalogue (soft-cover)	$23.95
1910 Catalogue (hard-cover)	$33.95

1904 Unger Bros.

This 200-page catalogue from 1904 illustrates 3,200 different pieces of sterling silver. There are 213 pieces of flatware illustrated in Douvaine (50 pieces), Fontenoy (36 pieces), Narcissus (53 pieces), Passaic (61 pieces) and more. Over 900 different pieces of jewelry are illustrated including 16 lorgnettes, 148 belt pins, 179 brooches, 246 hatpins, 39 tie clasps, 80 fobs, 110 link buttons (cuff links), 68 scarf pins, and 68 lockets. There are 207 holloware items including tea sets, berry bowls, cups, butter dishes, candlesticks, Tabasco Sauce holders, shaving items, flasks, shoe horns, tooth brushes, tobacco items, pin cushions, mustard cups, vases, baby items, bookmarks, whistles, Vaseline jars, bag tags, funnels & more. The foreword is written by Ulysses Grant Dietz, Curator of Decorative Arts at the Newark Museum. Unger Brothers Biography is written by Janet Zapata, Jewelry Historian. Indexed. 7" x 10" (ISBN 0-9656139-3-3) $59.95 postage paid.

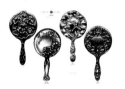

UNGER BROS.
MANUFACTURING
Jewelers
Silversmiths
and
Glass Cutters
FACTORY AND SALESROOM
412-418 Halsey Street
26-38 Beecher Street Newark, N. J.

1905-1906 Unger Bros. Supplement

This 64-page catalogue reprint is filled with wonderful art nouveau sterling silver designs including jewelry, silverware and holloware. All of the 700 plus designs illustrated are different than any of the items illustrated in the 1904 Unger Bros. catalogue. This previously unknown catalogue provides wonderful insight into the Unger Bros. as jewelers and silversmiths. The original catalogue measured an unbelievable 20" x 14". We have reduced the catalogue to a more manageable size of 11" x 8 1/2". Ulysses Grant Dietz, Curator of Decorative Arts at the Newark Museum, has written the introduction. The preface has been written by Dorothy T. Rainwater, author of "The Encyclopedia of American Silver Manufacturers". (ISBN 0-9656139-5-X) Indexed. $29.95 postage paid

Call 1-800-385-3336 to place your order today!

Figure A.03. The Historical Catalog Series

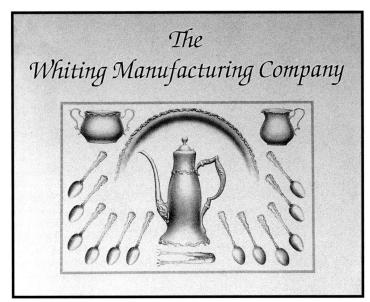

Figure A.04 The Whiting Manufacturing Company

Right and below:
Figure A.05 Pages from the catalog illustrating *Imperial Queen*

Figure A.06. Gorham Mfg. Co Silversmiths Catolog Year 1888

Figure A.07. Page 33 from the Gorham catalogue

Figure A.08. Cover from Colonial by Towle

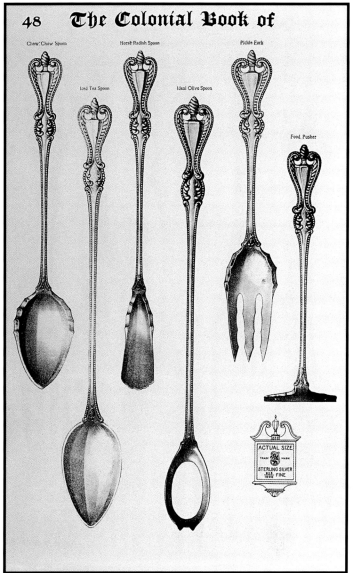

Figure A.09. Page 48 from Colonial catalog

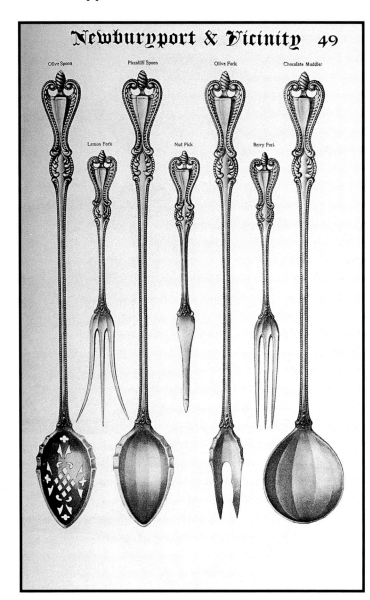

Figure A.10 Page 49 from Colonial catalog

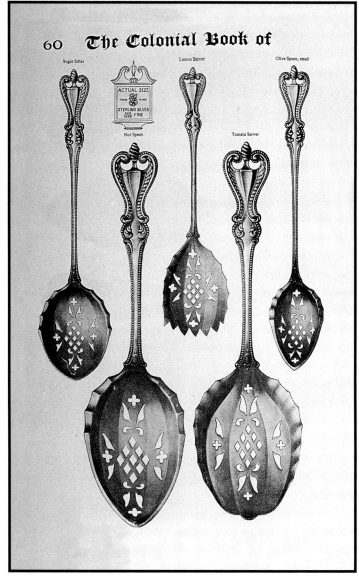

Figure A.11. Page 60 from Colonial catalog

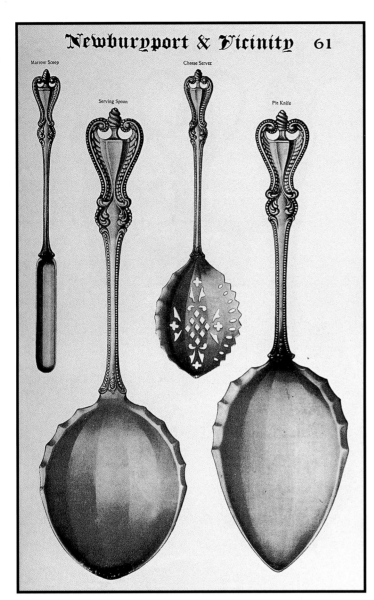

Figure A.11B. Page 61 from Colonial catalog

Figure A.12. Page 68 from Colonial catalog

Figure A.13. Page 69 from Colonial catalog

Figures A.14 from Reed and Barton's *Intaglio* catalog

List of the eight flowers shown in the Intaglio pattern: Nectarine, Petunia, Peony, Wild Rose, Poppy, Orchid, Treasure Vine and Fleur de lis

Approximate Weights of Spoons and Forks

Tea Spoons	Nectarine	12 ounces and 15 ounces per dozen
Dessert Spoons	Petunia	20 ounces and 24 ounces per dozen
Table Spoons	Peony	28 ounces and 33 ounces per dozen
Dessert Forks	Wild Rose.	20 ounces and 24 ounces per dozen
Table Forks	Poppy	28 ounces and 33 ounces per dozen

Alphabetical List of Articles

In ordering, the name of the pattern should be mentioned

400	After Dinner Tea Spoons .	Treasure Vine	443	Child's Spoons	Nectarine
401	Almond Spoon, hand-pierced bowl	Treasure Vine	444	Child's Forks	Nectarine
402	Asparagus Fork, hand-pierced blades	Poppy	445	Child's Knives, flat handles . . .	Peony
403	Asparagus Servers, hand-pierced blades	Poppy	446	Child's Knives	Orchid
404	Asparagus Servers	Poppy		Hollow handles, plated steel blades	
	Hollow handles, hand-pierced blades		447	Chutney Spoons	Nectarine
405	Asparagus Tongs, hand-pierced .	Petunia	448	Cheese Knives	Peony
406	Asparagus Holders, individual, pierced	Peony	449	Cheese Forks, hand-pierced . .	Nectarine
407	Beef Forks, hand-pierced . . .	Petunia	450	Cheese Servers, hand-pierced .	Nectarine
408	Berry Spoons, large	Orchid	451	Cheese Scoops, large	Poppy
	O. x Adrianae Victoria-Regina		452	Cheese Scoops, medium . . .	Petunia
409	Berry Spoons, small	Poppy	453	Cheese Scoops, small	Nectarine
410	Berry Forks	Treasure Vine	454	Claret Spoons, long handles .	Nectarine
411	Bird or Steak Carving Knives	Wild Rose	455	Claret Spoons, short handles .	Nectarine
	Hollow handles, unplated blades		456	Coffee Spoons	Treasure Vine
412	Bird or Steak Carving Knives	Wild Rose	457	Cocktail Forks	Treasure Vine
	Hollow handles, plated blades		458	Cold Meat Forks, large . . .	Poppy
413	Bird or Steak Carving Forks	Wild Rose	459	Cold Meat Forks, small, hand-pierced	Petunia
	Hollow handles, plated tines		460	Confection Spoons, hand-pierced	Nectarine
414	Bird or Steak Carving Forks	Wild Rose	461	Cucumber Server, hand-pierced	Poppy
	Hollow handles, unplated tines		462	Cracker Spoons, hand-pierced .	Poppy
415	Bouillon Spoons, large . . .	Nectarine	463	Cracker Servers, hand-pierced . .	Poppy
416	Bouillon Spoons, small	Peony	464	Crumb Knives, hand-pierced blades	Poppy
417	Bouillon Ladles	Petunia	465	Crumb Knives	Poppy
418	Bon Bon Scoops, hand-pierced .	Peony		Hollow handles, hand-pierced blades	
419	Bon Bon Spoons, small .	Treasure Vine	466	Croquette Servers, hand-pierced .	Petunia
420	Brandy Burners	Treasure Vine	467	Cream Dippers	Petunia
421	Breakfast Knives . . .	Wild Rose	468	Custard Servers	Nectarine
	Hollow handles, plated blades		469	Dessert Knives	Wild Rose
422	Breakfast Knives . . .	Wild Rose		Hollow handles, plated blades	
	Hollow handles, unplated blades		470	Dessert Knives	Wild Rose
423	Bread Forks, hand-pierced . .	Petunia		Hollow handles, unplated blades	
424	Butter Knives	Peony	471	Egg Spoons	Peony
425	Butter Knives, hollow handles . .	Orchid	472	Egg Spoons, enameled bowls .	Peony
426	Butter Spreaders	Wild Rose	473	Fish Knives	Poppy
427	Butter Pat Spreaders, hand-pierced .	Nectarine		Large, serving, hand-pierced blades	
428	Butter Picks, No. 1	Petunia	474	Fish Forks	Poppy
429	Butter Picks, No. 2	Petunia		Large, serving, hand pierced tines	
430	Butter Picks, No. 3	Petunia	475	Fish Knives, small, serving, hand-pierced	Petunia
431	Cake Knives, hand-pierced, saw edge	Peony	476	Fish Forks, small, serving, hand-pierced	Petunia
432	Cake Knives, hollow handles, saw edge	Wild Rose	477	Fish Knives, large, individual .	Peony
433	Cake Forks, hand-pierced . .	Petunia	478	Fish Forks, large, individual .	Petunia
434	Carving Knives	Poppy	479	Fish Knives, small, individual .	Peony
	Hollow handles, unplated blades		480	Fish Forks, small, individual .	Nectarine
435	Carving Knives, hollow handles, plated blades	Poppy	481	Fish Knives, individual . .	Wild Rose
436	Carving Forks, hollow handles, plated tines	Poppy		Hollow handles, plated steel blades	
437	Carving Forks, hollow handles, unplated tines	Poppy	482	Five O'Clock Tea Spoons . .	Peony
438	Carving Steels, hollow handles . .	Poppy	483	Food Pushers, large	Peony
439	Cereal Spoon	Nectarine	484	Food Pushers, large, ornamented scenes	Peony
440	Chocolate Spoons, large . . .	Peony	485	Food Pushers	Peony
441	Chocolate Spoons, small .	Treasure Vine		Large, ornamented scenes and words	
442	Chocolate Muddlers	Nectarine	486	Food Pushers, small . .	Treasure Vine

487 Food Pushers Treasure Vine Small, ornamented scenes	544 Oat Meal Spoons Poppy
488 Food Pushers Treasure Vine Small, ornamented scenes and words	545 Olive Spoons, hand-pierced . . . Petunia
489 Frappe Spoons Petunia	546 Olive Spoons, long handles, hand-pierced . Petunia
490 Fried Oyster Servers, hand-pierced Petunia	547 Olive Spoon and Fork, combination Petunia
491 Fruit Knives, flat handles . Wild Rose	548 Olive Forks Petunia
492 Fruit Knives, hollow handles . . Orchid	549 Olive Forks, long handles . . . Petunia
493 Game Carving Knives Poppy Hollow handles, unplated blades	550 Olive Tongs Peony
494 Game Carving Knives . . , . Poppy Hollow handles, plated blades	551 Orange Spoons Nectarine
495 Game Carving Forks Poppy Hollow handles, plated tines	552 Orange Knives, flat handles . . . Peony
496 Game Carving Forks Poppy Hollow handles, unplated tines	553 Orange Knives Orchid Plated steel blades, saw edge, hollow handles
497 Gravy Spoons Poppy	554 Oyster Forks Petunia
498 Horse Radish Spoons Petunia	555 Oyster Cocktail Fork . . . Treasure Vine
499 Ice Cream Forks, large . . . Nectarine	556 Pastry Forks, hand-pierced . . Nectarine
500 Ice Cream Forks, small Peony	557 Pancake Servers, hand-pierced . . Poppy
501 Ice Cream Spoons, large . . . Nectarine	558 Pap Spoons Nectarine
502 Ice Cream Spoons, small Peony	559 Patty Servers Petunia
503 Ice Cream Servers, large, hand-pierced . Poppy	560 Pea Spoons, hand-pierced . . . Poppy
504 Ice Cream Servers, small, hand-pierced . Petunia	561 Picalilli Spoons Petunia
505 Ice Cream Slicers, large, hand-pierced . Poppy	562 Pie Forks, hand-pierced Petunia
506 Ice Cream Slicers, small, hand-pierced . Peony	563 Pie Knives, hand-pierced Poppy
507 Ice Cream Slicers Poppy Hollow handles, hand-pierced	564 Pie Servers Wild Rose Hollow handles, plated steel blades
508 Ice Tea Spoons Petunia	565 Pickle Forks Nectarine
509 Ice Spoons, hand-pierced bowls . Poppy	566 Preserve Spoons Petunia
510 Ice Tongs, hand-pierced . . . Nectarine	567 Pudding Spoons Poppy
511 Infants' Forks Peony	568 Ramequin Forks Peony
512 Infants' Knives Wild Rose	569 Ramequin Forks, large . . . Nectarine
513 Infants' Spoons Peony	570 Salad Spoons, extra large . . . Orchid O. x Adrianae Victoria-Regina
514 Jelly Cake Servers, hand-pierced . Petunia	571 Salad Forks, extra large, hand-pierced . . Orchid O. x Adrianae Victoria-Regina
515 Jelly Spoons Petunia	572 Salad Spoons, large Poppy
516 Jelly Servers, hand-pierced . . . Petunia	573 Salad Forks, large, hand-pierced . Poppy
517 Joint Forks Poppy Large, hollow handles, steel tines	574 Salad Forks, large, individual . Petunia
518 Joint Forks Wild Rose Small, hollow handles, steel tines	575 Salad Forks, small, individual . Nectarine
519 Joint Holders, hollow handles . . Poppy	576 Salad Servers, hand-pierced . . . Poppy
520 Knife Sharpeners, hollow handles . Poppy	577 Salt Spoons Treasure Vine
521 Ladles, Cream Petunia	578 Sardine Forks, hand-pierced . Nectarine
522 Ladles, Gravy Petunia	579 Sardine Servers, hand-pierced . Nectarine
523 Ladles, individual, large Poppy	580 Saratoga Chip Servers, hand-pierced Poppy
524 Ladles, individual, small Petunia	581 Serving Forks, hand-pierced . . . Poppy
525 Ladles, Oyster Poppy	582 Serving Spoons Poppy
526 Ladles, Punch, long handle . . . Poppy	583 Sherbet Spoons, large Peony
527 Ladles, Punch, short handle . . . Poppy	584 Sherbet Spoons, small . . . Treasure Vine
528 Ladles, Soup Poppy	585 Sherbet Spoons, long handles . . Petunia
529 Lettuce Forks, hand-pierced . . . Petunia	586 Smelt Forks, hand-pierced . . Nectarine
530 Lemon Forks, hand-pierced Treasure Vine	587 Smelt Servers, hand-pierced . . Nectarine
531 Lobster Cracks, hollow handles . Poppy	588 Soup Spoons Petunia
532 Macaroni Spoons, hand-pierced . Poppy	589 Sugar Sifters, large, hand-pierced Petunia
533 Macaroni Servers, hand-pierced . Poppy	590 Sugar Sifters, small, hand-pierced Nectarine
534 Mango Fork Orchid	591 Sugar Spoons Fleur de lis
535 Meat Carving Knives Poppy Hollow handles, unplated blades	592 Sugar Tongs, tete-a-tete . . . Nectarine
536 Meat Carving Knives Poppy Hollow handles, plated blades	593 Sugar Tongs, large Peony
537 Meat Carving Forks . . . Poppy Hollow handles, plated tines	594 Table Knives Poppy Hollow handles, plated blades
538 Meat Carving Forks Poppy Hollow handles, unplated tines	595 Table Knives Poppy Hollow handles, unplated blades
539 Meat Carving Steels, hollow handles . Poppy	596 Tea Knives, flat handles . . Wild Rose
540 Mustard Spoons . . . Treasure Vine	597 Tea Spoons, small Peony
541 Nut Crackers Wild Rose Hollow handles, steel cracks	598 Terrapin Fork Nectarine
542 Nut Picks Treasure Vine	599 Toast Servers, hand-pierced . . . Poppy
543 Nut Spoons, hand-pierced . . . Poppy	600 Tomato Servers, hand-pierced . . Poppy
	601 Vegetable Forks, hand-pierced . . Poppy
	602 Vegetable Spoon Poppy
	603 Waffle Servers, hand-pierced . . Poppy

 Bartlett & Company, The Orr Press. New York

Figure A.15 from Reed and Barton's *Intaglio* catalog

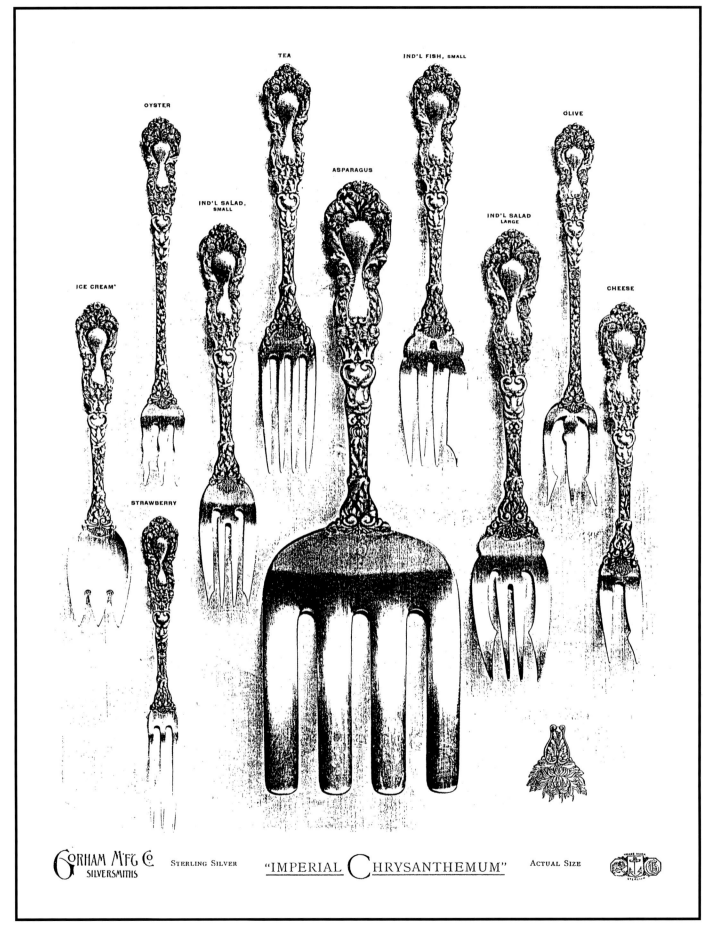

*Figure A.16 from Gorham's *Imperial Chrysanthemum*.
NOTE: Items marked with a * are not available from Eden Sterling

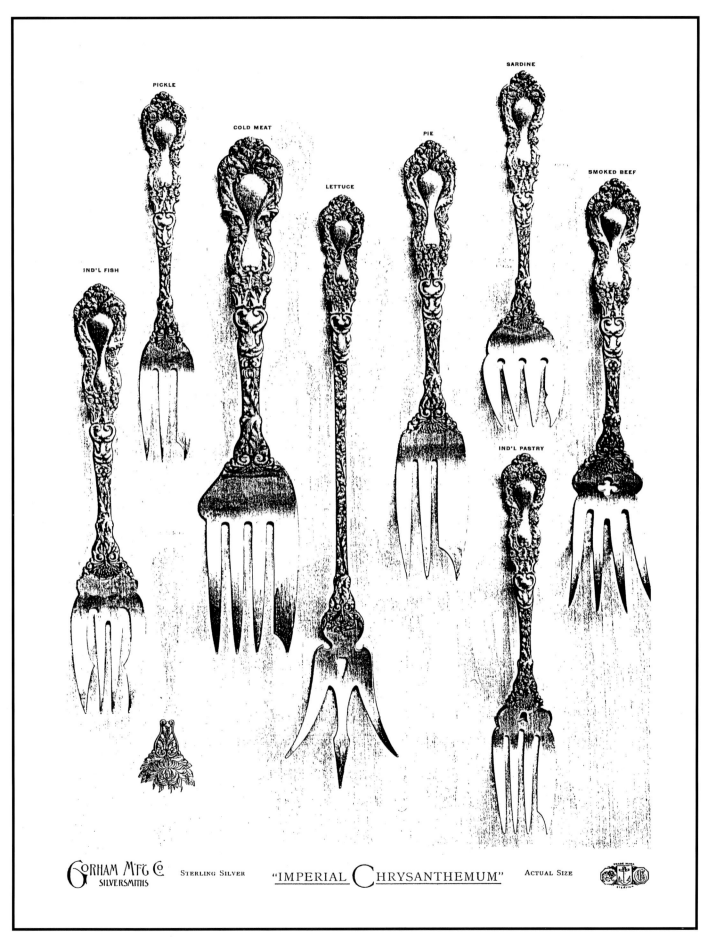

*FigureAl.17 from Gorham's *Imperial Chrysanthemum*

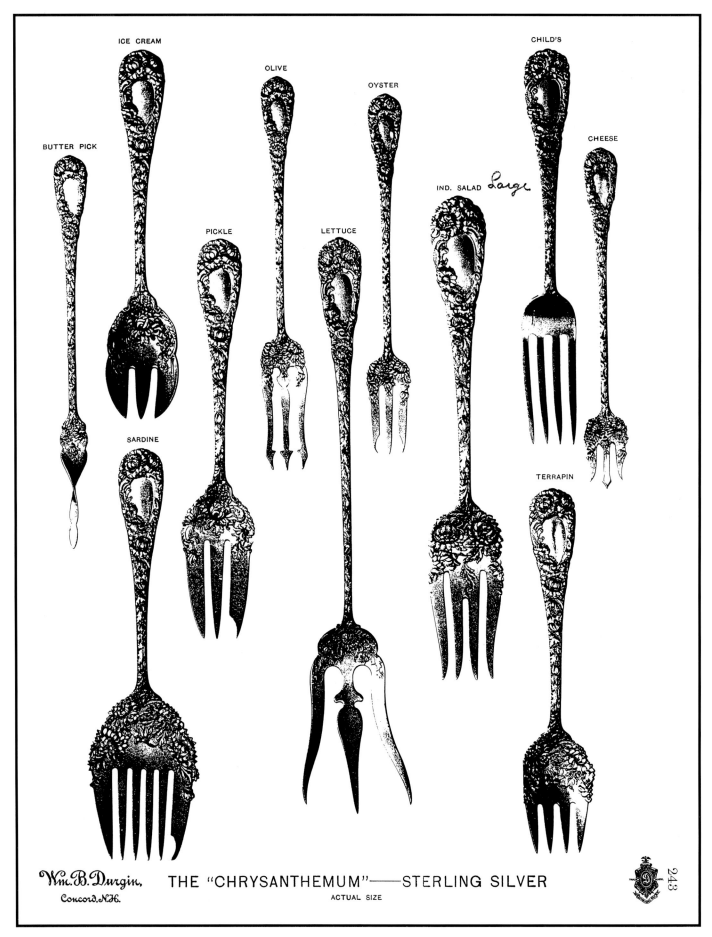

BUTTER PICK

ICE CREAM

OLIVE

OYSTER

CHILD'S

CHEESE

PICKLE

LETTUCE

IND. SALAD *Large*

SARDINE

TERRAPIN

Wm. B. Durgin,
Concord, N.H.

THE "CHRYSANTHEMUM"——STERLING SILVER

ACTUAL SIZE

243

*Figure A.18 Durgin's *Chrysanthemum*.

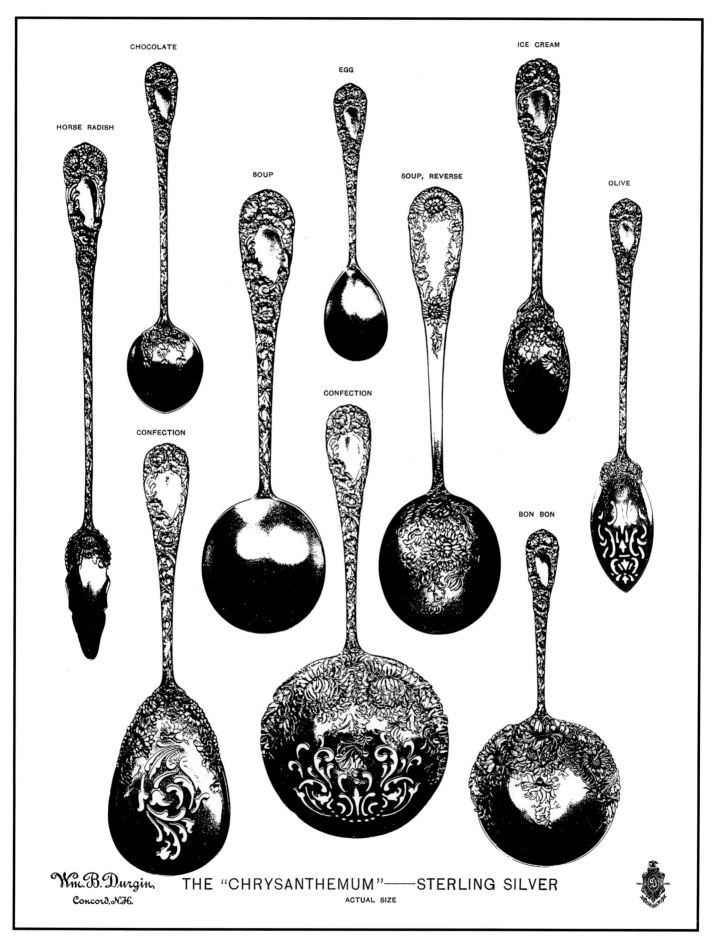

*Figure A.19 Durgin's *Chrysanthemum*.

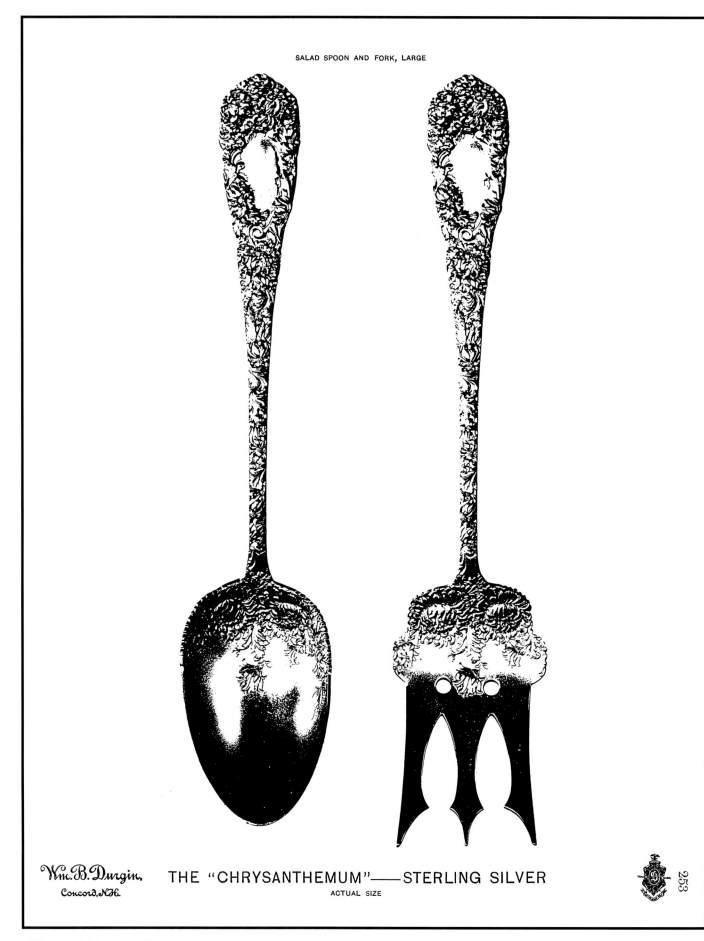

SALAD SPOON AND FORK, LARGE

Wm. B. Durgin.
Concord. N.H.

THE "CHRYSANTHEMUM"——STERLING SILVER

ACTUAL SIZE

253

*Figure A.20 Durgin's *Chrysanthemum.*

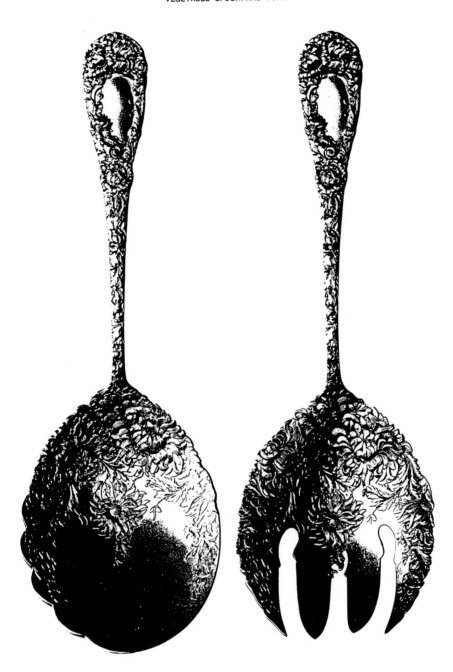

VEGETABLE SPOON. AND FORK

Wm. B. Durgin.
Concord. N.H.

THE "CHRYSANTHEMUM"——STERLING SILVER

ACTUAL SIZE

254

*Figure A.21 Durgin's *Chrysanthemum*.

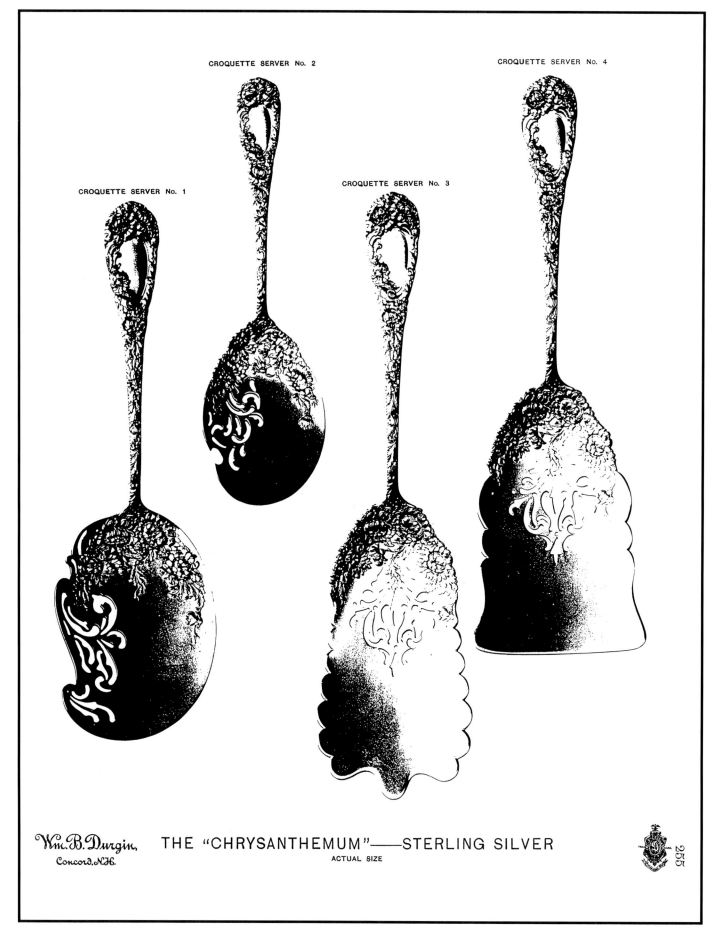

CROQUETTE SERVER No. 2

CROQUETTE SERVER No. 4

CROQUETTE SERVER No. 1

CROQUETTE SERVER No. 3

Wm. B. Durgin,
Concord, N.H.

THE "CHRYSANTHEMUM"——STERLING SILVER
ACTUAL SIZE

255

*Figure A.22 Durgin's *Chrysanthemum*.

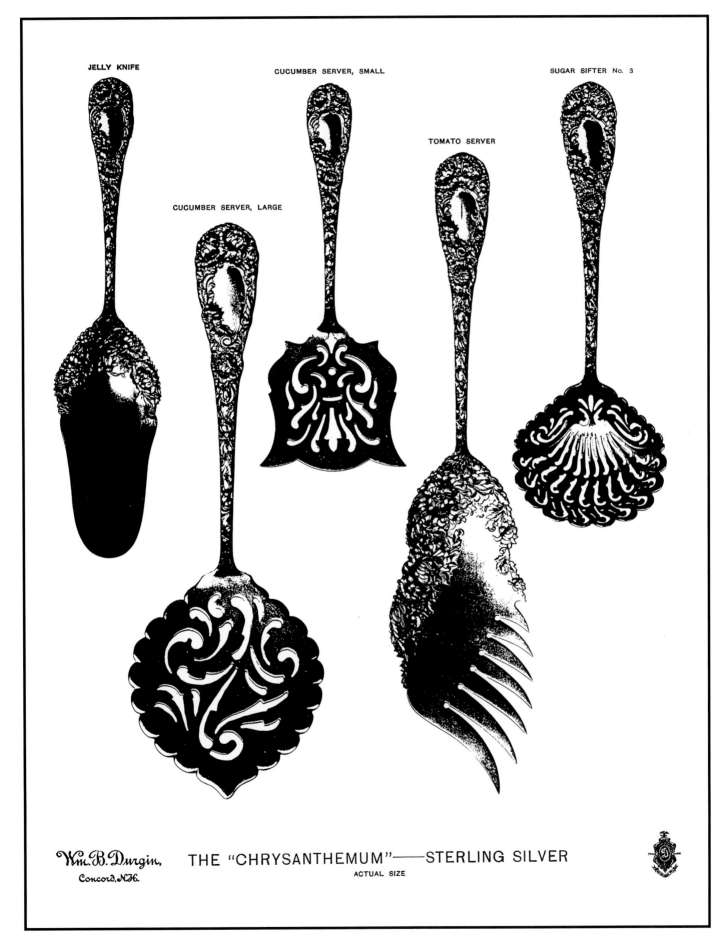

*Figure A.23 Durgin's *Chrysanthemum*.

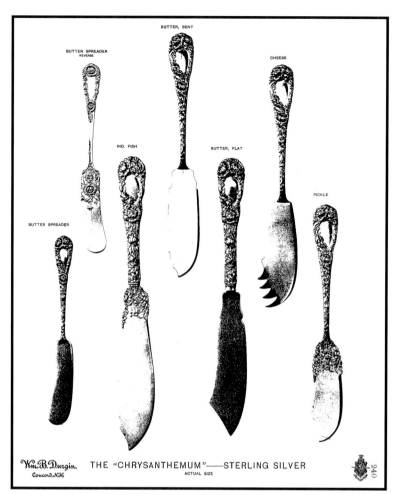

*Figure A.24. Durgin's *Chrysanthemum*.

*Figure A.25. Durgin's *Chrysanthemum*.

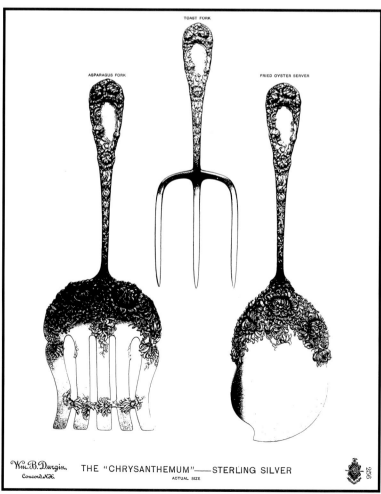

Appendix 2
Charts

These charts have proven very convenient for keeping records of sterling silver flatware. Collectors are encouraged to reproduce this page for use with their own collections. Each chart should be headed with the name of a particular type of item—Iced Tea Spoons, Asparagus Servers, Bird Sets, etc.; the details of each piece in the collection can then be cataloged in a list below. The columns for insurance information provide a helpful reminder, but keep in mind that insurers require professional appraisals. Please make copies as necessary.

PLACE PIECES: Item			Provenance		Date
Pattern	Cost	Monograms/Marks	Manufacturer	Insurance Schedule Y N	Value

SERVING PIECES: Item			Provenance		Date
Pattern	Cost	Monograms/Marks	Manufacturer	Insurance Schedule Y N	Value

Bibliography

Books

Agmew, Margaret Chason. *Entertaining with Southern Living.* Birmingham, Alabama: Oxmoor House, 1990.

Carpenter, Jr. Charles H., and Mary Grace Carpenter. *Tiffany Silver.* New York: Dodd, Mead & Company, 1978.

_____. *Gorham Silver.* San Francisco:Alan Wofsy Fine Arts, 1997.

Celebrating 150 Years of Haviland China 1842-1992., Haviland Collectors Internationale Foundation, 1992.

Chefetz, Shela. *Antiques for the Table.* New York: Viking Book Company, 1993

_____. *Modern Antiques for the Table.* New York: Penguin Studio Books, 1998.

Dolan, Maryanne. *1830's to 1990's American Sterling Silver Flatware.* Florence, Alabama: Books Americana, Inc., 1993.

Gaston, Mary Frank. *The Collector's Encyclopedia of Limoges Porcelain.* .Paducah, KY: Collectors Books, 1980.

_____. *Haviland Collectables & Objects of Art.* Paducah, KY: Collectors Books, 1984.

Giblin, James Cross. *From Hand to Mouth.* New York: Thomas Y. Crowell, 1987.

Hood Jr., William P. *Tiffany Silver Flatware.* Woodbridge, Suffolk, England: Antique Collectors' Club, 1999.

Klapthor, Margaret Brown. *Official White House China, 2nd Edition.* New York, Harry Abrams, 1999.

Ohrback, Barbara Milo. *Tabletops.* New York: Clarkson Potter/Publishers, 1997.

Osterberg, Richard F., and Betty Smith. *Silver Flatware Dictionary.* San Diego: A.S. Barnes, Inc., 1981.

Osterberg, Richard F. *Sterling Silver Flatware for Dining Elegance.* Atglen, PA: Schiffer Publishing Ltd. 1994.

_____. *Sterling Silver Flatware for Dining Elegance, 2nd Edition.* Atglen, PA: Schiffer Publishing Ltd. 1999.

Prentiss, Nancy. *The Perfect Hostess.* New Kensington, PA: Westmoreland Sterling, 1946.

Rainwater. Dorothy T. *Encyclopedia of American Silver Manufacturers, Third Edition Revised.* Atglen, PA: Schiffer Publishing Co., 1986.

Roberts, Patricia Easterbrook. *Table Settings.* New York: Bonanza Books, no date

Rinker, Harry L. *Silverware of the 20th Century: The Top 250 Patterns.* New York: The Ballantine Publishing Group, 1997.

Soeffing, D. Albert. *Silver Medallion Flatware.* New York: New Books, Inc., 1988.

Sterling Flatware Pattern Index. 4th Revision. Radnor, PA. 1989.

Travis, Nora. *Haviland China.* Atglen, PA: Schiffer Publications Ltd., 1997.

_____. *Evolution of Haviland China Design.* Atglen, PA: Schiffer Publications, Ltd., 2000.

Turner, Noel D. *American Silver Flatware.* San Diego: A.S. Barnes and Co., 1973.

Venable, Charles L. *Silver in America, 1840-1940.* New York: Harry N. Abrams, Inc., 1994.

Venable, Charles L., Ellen P. Denker, Katherine C. Grier, and Stephen G. Harrison. *China and Glass in America, 1880-1980.* New York: Harry N. Abrams, Publishers, 2001.

Waterbrook-Clyde, Keith & Thomas. *The Decorative Art of Limoge.* Atglen, PA: Schiffer Publishing Ltd., 1999

_____. *Distinctive Limoges Porcelain.* Atglen, PA: Schiffer Publishing Ltd., 2001

Young, Harriet. *Grandmother's Haviland.* Des Moines: Wallace-Homestead, 1970.

Catalogs

The "Buttercup" Gorham, Providence, Rhode Island, no date

Chambord Pattern, Reed and Barton, Taunton, Rhode Island, no date

The Gorham Mark, Serial No. 705AN, New York, c. 1914.

Francis I, by Reed and Barton, Taunton, Massachusetts, no date

Intaglio, Reed and Barton, Taunton, MA, no date

Virginiana, Gorham, Providence, Rhode Island, no date

Index

Pattern Index

Serving Pieces Index

Flatware Catalog

Excerpts